CW01023212

£33-75

PERSIAN
FLATWEAVES

PERSIAN FLATWEAVES

A Survey of Flatwoven Floor Covers and Hangings
and Royal Masnads

Parviz Tanavoli

Translated from Persian to English by Amin Neshati

ANTIQUE COLLECTORS' CLUB

©2002 Parviz Tanavoli

World copyright reserved

ISBN 1 85149 335 2

The right of Parviz Tanavoli to be identified as author of this work has been asserted by him in accordance with the Copyright, Designs and Patents Act 1988

All rights reserved. No part of this publication may be reproduced, stored in a retrieval system, or transmitted in any form or by any means electronic, mechanical, photocopying, recording or otherwise, without the prior permission of the publishers.

British Library Cataloguing-in-Publication Data
A catalogue record for this book is available from the British Library

Frontispiece: *The field of a mid-late 18th century gelim (see Plate 4).* PRIVATE COLLECTION

Printed in Italy
Published in England by the Antique Collectors' Club Ltd.,
Woodbridge, Suffolk

THE ANTIQUE COLLECTORS' CLUB

The Antique Collectors' Club was formed in 1966 and quickly grew to a five figure membership spread throughout the world. It publishes the only independently run monthly antiques magazine, *Antique Collecting*, which caters for those collectors who are interested in widening their knowledge of antiques, both by greater awareness of quality and by discussion of the factors which influence the price that is likely to be asked. The Antique Collectors' Club pioneered the provision of information on prices for collectors and the magazine still leads in the provision of detailed articles on a variety of subjects.

It was in response to the enormous demand for information on 'what to pay' that the price guide series was introduced in 1968 with the first edition of *The Price Guide to Antique Furniture* (completely revised 1978 and 1989), a book which broke new ground by illustrating the more common types of antique furniture, the sort that collectors could buy in shops and at auctions rather than the rare museum pieces which had previously been used (and still to a large extent are used) to make up the limited amount of illustrations in books published by commercial publishers. Many other price guides have followed, all copiously illustrated, and greatly appreciated by collectors for the valuable information they contain, quite apart from prices. The Price Guide Series heralded the publication of many standard works of reference on art and antiques. *The Dictionary of British Art* (now in six volumes), *The Pictorial Dictionary of British 19th Century Furniture Design*, *Oak Furniture* and *Early English Clocks* were followed by many deeply researched reference works such as *The Directory of Gold and Silversmiths*, providing new information. Many of these books are now accepted as the standard work of reference on their subject.

The Antique Collectors' Club has widened its list to include books on gardens and architecture. All the Club's publications are available through bookshops world wide and a full catalogue of all these titles is available free of charge from the addresses below.

Club membership, open to all collectors, costs little. Members receive free of charge *Antique Collecting*, the Club's magazine (published ten times a year), which contains well-illustrated articles dealing with the practical aspects of collecting not normally dealt with by magazines. Prices, features of value, investment potential, fakes and forgeries are all given prominence in the magazine.

Among other facilities available to members are private buying and selling facilities and the opportunity to meet other collectors at their local antique collectors' clubs. There are over eighty in Britain and more than a dozen overseas. Members may also buy the Club's publications at special pre-publication prices.

As its motto implies, the Club is an organisation designed to help collectors get the most out of their hobby: it is informal and friendly and gives enormous enjoyment to all concerned.

For Collectors — By Collectors — About Collecting

ANTIQUE COLLECTORS' CLUB
Sandy Lane, Old Martlesham, Woodbridge, Suffolk IP12 4SD
Tel: 01394 389950 Fax: 01394 389999
e-mail:antiquecollecting@antique-acc.co
website: www.antique-acc.com
—— or ——
Market Street Industrial Park, Wappingers' Falls, NY 12590, USA
Tel: 845 297 0003 Fax: 845 297 0068
e-mail: info@antiquecc.com
website: www.antiquecc.com

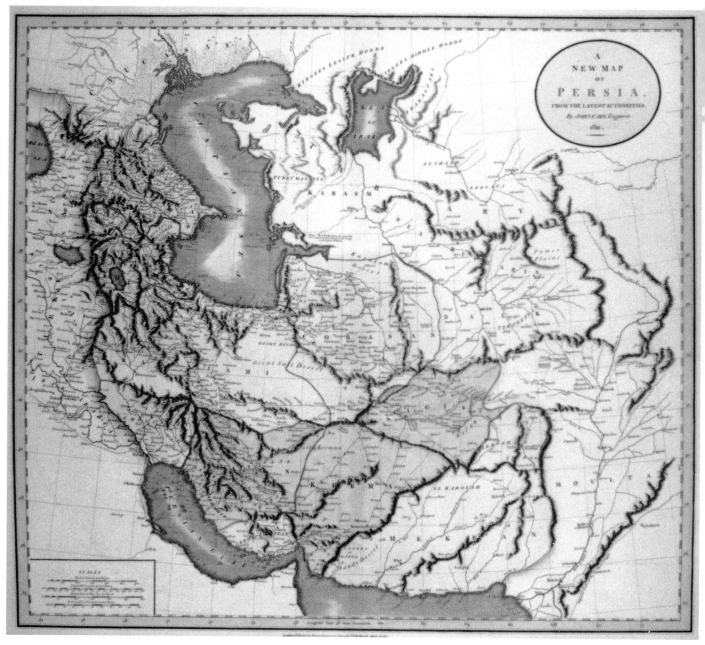

FIGURE 1. *Map of Iran by John Cary, Engraver, published in 1811, London. 51.5 x 45.5cm (201/4 x 18in.).*

COLLECTION J.G. WAIBEL, VANCOUVER, CANADA

CONTENTS

ACKNOWLEDGEMENTS

During the various stages of the preparation of this book for press, I have received help from friends and others too numerous to mention in a few lines. Among them I feel indebted most to the simple-hearted and kind folk in the remote villages and tribal areas in the heart of the plains and mountains of Iran. Not only did I spend many an hour in their clay dwellings and tents, benefiting from the valuable information they provided about their *gelims* and *palases*, but also I partook of their meals. Not once, however, do I recall them ever asking for or accepting anything from me. Perhaps it is best that their kindness and generosity, like their *gelims* and *palases*, remain unattached to any single name.

Throughout the writing of this book, I must admit, fortune has been on my side and has placed helpful people in my path. I feel duty bound to mention some of them beginning with my daughters, Tandees and Tandar. In the process of writing the book I have availed myself more of the assistance of Tandees and Tandar than of anyone else. Whenever they saw their father in need of help – and such instances were not rare – they offered their unstinting support.

Amin Neshati is another person with whom I have had the opportunity of collaborating. With his command of both English and Persian, and his meticulous care and faithfulness in the work of translation, this important phase has also come to a successful conclusion.

Qasem Salimi was always on the ready for travelling. The companionship of a fellow-traveller and skilful photographer like him has been of immense value to me, and some of his photographs are included in this book.

There are other colleagues and friends in various fields whose assistance I have called on. Among them I must mention Houshang Adorbehi, Philip Cooper, Primrose Elliott, Alan Marcuson, Moqaddam Tehrani, Marie-Louise Nabholz-Kartaschoff, Sarah B. Sherrill, Abolala Soudavar, Richard Tapper, Jon Thompson and Werner Weber.

I would also like to express my heart-felt gratitude to museum curators, auction houses and rug collectors who, by placing their holdings at my disposal, have considerably enriched this volume. Among them Adil Besim Gallery, Siawosch Azadi, Ferdi Besim, Rippon Boswell, Roger G. Cavanna, Thomas Cole, Guiseppe Contillo, Michael Craycraft, Theo Haberli, Eberhart Herrmann, Kailash Gallery, Heinrich Kirchheim, Fritz Langaur, Uno Langmann, Sion Mahgerefteh, Murat Nemet-Nejat (Murat Oriental Rugs), Yanni Petsopoulos, Hamid Sadighi, Sailer Gallery, Qasem Salimi, Daniel Shaffer, Manijeh Tanavoli, Ignazio Vok and J.G. Waibel.

Finally, I would like to acknowledge my indebtedness to individuals and institutions who provided much-needed photographs. Their names, along with information on the material and sources, appear elsewhere in the book.

Parviz Tanavoli

INTRODUCTION

Of all the products manufactured by human hands, textiles are among the most vulnerable to damage. It is very rare to find a piece of fabric among the thousands of metal or earthenware artefacts dug up every year in Iran. Unlike Egypt or Peru, Iran's humid soil is inhospitable to textiles and any such pieces laid to rest in the earth have long since been reduced to dust. In any historical study of Iran's textiles and floor coverings, therefore, it is necessary to turn to other art forms, such as poetry and painting, for information. Judging from poetic allusions or the works of travellers, there were countless weavings in Iran. The terms relating to weaving could alone fill a sizeable volume.

According to historical sources, a thousand years ago every town in Iran had its own variety of weavings and floor coverings. Some products were of such fine quality that they established a reputation for the towns in which they were made. The type of weaving also served as a sign of distinction: the wealth of kings and nobles was indicated by the soft, silken textiles which they wore as garments or used as floor coverings, and which complemented their silver and gold utensils. Sufis and dervishes, having turned their back on earthly possessions, were recognized by their rough woollen clothes and spreads. However, all that remains of this ancient tradition is no more than a few fragments.

This book, which focuses on the flatwoven floor covers used by tribespeople and villagers, is based from necessity on literary sources and the objects that remain. Even with such a narrow scope, this work is not complete or exhaustive, but rather a succinct overview. A complete volume can (and should) be written about each of the types of floor covering discussed here. (For instance the *palas*, a floor cover with a different structure from the *gelim*, is no less important than the *gelim*, which has found a permanent place in the culture of rug-weaving, yet there is not even a single published article on the *palas*). The names of some floor coverings, as we shall see, do not even appear in carpet literature.

Iranian homes traditionally lacked any furniture in the Western sense of the term – rugs and other woven objects filled this role. The dining table was the *sofreh*, a woven fabric spread on the floor. Iranians sat on the floor rather than on chairs, while providing *masnads* (floor covers used for dignitaries), *mokhaddehs* (seat cushions) and *rufarshis* (a form of carpet cover) for their guests. They decorated their walls with fabric hangings instead of paintings and in place of chests of drawers, cupboards and hard wooden beds they had cloth containers, woven drapes and soft bedspreads such as the *gabbeh* and the *palas*. The floors in their mosques and shrines were fully carpeted. Where it was warm and dry, city dwellers would spread cotton floor coverings which were adorned in white and blue, the first to alleviate the heat and the second to palliate their acute shortage of water. Among tribespeople woven textiles were far more important than among city-dwellers. Even now some of them live in homes made out of wool or goat hair. Their nomadic wandering has taught them to keep life's necessities light and portable.

The cultural history of a rug is far more important than the material it is made of. If a rug is analysed merely on the basis of its knot count, delicacy or choice

of colours, then only one part of its pedigree is established. There remains a whole unexplored area: its cultural dimension. Many of the rugs we see today were not woven merely as floor covers; they also embody certain other functions and traditions. It is only through studying these that one can truly fathom a rug's significance.

Our knowledge of these functions today would have been far greater had the Europeans and Americans who first devoted themselves to the study, introduction and trade of Persian and Turkish rugs had paid greater attention to the culture and traditions that accompanied them. Many of these traditions were more vital a hundred years ago than they are today, but these men were so captivated by the rugs' alluring colours, designs and patterns that their cultural significance held little attraction for them.

This book is a preliminary attempt at linking the past with the present and finding the connection between the material that has gone into the making of a rug and its cultural and utilitarian aspects. With a single fossil the palaeontologist is able to reconstruct a prehistoric creature; similarly, with the aid of Iran's literary and artistic tradition, I propose to reconstruct some of the textiles and rugs of the past.

I believe it is wrong and unfair to view all rugs as mere floor coverings or handicrafts. Many of the examples discussed in this book have all the criteria that distinguish works of art. Creativity, the chief among them, is woven into each warp and weft.

PART 1

BACKGROUND

Along a vast stretch of land in the south-western region of Asia stretches a plain, bounded by lofty mountains, that today is called Iran. The Alborz (Elburz) mountain range, after its break with the mountains of Armenia, runs east along the southern coast of the Caspian Sea and joins the Hindukush. It marks the northern and eastern frontiers of the plain. To the west and south-west of the plain stretch the Zagros mountains, extending from the Caucasus to the Gulf of Oman and running along the Persian Gulf coast through Kurdestan, Lorestan, Fars and Kerman.

This extensive area is known as the Iranian plateau. It has been politically united only for brief periods, usually ones that witnessed the ascendancy of mighty empires such as those of the Achaemenids (530-330 BC), the Sassanids (AD 224-642) and the Safavids (1501-1732). From the beginning of the nineteenth century onwards its borders shrank, so that present-day Iran, with an area of approximately 1.65 million square kilometres (1.02 million square miles, nearly three times the size of France), is one-third smaller than it once was. With its extensive areas of mountains and plains and its varied climes, Iran has long provided an ideal home for the nomadic and migratory tribes whose weaving makes up a large part of this book.

Iranian soil has been inhabited for at least 40,000 years.[1] The first true Iranian civilization, however, was that of the Elamites, which existed 4,000 years ago. The difficulty of their language has thwarted efforts to learn more about them, but there are other relics – such as the extraordinary ziggurat temple towers – that bear witness to the brilliance of their civilization.

The land of the Elamites lay in western Iran, the region now known as Khuzestan, Lorestan and Bakhtiari. In the first pre-Christian millennium, the Elamites were the dominant power in the region, responsible for the overthrow of the Sumerians. Later, they themselves fell to the Assyrians. Other ethnic groups that existed during the reign of the Elamites and later rose to power included the Medes in Kurdestan and Azarbaijan, and the Persians in Fars. Ultimately, the Persians prevailed over the Medes and established the Achaemenian dynasty which lasted from 550-330 BC. The Greek word Persus, which was erroneously applied to the entire land of Iran, is a remnant of those times.

Eastern Iran (present-day Khorasan) witnessed the rise of another group, the Parthians, who assumed power after the fall of the Achaemenids. They went on to rule for five hundred years (250 BC-AD 224). Although two thousand years separate us from these ancient people, there are many today who consider themselves their lineal descendants. Thus, the Kurds are traced back to the Medes, the Lors to the Elamites and the people of Sistan (south-east Iran) to the Sakas. The names of some people, such as the Kurds, have retained the same form that we find in Greek histories and in Achaemenid rock inscriptions. References to the Lors and the Baluch go back a thousand years, and the land that these people presently occupy corresponds to the territory mentioned in the historical sources.

After the Arab conquest of Iran in the seventh century, several waves of western invaders joined the native population. A few centuries later the Ghuz Turks and the Mongols began to appear. Some of these outsiders, among them the Arabs and the Mongols, mingled with the Iranians and were assimilated, so much so that they relinquished their own languages. Many of the Turks, however, despite their existence among Iranians and Persian-speakers, clung for a long time to their own traditions and language. Even if their names and languages have now changed, the tribal people of today are closely related to those of the past.

There has been a considerable shift in the demographics of Iran since the nineteenth century, when half of the population consisted of nomadic tribes. By about 1882 the population was more or less evenly divided among tribespeople, city dwellers and villagers; the recent census shows the tribal population as less than five per cent, the number of village dwellers on a sharp decline and urban population on the rise. Iran's various governments have dealt with the nomadic tribes in different ways. Until the turn of the twentieth century, these tribes formed the backbone of the Iranian army and had the duty of guarding the nation's borders. Today they play little role in national affairs. Their territory is slowly shrinking and being taken over by developers to build homes, towns or industrial complexes. Sometimes even their migratory routes from the colder climes to warmer ones are closed off, and they are gradually being compelled to settle down and abandon their tents and herds.

Most of the weavings dealt with in this book are from the nineteenth century or the early years of the twentieth, a time when the nomadic tribes still enjoyed some influence and status. Although certainly not an easy task, it is still possible to trace the link between these weavings and their original makers and owners.

FLATWEAVES IN ANCIENT PERSIA

Weaving enjoys a special place in Persia's mythology. It plays a part in legends surrounding the first humans on earth, for example, and one of Persia's earliest kings. On metamorphosing from plants into human form, Mashyak and Mashyanak (the Persian Adam and Eve) spun thread from their own hair, out of which they wove their clothes.[2] The legendary King, Jamshid, meanwhile, is credited not only with the discovery of fire and the smelting of iron, but also with teaching his subjects the art of spinning, weaving and sewing.[3]

Just as weaving was considered important and familiarity with it a source of pride, ignorance of the art was condemned as a flaw. One of the qualities that distinguished Persia's mythological demons (divs), and highlighted their barbarity and lack of refinement, was their unfamiliarity with sewing and weaving.[4]

There is archaeological evidence of the importance of weaving to Persians. Stone reliefs in Persepolis depict a retinue of gift-bearers taking spun yarn and textiles to Darius the Great (Figure 3). An Elamite stone relief, dating to the first millennium BC, vividly depicts a queen or a princess spinning thread

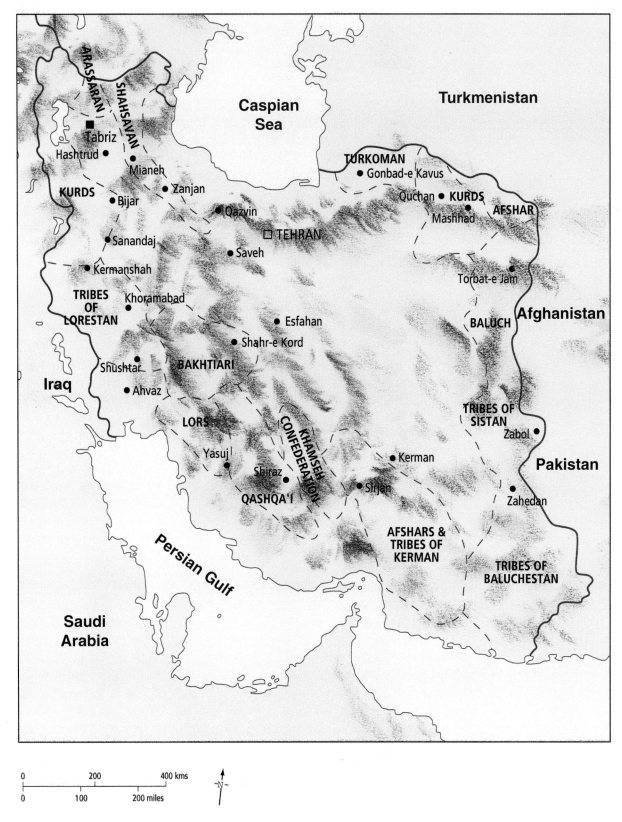

FIGURE 2. *Distribution of the tribes of Iran.*

13

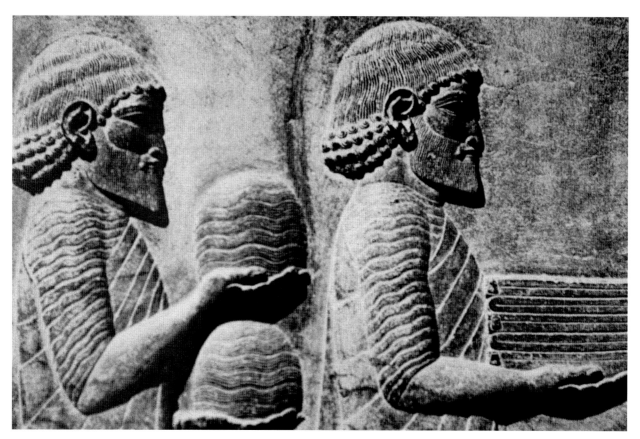

FIGURE 3. *Detail, Persepolis relief showing yarn and textiles being offered to the king. 5th century BC.*

(Figure 4). The bronze and stone spindles and other implements of spinning and weaving that have survived from pre-Christian eras testify to the importance of the craft among royalty. The care that has gone into the making of these implements indicates that they were not intended for the general populace (Figure 5). Remnants of these ancient traditions can still be seen among the nomadic tribes. The rugs produced by the wives of khans (tribal leaders), called *bibi-baf*, are still among the finest of all weavings in Persia, and command the highest price.

Along the shores of the Caspian Sea and in parts of Kurdestan, woven pieces have come to light that date back to 5000 or even 6000 BC.[5] Other specimens have been found from the Elamite era and the third millennium BC onwards. Most of these fragments are fabrics rather than floor coverings. Regarding the latter, however, there are references by the Greek historian Xenophon to the status they enjoyed in Achaemenid Persia,[6] although he makes no distinction between the pile-woven and the flatwoven varieties. A statement by Athenaeus (c. AD 192-230), however, removes all doubt about the Persian mastery of the art of flatweaving. He refers to a Persian carpet embroidered with exquisite art, having some beautiful designs of figures woven into them with minute skill.[7] This is borne out by extant remnants. Alongside the famous Pazyryk rug discovered in a mausoleum in the Altai mountains in Siberia, a knotted-pile carpet which has been carbon-dated to 500 BC, were found two *gelim*-woven

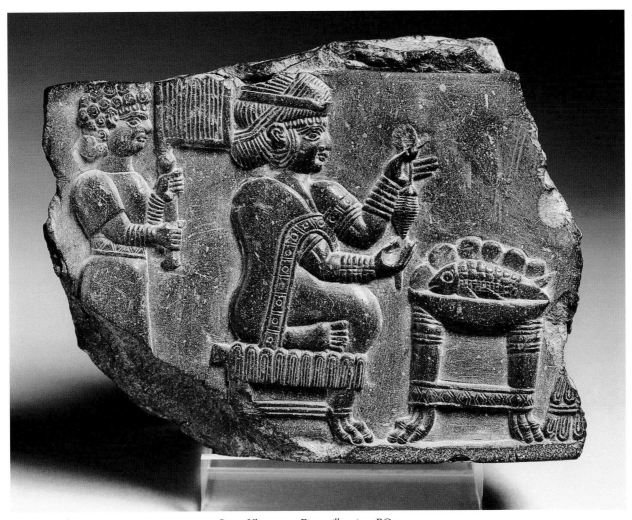

FIGURE 4. *Elamite queen or princess spinning, Susa, Khuzestan. First millennium BC.*

MUSÉE DU LOUVRE, PARIS

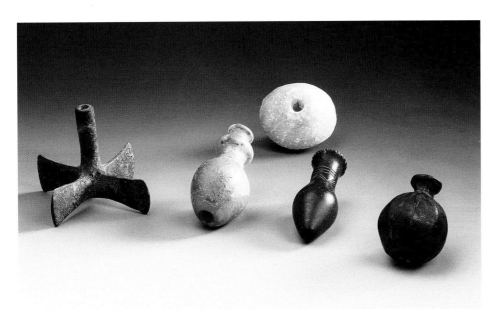

FIGURE 5. *Bronze and marble spindles, north-west and west Iran. First millennium BC.*

PRIVATE COLLECTION

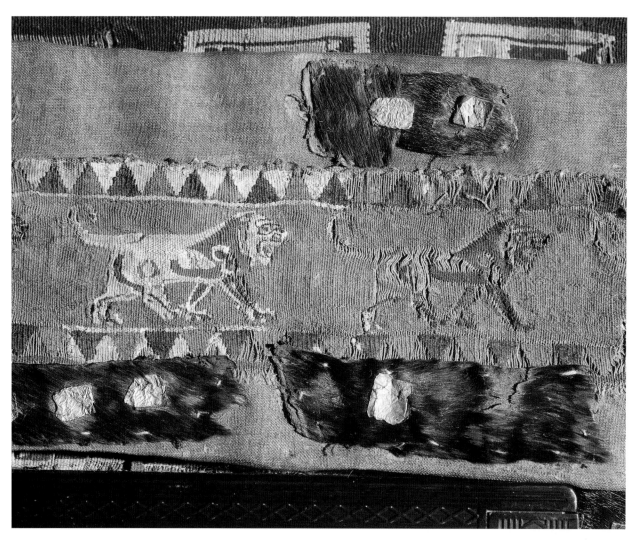

FIGURE 6. *Procession of Lions, wool tapestry from Pazyryk. 5th to 4th century BC. 7 x 80cm (2¾ x 31½in.).* HERMITAGE MUSEUM, ST PETERSBURG

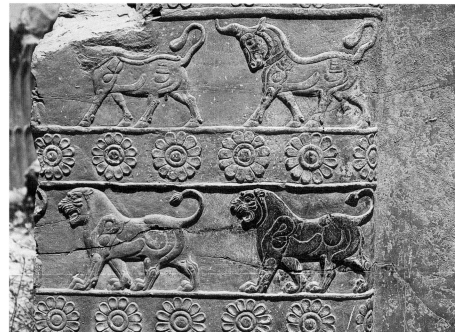

FIGURE 7. *Procession of Lions, Persepolis, 5th century BC.*

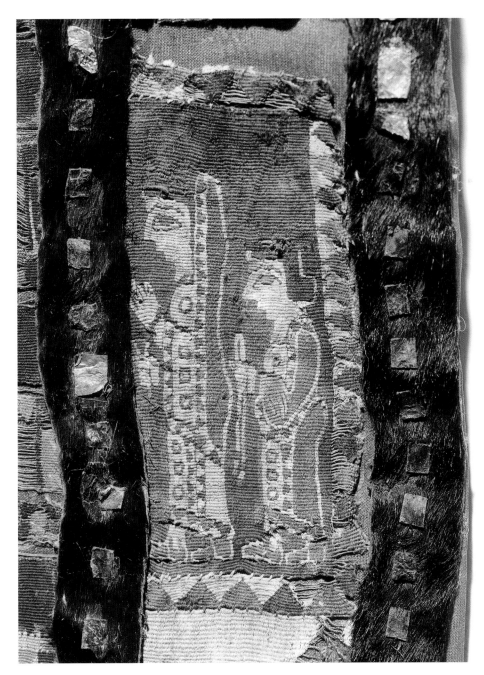

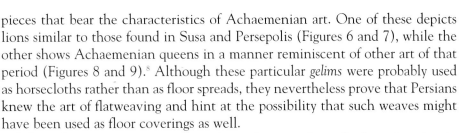

FIGURE 8. *Achaemenid queen or princess, detail of a wool tapestry from Pazyryk. 5th to 4th century BC.*
HERMITAGE MUSEUM, ST PETERSBURG

FIGURE 9. *Kohl flask in shape of a queen. West of Iran. 7th to 5th century BC. Bronze, height 8.5cm (3⅜in.).*
PRIVATE COLLECTION

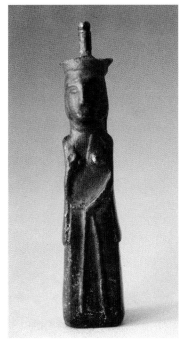

pieces that bear the characteristics of Achaemenian art. One of these depicts lions similar to those found in Susa and Persepolis (Figures 6 and 7), while the other shows Achaemenian queens in a manner reminiscent of other art of that period (Figures 8 and 9).[8] Although these particular *gelims* were probably used as horsecloths rather than as floor spreads, they nevertheless prove that Persians knew the art of flatweaving and hint at the possibility that such weaves might have been used as floor coverings as well.

Other *gelim*-woven coverings have been discovered not far from this site, in areas adjacent to Persia.[9] Of these, the simpler examples were most probably used as floor spreads while the more elaborately patterned pieces had other uses. Those found in Qomes (near Damghan), dating back to the fifth or sixth

century AD,[10] are of this latter type (Figure 10). The famous rug known as Khosrow's Baharestan (Spring Palace) has been considered by some as a drape or wall hanging because of its complex pattern. The Arab writer Tabari (d.922), however, refers to its use as a floor covering as well. Tabari's description of the Arab seizure of this rug in the palace of Khosrow Parviz, the last powerful Sassanian king, hints at the importance of weaving in those days:

> They found a floor covering of silk brocade, sixty cubits by sixty cubits…They laid it out in the winter, at a time when no flower bloomed anywhere, when the earth was nowhere covered in verdure, even as that floor covering was woven all around the edges with green emeralds and chrysolite. Umar had all those precious stones and that floor spread torn up and gave to each man a piece…One piece of that floor covering came into the possession of Ali b. Abi Talib – may God be pleased with him – which, together with all its gems, he sold for a thousand dirhams.[11]

There has been much debate about this rug, and its intended use. Tabari's reference to the precious stones worked into this piece has led some to believe that it was not meant for floor use but employed as a wall hanging or curtain. Others rejected this notion because of the dimensions of the rug and its weight. Considering the legendary wealth of Khosrow Parviz, it is not improbable that this rug was a flatwoven silk piece embroidered with emeralds and chrysolite.[12]

While no flatwoven rugs have come to light which date from the early Islamic era, numerous references to them in the writings of the period attest to the endurance of this weaving tradition – albeit with changes in pattern and design – following the advent of Islam. I have dealt with these rugs and the continuity or change in their weaving wherever appropriate in the book.

REASONS FOR THE SCARCITY OF OLD PERSIAN FLATWEAVES

The past two decades or so have witnessed greater access to Anatolian gelims than ever before. Many first-rate exhibitions, and their accompanying catalogues and other literature, have provided an invaluable opportunity to examine them. The discovery of hundreds of old *gelims* within a short time-span has raised several questions. Where had these *gelims* been, and how was it that no one had paid them any attention until the 1970s? Where, particularly, were Persia's *gelims* from bygone eras and what had become of them?

As was the case with antique rugs, Anatolian *gelims* were mosque property in Turkey. The best explanation for their endurance is the lack of interest and demand for them. As will be seen in the section on the *gelim* below, even veteran rug collectors and researchers persisted in ignoring *gelims* in the years following World War II, when pile rugs were being discarded. The mosques, therefore, remained the safest and most secure repositories for them. One may ask why the same thing did not happen in Persia. How is it that Persian mosques, all of which are carpeted, own no antique rugs or *gelims*? What became of the floor spreads in Persian mosques, and where are they now? The answer lies in the factional differences between the two countries in terms of the Islamic religion. It is only

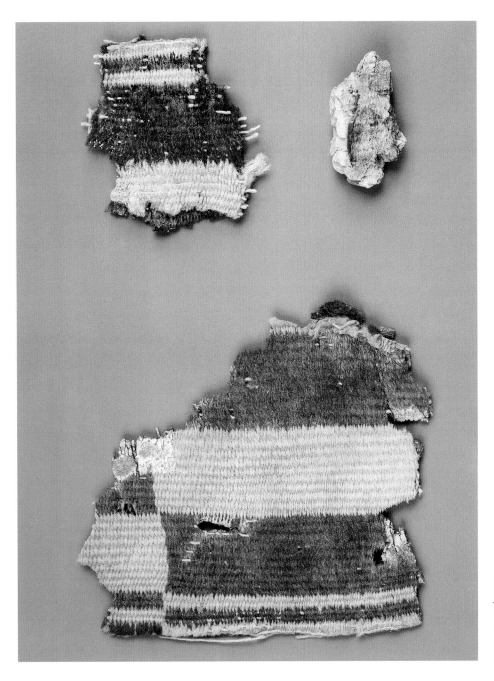

FIGURE 10. *Flatwoven fragment, Shahr-e Qomes, Damghan. 6th century AD. All wool. Length 13cm (5in.).* METROPOLITAN MUSEUM OF ART, NEW YORK, INV. NO. 69.24.32 ABC

by paying attention to these that the causes for the abundance of antique rugs in Anatolia, and their scarcity in Iran, can be explained.

There are explicit instructions in the Koran bidding Muslims to pray in mosques. Islam assigns greater value to prayer and worship in the mosque than that performed at home. Muhammad himself frequently prayed in mosques and encouraged his followers to do the same.[13] Here was a place for the faithful to gather together and exchange ideas. From the Prophet's time onwards, then, mosques became akin to a second home for Muslims. It was common to find believers who, in addition to visiting for the five daily prayers, would spend a good deal of their time in the mosque and would play an active role in the extension and renovation of their place of worship. In the big cities it was the

kings and rulers who built the mosques, but in the villages this solemn duty fell to the general populace. The same was true for the carpeting of mosques. The rugs in city mosques were commissioned by royalty, while the carpeting of village mosques was provided by commoners. Rugs were considered a necessity, for all manner of traffic and worship occurred in a mosque, and few mosques remained bare. Moreover, owing to the prevalence of rug-weaving among Persians and Turks, there was no shortage of the commodity. Each area had specific varieties of rugs, and the local variety of weave became the rug of choice for the mosque. This continues to be true today.

Rugs, or for that matter any goods given to mosques, assumed the form of an endowment (waqf) and became the permanent property of the mosque which the prayer leader or custodian was duty-bound to preserve. Islamic jurisprudence condemns any unlawful seizure or appropriation of endowment property, particularly mosque property, and such strictures retained their significance until very recently among orthodox Muslims (such as the Ottoman Turks) who believed in a very literal implementation of Koranic injunctions. Shi'ism too treats waqf with great respect, but also has a provision called tabdil be ahsan, meaning to trade a property for something better.[14] In other words, the custodian has the authority, if he sees waqf property in the process of degeneration or damage, to sell it or trade it in and procure something else. Such judgement is left to the discretion of the custodian, who might well exchange a centuries-old rug that is tattered and falling apart for a newly woven rug. Many rugs would have been traded in this way, but the gelim and the palas were generally deemed inferior and were often given away to the poor. If the demand was too great for these floor coverings, they were cut into equal pieces and distributed.[15] It is for this reason that most of the floor spreads in Sunni mosques appear older and worse for wear than those in Shi'ite mosques. In Sunni mosques the tattered rugs remained and if the mosque acquired a newer floor spread, it was laid down on top of the old covering. Until not too long ago it was possible to see several layers of carpeting in a typical Ottoman mosque.

As well as the mosque, Shi'ite Iranians have another place for pilgrimage and worship: the emamzadeh, or shrine. Architecturally, the emamzadeh resembles the mosque and is crowned with a dome. Every emamzadeh holds the remains of a descendant of the Imam 'Ali or one of his children, and over the grave is placed a grillework sepulchre. Grasping the grilles and confiding their troubles to the Imam, pilgrims seek answers to their problems. They may bring a sum of money or a belonging as an oblation (nazr), or they may make a pledge to do so on their next pilgrimage. If their offering is money, they push it through the grilles themselves; if they have a gift, they hand it to the custodian. The less well off – particularly villagers and tribespeople – often bring as an offering floor spreads that they have woven themselves. Some of these grace the rooms in the shrine, while others are traded for objects of greater value (tabdil be ahsan). The number of these floor spreads is sometimes so great that they would more than fill a large warehouse. Only major centres of pilgrimage, such as Imam Reza's

mausoleum in Mashhad or the shrine of Ma'sumeh in Qom, have such large storage facilities. The smaller and more remote *emamzadehs* have no such capacity and therefore sell the surplus pieces.

With the hundreds of *emamzadehs* that dot the landscape in predominantly Shi'ite areas, the number of religious centres in Iran (mosques, *emamzadehs*, *takiyehs*, and *hosayniyehs*),[16] is much greater than in Turkey. But because of the practice of selling any surplus, the number of antique rugs that remain – particularly of the flatweave variety – is far fewer. They amount to little more than a few *zilus*, preserved in the remote and inaccessible towns and villages in the desert areas.

Another noteworthy factor that has contributed to the destruction of Iran's cultural artefacts, including rugs, is war. In the past, there have been numerous conflicts between Iran and its neighbours, particularly the Ottomans and the Uzbeks, chiefly because of Iran's adherence to Shi'ism, which provoked the hostility of the northern Turks almost as intensely as did the infidels. The Safavid shahs held an equal hostility towards the Ottomans, likewise rooted almost entirely in religious rancour. On several occasions the Ottomans captured and sacked towns in Azarbaijan, Kurdestan and Hamadan. The Shi'a-Sunni conflict was equally fierce in the north-east, with much fighting between Iranians and their Uzbek neighbours. These wars peaked in the sixteenth and seventeenth centuries, both in number and in intensity.

Just as Iran was easing into a period of relative calm, the tribes of Afghanistan, after invading and conquering towns in the east, marched into Isfahan, the opulent capital of the Safavids.

During this time, and in subsequent years when Iran was contending with foreign powers and domestic turmoil, the Ottomans were firmly entrenched. During their five hundred-year rule Anatolia never fell to hostile forces and no enemy ever set foot in Constantinople (now Istanbul). The endurance of family loyalty (the house of Osman) was a major factor in the preservation of the Ottoman cultural heritage. Thus the palaces and mansions of the Ottoman sultans, together with their furnishings, remained safe. Their Persian counterparts were not so fortunate. With every change of ruler in Iran, the property of the vanquished was destroyed or plundered by the conquerors.

It should also not be forgotten that in the structure of Islamic government the capital was considered the seat of the public treasury (*bayt al-mal*), and the Ottoman sultans, who considered themselves the caliphs of the Muslim world, took great care in the preservation of the public trust. The Iranian shahs, on the other hand, laid no claim to the caliphate (with a few exceptions) and their belongings were not the property of the public treasury. Rather, in the manner of the Sassanian kings, such holdings were considered personal wealth which the rulers were free to give away. Most of the old rugs that are now preserved in the West were gifts made by the Persian shahs to European royalty. Clearly, each of the factors cited above has played a crucial role in the loss of Persia's historical and cultural artefacts.

SCHOOLS OF WEAVING

Just as there exist schools in the arts, such as painting or poetry, so there are schools in rug-weaving. Over a thousand years ago the anonymous author of *Hodud al-`alam* (982) noted the presence of such schools. He described the rugs of Sistan as being influenced by the Tabarestan (northern Iran) school, while the *zilus* produced in the same area followed the Jahrom school.[17] Critics may contend that schools are appropriate only where there are recognized artists as leaders. Yet in Europe before the Renaissance there were a number of schools in the arts, especially architecture, which had not been established by a single innovator. The styles now known as the Romanesque and Gothic, for instance, each constitute a distinct school of architecture, with local variations in different parts of Europe.

While it may be too late to classify pile rugs according to schools, such an opportunity still exists for flatwoven pieces. Flatweaves have not yet become commercialized to the extent that pile rugs have, and have not yet been affected by the standardization, homogeneity, mass-production and interest from the West that have befallen the latter. For example, producers in Tabriz, one of Iran's major centres of pile-rug production, are capable of making any kind of rug, in any dimension, with whatever design, pattern, material or knot count is desired. This variety stands in marked contrast to the long-established centres of weaving which have schools associated with their place-names, yet the likes of Tabriz are on the rise in Iran, Turkey and all other rug-exporting countries.

The situation is different with flatweaves. There are at least two schools of *jajim*-weaving in Iran, for example the Azarbaijan school, as discussed in detail later (page 274ff.); and the Fars school. The Azarbaijan *jajim* is squarish, has narrower stripes and comprises eight to ten pieces; while the Fars *jajim* is larger and more rectangular, has broader stripes and a coarser weave, and is made in two pieces. Even the two ends of these *jajims* are different. With the *gelim,* too, we can distinguish the two schools of Azarbaijan and Fars with the Azarbaijan *gelim* being large, the Fars *gelim* more conventional, and so on. Other distinguishing features are noted where appropriate in Part Two.

These individual schools also spawn satellite schools. The *gelims* of Varamin, for instance, are influenced by the Fars *gelim* in dimensions and by the Azarbaijan *gelim* in pattern and design. It is possible for one village to be influenced primarily by one school, and a neighbouring village by the other. The *gelims* of Zarand draw on the Kurdestan variety, and those of Saveh draw on both the Azarbaijan and the Fars varieties. In Khorasan, too, there are schools in *palas*-weaving and *jajim*-weaving. The *palas* of Muteh is inspired by the Khorasan variety (Plates 174 and 161), even though the two are separated by more than a thousand kilometres (over 600 miles). Within Khorasan itself there are *jajims* that are inspired by those of Azarbaijan (Plate 222).

Certain tribes and weaving areas form no particular schools, even though they have achieved great renown for the fineness and delicacy of their work. For

instance, the Qashqa'i *gelim*, regardless of its exquisiteness and beauty, is not the product of a separate school, inasmuch as it owes its existence to the Lors. Certain *gelims* from Bijar that have acquired a worldwide reputation are probably primarily influenced by the *gelims* of Takab.

Iran's turbulent history has given rise to a great diversity of rug-weaving schools, more so than in adjoining lands. The schools of weaving that arose in Iran were often temporary, flourishing when a dynasty was at its height, and declining when those rulers lost their power. Such was the case with the rugs woven in the Safavid tradition (1501-1732). Such schools of weaving can usefully be termed court schools. They were born in the major cities and gradually developed specific characteristics, so much so that the cities of Tabriz, Isfahan, Kerman and Kashan each have independent schools of rug-weaving associated with them – or at least did in the recent past. At the same time, the basic elements of the Safavid rug can be detected in all of them.

The same is not true for tribal and rural weaves. No dynasty or king was ever associated with a *khorjin* (saddle-bag), a *jol* or a *palas*. Nevertheless, rural and tribal weaves in each area have features and schools specific to themselves.

In general, therefore, despite the remarkable diversity found in tribal and village flatweaves, each of them can be traced to a source, and each of these sources in turn goes back to a common origin, forming a single mighty root. It is through linking these subsidiary roots, based on the common features found in groups of weavings, that one can arrive at the true schools, such as the Khorasan and the Zagros. However, a lot needs to be done before we can arrive at that point.

TERMINOLOGY
AND CATEGORIZATION
OF FLATWEAVES

The chief difficulty with the language of rug-weaving in Iran is that of generic use. The same word is employed when speaking of ten different kinds of weave; at the same time, there is no standard usage throughout the whole country, for every region has its own set of terms. In western Iran, for instance, *gelim* refers to several different kinds of flatweave, even though the majority of those weaves have a structure unlike that which is generally understood by the term. In the north-east, particularly in Khorasan, the word *gelim* is seldom used, with *palas* being the preferred term. People in the more arid parts of the country – Kashan, Yazd and Kerman – use the word *zilu* more than any other and often apply it to *gelim* and *palas* as well. The generic use of such words in different areas is related to the kind of weaving specific to them. *Gelim*-weaving has long been the speciality of the Zagros region, while *zilu*-weaving has been particular to desert dwellers and *palas*-weaving to the people of Khorasan (see pages 258 to 269).

This is not to say, of course, that each area was limited to only one kind of weaving. It seems probable that each region produced several kinds of weave, and this holds more or less true even today. But, as a rule, each region produced the kind of weave most in character with local conditions and the inclinations of the local people. Thus the specific term used became commonplace. Although the general public was, not surprisingly, unaware of the various kinds of weave, among the weavers and rug-sellers of the bazaar such confusion of language is somewhat surprising.

If this confusion has also been the case historically, how then can we rely on the writings of historians and geographers in earlier times as sources of information? For example, the anonymous author of *Hodud al-`alam* speaks of *zilu*-weaving in the towns of Azarbaijan, such as Khoy, Nakhjavan and Bedlis.[18] We know, however, that *zilu*-weaving was – and still is – specific to eastern Iran (see pages 258 to 269). The warm, arid climate of the area made the cotton *zilus* woven here far more attractive than any woollen floor cover. Conversely, in the mountainous and cold areas of Khoy and Nakhjavan woollen floor spreads such as the *gelim* and the *palas* were favoured over the cotton *zilu*. The only explanation would be that the *zilus* of Azarbaijan were also made of wool. But if we base our argument on such a supposition (not an entirely unreasonable one), then what becomes of the continuity of tradition? Why would *zilu*-weaving have been discontinued in Azarbaijan, and why are there no traces of it today?

It is not only historical records that confront us with problems; so does lexicography. *Borhan-e Qate'* (1652), one of the earliest Persian dictionaries in the modern style, defines *palas* as a kind of *jajim*, and *jajim* as a category of 'multi-coloured felt *namad*'.[19] Later lexicons are no less prolific in errors in distinguishing among the various kinds of weave. It is likely that historians and travellers who were not well versed in the business of weaving recorded what they saw using the terms then prevalent.

Another complication in the use of terms is the differences between both

language and the structure of weaves in the cultures of Iran and Turkey. *Jajim* and *zilu* are specific types of weave in Iran. *Jajim* is a warp-faced weave and, consequently, its pattern is striped (see page 270ff.). In Turkey, however, *jajim* (written *cicim* and pronounced *jijim*) denotes something different. It is a group of brocading weaves with an extra weft on a weft-faced plain weave ground – worlds apart from the original *jajim*, which in Iran is none other than the *palas* (see page 198ff.). Likewise, in Iran *zilu* is a weft-faced, compound weave generally of cotton; in Turkey *zili* refers to a supplementary weft weave on a plain-weave ground. The Turkish *zili* has no connection whatever with the Persian *zilu*, which also has other names. Most of the terminology of weaving, such words as *gelim*, *palas*, *zilu*, and *jajim*, is Persian. It is not clear why the Turks of Anatolia preferred these words to ones that must have existed in their own language, and why they altered the meanings of those terms over time.

Yet another stumbling block is the question of words that have fallen into disuse such as *gostardani*, *afkandani*, *besat* and *mahfuri*. Why, one wonders, did such words die out? Were these floor coverings different from the floor spreads in use today? Meanwhile, there are several current terms that have retained their specific meanings, *gelim*, *palas* and *zilu* among them. Other words which did not exist earlier have now been added to the lexicon of floor coverings, such as *verneh*, *mowj*, *shiraki* and *sumak* (or *sumakh*). Among all these terms it is the pile rug (*qali*) that has never posed a problem and has always been easily identifiable. It was universally recognized by that name and continues to be.

In general, the structure of all pile rugs is essentially similar, whereas it takes some skill to distinguish the different types of flatweave floor spreads. Moreover, that expertise in distinguishing between flatweaves, even in the West, is barely more than fifty years old – a young science by common standards.

Corruption of Textile Terminology

Perhaps the time has arrived for the promotion of a standard terminology relating to flatweaves. The discipline of rug and textile studies, which began in the mid-nineteenth century, has made great strides in the past half century, particularly in the last three decades. New terms have entered its vocabulary as advances have been made, with local terms being preferred over their European-language equivalents. Today the terms *khorjin*, *jajim* and *gelim* are universal in rug literature. *Gelim* or *kilim* is no longer simply a Persian or Turkish word but has entered Western languages. The reason why Westerners have chosen the Turkish pronunciation over the Persian original is worth examining. The terms *gelim* and *qali* originated in Persian, but the Turks pronounce them *kilim* and *hali*. Since the first Western carpet scholars obtained Turkish rugs before they did Persian ones, they opted for the Turkish pronunciation. This set a precedent that has endured in Western literature.[20] Today, the world's most reputable rug journal calls itself *Hali* (rather than *qali*, which is what was originally intended) and numerous books and journal articles refer to *kilim* and not *gelim*.

Some sounds, such as 'g', 'kh' and 'q' are absent in certain Turkish communities, which would explain why the Turks pronounce *gelim* as *kilim*, *kharchang* as *harchang*, and *qali* as *hali*. Furthermore, Turks transpose those sounds that are difficult for them to pronounce. Hence, an ordinary Turk would say *Tarbiz* instead of Tabriz, *taski* instead of taxi, and *torba* instead of *tubreh* (feed bag for pack animals). This explains the near-universal use of *torba* rather than the Persian *tubreh* in rug literature.

Aside from the words that have already been mentioned, there are numerous others that are Persian in origin but have been altered through the filter of Turkish. Hassouri's collection of terms related to the implements and craft of rug-weaving shows that a vast majority of this vocabulary is originally Persian, although Turks have borrowed and adapted it.[21] Kasravi, too, who undertook detailed studies into the language of the Turks of Azarbaijan (among them Azari), concluded that Turks had Turkicized those Persian names which they found difficult to pronounce, or else they had adopted a Turkish pronunciation for Persian words.[22] Today, in view of the evolution of rug studies as a scientific discipline, it is important to follow a consistent system of transliteration, as will be used in this book.

CHANGES IN POLITICAL BORDERS

As a result of the Russo-Persian wars of the nineteenth century several Iranian territories were annexed by Russia. These changes had an adverse effect on rug weaving, particularly of the flatweave variety. The two treaties which ended thirty years of warfare also cut off many cities and territories in the Caucasus and the coastal Caspian Sea from Iran. These included firstly Georgia, Baku, Shiravan, Shaki, northern Moghan and Talesh, and subsequently Yerevan and Nakhjavan.

Sensing the weakness of the Persian government as a result of these wars, the Ottoman Turks attempted territorial gains of their own. Portions of north-western Iran, and the Kurdish areas of Sulaymaniyeh and Zahab, passed from Iranian into Ottoman hands in 1822. The east soon followed suit. Meanwhile, Tsarist Russia, having made gains in the west, annexed the Central Asian khanates of Khiva, Bukhara and Samarkand, which had been tributary to Iran. Soon thereafter, Herat was also separated from the domains of Iran and joined with Afghanistan, while portions of Baluchestan were ceded to India (they would subsequently become part of the new nation of Pakistan). More than any other factor, these changes affected the lives of frontier people, limiting their territories and tearing apart the fabric of their clan life.

The demarcation of new borders meant little to the nomadic tribes, whose lives were dictated by climate, land, pasture and constant motion. The new political borders effectively deprived them of around half their ancestral lands, a situation which many unsurprisingly found unacceptable. Some tribes still refuse to recognize these borders and consider land on both sides their domain.

The new geographical borders led to confusion in the rug world, too. Many experts prefer to use the name of the country in which the rug is woven rather than the name of the tribe from which it comes. Thus, to them 'Anatolian kilim' and 'Caucasian rug' are descriptive enough. In the rug markets of Iran one sees the handwoven textiles of the Shahsavans and Turkomans referred to as 'Russian', since the tribal lands adjoin that country. Scholars, meanwhile, tend to be more careful and designate rugs by the province in which they were woven, such as Talesh, Azarbaijan or Kurdestan. Those who wish to be more specific mention the name both of the country and of the province, such as Iranian Azarbaijan or Afghan Turkoman, while the more punctilious mention the name of the tribe as well, so that we learn of Iranian Jaf Kurdish or Afghan or Pakistani Bahluri Baluch. The result is that, despite all the advances made in rug studies, there exists no uniform system for naming tribal weavings. Indeed there may never be, for some of the weavings with their particular characteristics can be found on both sides of a frontier. A particular batch of brocading floor covers, for instance, which I have called chequered (Plates 176 and 177), has been variously attributed to four different regions: Turkey, Armenia, Azarbaijan and Iran. Considering the uniform characteristics of this group of flatweaves, it is certain that they were produced within a single territory, which must have been subsequently divided among four countries. Similar instances can be found in rug literature, especially those concerned with flatweaves dating from the nineteenth century or in the early decades of the twentieth – a time when borders were not only being redrawn, but there was also a marked lack of interest in flatweaves.

PROBLEMS OF CATEGORIZATION

In addition to the lexicographical problems associated with flatweave floor spreads (see pages 24 and 25), yet another difficulty is the rationale for their classification. A considerable number of flatweave fabrics are made from a number of different structures. As for how they should be classified, on the basis of which structures, and using what kinds of limits and standards, there is no easy answer. In the three sections below on the *gelim,* the *palas* and on weft-wrapped fabrics I have mentioned the specific structural characteristics of each. There is one point, however, that has been consciously avoided, and that is the boundaries that separate them. Are all *gelims* truly that? If not, to what extent are they *gelims?* In general, the term *gelim* applies to a floor spread that is entirely *gelim*-weave, that is, a weft-faced plain weave. If some percentage of this fabric were to be of the weft-wrapping or brocading variety, would this section also qualify as *gelim?* What percentage must we use as our basis? Many of the *gelims* of Azarbaijan, particularly the striped variety, contain a certain percentage of weft-wrapping or brocading within them. If this percentage is very small or limited to a few small motifs (such as animals or *gols),* the piece is still considered a *gelim.* If, however, a sizeable portion of it – say, two stripes out of five

(see Plate 35) – is of supplementary weft-weave and the rest *gelim*-weave, does it still qualify as a *gelim*? Or, if the number of non-*gelim* stripes in a floor covering is greater than the number of *gelim* stripes, but the *gelim*-weave area is larger than the compound-weave area (see Plate 42), which way must we decide?

With the *palas* it becomes even more complicated. Most *palases* have striped patterns, often with the stripes alternating between *gelim*-weave and *palas*-weave. Should we call these pieces *palas*, *gelim-palas* or *palas-gelim*? In another group of *palases*, the patterns worked into the simple field are not all of the same structure. This is particularly true of striped *palases*, where some of the stripes are often embellished with supplementary weft brocading, supplementary weft-wrapping or weft substitution weave, and placed adjacent to the *gelim*-weave section. Should we group each of these *palases* separately and independently or, like the layperson, view them all uniformly as *palas*? Quchan *palases* or *gelim-palases* are, without exception, multi-structured, and this is often true also of the floor spreads of Kerman, Sistan and Baluchestan, and Khorasan.

The same considerations apply in the case of weft-wrapping. As well as multiple structures and the question of percentages, there are other difficulties in the classification of these floor coverings. Weft-wrapped or *sumak* floor coverings are generally specific to Azarbaijan and the Caucasus, and a section of this book is devoted to them. But where do we place the weft-wrapped floor coverings of Kerman – among the *palases* or with the weft-wrapping fabrics? It is hardly fair to call these floor spreads *palases*. And yet, while in terms of delicacy some of them concede nothing to the Caucasian and Shahsavan weft-wrapping or so-called *sumaks*, they do not fit the group.

And then there are those obscure and nameless floor coverings which are genetic to all the weaving areas. Even the lands of origin and natural areas of these floor coverings are similar and adjacent. The political maps and the borders of today, however, have separated these regions which go by different names in different countries (see pages 26 and 27). What other way is there for dealing with these floor coverings than grouping them together?

This series of questions calls for answers which include grouping and naming, for without them there would be no solution to the problem of classifying flatweaves.

TRADITIONS IN NAMING

One of the great traditions of the past, whose vestiges can still be seen today, is the naming of weavings by the town or village in which they were produced. It seems that the products of certain towns achieved such fame that their names came to define the objects themselves. For instance, the floor covers produced in Mahfur, a town on the Mediterranean coast, enjoyed great renown in the Islamic world, and in the process of being traded became known simply as *mahfuri* (see page 239). Today nothing remains of either *mahfuri* or Mahfur. Another kind of floor covering has retained the name of the town in which it

was originally made: *shushtari* (see page 162). Shushtari enjoyed widespread fame a thousand years ago; not only did the traveller Naser Khosrow (1003-1088) refer to it, but Farrokhi (d.1037) also mentioned it in a graceful poem as a rug akin to the prairie and the plain.[23] Even today, the term denotes a variety of the finest gelims of Khuzestan.

As certain weavings and rugs became sought after for their fine quality, their names also became widely known. Towards the middle of the tenth century Ibn Hawqal commented on the fame of the *gelims (jajims)* of Jahrom, stating that, by virtue of their excellence, these pieces were known throughout the world as *jahromi*.[24] Some fabrics from Talesh had achieved renown as *talisan*, and a silk textile produced in Yazd is widely known as *yazdi*.[25]

An interesting variation on this naming tradition concerns the variety of textiles known as *rashti-duzi*, a form of embroidery prevalent all over Iran. The reason for the name is most likely that the embroidery of Rasht was superior to that of any other place in Iran, a theory upheld by Polak.[26]

Not all woven goods attained the glorious stature of the *mahfuri* or the *shushtari*. As the writings of various historians tell us, each enjoyed a renown commensurate with its quality. The *gelims* produced in Ruzan, for instance, were used only in Tabarestan,[27] while the hangings made in Basana (Khuzestan) were, it seems, transported everywhere.[28] Some of these goods and textiles were of such high quality that they were cited in proverbs and poems as epitomes of their kind. When a proverb refers to a Kerman rug or a Kashan velvet, it is an indication of the fineness of quality, although the object itself may not have been found anywhere else in the country.

Another tradition from times past is the naming of certain textiles by their patterns. Names such as *shatranji* (chequered), *sad-rangi* (of a hundred colours) or *haft-rang* (seven-coloured) are sometimes used following the name of the *gelim* to describe the fabric or colour of the piece. Other examples are the *safid-gush* (white-eared) *gelim* of Amol (of white cotton, see page 142), the *boz-vashm* (goat-like) *gelim* of Qazvin (see pages 164 to 169), and the violet *gelim* of Rudan (Tabarestan). Some rugs were named after individuals and it is probable that kings and other men of great standing had a hand in their commission and design. Some fairly recent examples of this are Fath 'Ali Shahi (see page 95), *Zell al-Sultani*, *Garrusi* and *Sananbar*.[29]

As a rule, therefore, these traditions, some of which have survived, have served as major factors in the recognition and compilation of the pedigree of various types of rugs and flatwoven pieces.

GENERAL USES OF
PILE-WEAVE AND FLATWEAVE

THE IMPORTANCE OF FUNCTION AND LOCATION

As well as the structural process that classifies the spreads into the two general categories, other factors, including their function and the kind of residence in which they are used, play a role in their criterion. For instance, the pile rug (*qali*) is often spread in buildings and permanent structures, while the *gelim* and the *palas* are mostly used in tents.

The constant movement of tribal people dictates the use of lightweight, portable houses which can be dismantled and carried away easily and quickly (the Persian term *khaneh be-dushi*, those who carry their homes on their back, is an apt description of this practice). Over the centuries nomads have learned to make do with the minimum of possessions. The *jajim* and the *gelim* are much lighter than the pile rug, and it is far easier to roll up these thin flatwoven floor spreads. Another advantage of flatweaves over the pile rugs is their adaptability. At the time of the seasonal migration, many tribal people roll up their bedspreads in a *jajim* or a *gelim*, lay them on top of a horse or camel and, during short stops, use the bedrolls as blankets and mattresses, and sometimes as temporary tents (Figure 11).

The choice of flatweave rather than pile rug is also determined by location. Nomads set up their tents on rugged terrain, whereas city houses have tiled floors which are better suited to the pile rug, the latter being woven in knots and far more steady on a level floor than the *gelim* and the *jajim*. The *gelim* is preferable on earth floors as its flexibility adapts to the contours of uneven ground, although it is not as soft or comfortable as the rug.

This does not mean that nomads are unacquainted with the pile rug, but rather that they have a different use for them. There, the pile rug would be rolled out solely for guests, and otherwise kept in a corner. After the guests departed the rug would be rolled up again and put it away for the next occasion. Tribal weavers would have little use for the many pile rugs commissioned by khans. Although they do weave smaller pile rugs, this is in order to sell them to city dwellers to supplement their income.

FLATWEAVING, POVERTY AND ASCETICISM

Written sources suggest that in the past floor coverings often served as markers of wealth and status among different social classes. The pile rug (*qali*) pertained primarily to the wealthy, while the flatwoven rug denoted poverty. The earliest written testimony to the superiority of the pile rug over the flatwoven rug is in the following lines from the celebrated eleventh-century traveller, Naser Khosrow:

> Though wool be the stuff of both,
> Yet is the *qali* better by far than the *palas*.

For the wealthy, of course, sitting and sleeping on the soft pile rugs was preferable, and the pleasure of their use could never be matched by the *gelim* or the *palas*. But just as the soft rug, particularly the silken variety, denoted wealth and prestige to one group, it signified baseness and bondage to another. Among those who

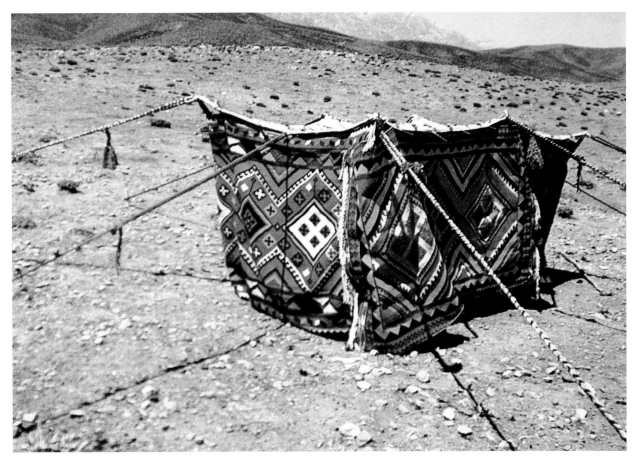

FIGURE 11. *Matrimonial tent made of floor cover* gelim. *Qashqa'i, Fars.*

preferred the *gelim* and the *palas* to the pile rug were the dervishes and the Sufis. With their lives rooted in spirituality, they favoured poverty over riches, considering wealth an impediment in the path of spiritual knowledge. *Gelims* and *palases* are mentioned as floor coverings for dervishes and the poor in Persian literature. The maxim by Sa`di that ten dervishes can sleep in a single *gelim*, while two kings cannot dwell in the same realm,[30] is a vivid example of this attitude. As well as serving as floor coverings, the *gelim* and the *palas* were also used as clothing by dervishes and mystics. In Persian literature any description of the beliefs and lifestyles of dervishes and Sufis is accompanied by mention of their garb. The clothing particular to these strata of society not only distinguished them from others but also served as visible testimony to their beliefs.

The term *pashmineh-pushi* (the wearing of woollens) is itself a reference to dervishes and has been associated from ages past with their appearance. The word Sufi comes from *suf*, Arabic for wool. Being clad in wool was an indication both of the Sufi's piety and detachment from the world, and of his protest against the lifestyle of the wealthy – the wearers of more delicate clothing. The mystical classes, aside from appearing in the wool robe, were detached from house and property and all other possessions, making do with little. They considered wealth and belongings as a veil *(hejab)*, a barrier between them and God; poverty they

regarded with reverence, for it was one of the stations *(maqamat)* that every seeker must pass through in the path of purifying his soul and attaining union with the True One. Such poverty was often accompanied by penance, hardship, seclusion and late-night vigils.[31] It is for this reason that we find Persian literature interspersed with references to the arduous lives of the Sufis, including mention of the use of the *gelim* and the *palas* as floor coverings or clothing. In certain dictionaries and in the *Da'erat al-ma'aref-e eslami* (Encyclopedia of Islam), the word *gelimineh* often appears as a synonym for *pashmineh,* both denoting clothing for dervishes.[32] There was a time when the *gelim* itself was an item of clothing. In 'Attar's *Tadhkirat al-awliya* we read: 'Faruq saw Ovays dressed in a *gelim* of camel's wool, his head uncovered and his feet bare'.[33]

The crudest variety of *gelim* was the thousand-nail *gelim,* considered the clothing of choice for penance and bodily discomfort (Figure 12). We have no precise details about the quality of weave of this *gelim.* Some have taken the name to mean a robe with many patches, while others have understood it as the full star sky.[34] However, a few verses by Khaqani (d.1186) seem to indicate that the thousand-nail *gelim* was a crudely made robe[35] (see page 164 and Figure 12). The *palas* has also been mentioned as clothing for the poor and for dervishes, with the compiler of *Borhan-e Qate'* (Persian lexicon) defining it as a stout *pashmineh* worn by dervishes.[36] A more telling description is given by Naser Khosrow. Recalling his days in Iraq, which he spent in the depths of poverty, he wrote:

> We seemed as naked and powerless as the insane. I wanted to go into the bathhouse to become warm. It was cold and I had no clothes. My brother and I each were covered with an old *long,* protecting ourselves from the cold with a tattered *palas.*[37]

The *palas* has also frequently been referred to in connection with the *jol,* the covering for horses and other pack animals. The expression *jol va pala'* appears in many written sources and sayings in reference to the clothing or floor spreads of dervishes. The wearing of *jols* in itself constituted one of the practices of the dervishes and indicated their humility and lowliness. The Moroccan traveller Ibn Battuta (d.1377), who passed through Izeh (northern Khuzestan), writes of the '*jol* of beasts' in mourning ceremonies.[38]

The attitude towards flatweaves among the dervishes and Sufis found great resonance in tribal and rural societies, themselves always among the deprived and poor classes. Here, too, poverty and humbleness enjoyed a higher state than wealth, while wealth and pride were frowned upon – a trend that continues today.

ROYAL FLATWEAVES

Although the flatweave tended to denote poverty in Iranian society, as discussed above, the situation is not wholly clear-cut. References by some writers of the past to the qualities of certain flatweaves, and their connection with the kings and men of power, lend some ambiguity to this association.

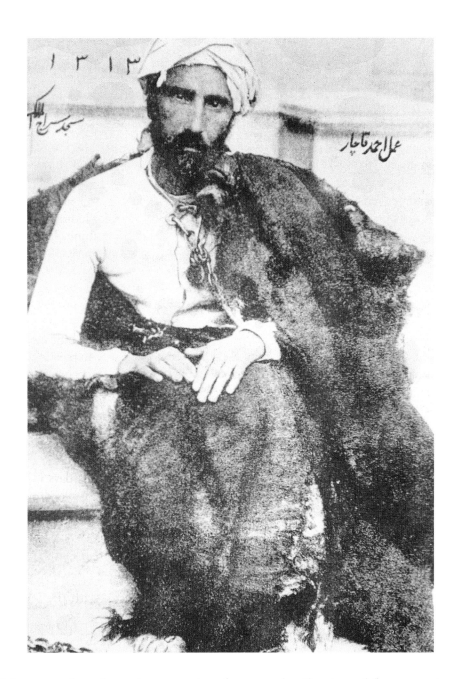

FIGURE 12. *Mirza Reza Kermani in chain with a goat hair,* hezar meekh? *(thousand nails) robe. The picture is taken after Mirza Reza assassinated Naser-al Din Shah in 1896. Photograph by Ahmad Qajar, 1896. From the I. Afshar, A Treasury of Early Iranian Photographs.*

Moreover, they throw into question the very classification of floor coverings into the categories of flatweave and pile-weave. From ancient remains, we know that one of the floor coverings woven in the royal workshops of the Safavid kings in the sixteenth and seventeenth centuries was the *gelim*. We know, likewise, that some of these *gelims* were given as royal gifts to sites of religious importance or to other rulers.[39] One difference between these *gelims* and the ordinary ones is their quality, with the royal *gelims* being of silk and gold or silver thread. Another is their pattern and design, which are the work of master craftsmen (see pages 42 to 46).

In order to determine whether such traditions existed before the Safavids and the sixteenth century we need to look at some early Islamic histories which, although not explicit, speak of rug-weaving traditions similar to those of the Safavids. For instance, in the first half of the tenth century Estakhri pointed to

the floor coverings and wall hangings (*pardehs*) produced in the royal workshops of Ghandjan, Fars.[40] While Estakhri has provided no details about the floor coverings and *pardehs* of Ghandjan, there is general agreement that pile rugs were not the same thing as *besat* (flatwoven floor coverings), nor were they used as wall hangings. Unfortunately, he also gave no description of the qualities of the floor coverings and *pardehs* of Ghandjan. However, several years after Estakhri, the anonymous author of *Hodud al-`alam* described the silk *suzanis* of Qarqub, Khuzestan,[41] although he failed to dispel the obscurity surrounding their details. Likewise, Bayhaqi (995-1077) refers to the use of several *mahfuris* in the royal tent,[42] but is unforthcoming regarding their quality and workmanship.

It appears that silk was generally considered a more valuable material by far than wool, and that it often served as the material for the royal wardrobe and floor coverings, sometimes even for the tent itself. Although floor spreads were sometimes made of silk, references to them are often couched in generic language (rug or floor covering, for instance), and probably refer to the pile rug. Meanwhile, mention of the superior qualities of certain flatwoven floor coverings places them in a category quite apart from the *gelims* and *palases* of the poor. For example, the reference in *Hodud al-`alam* to the costly *zilus* and *gelims* of Fars[43] sets them apart from the rest of the *zilus* and *gelims*, while the same source refers to the gold-threaded Daylamite *gelim*,[44] which makes it certain that such *gelims* were not woven for the poor. And Gardizi (d.1061) writes of Armenian *mahfuris* when describing the gifts sent by Sultan Mahmud to Qadar Khan[45] (see page 240).

As regards the weave, quality and uses of flatwoven textiles, nothing can be asserted with certainty, even in the drawings which show kings sitting or leaning on flatwoven floor coverings assumed to be of silk.

CITY DWELLERS AND FLATWEAVES

As we have seen, flatweaves were used primarily by tribes and rural folk, but city dwellers also needed flatwoven spreads, despite their partiality for the pile rug. While it was ideal for use in rooms and buildings as a comfortable floor covering, the pile rug did not meet all their needs. Travel and pilgrimage between cities, which took several months, meant taking only what the traveller could conveniently fit into a saddlebag thrown over the back of a horse or mule. A lightweight floor covering, such as a *jajim* or one of the lighter *gelims*, was the most suitable item to pack. Certain lightweight *gelims*, such as those known as the Mazandaran and *Shushtari* varieties, were perhaps the best sort for such uses (Plates 100, 101 and 116).

The same applied to kings and nobles. Hunting and other excursions often entailed weeks or months of travel and despite their greater means such personages would have found flatwoven and easily folded floor coverings more suitable to their needs than pile rugs. A depiction of a hunting party accompanying Khosrow Parviz, Sassanian King, in Taq-e Bostan shows a rug that is

more akin to flat- than pile-weaves.[46] Similarly, a fifteenth century painting of Rostam (see Figure 25) shows the epic hero of Iran resting on a *gelim* of the Mazandaran variety, one of the lightest kinds.

City dwellers had other uses for flatwoven floor spreads. Each house had a garden or courtyard and during the hot days of summer, particularly in the late afternoons, it was common for people to spread their *gelims* or *jajims* by the little pool, or on the porch, and eat their evening meal there. Basements were also primarily carpeted with flatweaves, for these were lighter more pleasant floor coverings for general use, especially in the summer. Finally, on festivals and days of rejoicing, when people enjoyed the wilderness and the outdoors, flatwoven spreads were – and still are – more appropriate.

TRADE AND THE EXPORT OF FLATWEAVES

Many people think of the export of rugs as a new phenomenon which goes back only a couple of centuries. They consider that formerly each town or village produced only enough rugs to meet its own needs – that it was self-sufficient and that consequently the motifs and patterns used in any given region were specific to it. A look at the evidence, however, gives us a very different picture. Recently two rugs were discovered in a Nepalese temple, one Persian, the other Anatolian. Both date from at least the twelfth to the fourteenth centuries, and are currently preserved in the Kirchheim Collection.[47] These two rugs provide evidence that even eight hundred years ago rugs were transported from one part of the world to another. There is no information about the circumstances surrounding the appearance of these western Asian rugs further east, nor can we accept the idea that they were transported to their destination centuries after they were woven. The location of these rugs, and the fact that they have survived, are functions solely of the rigid ways of the mosque and the temple.

If we can accept the transfer of rugs from Anatolia and Azarbaijan to Nepal – a distance of more than 3,000 km (1,800 miles) – it should help us in establishing the authenticity of the Pazyryk, arguably a Persian rug found in the Altai mountains of Siberia. If less than a thousand years ago rugs were traded from one end of Asia to the other, it is probable that such commerce could also have existed in Achaemenid times. The distance between Azarbaijan or Anatolia and Nepal is no less than that between the Achaemenid capital or Fars and China or Mongolia. Furthermore, the sheer volume of artefacts unearthed in China that relate to Iran's pre-Islamic past leaves no doubt about the extensive commercial and trade relations that existed among the peoples and nations of Asia.

While the appearance of Persian rugs in the furthest reaches of the then-known world should be evidence enough, accounts by travellers in the early years of Islam further substantiate the widespread trade in the commodity. Maqdesi refers to the export of several varieties of Fars rug to other regions[48] in the middle of the eleventh century. Around the same time we learn from Estakhri about the immaculate *gelims* of Shahr-e Rayy (near Tehran) which

were taken to all parts of the world.[49] *Hodud al-'alam* tells of the fine *pardehs* of Basna (Khuzestan) which went all over the world.[50] Other travellers were less explicit but none the less confirm the same fact. Ibn Hawqal, for instance, points to 'the worldwide renown of the *gelims*, *jajims* and *zilus* of Fars'.[51] Other proof for such widespread presence of rugs included references to the *mahfuri* of Azarbaijan and Anatolia as floor coverings or royal gifts in Khorasan. What can this mean, other than these rugs were transported from one part of the country to another more than 1,600 km (1,000 miles) away?

Even more important is the evidence showing the availability of varieties of rugs in the remotest corners of the country. In Shah Tahmasb's decree relating to the reception of the Mughal emperor Humayun, the *gabbeh*, which is a typical floor cover of Fars, is mentioned in addition to rugs from Khorasan.[52] This means that the *gabbeh*, a product of Fars, was available for sale in Khorasan. We should not assume that the procurement of such pieces was possible only for royalty, however. The poet Farrokhi (d.1037) of Sistan, for example was the owner of a few Anatolian rugs and at least one *mahfuri*, as mentioned in the following verse:

> I spread on the ground Anatolian rugs in two or three places,
> At the time when I cast away my *mahfuri*.

Despite the distance that separated the country's eastern and western regions, therefore, flatwoven rugs were available for sale to the people. (It should be noted that the more wealthy often preferred imports to the local product).

Other important considerations are the transportation network and the mercantile trading centres. In the eleventh and twelfth centuries there were no borders separating the Islamic countries. From Samarkand to Alexandria, from the Mediterranean to India, this land was all one country. The trading routes, and the numerous caravans that traversed it, created an extensive system of communication. Many of the writers and travellers referred to here undertook lengthy journeys in order to obtain material for their writings.

By Naser Khosrow's own account, during his journey from Khorasan to North Africa and back he covered over 8,000 km (5,000 miles).[53] In his travelogue he included interesting details about merchants and merchandise. In one district in Esfahan he noted fifty fine caravanserais, while the caravan with which he himself travelled transported 1,300 mule loads (39 tonnes) of goods.[54] While Naser Khosrow did not list the contents of these loads, he did note 400 *zilu*-weaving looms in the town of Tun.[55] If we suppose that the volume of production in Tun was comparable to what it is today, then daily output would have been 800 square metres (8,600 square feet) and annual output 292,000 square metres (3,150,000 square feet), far in excess of demand in such a small town. The anonymous author of *Hodud al-'alam* paid greater attention than most to textiles and pointed out every town, from China to Egypt and from India to the Caucasus, which produced anything worthy of attention. He also listed centres of commercial activity that had sprung up in rug-producing regions and

took note of the volume of money that exchanged hands.[56]

In addition to rugs, *gelims, zilus* and other woven items, the raw materials for textiles were also exported. Wool, silk, cotton yarn and dyestuffs such as cochineal were important components of the trade,[57] and around each was built a particular profession and industry. Some of these professions are listed in Safavid sources as independent guilds,[58] while earlier Habish of Teflis (d.1228) had mentioned the profession of the *gelim*-seller.[59]

The Safavids were responsible for the burgeoning network of caravanserais that sprang up between cities, greatly facilitating all kinds of trade, including that in rugs. These caravanserais, the equivalent of today's communication centres, proved to be very suitable as temporary storehouses for goods in transit. Europeans, who began to travel in greater numbers to Iran from the seventeenth century onwards, have provided us with detailed descriptions of the system of communication and transportation spawned by these caravanserais.[60] Not only were rugs and other weavings part of the inventory at these way stations, but their transportation also proved to be easier than that for most other goods.

The growing ties between Iran and the West and the new markets that were opened to rugs in Europe (and subsequently in the U.S.) resulted in a decline in the rug trade among Muslim nations. The interest that Westerners have traditionally shown in pile-woven rugs (rather than flatwoven pieces) has proved to be a major factor in the declining production and export of flatwoven rugs, and in the disappearance of some of them. Samuel Green Benjamin, the first U.S. ambassador in Iran, took up his post towards the end of the nineteenth century. While referring to pile rugs, he wrote: 'Another species of Persian rug which rarely reaches Europe is the ghileem'.[61] As regards the future export of flatwoven pieces perhaps we should look at some of the reports of Iran Export Center. According to the annual statistics of this organization, the export of *gelims* (and other flatweaves) has been on constant rise during the last three decades.[62]

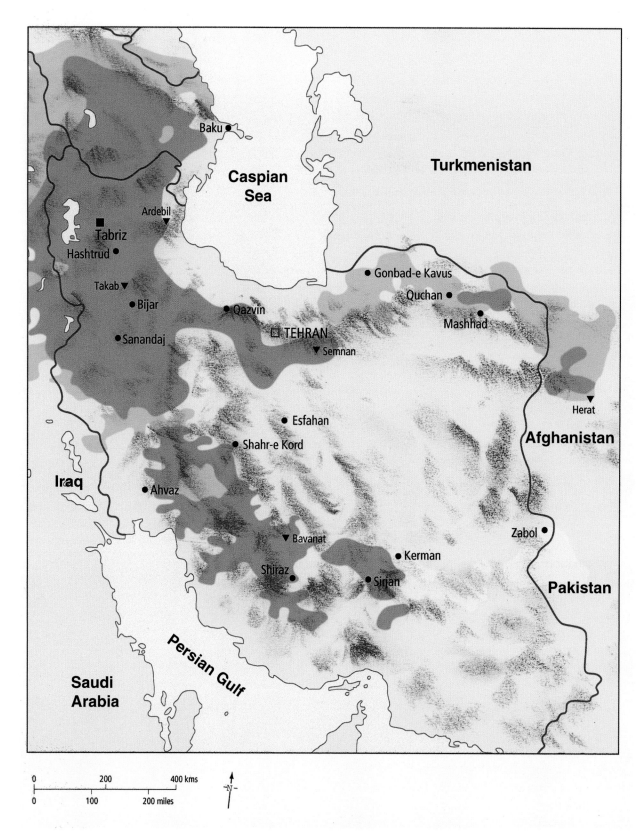

Map of Iran showing the extent of gelim weaving areas.

38

PART 2

GELIM

The year 1977 proved to be an most important one for *gelims* and rugs. It saw not only the publication of the first book on *gelims*,[63] but also marked the centenary of the publication of the first book on oriental rugs, an anniversary which was commemorated with the compilation of a bibliographic survey of 666 titles in rug literature.[64]

The study of rugs began around the middle of the nineteenth century, taking root first in Europe and subsequently growing in the U.S. The earliest researchers and experts were merchants who travelled to Ottoman Turkey and Iran in pursuit of commerce. It was not long before the merchandise they traded as a commodity captivated them by its aesthetic qualities, and they began to collect different varieties of rugs and introduce them to the West. The early aficionados were primarily interested in workshop rugs, particularly the older Safavid and Ottoman specimens, and travelled only to those sites and towns where they could find such pieces.

At the beginning of the twentieth century the study of rugs began to undergo great changes. Wider recognition of and interest in oriental carpets led to an increase in demand, while at the same time the number of Ottoman and Safavid rugs available for sale declined. For this reason, attention turned to the richer stores preserved in the villages and among the nomadic tribes. Rugs now began to be used and studied more extensively, but the *gelim's* time had not yet come.

The situation during the first half of the twentieth century is perhaps best embodied by Cecil Edwards. Without doubt, Edwards can be considered one of the most distinguished experts on Persian rugs, having spent thirteen years in Iran and fifty years of his life trading and identifying them. In researching his comprehensive book, *The Persian Carpet* (1953), Edwards undertook several further trips to Iran, visiting practically every rug-producing area, from urban centres to villages and tribal lands. Edwards' book lists over 200 specimens of Persian rugs, from all varieties and groups. Among these, however, there is not a single *gelim* and nowhere does Edwards make any mention of them. (Only twice does the word *gelim* appear in his book, in one instance in connection with the *gelim* section found in certain Baluchi pile-rugs.)[65] Edwards' travels nevertheless took him through such *gelim*-rich areas as Azarbaijan, Kurdestan and Fars, and he spent time among the Qashqa'i, Afshar, and Lor tribes. Amongst all the types of flatwoven rugs in the Qashqa'i and Lor tents, he must surely have come across *gelims*, since these items are visibly spread out all over tribal dwellings.

Perhaps Edwards simply reflected the spirit of his age, a period that witnessed the peaking of the rug trade.[66] The *gelim* at this time was still considered a floor covering for the poor, and there was little interest in trading it. If *gelim* specimens

reached the rug markets, it was by chance, or else they appeared as sacks or packing for rugs. This trend continued through to the mid-1960s. It was only in the late 1960s and early 1970s that interest began to grow in the *gelim* and other flatweaves, culminating in the publication of the first book on the *gelim*, aptly entitled *Undiscovered Kilim*. Other books followed, and interest soon reached such a peak that 1990 was called the The Year of the Anatolian Kilim.[68] Nor was such attention unjustified, for some of the best rug exhibitions during this period were devoted to the *gelim*. Among the by-products of these exhibitions were seminars and conferences devoted to its study. Most of this buzz of activity, however, centred on the Anatolian *gelim*;[69] the Persian variety attracted little interest.

The sudden spotlight on the Anatolian *gelim* and the desire to understand it, gave rise to many theories about its origin. The pieces that survive are only a few hundred years old at most, but some people came up with pedigrees for them going back thousands of years. Before long, a connection had been established between the Anatolian *gelim* and the eight thousand year old ruins at Çatal Huyuk; the paintings in the ruins and some cloth discovered there provided the basis for such conjecture.[70]

Following these debates, two theories emerged, each backed by steadfast and committed advocates. The first group traced the genesis of the *gelim* to Central Asia and identified the Turks, who moved from east to west, as being responsible for its appearance in Anatolia.[71] The second remained loyal to the Çatal Huyuk theory and considered Anatolia the birthplace of the *gelim*. Proponents of this view chose one among many *gelim* motifs as their logo and called it the goddess of Anatolia,[72] equating the symbol with all the fertility figurines that can be found throughout the region.

Both the above theories leave out important numbers of the region's indigenous people, such as the Kurds and the Armenians.[73] It is true that Anatolia has played a great role in the creation of the *gelim*, but this does not necessarily mean that this art form is a speciality of the Turks, especially since the oldest specimens of *gelim* found so far do not relate to them.

It is difficult, if not impossible, to point exactly to the originators of the *gelim*. However, if we choose to base our knowledge on existing circumstances, perhaps we could say that there are two different groups: the *gelim*-weaving originated in a long stretch of land in the Zagros region between Anatolia and Fars.

The Gelim in Persian Literature

The word *gelim* enjoys a special place in Persian literature and culture and has been used in several contexts. Although usually employed to denote a floor covering, it has been used in the context of clothing or containers. More interestingly, the word *gelim* also appears in certain traditional maxims and proverbs. Not only do these proverbs serve to embellish the Persian language, but they also provide us with leads for tracking down certain previously unknown *gelims*.

Historical writers have often distinguished *gelims* in terms of their colour: dark violet, red, white, black and so on. We do not know what historians intended by

naming *gelims* thus. Did they mean that a *gelim* described as dark violet, red or black was entirely of that colour? Were these *gelims*, like some plain-field varieties today, devoid of designs only in the field and patterned in the rest? When the author of *Hodud al-`alam* refers to the dark violet Tabarestan (Caspian coastline) *gelim*,[74] does he mean the violet or purple *gelim* that was so rare and difficult to procure? Did he thus want to distinguish between the colour of this *gelim* and those from other areas? Or when he mentions the white-cotton (white-eared) *gelims* of Amol, does he intend to mark them as distinct from the woollen *gelims* of other areas? My study of some of these *gelims* constitutes an experiment in linguistic and historical reconstruction (for example see page 164ff.).

It is known that in some instances a particular colour denoted certain beliefs and practices. 'One day we will sort this out on a red *gelim*', said an 'alawite Sufi *shaykh*,[75] thereby designating this variety of floor covering as a site for settling controversies. But it is the black *gelim*, the floor covering of the hapless and the cursed, which has inspired probably the largest number of literary references. Perhaps the best example is the following from Hafez:

> Once a man's *gelim* of fortune is woven in black,
> Not even the springs of paradise can whiten it.

Farrokhi (d.1037), for his part, considered the glance of his beloved so potent that it could change the blackness of a *gelim* to white:

> Many a black *gelim* was bleached by thy glance:
> One look from thee washes out entire the blackness of the *gelim*.

Even worse than the black *gelim* was the straw-coloured one. Flaxen shades, caused by the failure of certain actions and reactions in the pigmentation that produces blackness, are still considered a flaw in rug-weaving. Even the black *gelim* was preferable, as shown by Naser Khosrow:

> Beware lest thou follow that fair one's advice,
> Even as tar upon that disreputable wretch (*siah-gelimi keh gasht bur*).

Interestingly, certain specimens of black *gelims* are still being made in Khuzestan and eastern Turkey (see Plate 125).

There are innumerable literary allusions and proverbs referring to *gelims* and water. To be able to pull one's *gelim* out of the water, for instance, usually indicates an ability to fend for oneself.[76] There is no immediately clear explanation for this expression, but it might well have originated with the *gelims* of dervishes, which were sometimes lost when they waded across wide and swollen rivers. These *gelims*, used as floor coverings, blankets or clothes, were often their sole possessions. Sa`di brought just such a picture to life in his verses, saying:

> One snatches away his *gelim* from the waves,
> While another strives to save the drowning man.

And elsewhere:

The poor unfortunate *(siah-gelim)* manages to get by
 [lit., pulls his *gelim* from the water],
While perhaps his friend's *gelim* brings him disgrace.

The *gelim* has also been linked to the wind, and one has to assume that here the poet intended a lighter variety of *gelim*, such as those of Shushtar or Mazandaran (see Plates 116-118 and 100-101). It is this kind of *gelim* to which Abu Shokur-e Balkhi, writing in the first half of the tenth century, refers:

The *gelim* that can be whisked away by the wind
Trembles from the neck, from the morn.

Another expression relates to those who do not know their bounds, and who step beyond their own *gelims*,[77] thereby bringing shame to themselves and those around them.

In terms of other uses for the *gelim*, the evidence points predominantly to clothes made of the material. Here the word must have meant woollen clothes rather than patterned *gelims* such as those found today. Generally *gelims* were clothes for the poor and for dervishes (see page 32). But even in this regard there can be no absolute certainty; in some of Ferdowsi's verses, *gelim* apparel is equated with gold and silver:

On their feet they wore shoes and on their bodies *gelims*.
All accoutred were they in jewels, gold and silver.

Or elsewhere:

The hosts undid their silver belts,
Whereupon they were dressed in *gelim* robes.

There are contradictions here that make it difficult to ascertain the poet's meaning. Ferdowsi was probably referring to *gelim* robes that were of a finer weave and material. While Ferdowsi has not detailed the material of *gelim* robes, others sometimes have. 'Attar, for instance, speaks of a *gelim* robe made of camel's hair, and Estakhri mentions a *gelim* used as a floor covering and made of goat's hair (see page 164ff.). The uses of the *gelim* as a container are even older and go back to Zoroastrian literature written between AD 881 and 900, where mention is made of putting wheat and barley in *gelims*.[78]

Gelims also appear as wall hangings. The section on *pardeh* below includes illustrations showing such a use for the *gelim* (see Figure 77). The writer Ghazzali (1058-1155) has shown that whenever the need arose, *gelims* spread on the floor were picked up and used as *pardehs* (see page 320.).

THE SAFAVID GELIM

Apart from a few fragments from archaeological excavations, the oldest surviving Iranian *gelims* are those from the Safavid era (sixteenth and seventeenth centuries). To date, more than forty pieces of Safavid *gelims* have been identified,

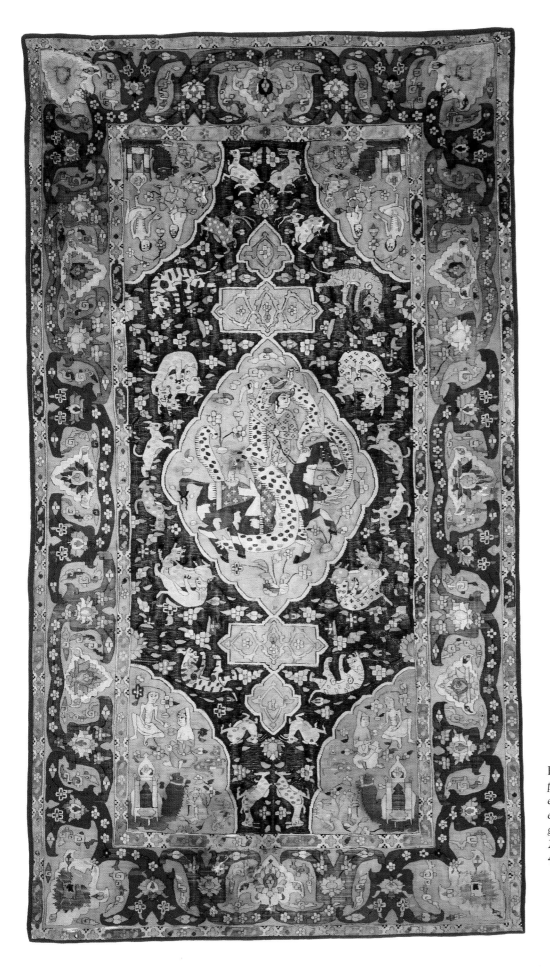

PLATE 1. *Safavid gelim, probably Tabriz. Late 16th or early 17th century. All silk, enriched with silver and silver gilt strip. Slit tapestry weave. 249 x 139cm (8ft.2in. x 4ft.7in.).*

MUSÉE DU LOUVRE, PARIS, DOISTAU GIFT, NO. 5946

43

most of which are kept in European or American museums or in personal collections in the West.[79]

All are of an exquisite weave, and the material is generally silk with a combination of gold and silver threads. We have little information about the Safavid *gelim* other than a few allusions in historical sources and a European painting (Figure 12A). From one source, we know of an Armenian merchant who was sent to Kashan in 1601, by King Sigmund III Vasa of Poland, on a mission to acquire a number of rugs and tapestry-woven rugs with gold and silver threads.[80] The Vasa family's coat of arms, which appears on two surviving *gelims*, corroborates this story. For some time it was generally believed that most silk Safavid *gelims* came from Kashan (a belief that persists even to this day). Of the eleven Safavid *gelims* illustrated by Pope, eight are attributed to Kashan, one each to Isfahan and Yazd, and one to north-western Iran.[81] It is possible, however, that the source of these *gelims*, or at least of the oldest of them, was Tabriz.

Tabriz, the first capital of the Safavids, played a more important role than any other city in laying the groundwork for Safavid art and culture. As such, it was coveted by the Ottomans more than any other part of Iran, and suffered the greatest from attack. Less than half a century after the Safavid dynasty was founded, it was abandoned as the capital. Considering the pre-eminent role that Tabriz played in advancing Safavid art, it would not be far off the mark to suppose that the city was also the birthplace of Safavid *gelim*-weaving. Written sources seem to indicate that it was so. In describing the visit to Iraq by Shah Esma'il (1505-9), the author of *Habib al-sayr* refers to the silk *gelims* that the king brought as offerings.[82] He says nothing about the place where these *gelims* were woven. But another source, a poem by Nezam Veqari (d.1585) praising the thin *gelim* of Tabriz, compensates for this silence:

Shouldst thou, my love, bring to my bosom a thin *gelim* from Tabriz,
I would give away Samarkand and Bukhara for its bird on tree pattern.

The Safavid kings, who rose to the throne with the aid of the Sufis and were themselves progeny of a Sufi tradition, did not entirely forget their heritage once installed in power. They commissioned the finest materials, including rugs, for their shrines, of which the famous Ardebil rug now in Victoria and Albert Museum is one example. It appears from sources, however, that the silk Safavid *gelims* were intended as coverings for tombs rather than for floor use. *Habib al-sayr* specifically states that this was the case. Describing Shah Esma'il's pilgrimage to the shrines in Iraq (*atabat*) and the *gelims* that he brought as offerings, the author distinguishes clearly between *gelims* and rugs:

He [Shah Esma'il] adorned the precincts of that hallowed dome with silk *gelims* that seemed like the firmament of paradise, and at the threshold of that sanctified seat of proximity...he spread wondrous rugs.[83]

The special function of certain rugs is continued by a comment made by Naser al-Din Shah Qajar (r.1848-96) in recounting his visit to Iraq and his pilgrimage at the

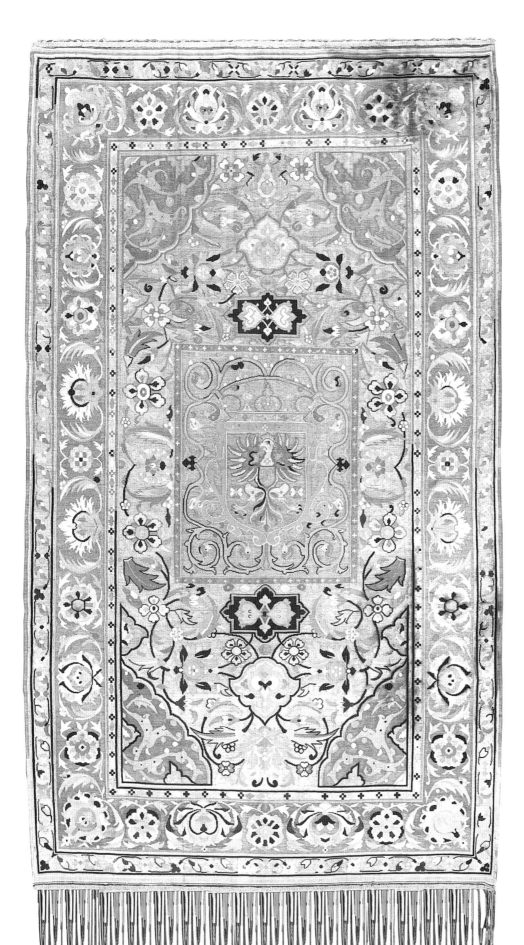

PLATE 2. *Safavid gelim, Kashan, containing the Vasa Arms of Poland. c.1601-2. All silk, enriched with silver and silver strip. Slit tapestry weave. 246 x 135cm (8ft.1in. x 4ft.5in.).*
MUNICH, RESIDENZ MUSEUM, NO. WC3

shrine of the Imam 'Ali in Najaf. At the shrine the Qajar king saw a number of rugs, including a single silk embroidered rug bearing the name of the dog of the threshold of 'Ali, 'Abbas (Shah 'Abbas).[84] What is interesting is that the Qajar shah compared these rugs and the embroidered silk piece with similar items that he had seen at the shrine of Ma`sumeh in Qom. There can be no doubt that there is a difference between the average silk rug and the embroidered silk pieces to which he refers.

Writing in 1977, Pope points to two silk *gelims* that were moved in his time from the mausoleum of Shaykh Safi to the National Museum in Tehran. Even though he referred to them as floor coverings,[85] it is hard to believe that such thin and delicate *gelims* were intended for floor use, especially since almost all of them are in good condition. Elsewhere Pope has called the pictorial examples amongst these *gelims* '*pardehs*', which would seem to be more appropriate (see page 322). The non-pictorial *gelims* would probably have been used to cover the tombs, and the pictorial kind used as *pardehs*.[86]

Aside from the three *gelims* seen by Naser al-Din Shah and Pope in the shrine of Ma`sumeh in Qom and the National Museum in Tehran, there is another important *gelim* which has not previously been discussed. This *gelim* (Plate 4) differs in every respect from the Safavid *gelims* discussed above as only the warp is silk and the rest is wool. The weave used in this *gelim* is also different from that used in the others resembling more closely that of Kurdestan and Azarbaijan, i.e. wefts sometimes passing in a 2/2 sequence through warps. Most interesting of all, however, is its design. Amid the arabesques on this *gelim* are representations of animals and birds that recall Safavid and Mughal rugs.[87] It also features a portrait of Shah 'Abbas and the inscription Shah 'Abbas the Great. Although the inclusion of a portrait might at first seem unexpected, it is not so surprising when we consider that this *gelim* may in fact have been a wall hanging. Placing the portrait at the very top of the piece is therefore appropriate and adds to the overall effect. This *gelim* was probably woven in the mid to late eighteenth century.

No study has yet been undertaken that does full justice to the Safavid *gelim*, its context and its design. The connection between these *gelims* and the *suzanis* of Azarbaijan should be noted. Both are a type of royal flatweave; that is, they were commissioned either by or for the Safavid shahs and were made in royal workshops by master craftsmen. Shared design features include living forms, stories of royal exploits, and typically Iranian motifs such as *gereft-o gir* (give and take of animals locked in battle). All of these directly reflect the intention of the Safavid kings to encourage manifestations of Persian culture.

VARIETIES OF GELIM IN IRAN

Every *gelim* or rug has its own unique structure which is an integral part of its pedigree. By identifying this structure we can draw closer to pinpointing the place and circumstances of its production. Pattern and design can also assist in this and

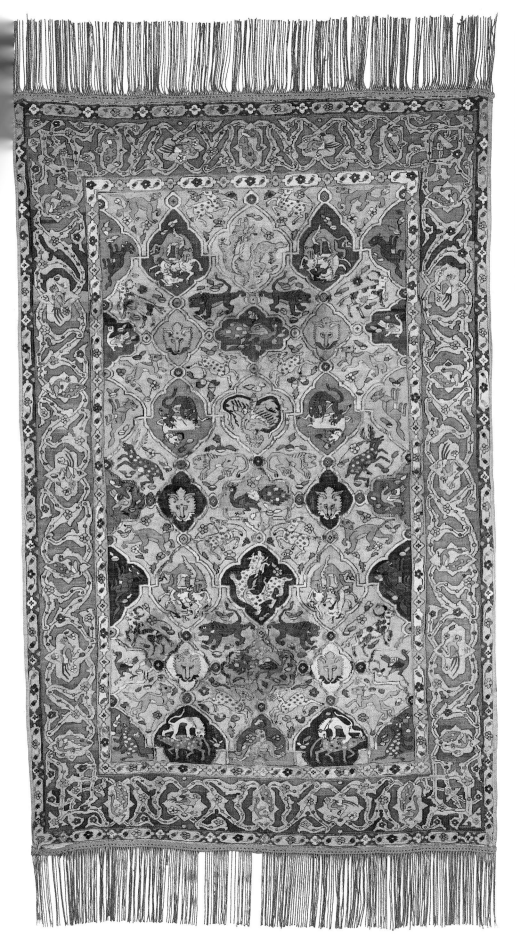

FIGURE 12A. *Portrait of Stanislaw Teczynski by Tomas Dolabella(?), after Christine Klose, c.1634.* WAWEL COLLECTIONS, KRAKOW. PHOTOGRAPHY BY STANISLAW MICHTA

PLATE 3. *Safavid gelim, probably Kashan. Early 17th century. All silk. 197 x 29cm (6ft.6in. x 11½in.).* THYSSEN BORNEMISZA COLLECTION

47

FIGURE 13. *Slit-tapestry weave*.

FIGURE 14. *Inclined slit-tapestry weave*.

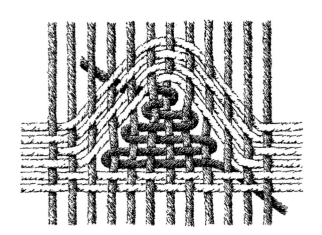

FIGURE 15. *Slit-tapestry, eccentric wefts*.

FIGURE 16. *Dovetailed weave*.

serve to complete our understanding. In this book the design and pattern of each piece are compared with others that share those features, and its structure explained.

There are at least four basic structures in *gelim*-weaving. These can be used together or combined with other structures, such as weft-wrapping or *palas*-weave, to produce yet more structures. The basis of the weave of any *gelim* is the interworking of one set of warps with one set of wefts. Such interworking creates a weave in which the wefts are revealed while the warps are hidden, hence it is called a weft-faced plain weave. Using this weave, it is possible to create a simple monochrome *gelim* or, at most, a *gelim* with coloured horizontal stripes that run along the path of the wefts. If the weaver wishes to execute figures or *gols*, using diagonal or vertical lines, she can do so in one of several ways. First, in order to separate the colours in a diagonal direction, stepped lines can be used. These create a vertical slit between each pair of staggered lines; the weave, therefore, is called a slit tapestry weave (Figure 13). This is the most common type of weave for the *gelim* and is used throughout Turkey, the Caucasus and Iran. There are several variations, one of which is a weave in which the diagonal lines are executed in smaller staggered lines, so that slits are done away with altogether. This is called the inclined-weft weave

FIGURE 17. *Interlocking wefts*.

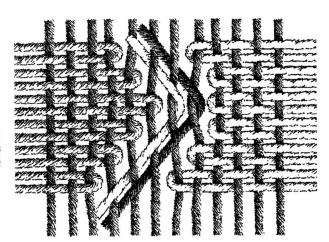

FIGURE 18. *Double interlocking wefts*.

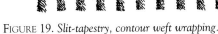

FIGURE 19. *Slit-tapestry, contour weft wrapping*.

FIGURE 20. *Slit-tapestry, contour weft weave*.

(Figure 14) and is prevalent mostly in the northern Zagros region, particularly among the Kurds. Another variety of slit-tapestry weave employs curves and arcs and is especially useful in forming floral designs. It flourishes in Bijar and Sanandaj and is called the eccentric or curved-weft weave (Figure 15).

Second is the kind of *gelim*-weaving in which the change of colours is achieved through junction rather than slits. The junction can be created through the use of a shared warp that is interposed between two wefts (Figure 16), a process called dovetailing; alternatively, it can come about through the interlocking of the wefts at the junction of the colours, which is referred to as an interlock (Figure 17). While the use of the first style is fairly widespread, it is most common among the Tats and the Lors, especially in the Qazvin, Zanjan and Chahar Mahal areas. The second kind, sometimes used in Lori weaves, is less common in Iran.

Another kind of *gelim* that employs colour junctions is the double-interlock variety, one of the most difficult weaves for the gelim. This weave is known to be used mostly by the Bakhtiari Lors (Figure 18). Examples of this weave have in fact turned up in Kerman and Afghanistan,[88] but these must have been gifts carried there by Bakhtiari immigrants.

Aside from these structures, there are other ways for *gelim*-weavers to mark the separation of colours. One example is the contour line. This line is executed either in weft-wrapping (Figure 19) or in regular *gelim*-weave but using a different colour yarn (Figure 20). The *gelims* of Hashtrud, Qazvin and Varamin feature these structures.

Certain *gelims* are woven with a combination of slit tapestry and dovetailing (Plates 43 and 77). A large number of others also have sections in weft-wrapping or *palas*-weave. These are all essential elements in the identification of *gelims*.

The finish at the two ends of a *gelim* or on either side is also an important factor in determining its place of origin. Details of such finishes, with illustrations, have been pointed out wherever possible.[89]

Apart from structure, there are other criteria for distinguishing among *gelims*. These can be called type and function and have to do chiefly with the manner in which they are used. Different types include the *rufarshi*, the goat-like (*bozvashm*) *gelim*, the *shushtari* and the *gelimcheh* (little *gelim*) and the *pardeh*. Their functions will be discussed on the following pages.

Azarbaijan

For reasons explained above (pages 26 to 27), the classification of Persian floor coverings from different areas has not been done according to the country's present political divisions. Rather, the criterion is the same as that used in bygone days, since the present division into provinces does not correspond to weaving areas. The province of Azarbaijan (not to be mistaken with the Republic of Azarbaijan) is a good example of this discrepancy. In present-day maps of Iran, historical Azarbaijan has been divided into three provinces, and certain southern portions of it have been added to a fourth province, Zanjan. In practice, therefore, Azarbaijan has been quartered, while the *gelims* produced in each of these four areas have very close associations with one another. If one were to assign them to this or that province, the modern-day provincial border would sometimes divide the areas in which they are made. This is not to say that all *gelims* from Azarbaijan are alike or that they all belong to the same school of weaving. In fact, the variety found within the *gelims* of Azarbaijan cannot be matched by any other area of production in Iran. There are at least twenty important centres of *gelim*-weaving in Azarbaijan, some of which are no larger than a single small village.

Not all centres of *gelim*-weaving in Azarbaijan are connected to a school. Rather, they follow one of several sub-schools, each with its unique characteristics, within the Azarbaijan school. Two major sub-schools dominate the rest. One is the Moghan school, which is characterized by motifs along a horizontal line. The field of the *gelim* is evenly divided between alternating broad and narrow stripes, neatly placed side by side and covering the entire surface of the *gelim*. The broad stripes enclosed large motifs, and narrow stripes smaller ones. The second school, with its roots in Mianeh, is based on a different principle –

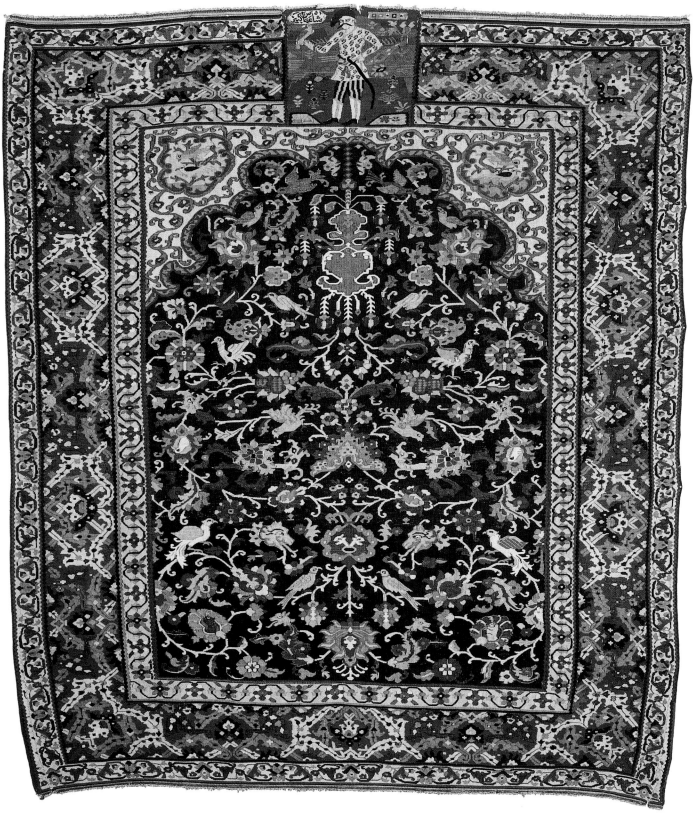

PLATE 4. *Gelim. Mid-late 18th century. Wool wefts on silk warps. Slit tapestry weave. 210 x 187cm (6ft.11in. x 6ft.2in.). Inscription: Shah 'Abbas the Great.* PRIVATE COLLECTION

that of a column of lozenges laid one on top of the other on a plain, unpatterned space. Since this column is reminiscent of the aura and shape of totem poles, here it is referred to as the totem (see, for example, Plate 18).

Yet another school among the *gelims* of Azarbaijan comprises rugs whose surfaces are filled with repetitions of the same motif, moving in directions other than horizontal. Diagonal motifs are often found. This school was probably born in Hashtrud. Having assimilated certain tribes from Moghan, however, Hashtrud is also the source of striped *gelims*.

These three major schools have spawned numerous subsidiaries. Certain striped *gelims*, for instance, are extraordinarily plain and unpatterned, while the totem *gelims* are sometimes composed of more than one totem placed side by side. Another factor in Azarbaijan *gelims* is the influence that Kurdish *gelims* have exerted over them, as discussed on pages 94 and 95. Instead of geometric motifs, Kurdish *gelims* employ plant-like motifs. The mingling among Kurds and Turks in Azarbaijan has resulted in a blending of the motifs specific to these two ethnic groups.

Without doubt, Azarbaijan is the greatest *gelim*-weaving area in Iran. A comparable region in terms of production is Fars, but far greater variety is to be found in Azarbaijan. Virtually every Fars *gelim* is woven by one of two tribes, the Qashqa'i and the Lor. These *gelims* have a great deal in common and can easily be placed alongside each other in the same school. In Azarbaijan, however, the schools of *gelim*-weaving are more numerous and the varieties of weave far more diverse – a result of the diversity of the area's population. While these different peoples have been coexisting for centuries and have now attained a certain degree of homogeneity, their weavings still reflect distinct ethnic characters.

A brief explanation about these people and this land will help to generate an understanding of their weavings. Azarbaijan has been the site of major historical developments in Iran. Its history has been inextricably linked to that of the entire country from at least the time of the Medes, who rose to power in this area during the seventh century BC. Its name, which means the guardian of the flame, is an apt reminder of the role it has played in keeping the fire of Zoroastrianism and Persian culture alive until the advent of Islam. Prior to the arrival of the Turks, the Azari tongue, a dialect of Persian, was the official language of the area and an important factor in uniting its people.

With the coming of the Turks, from the eleventh century onwards, the Turkish language gradually supplanted Azari. (The term Azari Turkish was a creation of the Ottoman Turks and has been used erroneously.) Even today, in some remote villages in Azarbaijan, traces can be found of the Azari language, which in some ways resembles Gilaki and Kurdish.[90] With its mountain heights and verdant pastures, Azarbaijan early on proved desirable terrain for the Turks and the Mongols, and in effect became their capital. From the fifteenth century onwards, waves of Turks from Anatolia and Syria moved there to escape oppression under the Ottoman sultans, taking refuge with the Safavid Sufis. With the support of these immigrants, who were known as the *Qizilbash* 'redheads', the Safavids rose to the throne.[91]

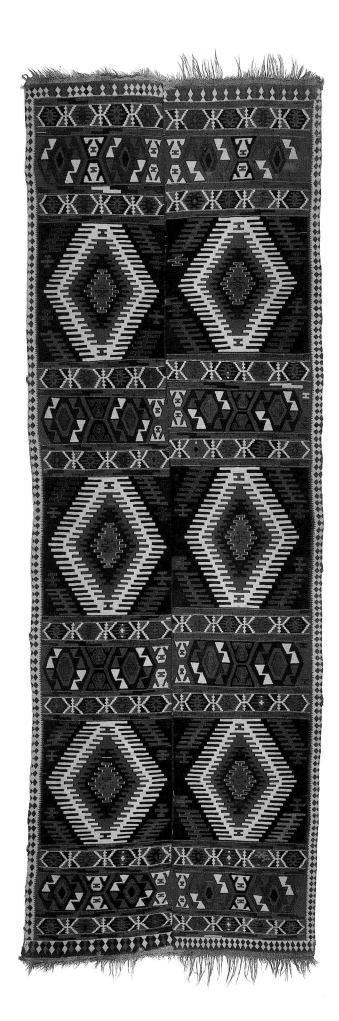

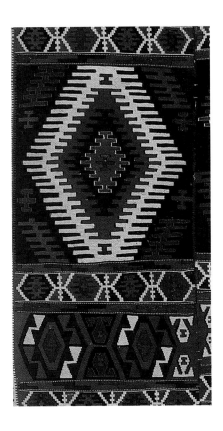

PLATE 5. *Gelim, Moghan, Azarbaijan. Early 19th century. All wool. Slit tapestry weave. Two strips sewn together. 450 x 150cm (14ft.9in. x 4ft.11in.).*

53

While initially obedient to the Safavid shahs, the Qizilbash Turks began to rebel once they too began to establish themselves. When Shah 'Abbas assumed the throne in 1588, he was compelled to disband the Qizilbash and institute a new clan known as the Shahsavan (those who love the shah).[92] This became the largest organized force in the north, standing as a mighty bulwark in the way of the powerful Ottoman armies. This situation remained more or less unchanged until the eighteenth century, when the Shahsavan began moving south towards Mianeh and Zanjan. The Russo-Persian wars of the nineteenth century, moreover, which resulted in Russian annexation of the Shahsavan territories to the north of the Aras (Araxes) river, forced more of them to move further south. Today we can trace the footsteps of the Shahsavan and recognize their weavings all over Azarbaijan, in areas such as Hashtrud, Mianeh and Zanjan, and even further down in the vicinity of Tehran.

The Shahsavan is not the only Turkish-speaking tribe in Azarbaijan. Another tribe is the Afshars, who until recently were one of the most powerful clans in Azarbaijan. While it has been a century or so since the Afshars lost their tribal cohesiveness, their weavings bear witness to their expertise in the craft (see pages 86 to 88).

Moghan

In the eastern corner of Azarbaijan is the land of the Shahsavan and the vast plain of Moghan. Because of its geographic location, Moghan enjoys a fairly mild winter when the rest of Azarbaijan, particularly the highlands, experiences great cold and frost. For this reason it plays host to the large Shahsavan clans during winter. With the arrival of spring and the onset of warm seasonal winds, Moghan gradually grows warmer and devoid of pasture, and the Shahsavan migrate south to the Sabalan highlands.

Weaving is to be found among all the Shahsavan sub-clans, which number some forty in all.[93] They specialize in the various flatwoven varieties, such as the *gelim*. While the diversity of Shahsavan *gelim* is very wide, they are easily distinguishable from those woven in other parts of Azarbaijan. The weave in these *gelims* qualifies as among the finest and tightest of all the *gelims* of Azarbaijan, and in this regard is comparable to the Caucasian *gelim*. The design and composition of the Moghan *gelim* bear a particularly close resemblance to those of the Caucasian variety, particularly to the *gelims* of Shirvan and Qarabagh, being composed of a striped pattern with repeated large stars.[94] The movement of the Shahsavan to and from Shirvan and Qarabagh prior to the sealing of the borders in the early years of the twentieth century explains the presence of common features between their work and that of the people of the Caucasus.

One of the specialities of the Moghan group is the two-piece *gelim*. This does not mean that one-piece *gelims* are few in number, however. Both of the Moghan Shahsavan *gelims* shown here have unique features. The first (Plate 5) exhibits three different kinds of stripes: broad, medium and narrow, each of which is covered in motifs. In Plate 6, however, the stripes alternate between

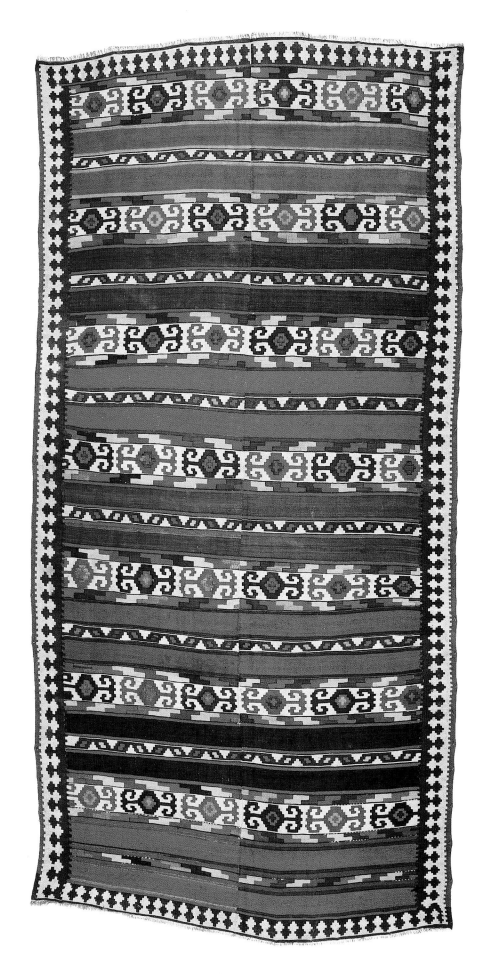

PLATE 6. Gelim, Moghan, Azerbaijan. Mid-19th century. All wool. Slit tapestry and weft-faced plain weave. Two strips sewn together. 360 x 175cm (11ft.10in. x 5ft.9in.).

those bearing motifs and those bearing none. Like most Moghan *gelims*, the two shown here have a border. By contrast, weavers to the north and west of the Moghan region seem to have preferred the borderless *gelim*.

Ardebil

As well as being the largest city in eastern Azarbaijan and the provincial capital since 1993, Ardebil is important in other ways to the Shahsavan and other Iranians. It was here that the Safavids rose to power and here, too, that the tombs of their ancestor, Shaykh Safi, and the founder of their dynasty, Shah Esma'il, are located. Until the early twentieth century, Ardebil and the nearby town of Meshkin were important to the Shahsavan khans, who were well established there. The weaving areas, too, drew attention. But with the advent of the international rug trade and the inroads made by merchants from Tabriz who demanded pile-rugs rather than flat-weaves, the tribal weavings of the Shahsavan quickly went into decline. A few decades later not even a trace remained in Ardebil of *gelim*-weaving, whereas nearby villages, such as Namin, continued the tradition.[95]

Nineteenth century *gelims* from Ardebil are represented here by one example. It is their compact weave, typical of the Shahsavan, which identifies their origins as Ardebil or the Shahsavan, although in terms of design and pattern they resemble those of the Bijar Kurds more closely than those produced by the Shahsavan Turks. The design in this piece is provided by elements of nature such as *botteh* (Plate 7) or trees. The fine, compact weave of Plate 7 resembles the Shahsavan style more closely than any other. On the other hand, the use of the repeated *botteh* motif is particular to city-dwellers. Ardebil fits both criteria and would therefore seem to qualify best as the place of origin.[96] Even if the *gelim* shown in Plate 7 is not from Ardebil proper, it cannot have been produced at any great distance from the city. At any rate, it is certainly not from Mianeh or Hashtrud, and its weave has little resemblance to that found in Kurdish areas.

Hamamlu

Although the name Hamamlu[97] is not a familiar one in rug literature, it is not unknown among experts on Azarbaijan. Anyone who travels to Azarbaijan and browses in the rug markets of Ardebil, Hashtrud, Mianeh, Takab and Tabriz will come across the name sooner or later. Whenever a salesman wants to assign the highest price to a flatwoven piece, he will either weave the name Hamamlu as an appendage or paste it on with a label.

There is an element of mystery surrounding Hamamlu, since there are no written records of the place. Geographers such as Kayhan, who has omitted few names, have not pointed to Hamamlu. Maps of Azarbaijan, particularly the more recent detailed ones, make no mention of it. In older maps, however, one occasionally comes across the name, referring to a village located 100 km (62 miles) north-east of Tabriz. One of few villages in the foothills of the Qaraja Dagh mountains, it is not too distant from Qaraja whose rugs have achieved considerable renown.[98]

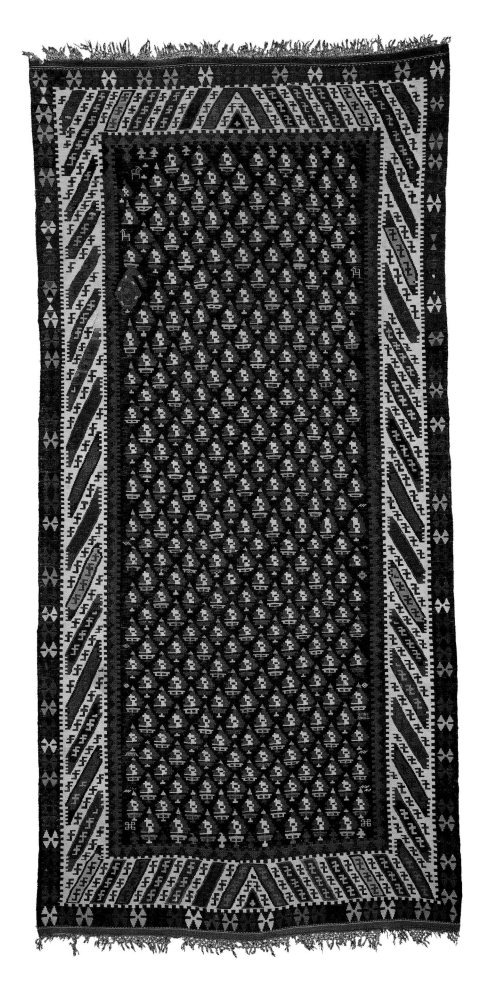

PLATE 7. *Gelim, Ardebil,
Azarbaijan. Mid-19th century.
All wool. Slit tapestry weave.
460 x 334cm (15ft.1in. x
10ft.11in.).*
LONGEVITY, LONDON

57

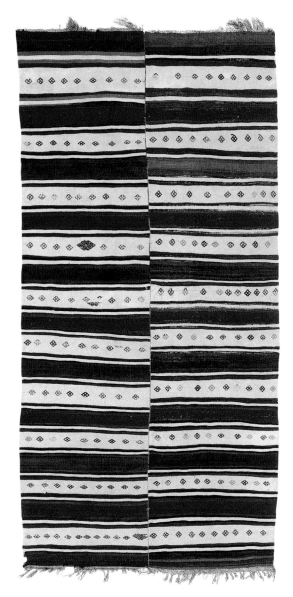

PLATE 8. *Gelim, Hamamlu, Azarbaijan. Late 19th century. Wool and cotton. Weft-faced plain weave patterned in certain areas by weft-float brocading. Two strips sewn together. 325 x 157cm (10ft.8in. x 5ft.2in.)*

As for who the Hamamlu are and how they arrived at their present home in Qaraja Dagh, no one seems to know. Their weavings bear a close resemblance to those of the Shahsavan, and I believe it would not be far from the truth to call them Shahsavans. But the fact that their name does not appear among the Shahsavan clans complicates the issue.[99] The only source in which we come across a name similar to Hamamlu is *Iranshahr*.[100] In this book, a table listing the various clans of the Shahsavan mentions one called the Hamonlu, but there are no further details. Are these Hamonlus the same as the Hamamlus, and did they separate from the Shahsavans after their departure from the Moghan plain and move to the foothills of Qaraja Dagh? Is Hamamlu their correct name, indicating that they (or their ancestors) were in the business of managing baths (*hamam*),[101] and has *Iranshahr* wrongly listed them as Hamonlu?

At present, with the paucity of sources at hand, it is impossible to answer these questions. As we shall see, the weavings of the Hamamlu are of such exquisite quality that one hopes some leads may turn up in the future. I would venture to say that the Hamamlu are a sub-group of the Shahsavan who, at some stage and for unknown reasons, departed from the tribe and settled north of Tabriz. Their separation from the rest of the Shahsavan cannot have happened very recently. It would probably have occurred at the time of the sealing of the border by the Bolsheviks during the 1920s. This development, leading to the migration of large numbers of the Shahsavan further south, has remained in their collective memory, but it has no relevance to the Hamamlu, for none of them can remember it.

The Hamamlu must be divided into two groups: the previously mentioned northern Hamamlu and the southern Hamamlu, who moved south to Mianeh and the environs of Aqkand. As we shall see, the weavings of the latter group have been completely subsumed into the weavings of their neighbours and their position vis-à-vis Mianeh is akin to that of a satellite. The northern Hamamlu, however, have preserved the distinctiveness of their weavings.

The Hamamlu *gelim* shown in Plate 8 exhibits fewer colours than some examples and features small patterns amid its white cotton stripes.

Although it seems that the Hamamlu had a preference for a plain, striped pattern, one cannot consider this an absolute condition as their *mafrashes* (bedding bags) and *khorjins* (large saddlebags) are covered with delicate patterns.

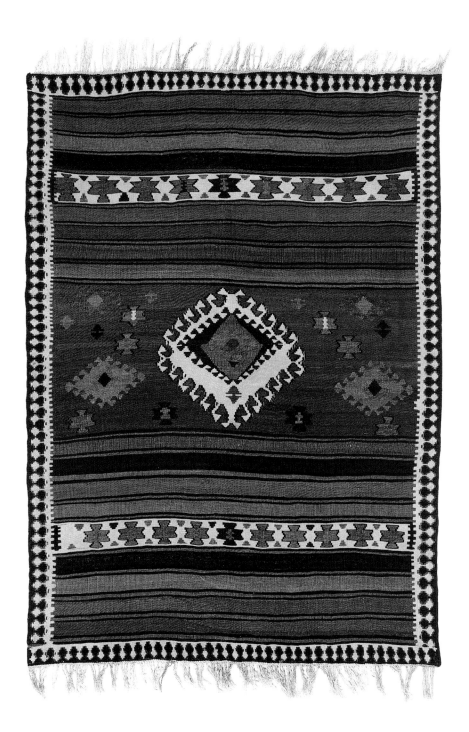

PLATE 9. *Gelim, Heris, Azarbaijan. Late 19th century. All wool. Slit tapestry, weft-faced plain weave. 241 x 174cm (7ft.11in. x 5ft.9in.).*

Heris, Bakhshayesh and Sharabian

The growing reputation in the twentieth century of the Heris pile-rug and its near cousins has proved to be such a powerful incentive for the region's weavers that all other weavings, including *gelims*, have been eclipsed. Today if one attempted to find a single Heris *gelim* for every thousand Heris rugs, one would be likely to fail. Had it not been for the small number of Heris *gelims* that have survived, even the contention by the Heris weavers themselves that *gelims* were woven there in the past might well have been disbelieved. Plate 9 shows one such rare *gelim*, a remarkable testament to the high quality of *gelims* from this

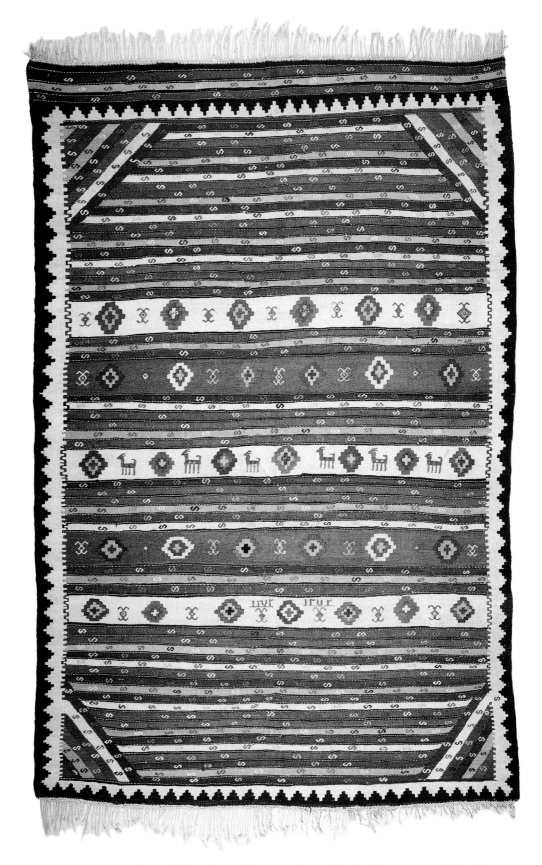

PLATE 10. *Gelim, Bakhshayesh, Azarbaijan. 1856-7. All wool. Slit tapestry, weft-faced plain weave patterned in certain areas by weft-float brocading 340 x 168cm (11ft.2in. x 5ft.6in.).*

COURTESY EBERHART HERRMANN

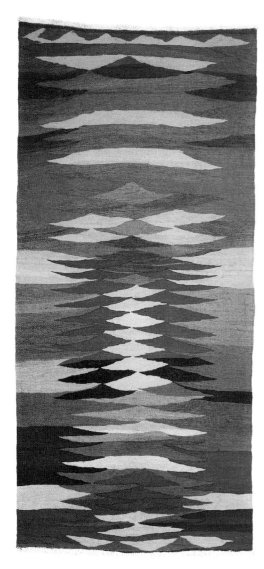

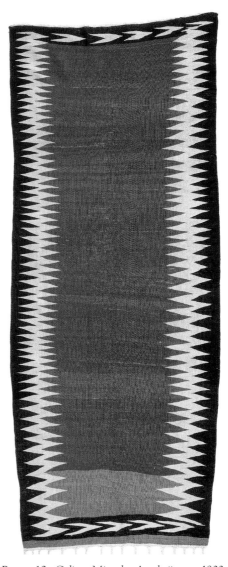

PLATE 11. *Gelim, possibly Qarabagh or Mianeh. Late 19th century. All wool, slit tapestry weave. 290 x 133cm (9ft.6in. x 4ft.4in.).*

COURTESY WERNER WEBER

PLATE 12. *Gelim, Mianeh, Azarbaijan, c.1900. All wool, slit tapestry, dovetail and weft-face plain weave. 338 x 137cm (11ft.1in. x 4ft.6in.).*

VOK COLLECTION

village. In terms of weave, colour scheme and composition, it is analogous to Shahsavan *gelims*.

Gelim-weaving has endured longer in the town of Bakhshayesh and its surrounding villages, than it has in Heris, and consequently there are greater numbers of examples from this area. For the most part these are striped, featuring brocading and weft-wrapping motifs within the stripes. Plate 10 shows a fine example of the Bakhshayesh *gelim*. Like some older rugs from the area, it bears representations of living forms, such as the goat and birds.

The further south we travel, the more distant becomes the influence of Moghan *gelim*-weaving and the stronger that of Mianeh and Hashtrud. Perhaps the line at which the influence of the Moghan Shahsavan ends is Sharabian and Bostanabad, because further south the striped *gelims* give way to the totem or repeating pattern variety.

Mianeh

The Mianeh *gelim* has been as influential in the weaving of Azarbaijan as the Moghan *gelim* has been. It, too, has its own school and its place of pre-eminence. This school greatly influenced the neighbours of Mianeh over a large area.

Until the beginning of the twentieth century Mianeh was an important centre of weaving, especially *gelim*-weaving. After the transit road was built through the town, however, it lost its prominence in weaving and instead became a major stop for travellers. The town did, however, retain its function as a centre for the trading of rural weavings from the area. Another reason for Mianeh's erstwhile importance was its production of cotton, one of the few areas in Azarbaijan to do so. This is clearly apparent in the *gelims* produced in the area prior to the halt of cotton cultivation in the mid-twentieth century, and is attested by the use of cotton not only in the warp, but also in fairly sizeable portions of the weft.

The field of Mianeh *gelims* is almost universally of a uniform crimson. Stacked up from the bottom of the field to the middle are several lozenges placed on top of one another, creating a totem. One of the most beautiful of these *gelims* is shown in Plate 13. As well as its central totem, this example also features small trapeziums with eight-pointed stars in the middle. The delicacy and care that has gone into the gelim's weaving and colour scheme places it at the top of the hierarchy of Mianeh *gelims*. The weaver of the *gelim* shown in Plate 14, on the other hand, has formed the totem entirely from lozenges of a uniform size, which cover the whole field. In Plate 15 a similar design has been employed, although the *gelim* is perhaps a century older than the previous piece. Another noteworthy *gelim* can be seen in Plate 16, which has a design very different from other Mianeh *gelims*. The design here is not that of a totem, but rather of a large crab-shaped motif placed in the centre. In terms of its weave and its use of colour, however, it appears to be a product of Mianeh or possibly further north. The weaver's unusual design conception, whereby borders at the top and bottom of the central design separate the field, lends a special character to the piece.

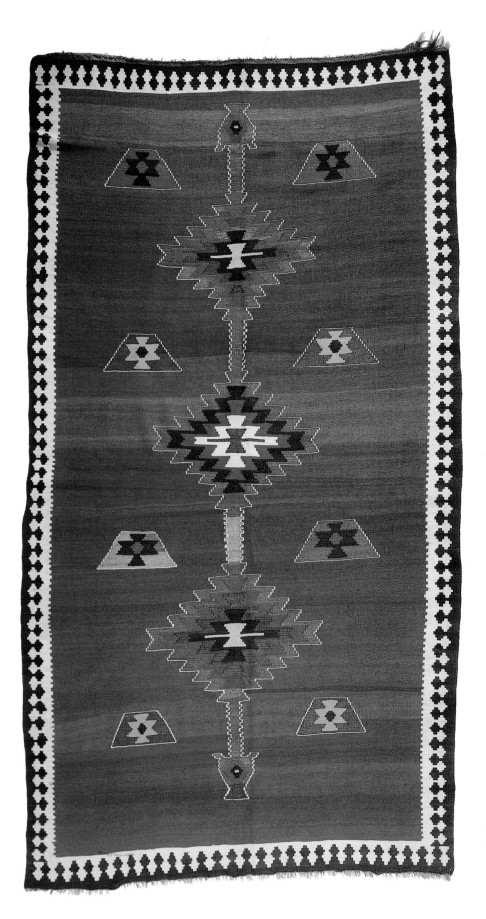

PLATE 13. *Gelim, Mianeh, Azarbaijan. Mid-19th century. All wool. Slit tapestry weave. 313 x 173cm (10ft.3in. x 5ft.8in.). Dated AH1272 (1855).*

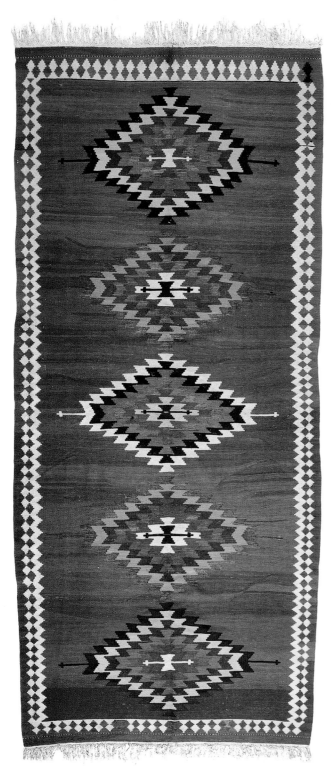

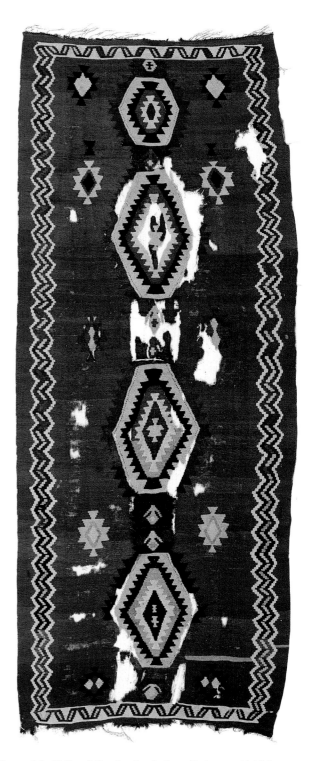

PLATE 14. *Gelim, Mianeh, Azarbaijan. c.1900. Wool wefts on cotton warps. Slit tapestry weave. 410 x 132cm (13ft.5in. x 4ft.4in.).*

PLATE 15. *Gelim, Mianeh, Azarbaijan. Early to mid-19th century. Wool wefts on cotton warps. Slit tapestry weave. 380 x 154cm (12ft.6in. x 5ft.1in.).*

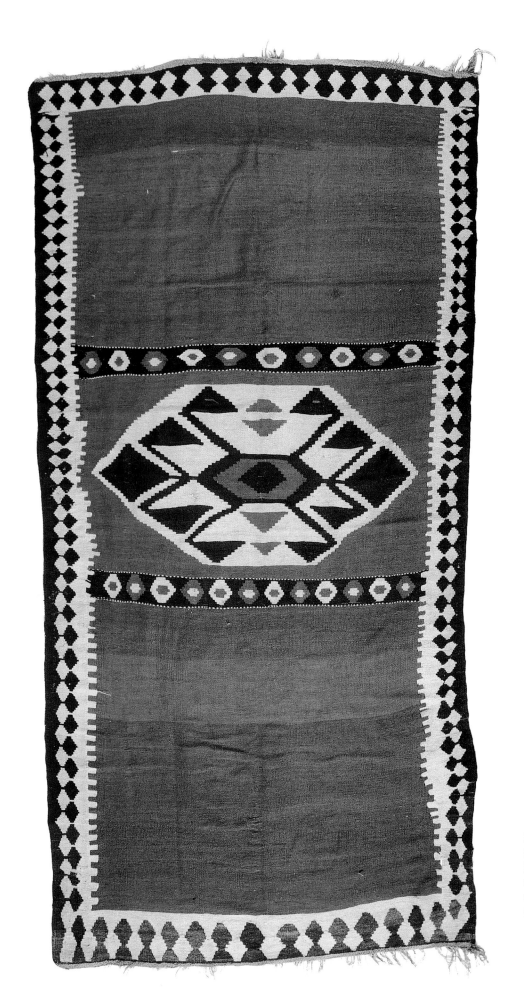

PLATE 16. *Gelim, Mianeh, Azarbaijan. Late 19th century. All wool. Slit tapestry weave. 352 x 165cm (11ft.7in. x 5ft.5in.).*

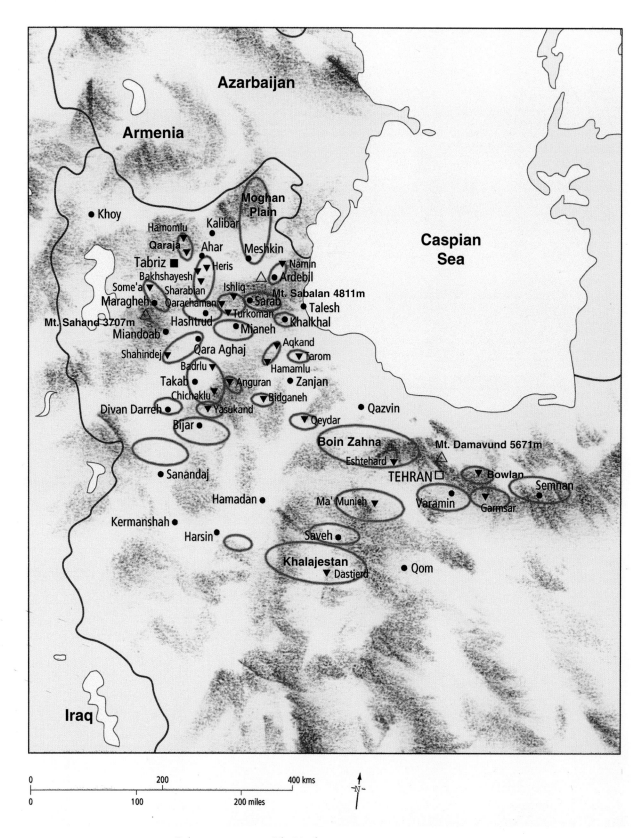

Azarbaijan

Armenia

Caspian
Sea

• Khoy

Hamomlu
Qaraja ▼
Ahar
Kalibar
Moghan
Plain
Meshkin

Tabriz ■
Heris
Namin ▼
Bakhshayesh ▼
△ Ardebil •
Some'a ▼
Sharabian
Ishlig
Mt. Sabalan 4811m
Maragheh •
Qarachaman •
▼ Sarab •
Mt. Sahand 3707m
△
Hashtrud
Turkoman ▼
Talesh •
Khalkhal •
Miandoab •
Mianeh •

Shahindej ▼
Qara Aghaj
Aqkand
Tarom ▼
Badrlu ▼
Hamamlu
Takab •
Anguran ▼
Zanjan •
Chichaklu ▼
Bidganeh ▼
Divan Darreh •
Yasukand ▼
• Qazvin
Bijar •
Qeydar ▼

Boin Zahna ▼
Mt. Damavund 5671m
Eshtehard ▼
△
• Sanandaj
TEHRAN □
Bowlan ▼
Semnan
• Varamin
Garmsar ▼
Hamadan •
Ma' Munieh ▼

Kermanshah •
Harsin •
Saveh •
Khalajestan
▼ Dastjerd
• Qom

Iraq

0	200	400 kms
0	100	200 miles

↑
-N-

Gelim weaving areas. The North-west group.

FIGURE 21. *Village of Qara Chaman, Azarbaijan.*

Qara Chaman, Torkamanchay and Ishliq

These three villages, located north of Mianeh, have a variety of *gelim* that are specific to them alone. Although their work cannot have escaped being influenced by that of their neighbours in Mianeh, Sarab and Hamamlu, each is distinct in its own way. The field in the *gelims* produced in these three villages, like that in the *gelims* of Mianeh, is often crimson, and the design is generally of the totem variety. But within the totems smaller designs have been worked in. Outstanding examples of this are shown in Plates 17 and 18. The composition, weave and even colour scheme of these *gelims* show strong similarities with the *gelims* of Mianeh. However, as mentioned earlier, here the central lozenges are filled in with very fine and delicate *bottehs*, a feature also seen in the products of Seneh and to some extent those of Ardebil (see Plates 53 and 7). A similar method has been employed in the *gelim* shown in Plate 19, but here, instead of the *botteh*, more geometric motifs are placed within the central lozenges; there is also a difference in weave, with these motifs being of the weft-float brocading kind (Plate 19). The presence of such scattered motifs in the field, and of larger *botteh* adjacent to them, creates a greater sense of activity. The *gelim* in Plate 20 has a pattern similar to that of Plate 19, apart from its supplementary wefts.

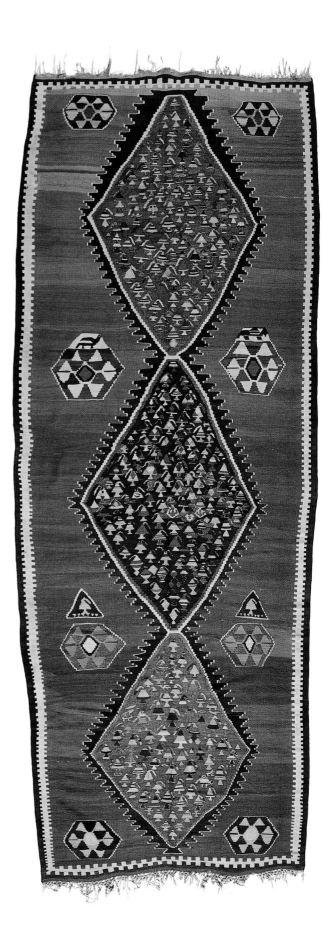

PLATE 17. *Gelim, Qara Chaman, Azarbaijan. Late 19th century. All wool. Slit tapestry and dovetailed weave. 358 x 135cm (11ft.9in. x 4ft.5in.).*

OPPOSITE LEFT:
PLATE 18. *Gelim, Qara Chaman, Azarbaijan. c.1900. All wool. Slit tapestry weave. 390 x 137cm (12ft.10in. x 4ft.6in.).*

OPPOSITE RIGHT:
PLATE 19. *Gelim, Torkamanchay, Azarbaijan. Late 19th century. Wool wefts on cotton warps. Slit tapestry weave patterned in certain areas by weft-float brocading. 442 x 150cm (14ft.6in. x 4ft.11in.).*

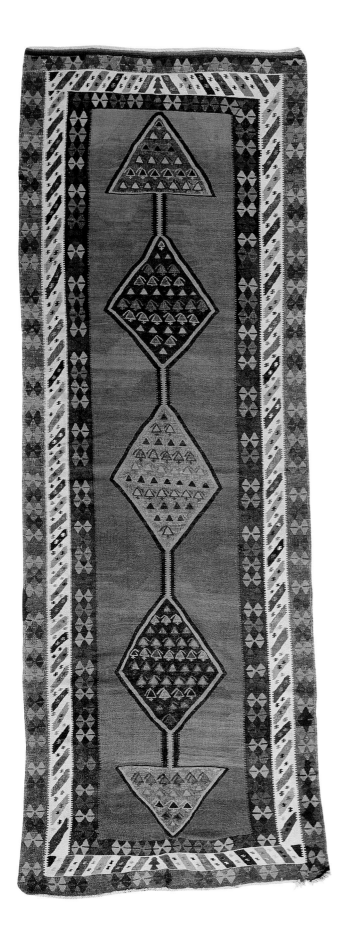
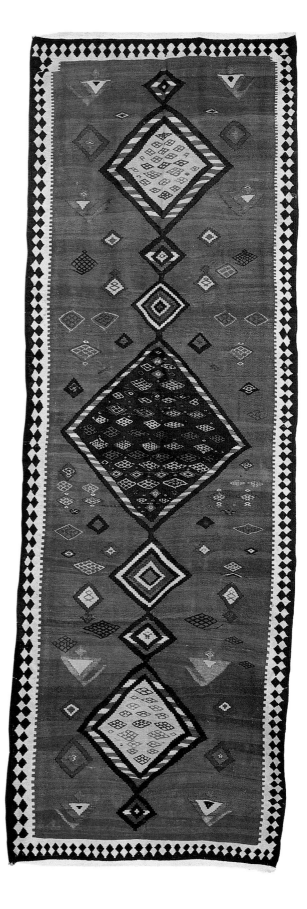

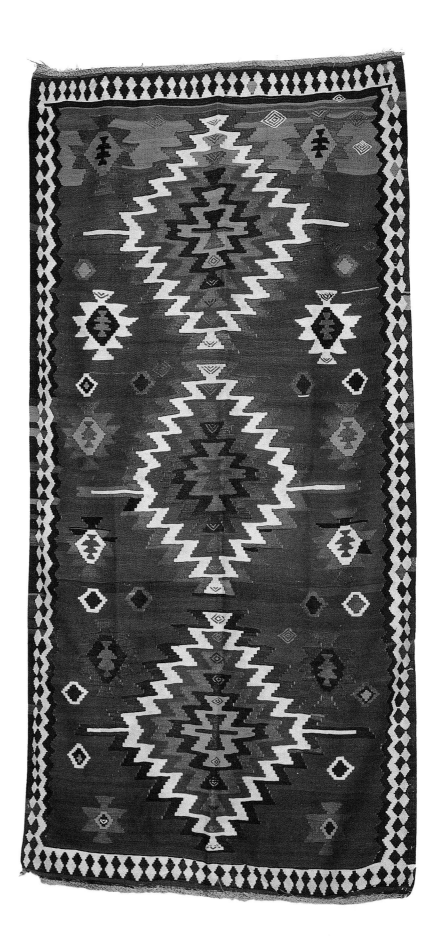

PLATE 20. Gelim, Ishliq,
Azarbaijan. Late 19th century.
All wool. Slit tapestry weave
patterned in certain areas by
weft-float brocading. 313 x
159cm (10ft.3in. x 5ft.3in.).

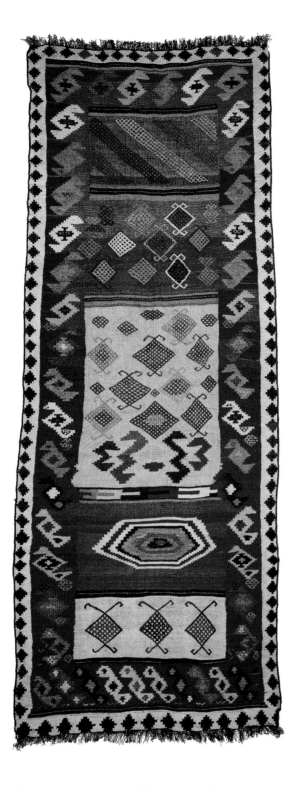

PLATE 21. *Gelim, Torkaman-chay, Azarbaijan. Late 19th century. All wool. Dovetailed weave patterned in certain areas by weft-float brocading. 320 x 125cm (10ft.6in. x 4ft.1in.)*

Another *gelim* from this area that differs from the rest in terms of design is featured in Plate 21. It would appear that here the weaver has ignored the order followed in most *gelims* woven in the area and created something original. Not only is the pattern exceptional, but the weave, too, is of the dovetailing kind, which is rare in the region. The decorations formed through the weft float brocading structure in various parts of this *gelim* resemble those in Plate 19.

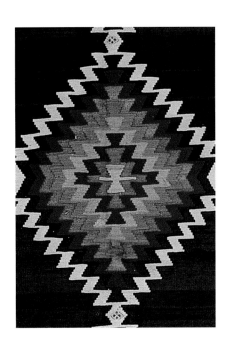

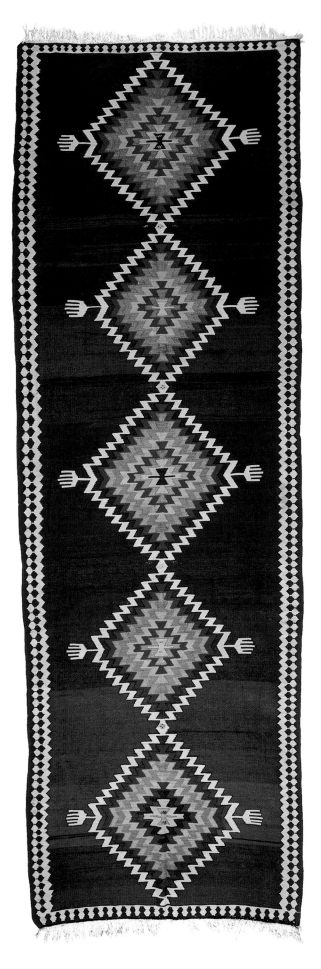

PLATE 22. *Gelim, Aqkand, Azarbaijan. Late 19th century. Wool wefts on cotton warps. Slit tapestry weave. 524 x 200cm (17ft.3in. x 6ft.7in.).*

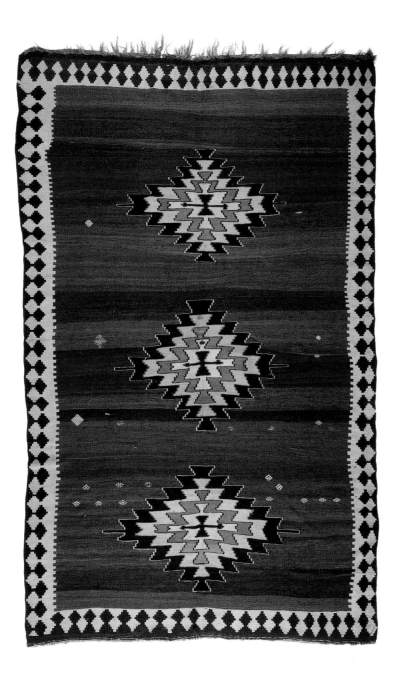

PLATE 23. Gelim, Aqkand, Azarbaijan. Mid- to late 19th century. All wool. Slit tapestry weave. 300 x 183cm (9ft.10in. x 6ft.).

Aqkand

Like the *gelims* of Torkamanchay and Qara Chaman, those of Aqkand are con-sidered a subset of the *gelims* of Mianeh. They exhibit minor, but noteworthy, variations from the Mianeh *gelim,* primarily in the colour of the field and the quality of the weave. The field in the majority of Aqkand *gelims* is dark blue, brown or aubergine. The patterns, however, continue to be totems on a plain field. Plates 22 and 23 represent this area.

Aqkand is situated 50 km (30 miles) south-east of Mianeh and comprises several villages. One of these, Lower Hamamlu, is to the south of Aqkand. It is said that the inhabitants are a branch of the northern Hamamlu (see pages 56 to 58) and the very delicate and compact weave in the *gelims* of this area would seem to bear this out. What casts doubt on the links between these Hamamlu and the Hamamlu north of Heris, however, is the difference in the patterns found on their respective *gelims.*

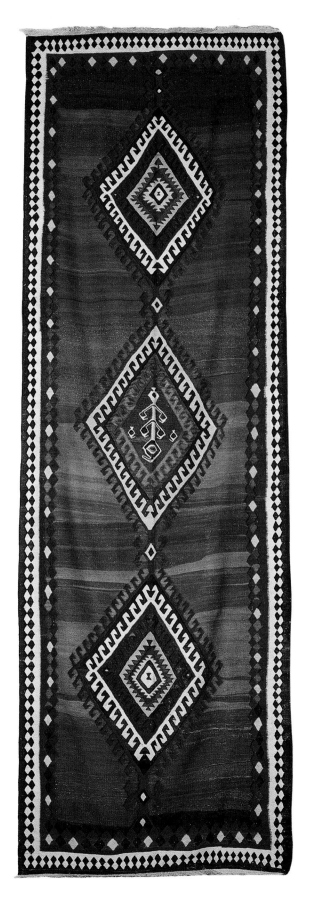

Maragheh

Although Maragheh is one of the larger and more densely populated towns in Azarbaijan, having served the Mongols as their capital in the fourteenth century, it has no separate school of *gelim*-weaving associated with its name. Its *gelim*-weaving is largely influenced by Mianeh and to some extent by Hashtrud. One batch of its *gelims* exhibits a totem pattern on a plain field, with the difference that on the external border of the totems a large number of hook-like patterns have been worked in (Plate 24). The components of the totem in Plate 25 differ from those of other *gelims* from the area. Here the totem is formed by chequered, concentric hexagons. The weave, likewise, is of the dovetailing kind which is far rarer than the slit tapestry variety in this area. One of Maragheh's important centres of *gelim*-weaving is the village of Sume'a. This village, at no great distance from Lake Urumia, was formerly an Armenian settlement and it is not unlikely that some of the *gelims* from the area were actually made by Armenians.

PLATE 24. *Gelim, Maragheh, Azarbaijan. c.1900. All wool. Slit tapestry and dovetailed weave. 512 x 168cm (16ft.9in. x 5ft.6in.).*

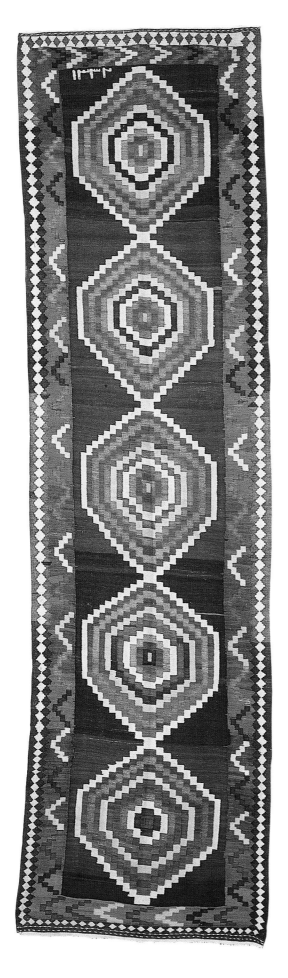

PLATE 25. *Gelim, Maragheh, Azarbaijan. Wool wefts on cotton warps. Dovetailed and slit tapestry weave, the date in pile weave, symmetrical knot. 466 x 131cm 15ft.3in. x 4ft.4in.). Dated AH 1332 (1913).*

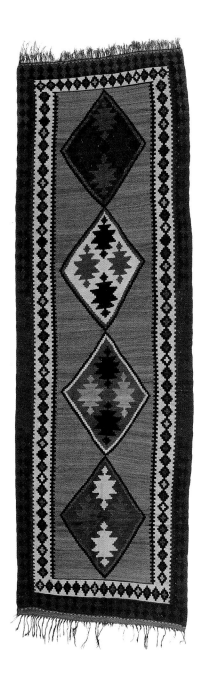

PLATE 26. *Gelim, Sarab, Azarbaijan. Late 19th century. All wool. Slit tapestry weave. 410 x 134cm (13ft.5in. x 4ft.5in.).*

Sarab

Sarab's special geographic location, between the two mountains of Sabalan and Bozqush, has rendered it a well irrigated and fertile region, resulting in the creation of numerous villages. Most of the villages in Sarab are as well known for their rug-weaving as they are for agriculture. But to the same extent that the pile-rugs of Sarab are famous,[102] its *gelims* are obscure and generally traded as Bijar gelims.

While the rugs of Sarab have distinct features, its *gelims* are influenced by surrounding areas. Many *gelims* from here feature totems, often with large stars placed in the middle. As with many rugs from the area, a large number of these *gelims* have a simple and uniformly brown field (Plates 26 and 27). Sometimes crimson or another colour is used for the field, as in Plate 28. This *gelim* contains two totems and therefore seems quite innovative. The *gelim* in Plate 27, whose totem is formed by three concentric lozenges, is also worthy of attention. The design and colour scheme of the lozenges seem to suggest lightning.

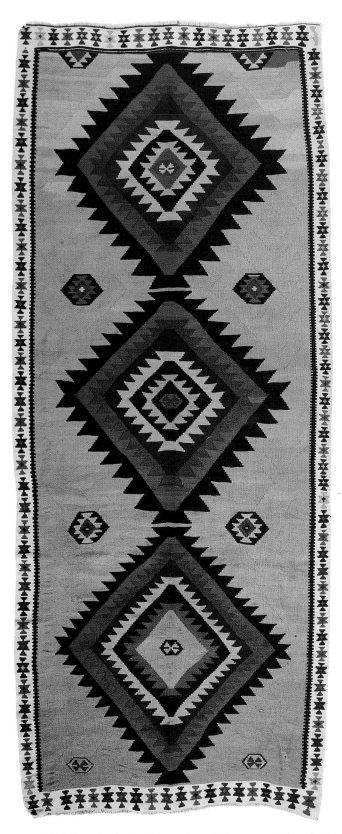

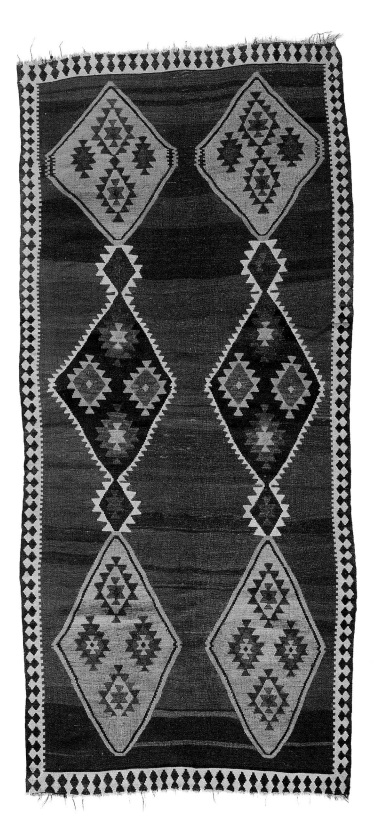

PLATE 27. *Gelim, Sarab, Azarbaijan. Late 19th century. All wool. Slit tapestry weave. 316 x 126cm (10ft.4in. x 4ft.2in.)*

PLATE 28. *Gelim, Sarab, Azarbaijan. Mid-19th century. All wool. Slit tapestry weave. 300 x 138cm (9ft.10in. x 4ft.6in.).*

Khalkhal

Khalkhal is situated east of Mianeh amid the Talesh mountains, the last outpost in eastern Azarbaijan. The town has little to show by way of weaving save for a few *gelims*. These generally have plain fields and few patterns. For the purposes of this book, however, I have bypassed these more typical *gelims* and chosen another example from the nineteenth century. This *gelim* (Plate 29), which has large portions in extra-weft wrapping, proved difficult to categorize. Ultimately the section on the *gelim* won out against those on the *palas* and weft-wrapping (see pages 27 and 28).

The composition of this *gelim* bears a close resemblance to those of Mianeh, but its colour scheme, weave and structure are in every way unconnected with that area. It is not clear in what quantities such *gelims* were woven in Khalkhal. An educated guess is that their numbers would not have been very great. Khalkhal is one of the important areas of the settlement of the Tat people and its weavings are considered under the work of the Tats (see page 286).

OPPOSITE: PLATE 29. *Gelim, Khalkhal, Azarbaijan. Late 19th century. Wool wefts on cotton warps. Weft-faced plain weave and dovetailed patterned extensively by extra-weft wrapping. 327 x 148cm (10ft.9in. x 4ft.10in.).*

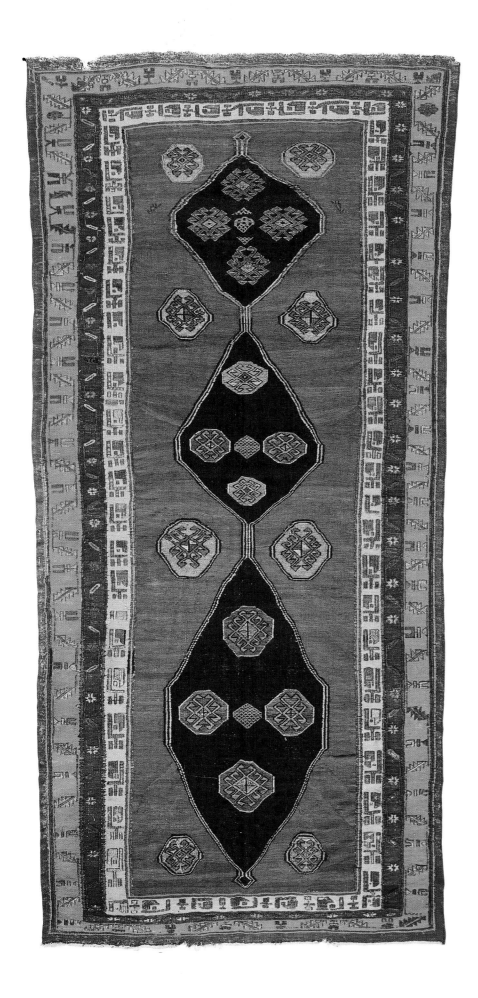

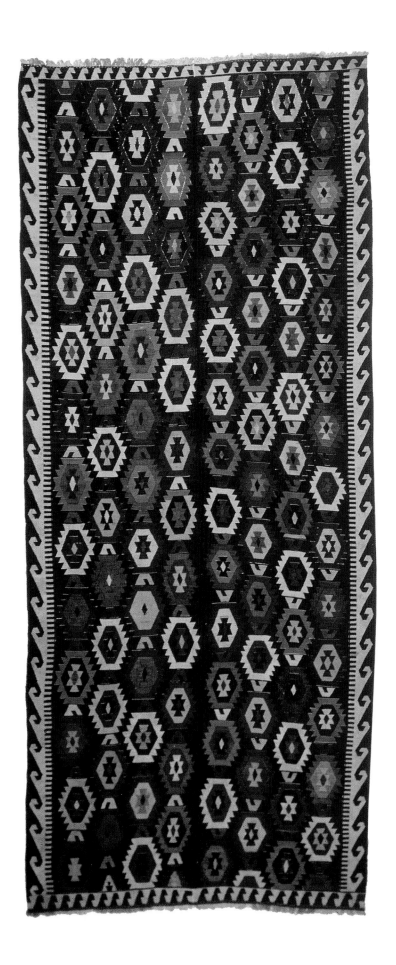

PLATE 30. *Gelim, Hashtrud, Azarbaijan. Late 19th century. All wool. Slit tapestry weave. Two strips sewn together. 424 x 184cm (13ft.11in. x 6ft.).*

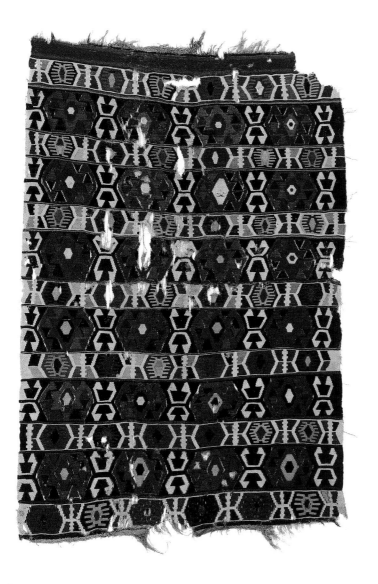

PLATE 31. *Gelim, Hashtrud, Azarbaijan. c.1800. All wool. Slit tapestry weave. Two strips sewn together. 290 x 191cm (9ft.6in. x 6ft.3in,).*

Hashtrud

As mentioned earlier, Hashtrud is one of the important centres of *gelim*-weaving in Azarbaijan and an area with a school of its own (see page 52). It is considered important for other flatwoven fabrics such as *jajim* and weft-wrapping.

Hashtrud (literally, eight rivers), whose name derives from the eight tributaries of the Qizil Uzun river that pass through and around the town, is situated between two mountains: Sahand and Bozqush. Aside from the native population, it is also inhabited by various Shahsavan clans which is precisely why the Hashtrud *gelim* is more varied by far than that of Mianeh or Moghan and can be classified into several categories. Of these, the most interesting and outstanding are those *gelims* whose pattern is formed by the repetition of large motifs, such as diamond-shaped stars. This group, identified in some sources as Talesh, is the most distinctive, and forms the basis for the Hashtrud school. Some of these *gelims* are in two pieces (Plate 30) and others in one. The second and most widely known batch of Hashtrud *gelims* is those with horizontal stripes in the manner of Moghan and Shirvan. This group can itself be divided into sub-groups, such as *gelims* without a border. Among the borderless *gelims* of Hashtrud, Plate 31 is especially important. This *gelim*, a relic of the nineteenth century, is

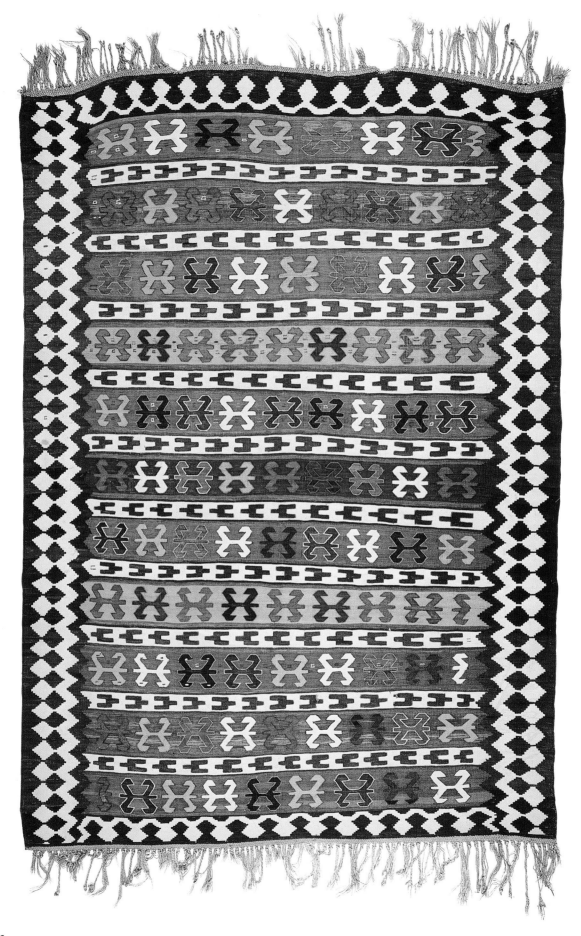

82

particularly suggestive of movement. The effect is achieved by the way the weaver has executed the motifs, featuring a horizontal as well as a vertical order and arranging them to create five columns through the length of the *gelim*. Of these five columns, two flank the two edges of the *gelim* and form a border.

Among the striped *gelims* with borders, those shown in Plates 32 and 33 are worthy of mention. The amount of cotton used in Plate 32 makes its attribution to Mianeh more logical, but its composition and use of colour are quite dissimilar from the Mianeh variety. The colouring of Plate 33 is reminiscent of Hashtrud *gelims*, although its composition resembles those of Moghan.

The *gelims* of Hashtrud are among the most colourful in Azarbaijan, with the weavers using every colour available to them. Their weave, too, is quite distinctive, being generally fine, compact and made around a woollen warp. These *gelims* were either made by the inhabitants of Moghan or influenced by their work. There is also a group of coarsely woven and loosely woven Hashtrud *gelims*.

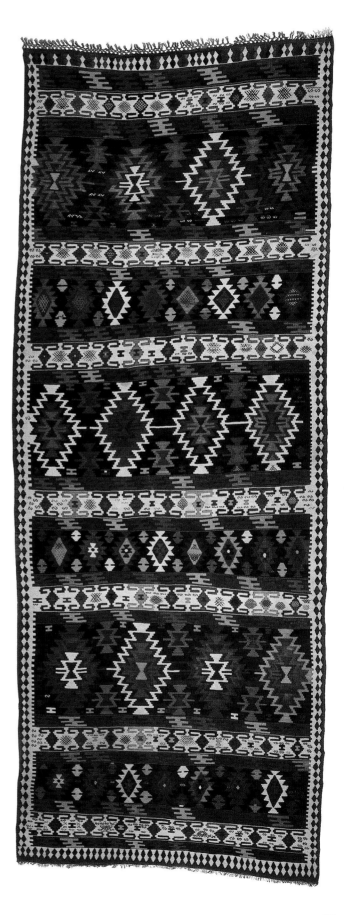

OPPOSITE:

PLATE 32. *Gelim, Hashtrud, Azarbaijan. Late 19th century. Wool and cotton wefts on wool warps. Slit tapestry weave with contour weft wrapping. 245 x 170cm (8ft. x 5ft.7in.).*

PLATE 33. *Gelim, Hashtrud, Azarbaijan. Late 19th century. All wool. Slit tapestry weave. 502 x 197cm (16ft.6in. x 6ft.6in.).*

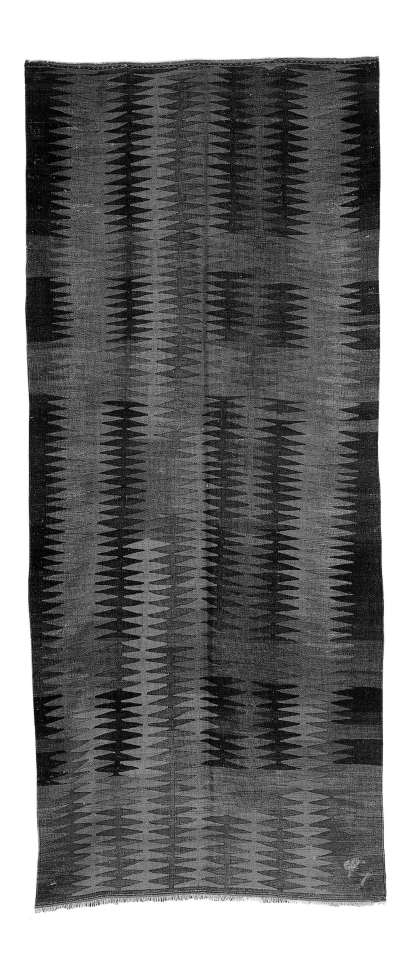

PLATE 34. *Gelim, Qara Aghaj, Azarbaijan. c.1900. All wool. Inclined slit tapestry weave. 355 x 152cm (11ft.8in. x 5ft.).*

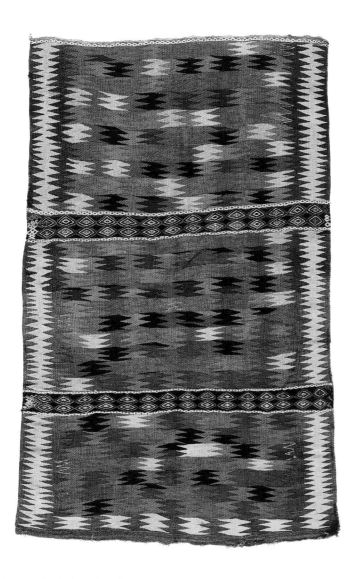

PLATE 35. *Gelim, Shahin Dezh, Azarbaijan. Wool wefts on goat hair warps. Inclined slit tapestry weave, two stripes patterned by weft-float brocading. 200 x 120cm (6ft.7in. x 3ft.11in.).*

Qara Aghaj and Shahin Dezh

To the south of Hashtrud, the area between the two towns of Takab and Miandowab is dotted with several villages and towns. The most important of these are Qara Aghaj and Shahin Dezh. According to the present-day political division of the country, Qara Aghaj is part of East Azarbaijan while Shahin Dezh is situated in West Azarbaijan. The border separating the provinces passes between these towns. For our purposes, however, we must consider them as one area, for their *gelims* have a great deal in common and both regions are influenced by Kurdestan and Azarbaijan *gelims*. Shahin Dezh, whose older name was Sa'in Qal'eh-ye Afshar, is a centre for the Afshar tribe. The colour scheme and weave of the Afshars' *gelims* and those woven in Qara Aghaj resemble those of the *gelims* of Takab (see below), with brown undyed wool being used for the field or borders. The designs, however, differ. The Afshars, it would seem, were more partial to repeating and eye-dazzling designs than were others. These designs are all found roughly in the Zagros region. The weave in the *gelims* of Qara Aghaj and Shahin Dezh is sometimes compact (Plate 34), as in the Azarbaijan *gelim*, and sometimes loose (Plate 35). In both these *gelim* types, an inclined slit tapestry weave is used.

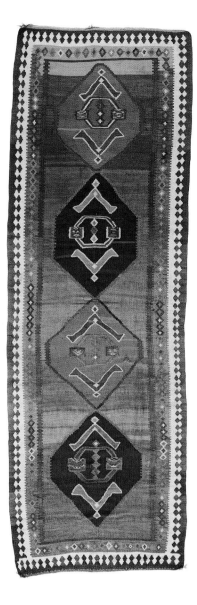
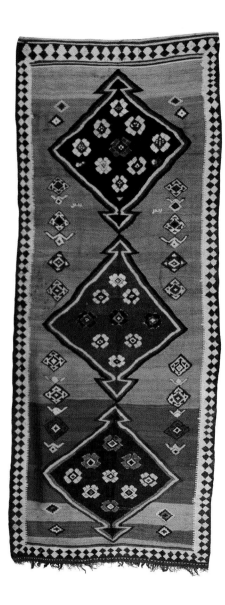

LEFT: PLATE 36. Gelim, Takab, Azarbaijan. Late 19th century. All wool. Slit tapestry weave with eight spots of pile weave; symmetrical knot. 402 x 135cm (13ft.2in. x 4ft.5in.).

RIGHT: PLATE 37. Gelim, Takab, Azarbaijan. Late 19th century. All wool. Slit tapestry weave. 350 x 144cm (11ft.6in. x 4ft.9in.).

Takab

The town of Takab enjoys the same importance in weaving in southern Azarbaijan that Bijar does in Kurdestan; rugs from here could very easily be sold under their own label. So far, however, there have been no attempts to introduce these rugs to the world at large, and the rugs and *gelims* of Takab are identified everywhere under the generic names of Azarbaijan or Kurdestan. This is despite the fact that, like Bijar and Heris, Takab can lay claim to an independent school of rug- and *gelim*-weaving.

Takab is located some 100 km (60 miles) north of Bijar, near the border between western Azarbaijan and Kurdestan. The town itself is divided into two parts by the narrow Takab river, one part inhabited by Turks and the other by Kurds. The Kurdish part of town is considerably smaller than the Turkish part and its weavings are not as important. Takab, whose older name is Tikan Tappeh, was one of the regions of Azarbaijan settled by the Afshars. Even now the name Afshar is used as a suffix for Takab and most of the Afshar-inhabited villages in the area. In terms of design and pattern the *gelims* of Takab are very

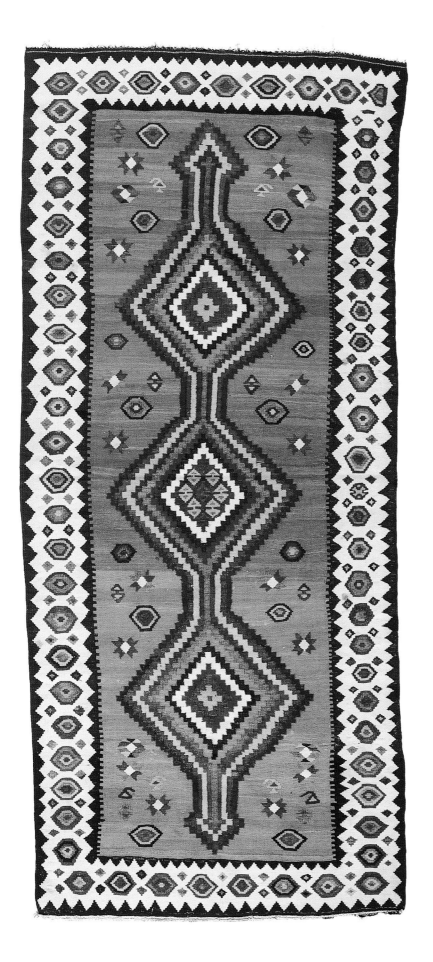

PLATE 38. Gelim, Takab, Azarbaijan. Around 1900. Wool and cotton. Dovetailed and slit tapestry weave. 287 x 127cm (9ft.9in. x 4ft.2in.).

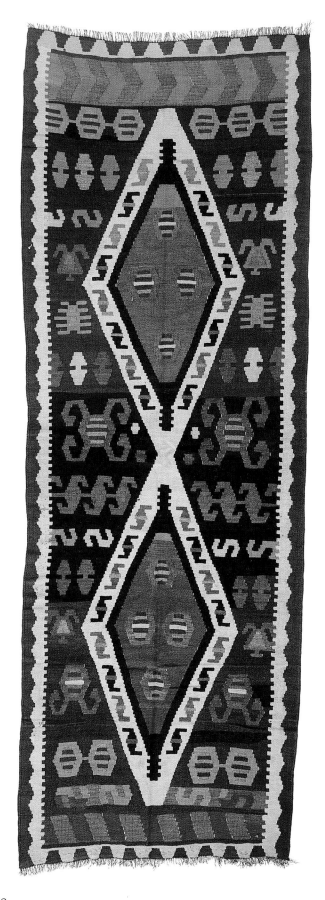

diverse. Some resemble those produced in Bijar in that they are inspired by floral motifs (Plates 36 and 37). Others, like those found in Mianeh, bear totems (Plate 38), while yet more follow the pattern of repeating diamond-shaped stars which is prevalent throughout Azarbaijan, especially among the Shahsavan. In each instance, however, they have preserved those unique features that set them apart as products from Takab.

One of the special features of the *gelims* of Takab is their weave. This is tighter than that in the *gelims* of Bijar, but only in a few instances does it match the compactness of the *gelims* of Moghan (see Plates 39 and 40). The quality of the weave is what sets apart Kurdish weavings from Turkish ones. Another special feature of the *gelims* of Takab is their use of colour, which marks out Takab weavers as an independent school. They generally use primary colours such as dark blue, red, blue and yellow on a brown field (see Plates 36, 37, 38 and 41). At other times crimson or dark blue are chosen as the colours of the field (Plates 39 and 40).

Takab is a fairly extensive region encompassing more than ninety villages, with the consequence that its *gelims* are fairly diverse. Some villages, such as Bardlu and Chichaklu, have played a larger role in *gelim*-weaving, but it is very difficult – if not impossible – to identify their older products today. For the most part, *gelim*-weaving has been abandoned here in favour of pile-rug weaving in non-Takab designs.

PLATE 39. *Gelim, Takab, Azarbaijan. Mid-19th century. All wool. Slit tapestry weave. 325 x 115cm (10ft.8in. x 3ft.9in).*

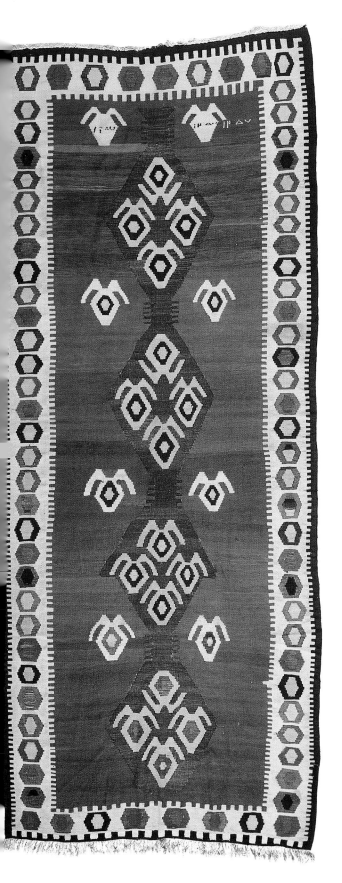

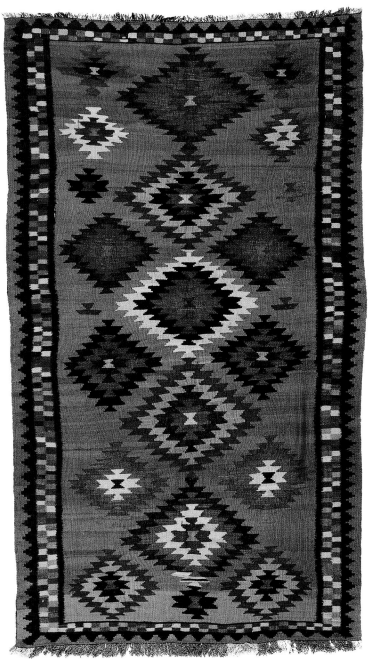

ABOVE: PLATE 41. *Gelim, Takab, Azarbaijan. Two plies of the warps cotton, one ply wool; wefts: wool. Slit tapestry and dovetailed weave. 247 x 142cm (8ft.1in. x 4ft.8in.).*

LEFT: PLATE 40. *Gelim, Takab, Azarbaijan. All wool. Slit tapestry weave. 350 x 148cm (11ft.6in. x 4ft.10in.). Dated: AH1305 (1887).*

Khamseh and Zanjan

The old province of Khamseh was a fairly large area to the south of Azarbaijan, between Khalkhal and Bijar to the north and south and Hamadan and Qazvin to the west and east. Present-day Zanjan province corresponds roughly to the Khamseh of former times, and the city of Zanjan was one of five cities (the word khamseh meaning five), each of which was named after one of the tributaries of the Qizil Uzun that ran through the area. Since time immemorial, this mountainous and fertile territory has been the home of numerous clans and communities. Its weavings are fairly diverse. The presence of large groups of Shahsavan in the south of Zanjan (between Qeydar and Bijar), of Afshars in the west of the province, and of other clans such as the Bayat, the Osanlu and the Moqaddam, has been a major factor in this diversity. Persian-speaking native tribes and the Tats (see page 286), who live in the highlands near Rudbar and Taromat, have also added to the richness of the weavings of Khamseh.

Plate 42 features a *gelim* from the Shahsavan of Khamseh. In terms of design and composition this *gelim* ranks with those of Moghan, but its weave is not as delicate. The colour scheme of the *gelims* of the Khamseh Shahsavans is also more muted than that of the *gelims* of Moghan. The most common design on these *gelims* is the large crab-shaped star.[103] Normally these *gelims* are two-piece weavings, but that is not the case with the *gelim* shown here, which is in one piece with its secondary stripes in a supplementary weft-float brocading structure. Another *gelim* (Plate 43) is from Bidganeh, a village about 30km (18 miles) west of Zanjan. The rugs of Bidganeh are recognized among experts as a distinct group, but the *gelims* made here are less well known. The number of *gelims* known to have come from Bidganeh has not been sufficient to merit their being called a group. I have seen three Bidganeh *gelims*, all of which exhibited well-extended and sizeable medallions (Plate 43). The medallion motif, one of the classic Persian designs, has been worked into the *gelims* of Bijar and Zarand more extensively than elsewhere. The weave used in these examples differs from that of the Bidganeh *gelim*, however. In the Bidganeh *gelim*, both the slit and dovetailing structures are used in equal proportion, and the weave is tight and stiff, although not very fine or delicate. It can be said that the Bidganeh *gelim* has been influenced by both the Turks and the Kurds.

Anguran is an area situated in the westernmost region of Khamseh closer to Takab than to Zanjan. This mountainous terrain, encompassing 153 villages, has produced some of the most exquisite flatwoven pieces, such as weft-wrapped *khorjins*.[104] The design in the *gelims* shown here is the tree-like totem, which is reminiscent of the Mianeh *gelim*, while the branches and leaves are features of the work of Kurds (see pages 94 and 95). The weave in this *gelim* (Plate 44) shows a very fine and compact weave similar to the work of the Shahsavan or the Afshars.

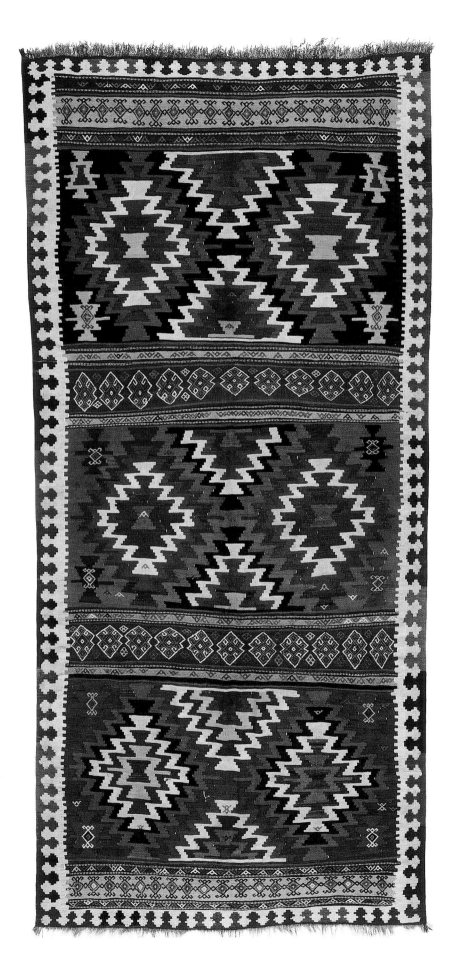

PLATE 42. Gelim, Qeydar, Khamseh of Zanjan. Late 19th century. All wool. Slit tapestry weave patterned extensively by weft-float brocading. 344 x 160cm (11ft.3in. x 5ft.3in.)

91

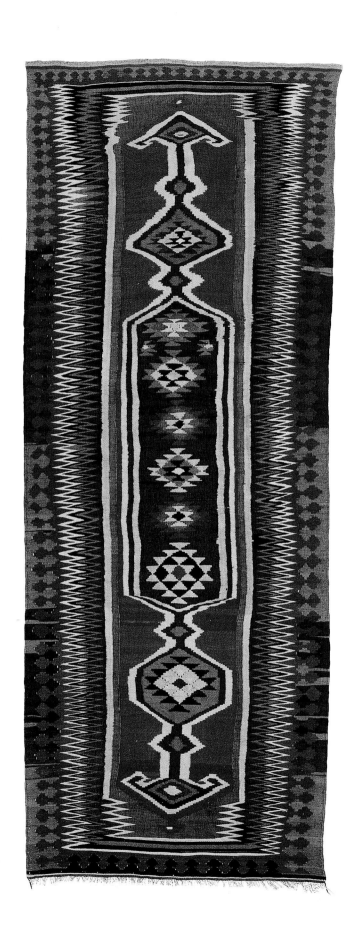

PLATE 43. Gelim, Bidganeh, Zanjan. c.1900. Wool wefts on cotton warps. Dovetailed and slit tapestry weave. 352 x 131cm (11ft.7in. x 4ft.4in.).

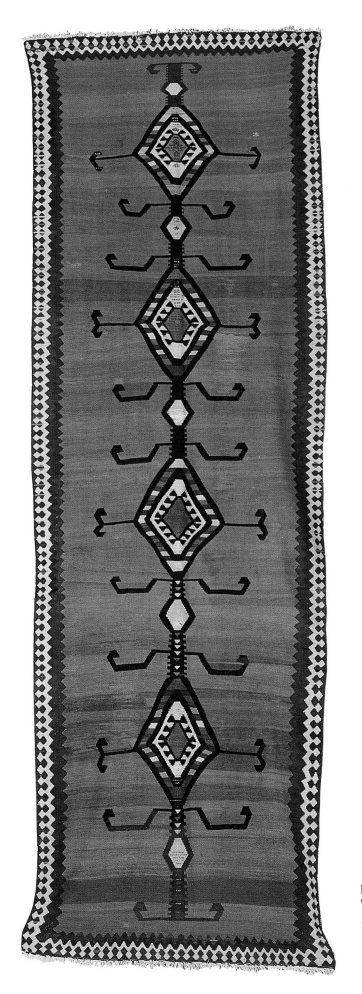

PLATE 44. *Gelim, Anguran, Zanjan. Late 19th century. Wool wefts on cotton warps. Slit tapestry weave. 460 x 152cm (15ft.1in. x 5ft.).*

93

FIGURE 22. *Bolbar, a Kurdish village in Huraman.*

Kurdestan and the Kurds

Although it has been a while since a province with clearly defined borders by the name of Kurdestan has existed south of Azarbaijan, organized Kurdish life thrives well beyond the bounds of this province. Aside from Kermanshah province, which is the homeland of the southern Kurds, these people live throughout western Azarbaijan, side by side with their Turkish neighbours. In some areas, such as Takab, Shahin Dezh and Miandowab, villages are divided into Turkish and Kurdish halves; elsewhere they live in neighbourhoods close to each other.

The Kurds, who must properly be termed an Aryan and Iranian people, have left a significant mark on Iran's ancient history.[105] Although the arrival of the Turks in Azarbaijan from the mid-eleventh century onwards had repercussions for the Kurds, the language and civilization of the new arrivals did not subsume those of the Kurdish population, and the weaving of the Iranian Kurds is an offshoot of Persian civilization.

The design and pattern of the Kurdish *gelim* draw upon elements of nature, such as flowers and plants. Consequently, Kurdish *gelims* exhibit softer and more curved lines, while their Azarbaijan counterparts are woven with straight and geometric lines. In their weave, too, they are different, with Kurdish *gelims* being flexible and Turkish ones compact. Another area of difference is the finishing at the ends and sides of the *gelims*. Regardless of the general validity of these principles, however, none of them is absolute or final. The reason for this

FIGURE 23. *Ritual ceremonies in Huraman-e Takht, Kurdestan.*

is the mingling among the Turks and the Kurds. In short, the Turks have been influenced by the Kurds to the same degree that they have influenced them. Of the five varieties of Kurdish *gelims* (or those influenced by the Kurds) in this book, three were woven in the province of Kurdestan and one in western Azarbaijan. The fifth variety was not woven by Kurds alone, but is the product of a blending of Kurdish and Lori influences. By no means do these five varieties represent all Kurdish *gelims*, for there are no specimens among them of gelims woven in the Iran-Iraq and Iran-Turkey frontier areas.[106]

Sanandaj (Seneh)

Ever since the reign of the Safavids, and particularly from the seventeenth century onwards, Sanandaj has been the seat of the governor of Kurdestan. The name derives from seneh dezh, which means three fortresses.[107] The *gelims* of Sanandaj have achieved renown under the name of Seneh for centuries. The Safavid *gelims* must be considered precursors to the Seneh *gelims*, for a great many features of the Safavid *gelim* can be found in them. The delicacy and tightness of weave in these *gelims*, as well as their patterns and designs, bear out such a relationship. It seems that the role played by Tabriz (the first capital of the Safavids) in the production of the royal *gelims* was turned over to Sanandaj when the Safavid dynasty ended.

The term Fath 'Ali Shahi *gelim*, which is prevalent in the rug markets of Iran, applies to a group of the finest Seneh *gelims*. These *gelims*, which are generally

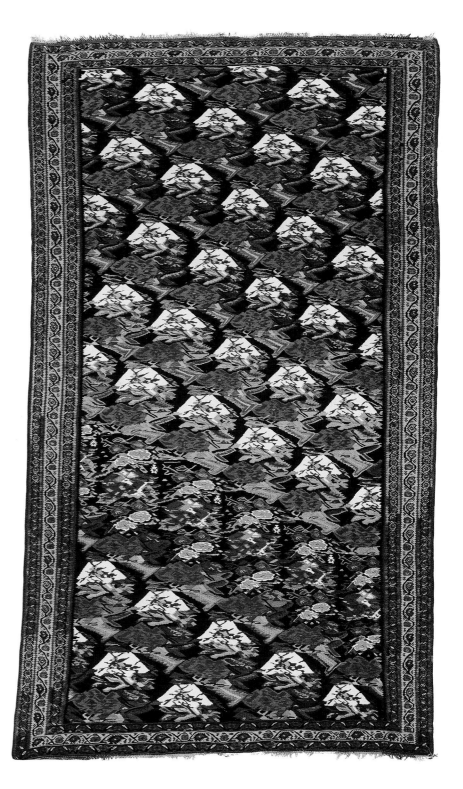

PLATE 45. *Gelim, Seneh, Kurdestan. Wool wefts on silk warps. Slit tapestry weave with eccentric wefts. 204 x 119cm (6ft.8in. x 3ft.11in.).*

COLLECTION CARPET MUSEUM OF IRAN

woven small with the dimensions of a prayer rug (1 x 1.5m/ 3ft.3in. x 5ft., known as the *zar-o-nim* format), are so fine and delicate that some of them can be folded and put away in a pocket despite the fact that only their warps are of silk, while their wefts are entirely of wool. The *gelims* known as the Fath 'Ali Shahi have also been called the seven-colour *(haft rang) gelims* by virtue of the fact that their warps are multi-coloured in batches (Plate 45).

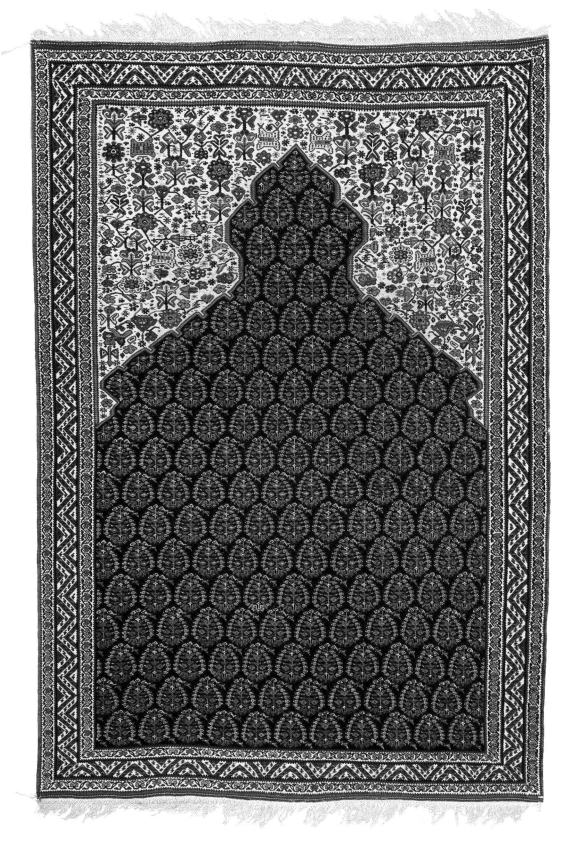

PLATE 46. *Prayer gelim, Seneh, Kurdestan. Mid- to late 19th century. All wool. Slit tapestry weave with eccentric wefts. 178 x 122cm (5ft.10in. x 4ft.).*

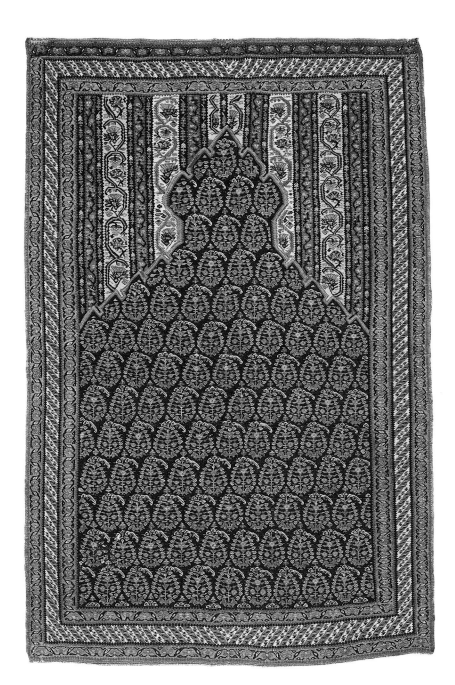

PLATE 47. *Prayer gelim, Seneh,
Kurdestan. Slit tapestry weave,
with eccentric wefts. 182 x
121cm. (6ft. x 4ft.)*

OPPOSITE: PLATE 48. *Gelim,
Seneh, Kurdestan. Mid-19th
century. All wool, slit tapestry
weave with eccentric wefts. 132
x 168cm (4ft.4in. x 5ft.6in.).*
COURTESY MURAT ORIENTAL
RUGS, NEW YORK

The pattern of Seneh *gelims* generally consists of repeated *bottehs* motifs. This design, which must have been particularly attractive to the Qajar court, can be seen on most weavings and fabrics produced throughout the nineteenth century and in the early years of the twentieth, including rugs, shawls and *qalamkars*. Many of the Seneh *gelims* were woven as prayer rugs and therefore are in the *zar-o-nim* format or larger. The surface of the *mehrab* or niche in these rugs is generally adorned with the *botteh* pattern (Plate 46); sometimes this motif is used as far up as the spandrel (Plate 47). Another common pattern in Seneh *gelims* was the *moharammat*. This pattern, comprising narrow vertical or diagonal stripes, was a fairly prevalent one, and variations can be seen in other textiles. The pattern forms the *mehrab* in some Seneh *gelims*, with the spandrels above adorned with small gols (Plate 50) or else with *bottehs*.

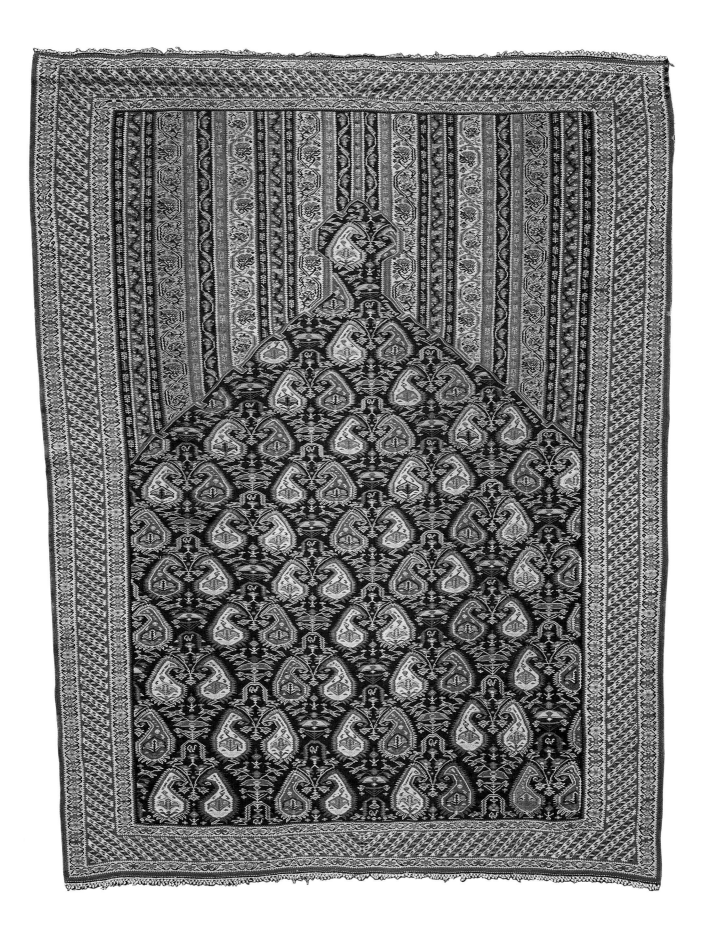

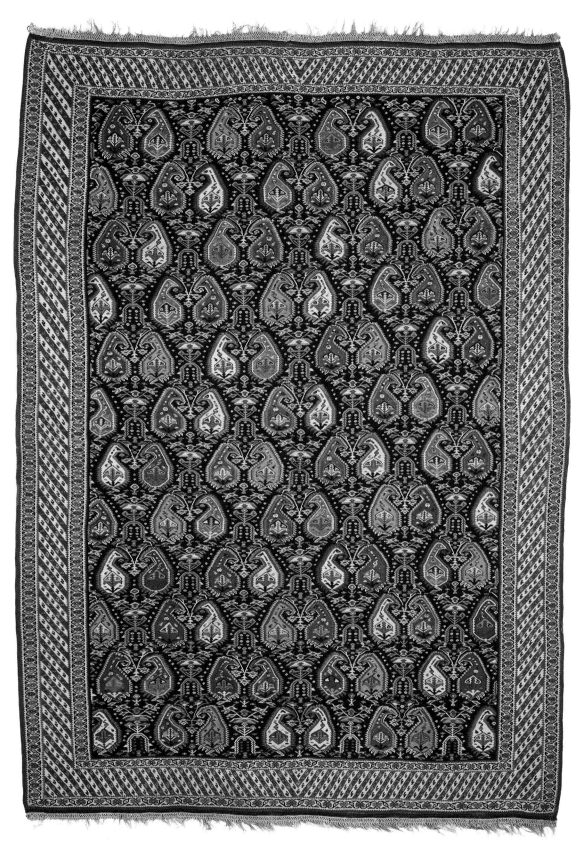

PLATE 49. *Gelim, Seneh, Kurdestan. 19th century. All wool, slit tapestry with eccentric wefts. 180 x 130cm (5ft.11in. x 4ft.3in.).*
VOK COLLECTION

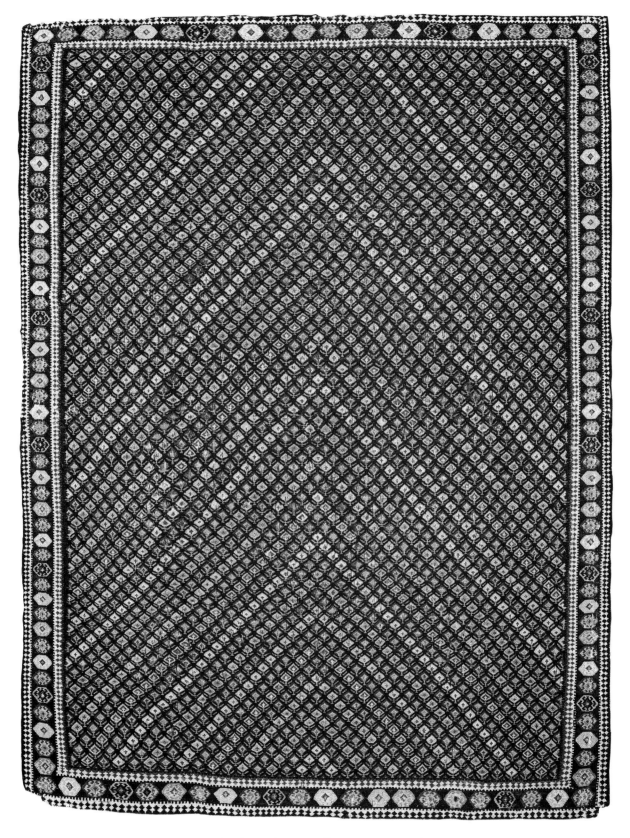

PLATE 50. *Prayer gelim, Seneh, Kurdestan. Mid- to late 19th century. Slit tapestry weave, with eccentric wefts. 162 x 122cm (5ft.4in. x 4ft.).*

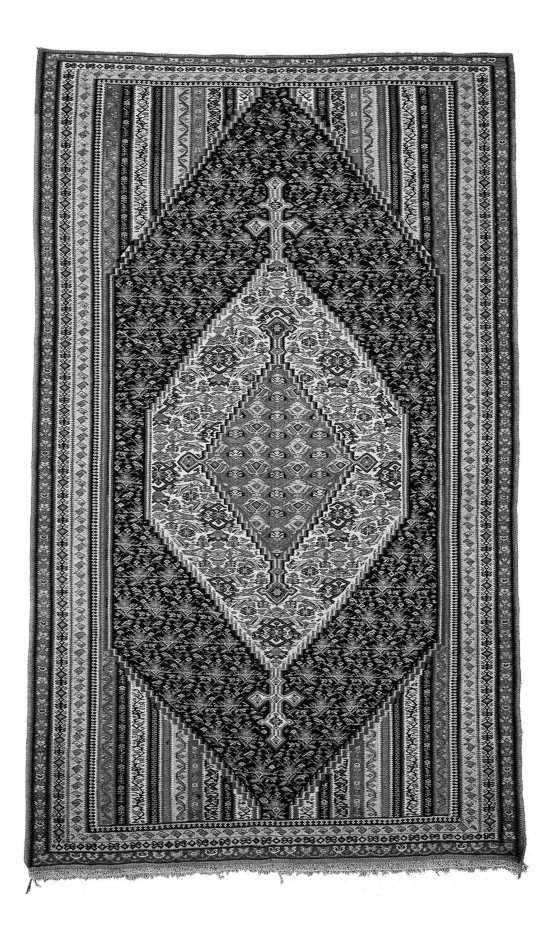

Aside from prayer rugs, other *gelims* have been woven in Seneh with different designs and compositions. One such *gelim* is shown in Plate 51, where the design features a medallion within a medallion. The field and the area surrounding the medallions are covered in *gols*; the remaining space at the four corners of the medallions is filled in with stripes, which are linked up with the stripes in the border.

Larger, more elaborate *gelims* were also woven in Seneh. A long *gelim* worthy of attention is Plate 52, which exhibits a *moharammat* design. While this *gelim* is not as delicate as those which were commissioned (see below), it boasts the same designs and colours.

The majority of the gelims mentioned here are called commissioned *(sefareshi)*, which refers to the fact that they were commissioned by the governors of Kurdestan and sent as gifts to the Qajar court or officials. These 'commissioned' *gelims* were not woven for the everyday use of the Kurds. The term workshop *gelim*, which is applied to the Safavid

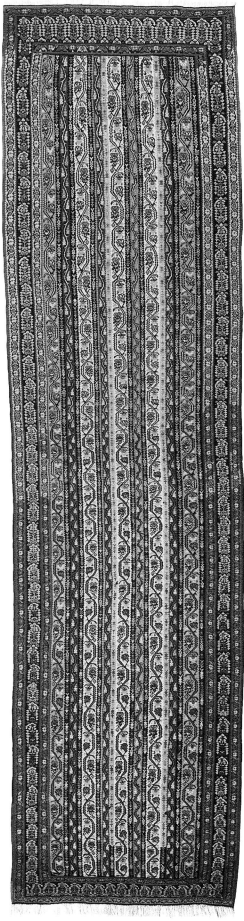

OPPOSITE: PLATE 51. *Gelim, Seneh, Kurdestan. Late 19th century. Wool wefts on cotton warps. Slit tapestry weave with eccentric wefts. 199 x 123cm (6ft.6in. x 4ft.).*

PLATE 52. *Gelim, Seneh, Kurdestan. Late 19th century. All wool. Slit tapestry weave with eccentric wefts. 530 x 143cm (17ft.5in. x 4ft.8in.).*

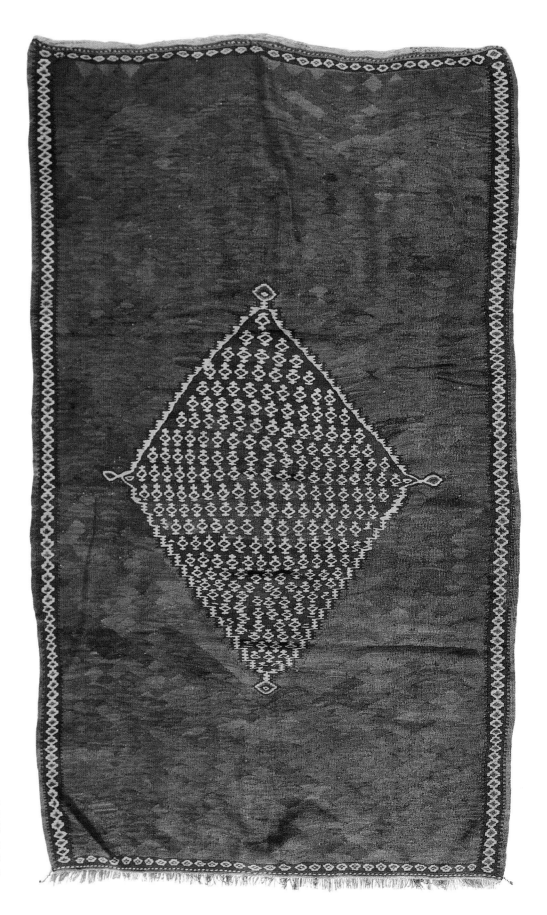

PLATE 53.
Gelim, Seneh area, Kurdestan. Early 20th century. All wool. Slit tapestry weave with eccentric wefts. 237 x 137cm (7ft.9in. x 4ft.6in.).

104

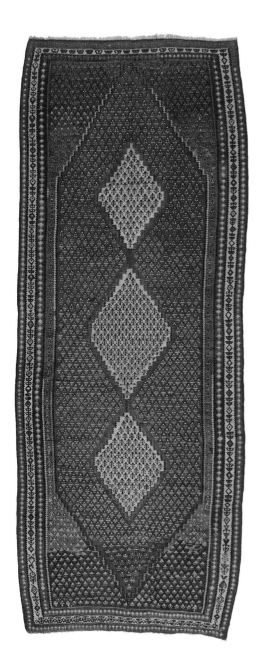

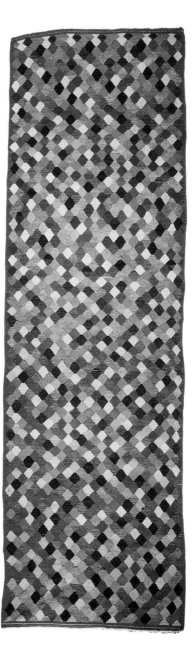

PLATE 54. *Gelim, Seneh area, Kurdestan. Around 1900. All wool. Slit tapestry weave with eccentric wefts. 410 x 160cm (13ft.5in. x 5ft.3in.).*

PLATE 55. *Gelim, Bijar, Kurdestan. Early 20th century. All wool, slit tapestry weave. 556 x 167cm (18ft.3in. x 5ft.6in.).* VOK COLLECTION

gelims and others produced by master craftsmen (see pages 42 to 46), would not describe those of Seneh, however, for it was women at home who wove these *gelims*. Seneh was also a centre for the production of very delicate *gelim*-like *jols* which shared all the characteristics of its *gelims*.[108]

Apart from the commissioned *gelims* of Sanandaj itself, there were areas close to the town where more everyday *gelims* were made in great number. While these *gelims* do not measure up to their superior counterparts in terms of delicacy, they share patterns and weaves. In order to distinguish between these *gelims* and the commissioned variety, they are referred to as Seneh-area *gelims* (Plates 53 and 54).

The weave structure generally used in the Seneh *gelim* is inclined slit tapestry with eccentric weft, as in Figures 14 and 15. The soft and gentle lines of these

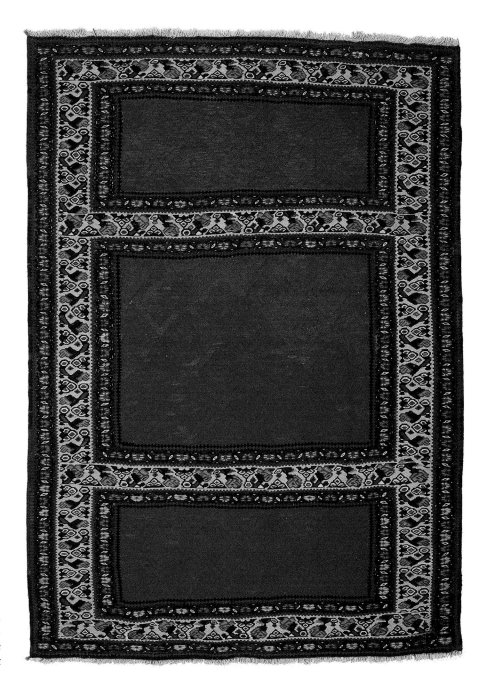

PLATE 56. *Gelim, Seneh, Kurdestan. Late 19th century. All wool. Slit tapestry weave with eccentric wefts. 174 x 125cm (5ft.9in. x 4ft.1in.).*

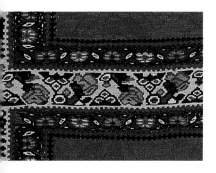

gelims and the *gols* and *botteh* worked into them make such a weave structure necessary. Another kind of weave used in Seneh *gelims* is the latticed weave. This weave, used in plain-field *gelims*, has the effect of dividing the *gelim's* simple ground into lozenge grids and turning the field, which is normally white, into a series of lattice-like designs. When the weave is held up to the light, it casts a latticed shadow. Plate 56 is an example of such a weave, which has not been found other than in Sanandaj.

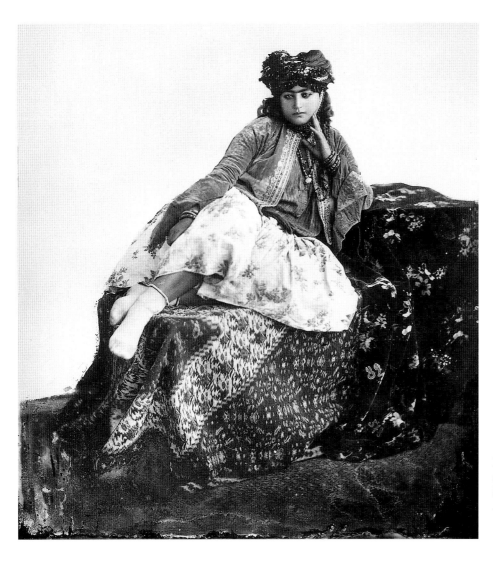

FIGURE 24. *Kurdish girl resting on a Bijari* gelim. *Photographed by Anton Sevruguin, turn of the 20th century.*
ARTHUR M. SACKLER GALLERY,
WASHINGTON DC

Bijar

Without a doubt Bijar is the most fertile *gelim*-weaving area in Kurdestan. Although the Bijar *gelim* is no match for the Seneh *gelim* in terms of delicacy, it outstrips its finer rival in terms of creativity and diversity.

The quiet little town of Bijar, left undisturbed by the passage of time and still fairly undeveloped, is situated in a dry, barren mountainous region. Its humble appearance and location can puzzle the visitor who is aware of the large inventory of rugs and *gelims* made there in the past. The houses in Bijar, however, with the array of rugs and *gelims* that the inhabitants have on their looms, prove that rug-making is everything to the people in this town.

Until the early twentieth century, Bijar was the seat of the governor of Garrus, the second most important subdivision within Kurdestan. Amir Nezam Garrusi, a leading statesman of the Qajar era, had a special fondness for the weavings of his homeland.[109] Although there is no reference to him on any Bijar *gelim*, it is entirely possible that he, or others in a similar position, took a special interest in the town's weavings, and there is a group of Bijar *gelims*, which we could call Bijar-city *gelims*, in which one can detect aristocratic influence. The design of most of these *gelims* is of the medallion type, similar to the composition of rugs from Bijar and other

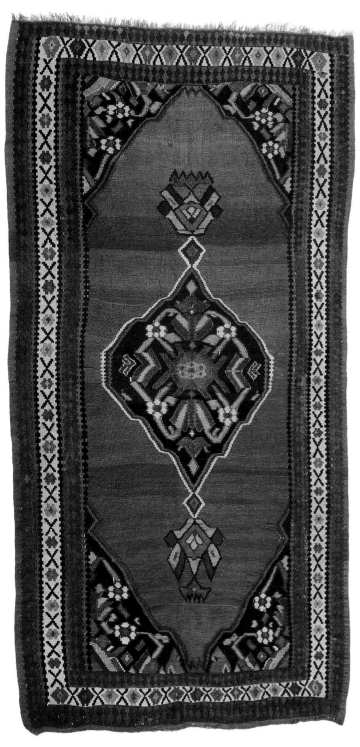

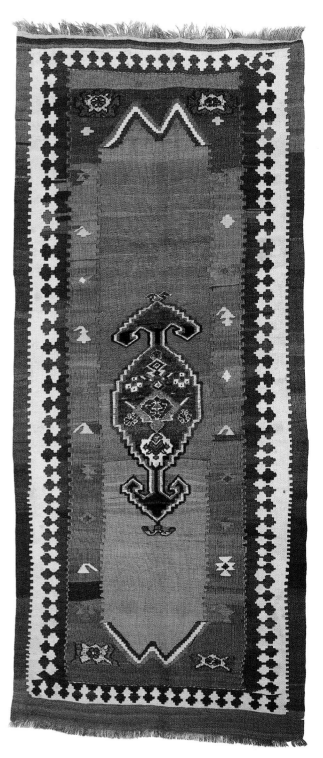

PLATE 57. *Gelim, Bijar, Kurdestan. Late 19th century. All wool. Slit tapestry weave. 400 x 145cm (13ft.1in. x 4ft.9in.).*

PLATE 58. *Gelim, Bijar, Kurdestan. Late 19th century. All wool. Slit tapestry weave, the medallion pile weave symmetrical knot. 287 x 119cm (9ft.5in. x 3ft.11in.)*

COURTESY ADIL BESIM, VIENNA

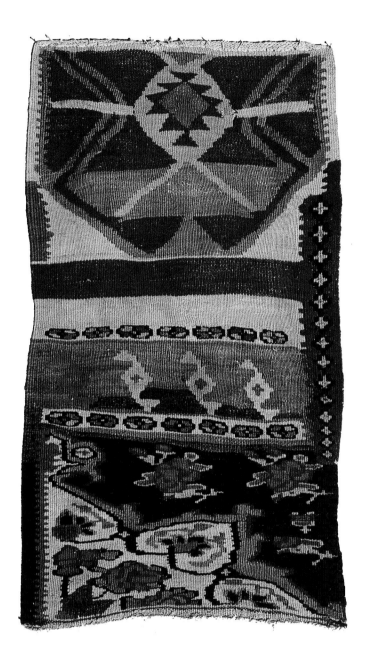

PLATE 59. *Vagireh 'sampler'*, *Bijar, Kurdestan. Late 19th century. All wool. Slit tapestry weave. 85 x 47cm (2ft.9in. x 1ft.6in.).*

places. In some, a large medallion with its head medallions sits proudly in the middle of a plain field, with a different design at each corner (Plate 57). The same composition appears in Plate 58, although with a smaller medallion executed in pile-weave. Medallion *gelims*, like medallion pile-rugs, have several border designs, and the overall conception is always symmetrical. The models for these *gelims* must have been the medallion rugs or *vagireh* (sampler), for it would otherwise be very difficult to execute such symmetry, balance and proportionality. The presence of a *vagireh* in Plate 59, while the only instance to have come to light for Bijar (or, for that matter, anywhere else), demonstrates that the weavers of Bijar used *vagireh* for difficult designs, such as the medallion.

The second type of *gelims* from Bijar consists of those woven in villages outside

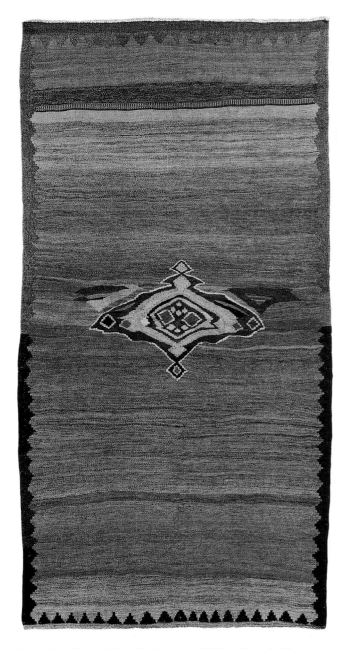

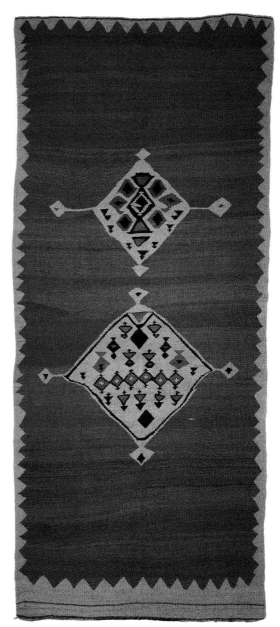

PLATE 60. *Gelim, Bijar, Kurdestan. c.1900. All wool. Slit tapestry weave. 245 x 131cm (8ft. x 4ft.4in.).*

PLATE 61. *Gelim, Bijar area, Kurdestan. c.1900. All wool. Slit tapestry weave. 365 x 158cm (12ft. x 5ft.2in.).*

the town limits. Although they do not share the symmetry of the Bijar-city *gelims*, they have a charm and simplicity all their own. One of these is shown in Plate 60, in which an attempt has been made to execute a medallion in the middle of a plain field, while Plate 61 features two medallions. In implementing the patterns of these *gelims* the weavers have fallen prey to certain mistakes, but these seem so innocent and endearing that they make these pieces, like children's paintings, more appealing.

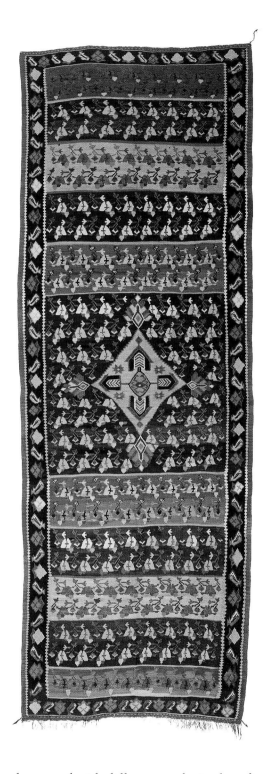

PLATE 62. Gelim, Bijar, Kurdestan. Mid- to late 19th century. All wool. Slit tapestry weave with eccentric wefts. 451 x 157cm (14ft.10in. x 5ft.2in.).

Medallions have been used with different results in the *gelims* shown in Plates 62 and 63. Rather than place the medallion on a uniformly plain field, the weaver of the piece shown in Plate 62 has divided the field into broad stripes and placed the medallion in a series of these stripes with floral motifs that appear like gardens. The use of colour combination here is admirable.

The villages surrounding Bijar have produced other designs, too. Among these is a plain-field *gelim* in which design and pattern are kept to a minimum

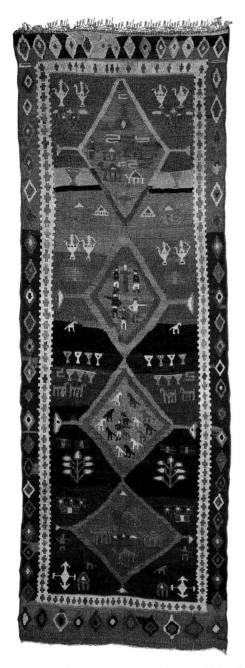

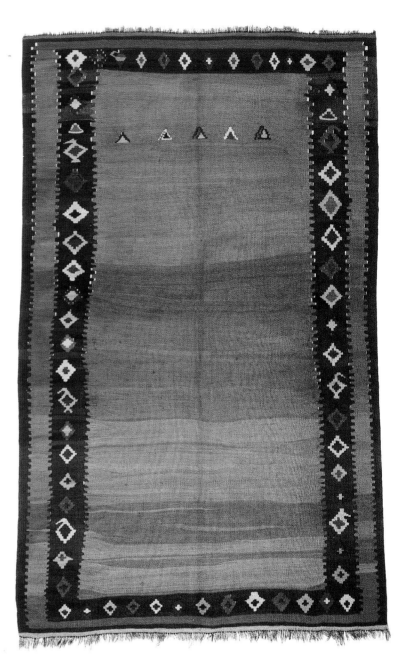

PLATE 63. *Gelim, Bijar area, Kurdestan c.1890. All wool. Slit tapestry weave. About 300 x 120cm (9ft.10in. x 4ft.)*

PLATE 64. *Gelim, Bijar area, Kurdestan. c.1900. All wool. Slit tapestry, weft-faced plain weave. 268 x 163cm (8ft.10in. x 5ft.4in.).*

and confined to small symbols (Plates 64 and 65). Another group of plain-field *gelims* from Bijar features lozenges stacked one on top of another in a totem-like fashion. An explanation of this pattern appears on pages 50 to 52.

While the *gelims* of Bijar's villages lack the delicacy and workmanship of Bijar-city ones, with their orderly composition and finely executed *gol* and fish motifs, and while they appear coarser and more unadorned, they have a simpler, direct beauty all of their own.

PLATE 65. *Gelim, Bijar area, Kurdestan. c.1900. All wool. Inclined slit tapestry, weft-faced plain weave. 315 x 135cm (10ft.4in. x 4ft.5in.).*

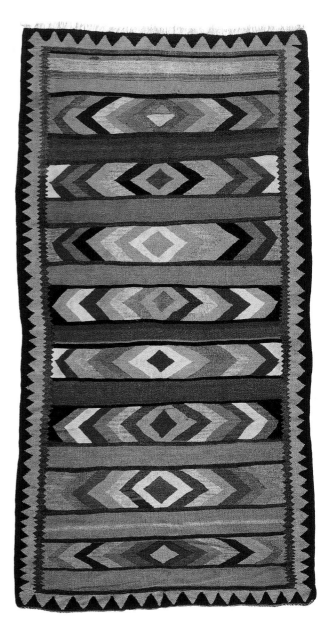

ABOVE: PLATE 66. *Gelim, Yasukand, Kurdestan. Late 19th century. All wool. Slit tapestry, weft-faced plain weave. 465 x 130cm (15ft.3in. x 4ft.3in.).*

LEFT: PLATE 67. *Gelim, Yasukand, Kurdestan. Early 20th century. Wool wefts on cotton warps. Slit tapestry weave. 268 x 135cm (8ft.10in. x 4ft.5in.).*

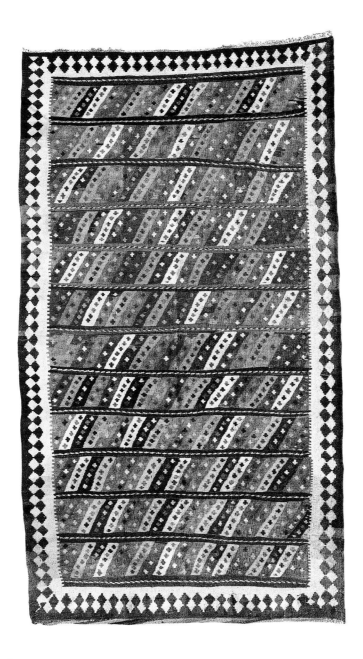

PLATE 68. Gelim, Yasukand, Kurdestan. Late 19th century. Wool and cotton wefts on mixed plied warps. Slit tapestry weave. 278 x 155cm (9ft.1in. x 5ft.1in.).

Yasukand

The third type of Kurdish *gelims* are those which were woven in the village of Yasukand or Hasanabad-e Yasukand. This village, situated some 65 km (40 miles) north of Bijar, has remained obscure and unrecognized in the carpet world, and its *gelims* are traded in the bazaars under the Bijar label. However, the *gelims* of Yasukand differ in many respects from those of Bijar and form a group by themselves. The most important distinguishing feature of these *gelims* is their weave, which is considerably softer and more flexible. They are also thicker than the *gelims* of Bijar and their coloration is paler and more muted than that of Bijar or even of its surrounding villages. There is also a tangible difference between the design and composition of these *gelims* and those of Bijar. They do not exhibit floral or vegetal designs and consequently lack the soft lines of the Bijar and Seneh *gelims*. Furthermore, they seem to be influenced by the

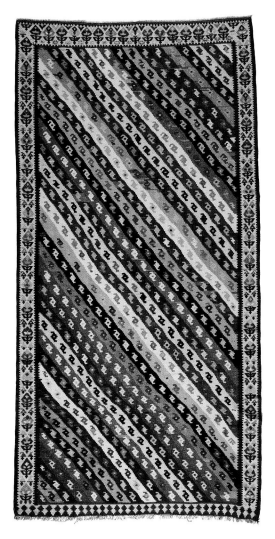

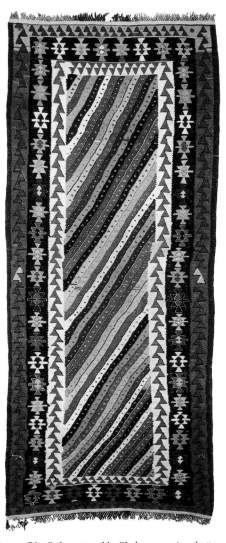

PLATE 69 Gelim, Yasukand, Kurdestan. Late 19th century. Wool and cotton wefts on mixed plied warps. Slit tapestry weave. 332 x 167cm (10ft.11in. x 5ft.6in.).

PLATE 70. Gelim, possibly Shahsavan, Azarbaijan. Late 19th century. All wool, slit tapestry and dovetail weave. 310 x 133cm (10ft.2in. x 4ft.4in.).
VOK COLLECTION

Azarbaijan school in the way they feature repeated geometric patterns, although their weave is not as compact as that of Azarbaijan *gelims*.

An important group of Yasukand *gelims* has a striped composition, with no design appearing in the stripes (Plate 66). Amongst these striped *gelims* one will occasionally come across a piece with horizontal stripes which feature a repeated single wishbone (< < < < <), as seen in Plate 67. In this example the weaver's skill is evident in the successful attempt to suggest an eye in the centre, while the surrounding wishbones appear as the 'ripples' of its gaze (<<< <> >>>). In Plate 68, however, the entire field is divided into broad horizontal stripes, each of which is filled in with narrow diagonal ones. A variation on this design can be seen in Plate 69, whose pattern is created by diagonal *moharammat* which cover the entire ground. The substantial use of cotton in this *gelim* and in Plate 68 must be a result of influence by Turkish neighbours. Other patterns can be also found in Yasukand, as shown in Plate 71.

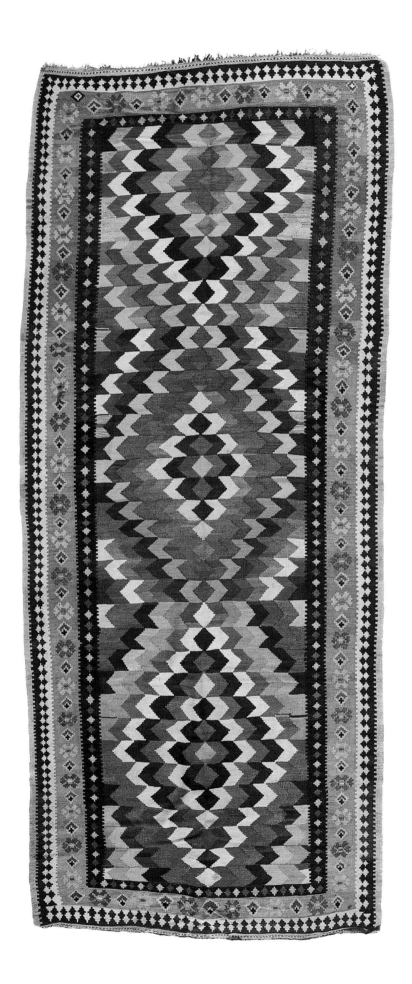

PLATE 71. *Gelim, Yasukand, Kurdestan. Late 19th century. All wool. Slit tapestry weave. 380 x 180cm (12ft.6in. x 5ft.11in.).*

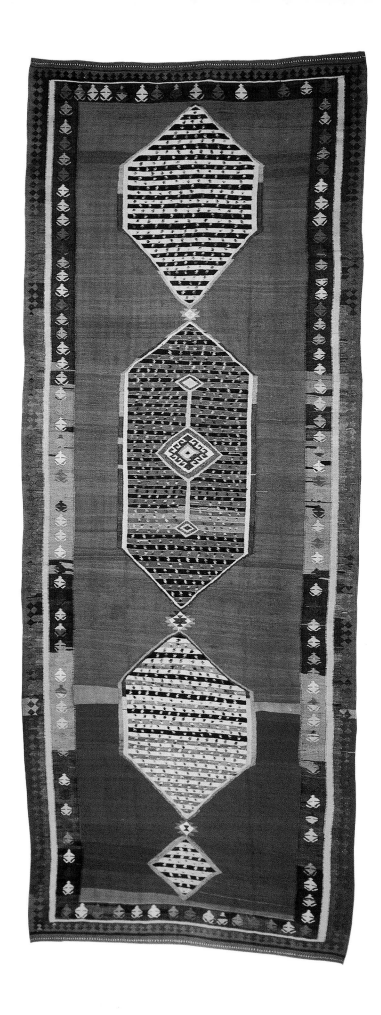

PLATE 72. *Gelim, Divan Darreh, Kurdestan. Early 20th century. Wool wefts on cotton warps. Slit tapestry and dovetailed weave. 460 x 180cm (15ft.1in. x 5ft.11in.).*

118

Divan Darreh

Another region of Kurdestan whose *gelims* have distinct features is Divan Darreh, which is located north of Sanandaj and west of Bijar. The *gelims* of Divan Darreh have a fairly compact weave, similar to that of Turkish pieces. It is still possible, however, to detect traces of Bijar and Seneh *gelims* in them. In some, for instance, although the composition is of a medallion (or several medallions linked together), the overall design resembles the totems seen on the *gelims* of central Azarbaijan and Mianeh.

A totem-like medallion can be seen in Plate 72. There, the field of the totem is covered by narrow stripes comprising tiny *gols*. Another *gelim* selected from this area (Plate 73) has several similarities with the Bijar *gelims*. As well as its flexible weave, it also exhibits soft lines and plant motifs. The central design in this *gelim* is positioned half-way between the multiple medallion of Bijar and the totems of Mianeh.

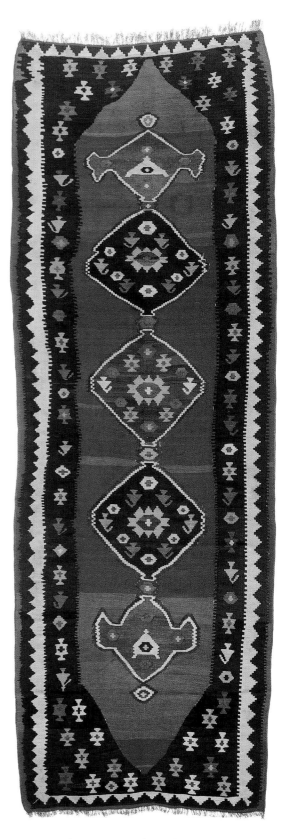

PLATE 73. *Gelim, Divan Darreh, Kurdestan. c.1900. All wool. Slit tapestry weave. 312 x 160cm (10ft.3in. x 5ft.3in.).*

119

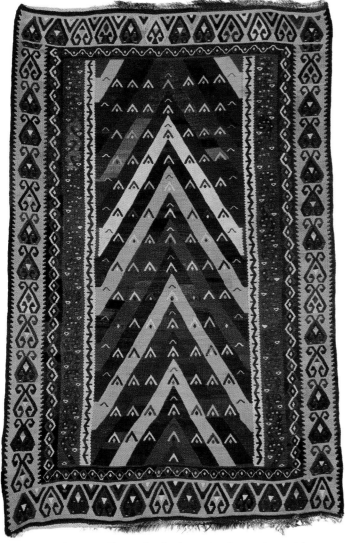

PLATE 74. *Gelim, possibly Kurds of Salmas, Azarbaijan. Late 19th century. Wool and goat hair, slit tapestry weave. 182 x 118cm (6ft. x 3ft.10in.).*

VOK COLLECTION

Urumia and Salmas

All *gelims* discussed so far were made to the east of Lake Urumia and no mention has been made of the *gelims* of the west of Lake Urumia. The vicinity of the inhabitants of the area – namely the Kurds – to the border of Turkey and the similarity of their weaving products is the main obstacle in differentiating the Persian ones from those of the Anatolians. Plate 74 is among the finest of the Kurdish work and it may have been made in Salmas, north of Urumia. Another example of the work of the people of this region will be discussed in the Palas section (see pages 230 to 235, The Northwest: Turkey, the Caucasus, Iran, Plate 178).

Harsin

Harsin is situated in the Kurdish province of Kermanshah, not well within the province, but stuck to the border with Lorestan. The inhabitants of Harsin are mostly Lors rather than Kurds, but this is not immediately evident. The two ethnic groups share many traditions and customs, so much so that for centuries some have thought of them as one people.

The Harsin *gelim* is among the most diverse of the *gelims* of western Iran, and the people of Harsin are among the most prolific of *gelim*-weavers. It is no exaggeration to say that hundreds of designs and patterns have their origins here.[110] An example is shown in Plate 75.

The gelims of Harsin can be divided into several categories according to their design and composition. Harsin weavers have employed practically every variation seen among the *gelims* of Kurdestan. Each group has distinct characteristics, such as the use of particular motifs and tiny ornaments. Sometimes these ornaments are so intertwined that they are reminiscent of the fish design of the Seneh *gelims*. Like the Seneh *gelims*, too, the weave structure of the Harsin *gelims* is based on two kinds: inclined tapestry and eccentric weft. Even the format of these two types is similar, being generally small and *zar-o-nim*. One feature, however, sets the Harsin *gelim* apart from the Seneh variety, and that is its weave. The Harsin *gelim* is as coarse as the Seneh is delicate and fine, which is why it is easy to tell them apart.

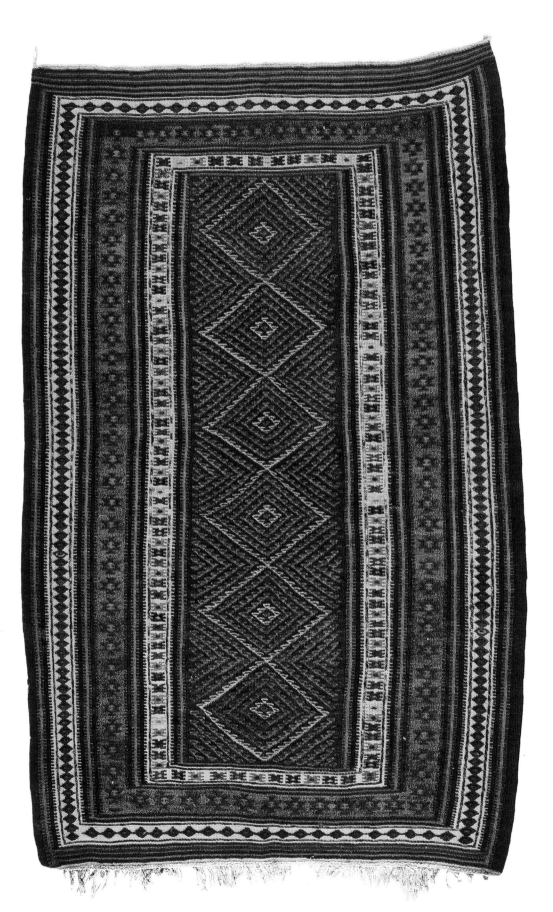

PLATE 75. Gelim, Harsin, Kermanshah. Early 20th century. Wool wefts on cotton warps. Slit tapestry weave with eccentric wefts. 266 x 140cm (8ft.9in. x 4ft.7in.).

121

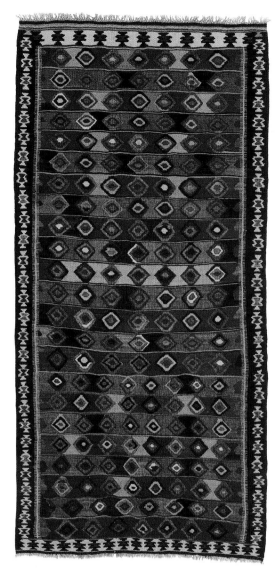

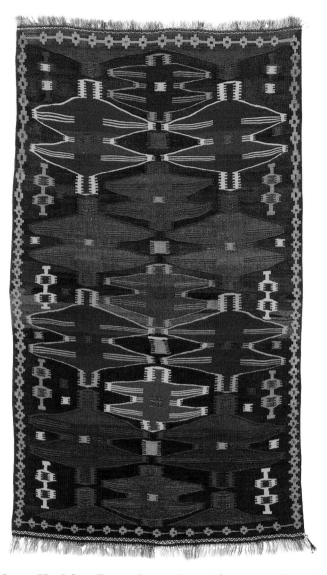

PLATE 76. *Gelim, Tarom, Zanjan. Late 19th century. All wool. Slit tapestry and dovetailed weave. 315 x 155cm (10ft.4in. x 5ft.1in.).*

PLATE 77. *Gelim, Tarom, Zanjan. Late 19th century. All wool. Dovetailed and slit tapestry weave. 231 x 135cm (7ft.7in. x 4ft.5in.).*

The Alborz Foothills

After its break with the Zagros mountains in the north-west, the Alborz range continues eastward to Khorasan. Along the Caspian coast these mountains become more lush and rise to higher altitudes, standing like a dividing wall before the Caspian Sea and preventing the moisture-laden air from travelling southwards. Snow gathers on the lofty peaks of the Alborz, sending water down into the plains further south. As a result, these plains have for thousands of years been the home of numerous tribes, during which time they have witnessed the growth of many human settlements. Two cities in this region have been elevated to the rank of the country's capital: Qazvin, which briefly served as the Safavid capital, and Tehran, which was chosen by the Qajars as the seat of government and remains so to this day.

The status of these two cities has undoubtedly been a major draw for various tribes, who brought with them their weavings.

Qazvin

Qazvin, also known as Minu-Dar, 'gateway to paradise', is an ancient site with an eventful history. In 1548 the Safavid Shah Tahmasb chose Qazvin as his capital, thus spawning numerous cultural and social trends. During Qazvin's brief period of prominence (the capital moved to Esfahan in 1591), the impact of cultural trends proved especially important and influenced the weaving in the city. In my opinion, the Qazvin rug, one of the rarest of Persian rugs, is a later manifestation of Safavid court carpets.

In the area of flatweaving, too, Qazvin has played an important role. Qazvin's *gelim* and other flatwoven fabrics clearly show the influence of both the Kurds and the Turks, who must have followed the Safavids to Qazvin. In order to maintain an equilibrium between them, Shah 'Abbas I settled the Kurds in the north and the Turks in the south of the town.[111] Kurdish clans such as the Rashvand, the Jalilvand, the Kakavand and the Mafi still inhabit the Alamut, Rudbar and Lower Tarom areas; among the Turks are the Inalu and the Afshars, who settled in the districts of Zahra and Kharaqan.

Two *gelims* have been selected to represent the Taromat area here. Plate 76 has a striped design embellished with repeated lozenges. Plate 77 differs completely in design from other *gelims* produced here and its design can be described most simply as the triple totem. Despite the variance in design, these two *gelims* are alike and somewhat akin to the Bidganeh shown in Plate 43. Like this example, the pieces shown in Plates 76 and 77 are made of both slit tapestry and dovetailing. These *gelims* and the *gelims* of Qazvin lend greater credence to my suggestion about the Tats and the kind of weave that is their speciality (see below).

A large number of *gelims* attributed to Azarbaijan and Kurdestan were actually made in the environs of Qazvin. There is still some difficulty in categorizing them. Some of these *gelims* are produced by the Shahsavan, some by the Afshars, and some by the inhabitants of Qazvin. One of the *gelims* shown here (Plate 78) is undoubtedly a product of the people of Qazvin, possibly the Tats, because it exhibits all the characteristics of the Tati *gelim*. Its design, however, is reminiscent of the products of the north, especially a particular batch of Shirvan rugs.[112]

Despite all these variations, there exists an important category of the Qazvin *gelim* that is the work of neither the Kurds nor the Turks. Ranking among the largest and most outstanding grouping of *gelims* in Iran, these were the handiwork of the Tats.

PLATE 78. *Gelim, Qazvin area. Late 19th century. Wool wefts on cotton warps. Dovetailed and slit tapestry with contour weave. 565 x 134cm (18ft.6in. x 4ft.5in.).*

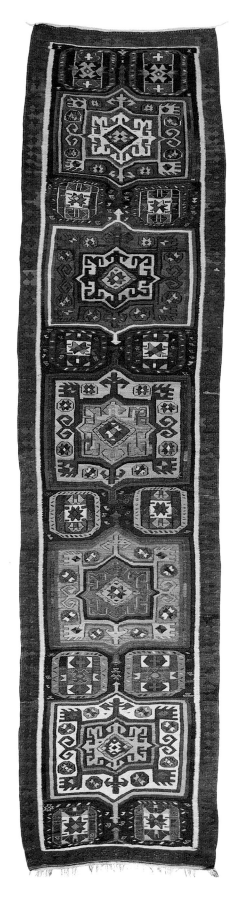

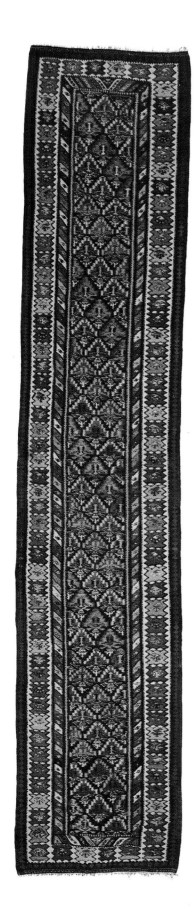

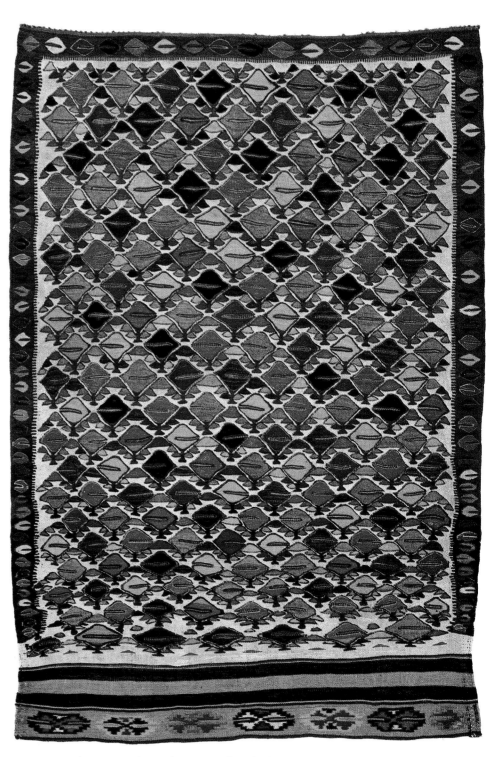

PLATE 80. *Gelim, Qazvin, late 19th century. All wool. Slit tapestry weave with eccentric wefts and contour weave. About 270 x 180cm (9ft. x 6ft.).*

PLATE 79. *Gelim, Saggezabad, Qazvin. c.1900. Wool wefts on cotton warps. Slit tapestry weave with eccentric wefts and contour weave. 494 x 100cm (16ft.2in. x 3ft.3in.).*

The Tats

There have been numerous attempts to explain the meaning of Tat and several theories have been advanced about its origin. The most logical of all, which also enjoys the widest support, is the view that the term was invented by the Turks to describe the non-Turkish, non-nomad, non-tribal people living in their midst.[113] In addition, it should be noted that the Tati group of dialects is related to Persian. The Tats then, are not a distinctly organized ethnic group but rather people who were not assimilated into their Turkish environment and who, despite the ascendancy of the Turks, succeeded in preserving their language and their traditions.

One explanation for the survival of the Tats is their peripheral life. They were never directly in the midst of the Turks but rather on the fringes of their land. Tat villages are generally located in selected areas, some of them relatively remote. Most of them have been identified in the stretch of territory between Qazvin and Daghestan in the Caucasus.[114] In all probability Qazvin was an important Tat centre.

Saggezabad is the regional headquarters of the Zahra district, which comprises a few dozen villages.[115] Most of these villages were destroyed in the disastrous earthquake of 1962, but those that have survived continue to produce *gelims*.[116] The *gelims* of Zahra are among the most distinctive in Iran, encompassing dozens of patterns and designs. Most of them are long and narrow and have two or three borders. The field on this group of *gelims* is covered with repeated designs, one of which is widely known as the leopard skin.[117] This design is created through the repetition of motifs that are in the shape of the leaves of the plane tree (Plate 79). If executed in large strokes, the design resembles a leopard skin. In other examples, the field of the *gelim* is striped horizontally, with some of the stripes bearing designs and others unadorned (Plate 81). In some *gelims* from Zahra district a substantial amount of dyed and undyed cotton is used (Plate 82). The warps in the Zahra *gelims* are generally of cotton also.

The Tat *gelim* is not confined to the villages of Zahra, but is also woven in other Tat-inhabited areas, such as the districts of Ramand, Taleqan, Alamut and Rudbar.

A distinguishing mark of the *gelim*-weaving of the

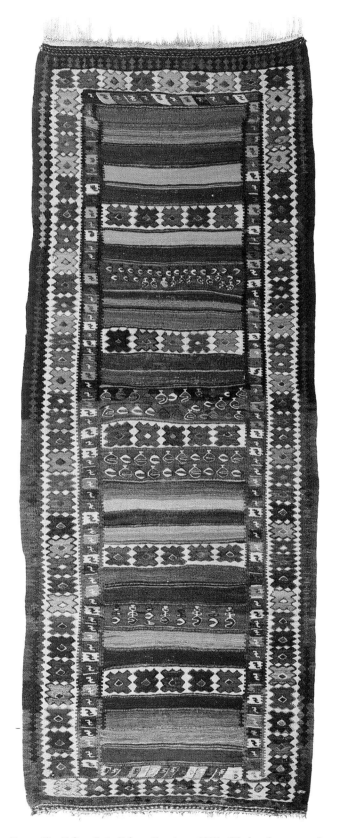

PLATE 81. *Gelim, Boin Zahra, Qazvin. c.1900. Wool and cotton wefts on cotton warps. Slit tapestry with contour weave. 297 x 119cm (9ft.9in. x 3ft.11in.).*

125

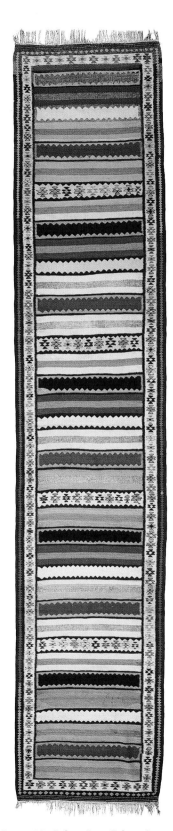

PLATE 82. *Gelim, Boin Zahra, Qazvin. c.1900. Wool and cotton wefts on cotton warps. Slit tapestry with contour weave. 548 x 111cm (18ft. x 3ft.8in.).*

Tats is the soft lines used in their motifs. Even the edges of their geometric motifs do not have the sharpness and jaggedness of Turkish ones, and are thus closer to the Kurdish model. Another feature of the Tati weaves of Qazvin is the use of contour lines, which serve to demarcate the separation of the motif from the field. Sometimes contour lines are created through weft-wrapping (Figure 19), at other times through contour-weft weave (Figure 20).

The Tats have made contributions to other weaving structures, such as the dovetailed *gelim* (Plates 76-78). Nowadays the dovetailing method is known far beyond the Tat territories. There is also a variety of *jajim* that must also have been woven by the Tats (see page 286).

Zarand

A short distance south of the district of Zahra is a cluster of several dozen villages known as Zarand, with its headquarters at Ma'muniyeh. The villages are populated by different Turkish and Persian tribes who moved to the area centuries ago and are now engaged in agriculture and animal husbandry.

Like the *gelims* of Qazvin, those of Zarand have complex designs comprising dozens of different patterns. It is no easy task, therefore, to categorize them, and no distinct sub-groups have been defined. The medallion pattern found in Bijar,[118] the totem pattern seen in Mianeh and Sarab, the repeated motifs of Hashtrud, the striped design seen in a number of regions, all of these are to be found in the *gelims* of Zarand. Perhaps the only criterion for distinguishing the Zarand *gelim* is its weave, which is centred on a cotton warp. Somewhere between a Kurdish and Turkish weave, it is neither as flexible as the former, nor as fine and compact as the latter.

The *gelim* from Zarand featured here (Plate 83) bears the comb pattern which also flourishes in Varamin, Khalajestan (not far from Zarand) and even Fars and Azarbaijan. Although usually used in a repeat design, as in the *gelims* of Hashtrud, this is not the case in Plate 83. Here the motifs are arranged not only horizontally and vertically but also diagonally through the use of colour.

The *gelim* shown in Plate 84 appears to differ not only from the previous one, but also from the other *gelims* that we have seen so far. But a closer examination shows us that this piece shares much in common with the Zarand *gelim*. The snow-white all-cotton field is a special feature, bringing out the colours and motifs more vividly and strikingly, but otherwise the use of colours and borders in this *gelim*, and even its weave, accord with the *gelims* of Zarand.

The frequent use of cotton in the warps and certain sections of the field in Zarand *gelims* is a result of the widespread cultivation of cotton in the area around the turn of the twentieth century.

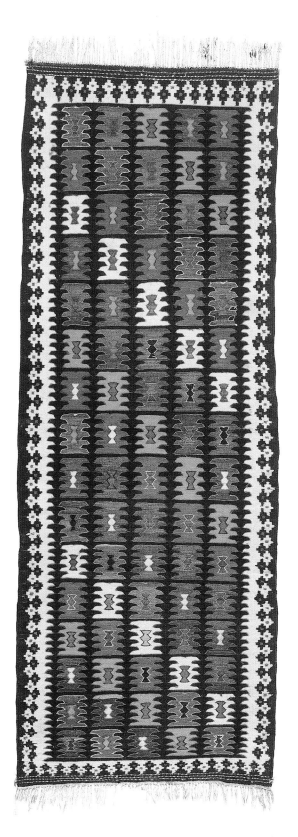

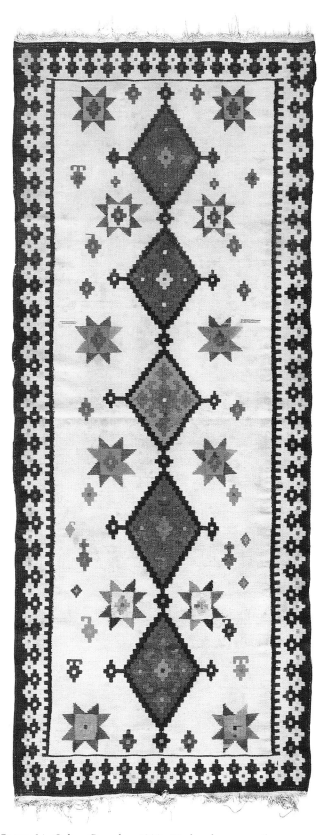

PLATE 83. *Gelim, Zarand. Early 20th century. Wool wefts on cotton warps. Dovetailed and slit tapestry with contour weave. 258 x 95cm (8ft.6in. x 3ft.1in.).*

PLATE 84. *Gelim, Zarand. c.1900. Wool and cotton wefts on cotton warps. Dovetailed weaving. 254 x 109cm (8ft.4in. x 3ft.7in.).*

127

Saveh

Saveh is one of Iran's ancient towns. Its centuries-old mosques, the artefacts that have come to light in the area, and the references to the town in historical writings all attest to its importance in the past. In 1220 it was sacked by the Mongols and its famous library set on fire. The town never regained its pre-eminent position.

With its strategic location at the crossroads of north, south, east and west, Saveh is often mentioned in the writings of travellers, among them Marco Polo.[119] Situated 100 kilometres (60 miles) south of Qazvin and 140 kilometres (87 miles) south-west of Tehran, Saveh comprises several villages which have long served as the home of various peoples. The most important of these are the Shahsavan of Baghdadi, and a sub-tribe of the Lor.[120]

The weavings and *gelims* of Saveh differ widely from one another. Some of its *gelims* closely resemble those of Zarand, which is understandable as Zarand and Saveh are neighbours. In previous political divisions Zarand was considered a part of Saveh, and even today their names are often mentioned together as Saveh and Zarand.

Basically the Saveh *gelim* has a stiffer weave than that of Zarand. Even the weavings of the Shahsavan here do not have the same delicacy as those of their northern cousins. The *gelim* from the Saveh area shown here is Persian-weave (Plate 85), possibly the work of the Lors of Saveh. This *gelim*, bearing the horizontal striped pattern, has a very soft coloration. Its concise comb-like motif is executed in different colours along the yellow and pink stripes of the field.

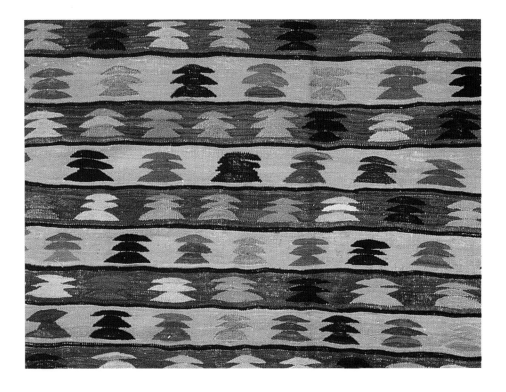

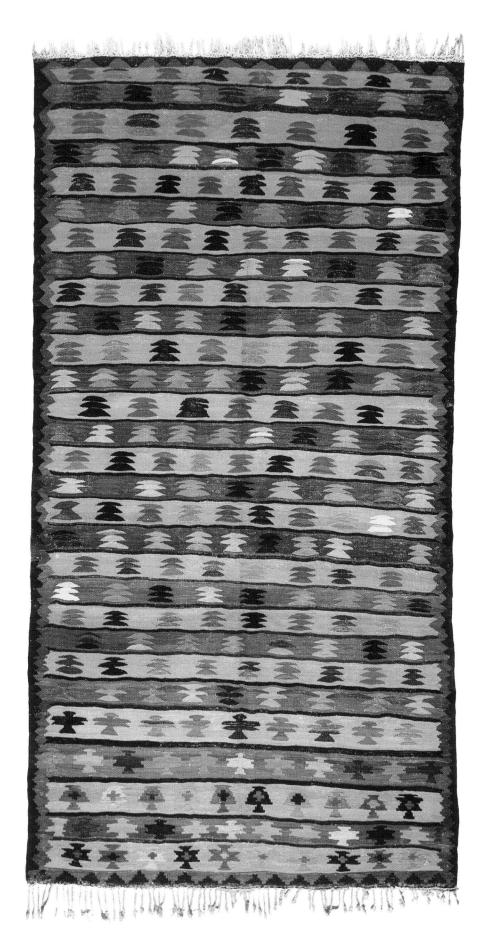

PLATE 85. Gelim, Saveh. Late 19th century. Wool and cotton wefts on cotton warps. Inclined slit tapestry weave. 322 x 171cm (10ft.7in. x 5ft.7in.).

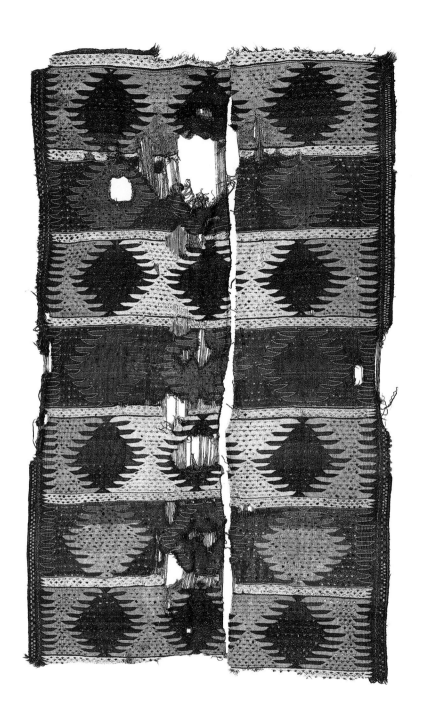

PLATE 86. *Gelim, Dastjerd, Khalajestan. Late 19th century. All wool. Inclined slit tapestry with contour weave patterned all over by weft-float brocading. 270 x 165cm (8ft.10in. x 5ft.5in.).*

Khalajestan

Fifty kilometres (30 miles) south of Saveh, in an area further away from the busy Saveh-Isfahan road, lies the region of Khalajestan. This is a confederation of seventy-seven villages, with its headquarters at Dastjerd. As evident from its name, Khalajestan must once have been the home of the Khalaj Turks. According to some sources, the Khalaj are affiliated with the Ghuz[121] who descended from Central Asia into Iran from the eleventh century onwards.[122] Other sources claim the Khalaj as belonging to the Qashqa'i and even suggest that the Qashqa'i are a sub-group of the Khalaj.[123] Present-day Khalajestan is the home to several different people, many of them Persian-speaking. It is probable

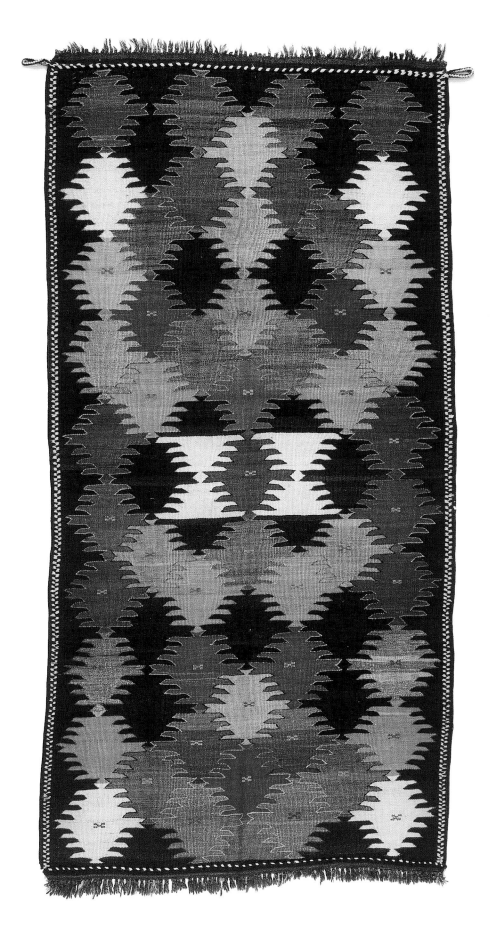

PLATE 87. Gelim, Dastjerd, Khalajestan. Late 19th century. All wool. Inclined slit tapestry with contour weave. 282 x 143cm (9ft.3in. x 4ft.8in.).

131

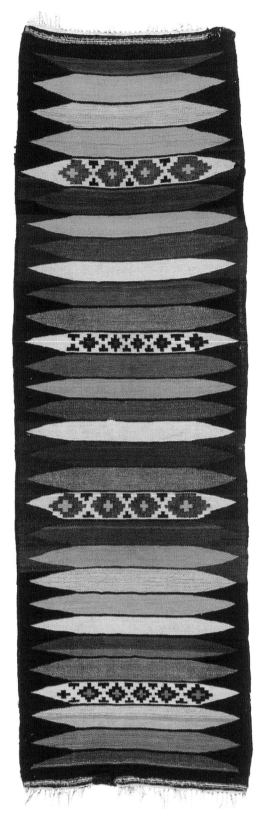

PLATE 88. *Gelim, Khalajestan. Late 19th century. Wool wefts on cotton warps. Dovetailed and inclined slit tapestry weave. 295 x 95cm (9ft.8in. x 3ft.1in.).*

that Kurds and Lors once were amongst them too, particularly since weavings from this area bear the influence of these people.

A large group of Khalajestan *gelims* have designs of large comb-like shapes or palmettes. Within this group a few *gelims* also show plant-like stars neatly arranged within wide stripes (Plate 86). In some, they are arranged more closely together in a repeat pattern (Plate 87). In another batch of *gelims* they have shorter projections, rather like the diamond-shaped stars of the Shahsavan. The empty spaces between them are filled with smaller stars. In yet other *gelims*, the spaces on the two sides of the stars are decorated with comb-like shapes with points.

A *gelim* with a completely different design is shown in Plate 88. It bears great resemblance to the work of the people of Muteh, situated south of Khalajestan, with the difference that this piece is entirely *gelim*-weave whereas the products of Muteh are a combination of *gelim* and *palas*.

The use of undyed brown wool for both the warps and the field is one of the specialities of the *gelims* of Khalajestan. However, Khalaj weavers, like their neighbours from Saveh, also use cotton warps. In Plate 88 the warps are entirely of cotton.

There are similarities between some *gelims* from Khalajestan and weavings from other areas. The *gelims* of Varamin, for example, have very similar end finishings, which can lead to a confusion between the two types. Other *gelims* that recall the products of Khalajestan are the products of Turkey popularly known as Parmaki, which also bear large palmette motifs.[124] The rigidity and coarseness of the Khalaj gelims, however, make them more in keeping with the work of the Kurds than the Turks. Older Khalaj *gelims* (Plate 86) not only include the palmette but also bear tiny dots that decorate the supplementary weft-float brocading wefts throughout the field and the motifs.[125]

Further down from Khalajestan the practice of *gelim*-weaving wanes, and one sees and hears nothing more of the *gelim* until the Chahar Mahal area, more than 300 kilometres (180 miles) away. The village of Muteh, situated between these two regions, produces floor coverings that go by the name of *gelim* but are in fact *palas*.

Tehran

Tehran has no *gelims* to call its own, but it has drawn *gelim*-weavers from every corner of the country. The selection of Tehran as the capital in 1795 and the founding of the Qajar dynasty launched a series of events in the life of the capital. One of these was the influx of tribes to the city and the neighbouring villages, moving either on the shah's orders or of their own free will. While Tehran seemed a suitable place for the chieftains and khans of these tribes and accorded with their desire to be close to the court and gain positions in government, it offered no special benefit to villagers and tent-dwellers. These people, who for the most part followed their leaders to Tehran, preferred the villages surrounding the city where they could continue with agriculture and animal husbandry. The region near Tehran that attracted the newcomers most was Varamin.

Varamin

Virtually every Iranian tribe or ethnic group is represented in Varamin. This expanse of wilderness, some 42 kilometres (26 miles) south of Tehran, comprises more than 400 human settlements. Anyone and everyone who established a colony there left their name as a legacy to posterity, so that there are few settlements that do not bear the suffix *abad* (habitable) in the name. Those founded by men with common names such as Hasan or 'Abbas, and consequently bearing the names Hasanabad or Abbasabad, number half a dozen or more. Varamin itself is not a new village but considerably predates Tehran. Relics found in Varamin from the eleventh century bear this out. Remains show that the Lors and the Kurds are the tribes with the oldest roots in the Varamin area, followed by various Turkish clans such as the Shahsavan, the Afshar and the Bayat, and finally the Arabs. This resulted in a diverse range of weavings and *gelims*. The few samples selected to represent Varamin here cannot do justice to the wide variety of design found in this area.[127]

A Kurdish *gelim* from Varamin (Plate 89) exhibits features common in other Kurdish *gelims* such as the curved-weft weave. It also has the pliability and coarseness of the *gelims* of Khalajestan, and shares their use of a brown wool warp.

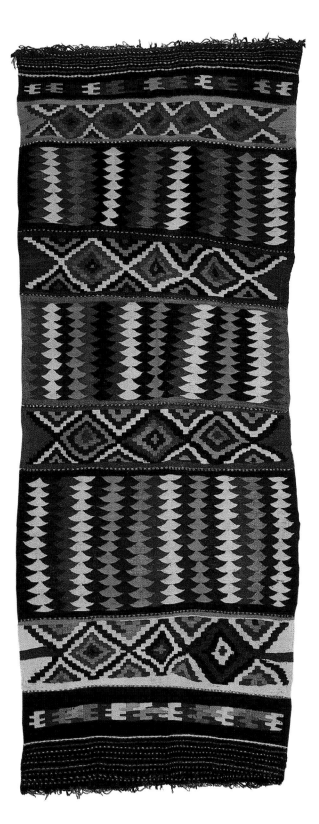

PLATE 89. *Gelim, Varamin. Around 1900. All wool. Dovetailed and inclined slit tapestry weave. 308 x 151cm (10ft.1in. x 4ft.11in.).*

133

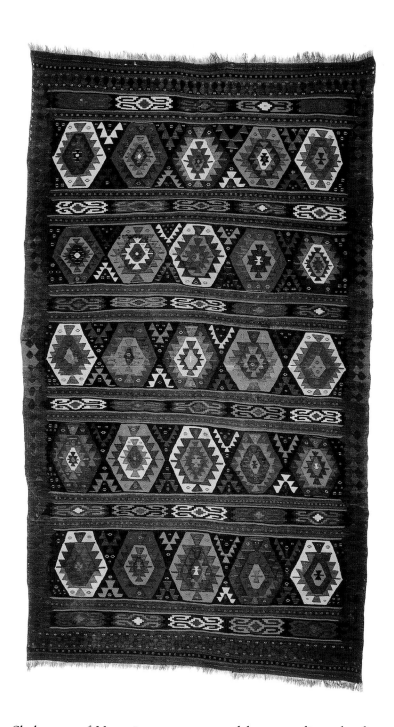

PLATE 90. *Gelim, Varamin.*
Mid-19th century. All wool.
Inclined slit tapestry patterned
in certain areas by weft
substitution. 342 x 182cm
(11ft.3in. x 6ft.).

The Shahsavan of Varamin are represented by two *gelims*, the first with a striped composition and diamond-shaped stars (Plate 90) and the second with a comb-like pattern (Plate 91). This is not unlike the comb-like *gelims* of Zarand shown in Plate 83, but it is considerably more rigid and geometric, with a weave that is closer to the work of the Turks.

The weavers of Varamin have often used eye-dazzling designs, executed in every imaginable configuration, sometimes with borders and sometimes without. It is no easy task to determine the ethnic origin of this group of *gelims* but it is sometimes possible, either from use of colour or weave count, to venture a tentative guess. Thus Plate 92 is most likely by Turkish-speaking tribes.

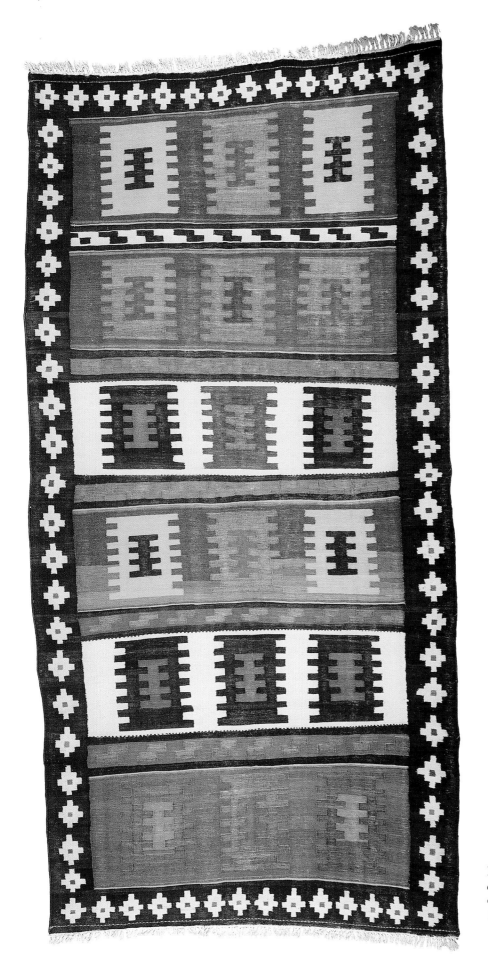

PLATE 91. Gelim, Varamin.
c.1900. Wool wefts on cotton
warps. Dovetailed weave. 305 x
150cm (10ft. x 4ft.11in.).

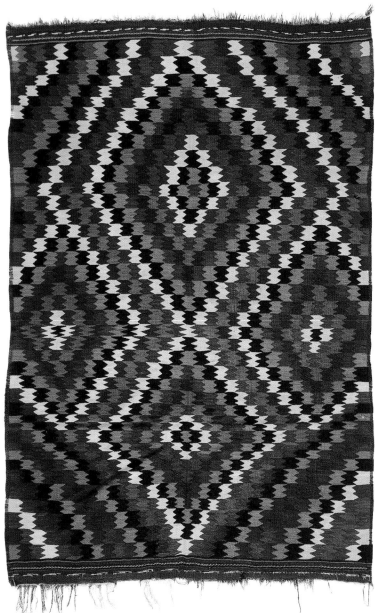

PLATE 92. *Gelim, Varamin. Mid-19th century. All wool. Inclined slit tapestry weave. 385 x 135cm (12ft.8in. x 4ft.5in.).*

PLATE 93. *Gelim, Varamin. Late 19th century. All wool, slit tapestry weave. 408 x 186cm (13ft.5in, x 6ft.1in.).*

VOK COLLECTION

Another interesting *gelim* can be seen in Plate 94. Its colour scheme and delicate weave are not unlike those of Plate 30, and it is possibly the work of the weavers of Hashtrud. The weaver's attempt to execute the two-headed *botteh* known as wrath and reconciliation (*qahr va ashti*), which is commonly found in rugs but as far as I know never in *gelim*, is worthy of consideration.[128] The region of Garmsar, situated south-east of Varamin and at the edge of the desert, also produces *gelims* worthy of mention. These share most of the features of the Varamin *gelims*, although their designs are far more limited.[129]

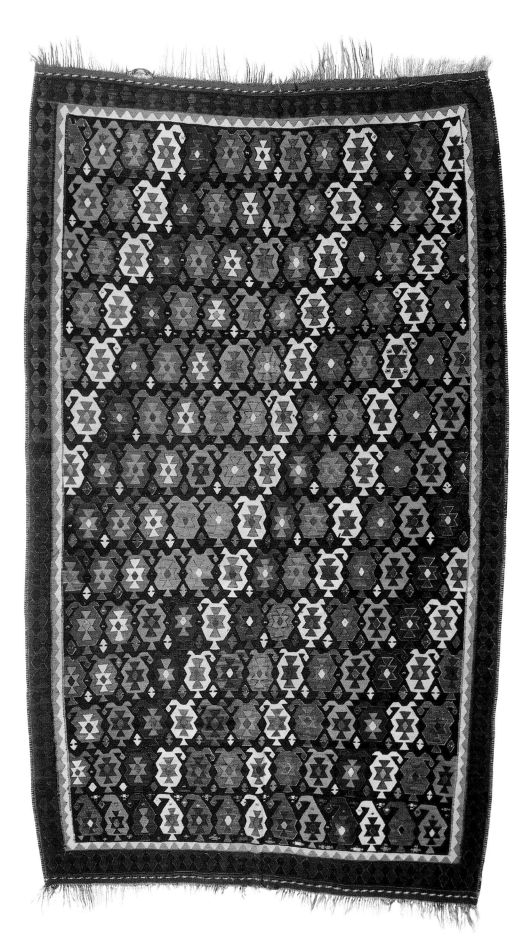

PLATE 94. Gelim, Varamin. Mid- to late 19th century. All wool. Inclined slit tapestry weave with contour weft wrapping. 319 x 192cm (10ft.6in. x 6ft.4in.).

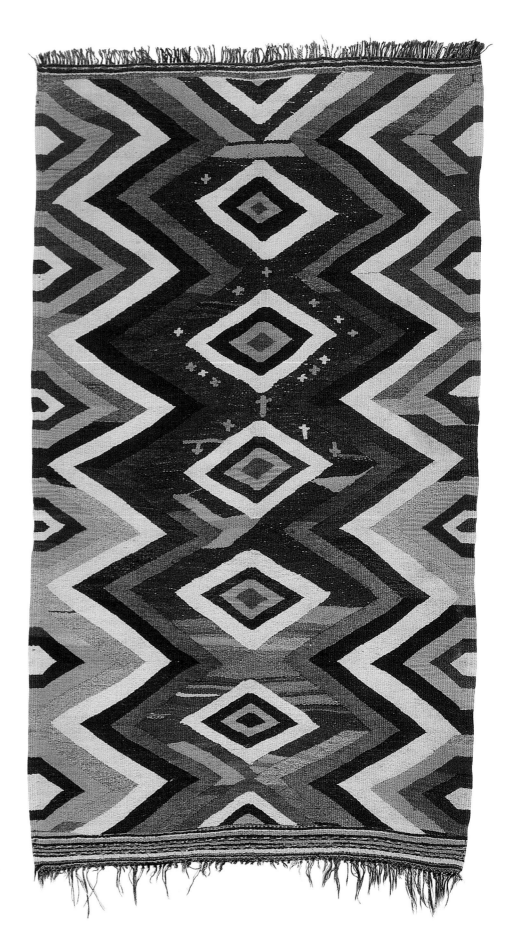

PLATE 95. *Gelim, Bowlan. Early 20th century. All wool. Inclined slit tapestry weave. 236 x 130cm (7ft.9in. x 4ft.3in.).*

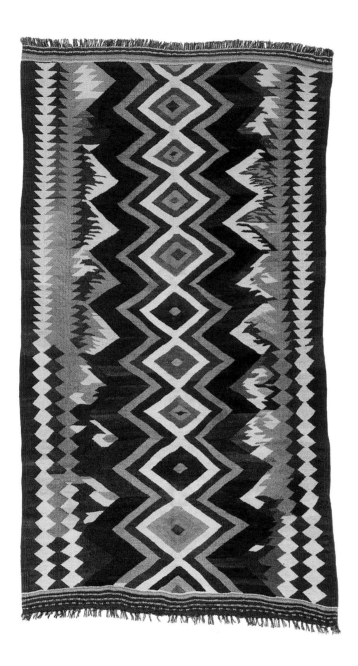

PLATE 96. *Gelim, Bowlan. Early 20th century. All wool. Inclined slit tapestry weave. 250 x 123cm (8ft.2in. x 4ft.).*

Bowlan

On the foothills of Mount Damavand, 40 kilometres (25 miles) north-east of Varamin and a short distance due north of Garmsar lies the small village of Bowlan, so tiny that its name seldom appears on maps. It is populated by barely a hundred households, yet this village has produced *gelims* that deserve great attention and merit a section all to themselves.

The *gelims* of Bowlan have specific features, both in terms of their design and colour and also their materials and structure. As with the *gelims* of Khalajestan, the warp in the Bowlan *gelims* is of undyed brown wool. The weave is inclined slit tapestry and, like the Khalaj *gelims*, is rather coarse. As for how there could be a connection between Bowlan and Khalajestan, considering the 200 kilometres (125 miles) that separate them, that is a different matter.

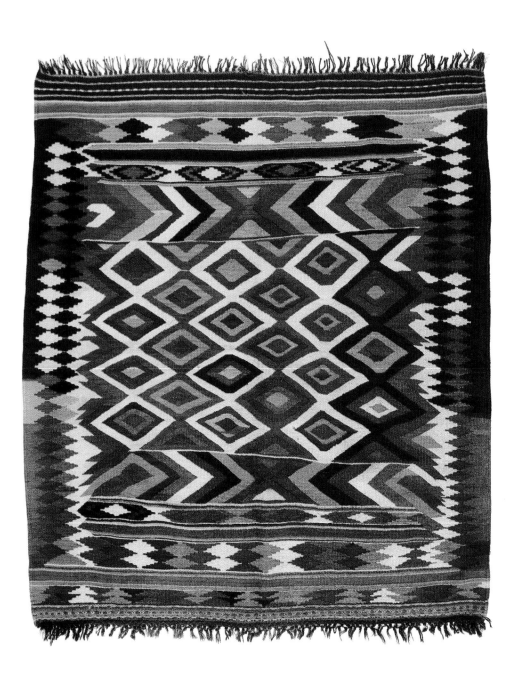

PLATE 97. *Gelim, Bowlan. Early 20th century. All wool. Inclined slit tapestry weave. 180 x 155cm (5ft.11in. x 5ft.1in.).*

Practically every kind of design and composition can be found in the *gelims* of Bowlan. One group has broad horizontal stripes, some with patterns and others without. These generally have no borders. Another group has the composition of vertical *moharammat*, especially the crenellated kind, while yet others bear totem designs (Plates 95 and 96). Sometimes they exhibit lozenge grids (Plate 97) or a combination of all of these designs (Plate 98).

The Bowlan *gelim* is generally small, measuring around 1.5 x 2m (5ft. x 6ft.6in.) although some are smaller (Plate 97). Others, however, are larger (Plate 98). A quick glance at the *gelims* of Bowlan reveals them to be closest to the weavings of the Kurds around Yasukand. Whether some of the people of Bowlan have any kinship with the Kurds of Yasukand and separated from them at some point in history is an unanswered questions, especially since some Bowlanies consider themselves Alika'i and indigenous of the Alborz valleys.

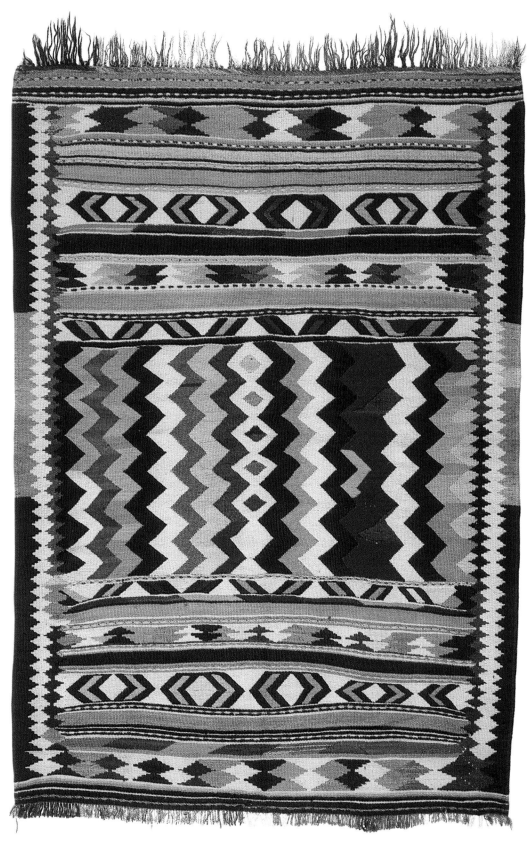

PLATE 98. *Gelim, Bowlan. Early 20th century. All wool. Inclined slit tapestry weave. 250 x 149cm
(8ft.2in. x 4ft.11in.).*

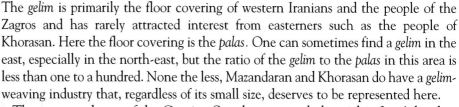

Semnan

Semnan is the final stop along the path of the north-western Zagros and Alborz foothills. The Semnan *gelim* still exhibits features of the Azarbaijan *gelim*. It is closest to the Varamin *gelim*, whose greatest influence is the Azarbaijan school. The province of Semnan has contrasting climates. To the south it is an arid, barren desert. This area falls within the central desert known as Kavir-e Namak ('salt desert'). A narrow strip along the northern frontier of the province, however, lies in the Alborz foothills and is home to pleasant, lush villages. Some of them, such as Sangesar and Shahmirzad, enjoy a great reputation for animal husbandry and it is in these villages and the surrounding ones that weaving flourishes. According to the historians of the area, prior to the advent of rug-weaving at the turn of the twentieth century, Semnan enjoyed a flourishing industry of *gelim*-weaving and felting, but these have now declined.[130]

A single *gelim* has been chosen to represent Semnan (Plate 99). Other than the influence of the weavers of Varamin, we can detect here the influence of the weavers of Khorasan, or *palas*-weavers, which is discussed later in this book. This is shown in the narrow bands executed along both sides of the patterned stripes in weft substitution. Other *gelims* with more diverse patterns have also emerged from Semnan.

The Caspian Sea, Mazandaran and Khorasan

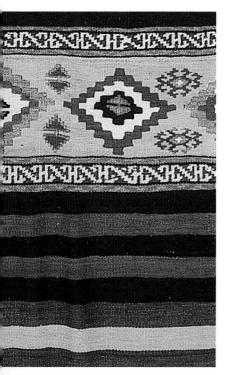

The *gelim* is primarily the floor covering of western Iranians and the people of the Zagros and has rarely attracted interest from easterners such as the people of Khorasan. Here the floor covering is the *palas*. One can sometimes find a *gelim* in the east, especially in the north-east, but the ratio of the *gelim* to the *palas* in this area is less than one to a hundred. None the less, Mazandaran and Khorasan do have a *gelim*-weaving industry that, regardless of its small size, deserves to be represented here.

The western shores of the Caspian Sea that currently lie within Iran's borders are inhabited by the Talesh and the Gilak, neither of whom have a *gelim*-weaving tradition. The geographical location of some of these areas renders the rearing of sheep and access to wool very difficult, but a short distance away from the shoreline and the forests, beyond the mountains, lies a land formerly called Daylaman and Tabarestan, and here *gelim*-weaving is to be found.

A good starting point for marking the boundary of the eastern Caspian shoreline is Amol, a town that had a *gelim*-weaving industry a thousand years ago. The author of *Hodud al-`alam* took note of the *gelims* of Amol, known as white-eared gelim of Amol. Beginning with Amol and moving east, there is a tangible difference in climate. Vegetation becomes sparser and the elevations lower. The plains grow more expansive until they link up with the great plains of the east in Khorasan. These regions are divided up among Mazandaran and Khorasan, as are the two batches of *gelims*.

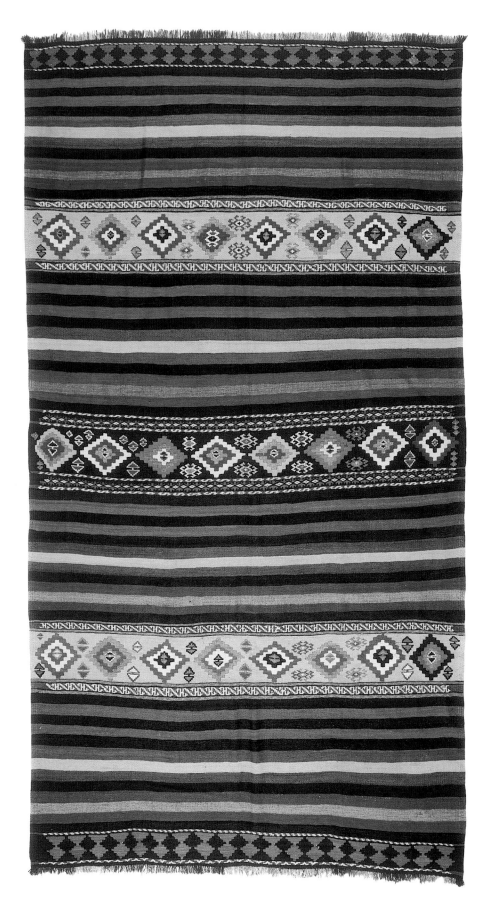

PLATE 99. Gelim, Semnan. c.1900. All wool. Slit tapestry, weft-faced plain weave, with some of the stripes patterned by weft substitution. 365 x 198cm (12ft. x 6ft.6in.).

143

Mazandaran

I must admit to errors in my earlier book, *Shahsavan*, in the attributions made for certain woven pieces. These errors generally relate to areas close to each other. For instance, I have sometimes referred to the *gelims* of Hashtrud as those of Mianeh. These errors may be relatively minor, but in the same book I have also been guilty of a major misattribution. I referred to a Mazandaran *gelim* as the work of the Shahsavan.[131] Ten years later, it is finally time to set the record straight. This *gelim* came into my hands in the early 1980s, when I was busy at work on Shahsavan weavings. It was so delicately made that I considered it to be closest to the Moghan variety. Later, however, when more specimens came to light, I realized that these were not the work of Azarbaijan weavers and that they must be from Mazandaran.[132]

Several such *gelims* have thus far been discovered. All are in two pieces, very thin and delicate, and all bear the striped pattern. They exhibit the weft-faced plain weave with minimum decorations in supplementary wefts. The end strands of these supplementary wefts sometimes overshoot the ends of the *gelim* and hang like a batch of hair (Plates 100 and 101), which is not to be found in Azarbaijan. Here the two ends bear more condensed decorations, also found in the *palases* woven in the area (see, for example, Plates 163 and 165). The true identity of the weavers of these *gelims* is not known. While it is not impossible to attribute the pieces to the Kurds of Mazandaran (for groups of Kurds do live in the province), in my opinion these *gelims*, and even some *palases*, must be the work of the natives of Mazandaran in villages south of Sari. This is borne out by a painting showing one such *gelim* from the fifteenth century, long before the resettlement of the Kurds in Khorasan (Figure 25). This painting is interesting not only for the resemblance of the *gelim* it depicts to the *gelims* with which we are concerned; but also because it tells us what area it is depicting. The artist has skilfully shown Rostam, Iran's epic hero, in the land of Mazandaran. As well as showing the lushness and verdure of Mazandaran, he has quoted a verse from Ferdowsi in connection with Rostam's legendary sojourn in the area. The other point of interest in this painting is that it shows Rostam using a very lightweight *gelim* (rather than a pile-rug) on this long and eventful journey (see pages 34 to 35).

FIGURE 25. *Rostam sleeping. Persian miniature painting from the* Shahnameh *of Ferdowsi. Herat school, c.1450.*

BRITISH MUSEUM, LONDON.
INV. NO. 1948.1211.0.23

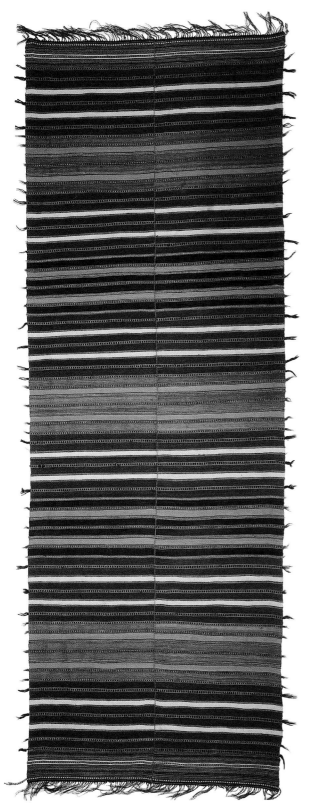

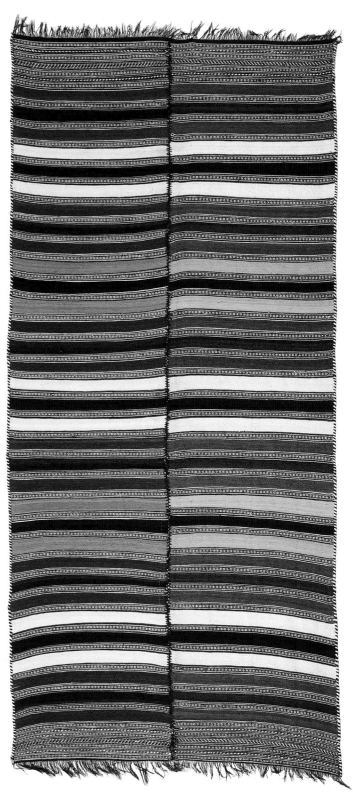

PLATE 100. *Gelim, Firuz Kuh, Mazandaran. Late 19th century. All wool. Weft-faced plain weave narrow stripes patterned by weft-float brocading. Two strips sewn together. 405 x 142cm (13ft.3in. x 4ft.8in.).*

PLATE 101. *Gelim, Firuz Kuh, Mazandaran. Early 20th century. All wool. Weft-faced plain weave, with some of the narrow stripes patterned by weft-float brocading. Two strips sewn together. 210 x 116cm (6ft.11in. x 3ft.10in.).*

Gonbad and Gorgan

Gonbad and Gorgan, now part of the province of Mazandaran, were considered places of strategic importance in the past as they marked the frontier between the tent-dwelling Turks and the villages and towns of Iran. It was once the policy of the Iranians to keep the tent-dwelling Turkomans, who roamed the wilderness north of these cities, as far away as possible. Present-day Gonbad-e Kavus now serves as a major urban centre for Turkomans, and the surrounding areas support their agriculture.

Although the Turkomans have achieved renown far and wide in rug-weaving and their rugs are the most sought after, their flatwoven products, which primarily comprise *palases* (see page 212), have not attracted much attention.

I have selected one Turkoman *gelim* to show here (Plate 102). As with other Turkoman weavings, the weave in this *gelim* is exceptionally fine and compact. Its pattern is produced by repeating designs, as is the case with Turkoman rugs and *palases*.

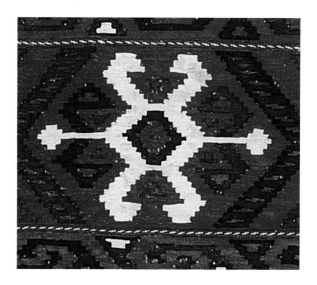

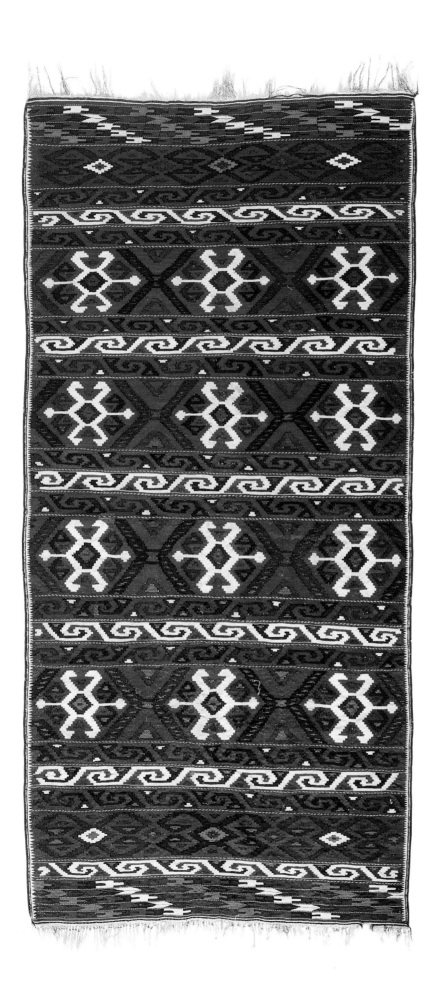

PLATE 102. Gelim, Turkoman, Yomut, Mazandaran. Early 20th century. Wool and cotton wefts on wool warps. Slit tapestry weave. 255 x 140cm (8ft.4in. x 4ft.7in.).

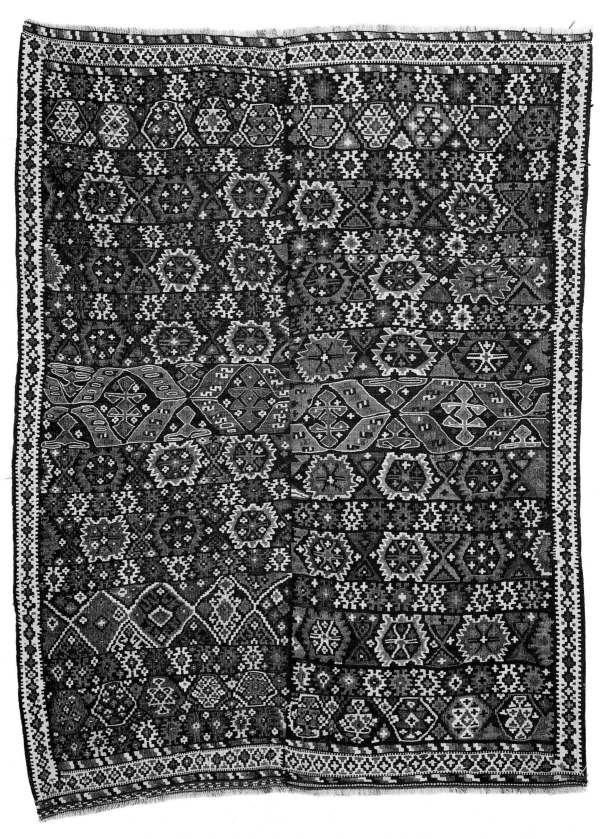

PLATE 103. *Gelim, Kurds of Darreh Gaz, Khorasan. Early 20th century. All wool. Slit tapestry with contour weft wrapping. Two strips sewn together. 147 x 110cm (4ft.10in. x 3ft.7in.).*

Darreh Gaz and Kalat

Let us follow the trail of the *gelim* from Mazandaran to Khorasan, especially to its easternmost regions which are at no great distance from Afghanistan. This brings us to Darreh Gaz and Kalat. The large area that we have left behind between Mazandaran and northern Khorasan is the territory of the Kurds of Khorasan, among the most prolific of Iran's weavers. They are not *gelim*-weavers, however; their floor covering is the *palas*. While Darreh Gaz and Kalat also have Kurdish populations, they are home to various other tribes and people such as the Afshar, the Baluch, and the Sistani.

Two *gelims* from the region are illustrated here, one made by the Kurds of Darreh Gaz (Plate 103) and the other by the Afshars of Kalat (Plate 104). The Kurdish product, like everything else woven in Khorasan by the Kurds, has a busy, design, filled with large and small motifs. Despite several centuries of separation from Azarbaijan, their work still exhibits the features of Kurdish *gelim*-weaving. Plate 104, on the other hand, shows the work of the Turkic Afshars of Khorasan who live in the vicinity of Kalat-e Naderi, Nader Shah's favourite fort. The use of colours and the weave in this example are reminiscent of certain *sofrehs* from Khorasan.

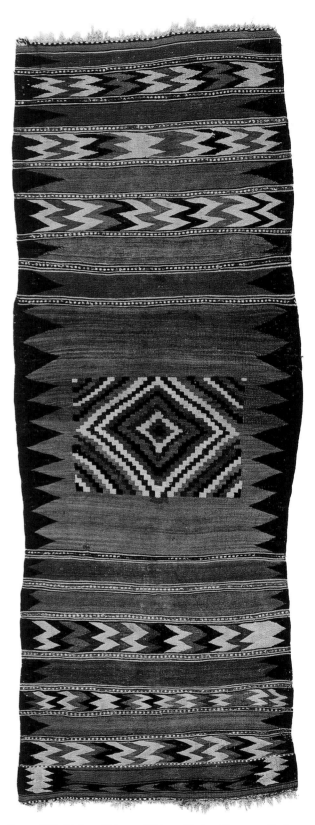

PLATE 104. *Gelim, Afshars of Kalat-e Nader, Khorasan. Early 20th century. All wool. Dovetailed and inclined slit tapestry weave. 212 x 80cm (6ft.11in. x 2ft.7in.).*

149

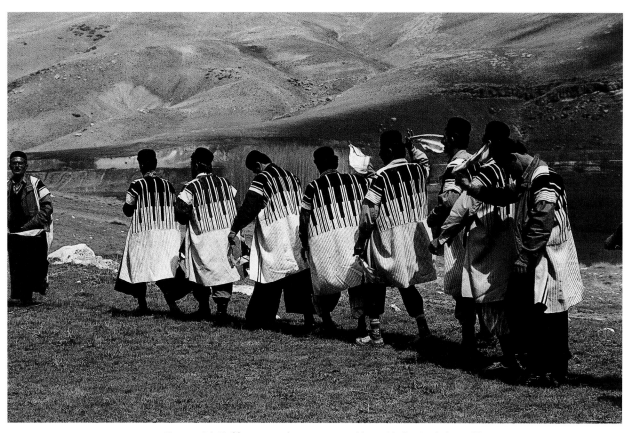

FIGURE 26. *Bakhtiari men dancing at a wedding, Chahar Mahal-e Bakhtiari.*

Return to Zagros, the Land of the Lors

The Lors are among the earliest inhabitants of the middle and southern parts of the Zagros region and are scattered all over this area, from Lorestan to Fars. Their proximity to the Kurds and their assimilation in an area originally settled by this ethnic group has led some to infer that they are a Kurdish sub-group.[133] The reason given for this theory is the closeness of the Kurdish and Lori tongues, which are both western Iranian dialects.

Some have supposed the Lors to be descended from the Kassites, an ethnic group whose history goes back to 2000 BC.[134] Yet others consider them Aryan immigrants who arrived in the area some time during the first millennium BC.[135] The first written reference to their name, however, occurs in the tenth century.[136] From this time on they have had a continuous presence in the history of Iran, particularly in the west.

The *gelim*-weaving Lors, with whom we are chiefly concerned, are centred in three provinces: Chahar Mahal and Bakhtiari (or Chahar Mahal-e Bakhtiari), Khuzestan and Fars. *Gelim*-weavers are to be found through the length and breadth of the Chahar Mahal and Bakhtiari area, which is replete with colourful and beautifully designed *gelims*. The products here are every bit as rich as those of Azarbaijan, though the weavers operate on a different basis and follow different schools. They present a variety of problems to the rug scholar. The first problem is the undeniable influence of the *gabbeh* on the Fars, Bakhtiari and Lor *gelims*. The second is the circumstances of our encounter with these *gelims*. Throughout Azarbaijan and the Alborz area, the

centres of *gelim*-weaving were villages, with a few exceptions. Many of the tribes in this area, however, are still nomads and, in order to classify them, one would need to trace their genealogies and clan histories. In some instances this has been possible, but in others not. The greatest difficulties have been encountered with the tribes of Fars, as explained below. The early part of our investigation, however, which begins in Chahar Mahal and Bakhtiari, is not bedevilled by such problems.

Chahar Mahal and Bakhtiari

While present-day Chahar Mahal and Bakhtiari is one of the smallest of Iran's provinces, it is considered very important in weaving, particularly rug-weaving. Chahar Mahal-e Bakhtiari is a largely rural province nestled in the foothills of Zagros and composed of a thousand villages. The permanent population of the province is augmented in the summer months by large groups of tent-dwelling Lors. In every village rug-weaving flourishes, but *gelim*-weaving has declined significantly.

The *gelims* of Chahar Mahal have diverse designs. The few pieces chosen for this book represent only a small sample, but present a good indication of this area's diversity. The designs are inspired by *gabbehs* and Bakhtiari rugs. A large group feature repeating patterns.

The *gelim* in Plate 105 has the same design and pattern as the square-grid (*kheshti*) pile-rugs of Chahar Mahal. As with this variety of rugs, each of the squares is filled with floral and plant-like motifs.

One group of Chahar Mahal *gelims* is inspired by Bakhtiari *gabbehs* (or perhaps vice versa). Like the Bakhtiari *gabbehs*, these *gelims* are large, but they are not as numerous. One of the *gelims* in this group (Plate 106) has an extraordinary pattern. While this pattern is familiar from its use in the *gabbehs* of the area, its appearance in the *gelim* is unprecedented and a few similar examples are known. The way the weaver of this *gelim* has displayed colours and placed frames around some of the squares, with tiny motifs and signs on some of them, shows great creativity. This is truly handicraft raised to the level of art.

The other *gelim* in this group can be seen in Plate 107. It has been woven with a zigzag design, which is also commonly found in the *gabbeh*. Another *gelim* that

PLATE 105. *Gelim, Bakhtiari, Chahar Mahal. Early 20th century. Wool wefts on cotton warps. Slit tapestry and dovetailed weave. 297 x 143cm (9ft.9in. x 4ft.8in.).*

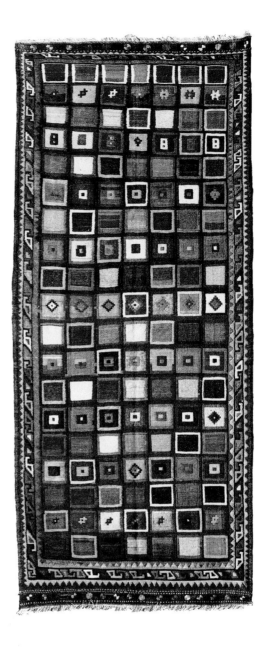

PLATE 106. *Gelim, Bakhtiari, Chahar Mahal. c.1900. Wool wefts on cotton warps. Dovetailed weave. 392 x 165cm (12ft.10in. x 5ft.5in.).*

exhibits the influence of the *gabbeh* is in Plate 108, executed in the *moharramat* design with a *botteh* motif. Such designs were at one time fairly common among the Seneh *gelims*. Among the repeating-design *gelims* is Plate 109.

All the *gelims* mentioned here have a similar structure. The warp in most of them is of wool and the weave structure is of the dovetailing kind – a kind of weave that could well have emerged from this area and spread to others. A certain unison can also be detected in the use of colour in these *gelims*. As with the Chahar Mahal rug, these *gelims* are adorned in bright, lively colours such as yellow, orange, pink, blue and green, colours are seldom seen in the *gelims* and other weavings of the tent-dwelling Lors.

The weavers of these rugs are the people of Chahar Mahal themselves and not the migrating Lors. As we shall see, however, the Lors, who live on the other side of the mountains in Khuzestan and spend only their summer in Chahar Mahal, weave *gelims* that are quite different from those made in Chahar Mahal.

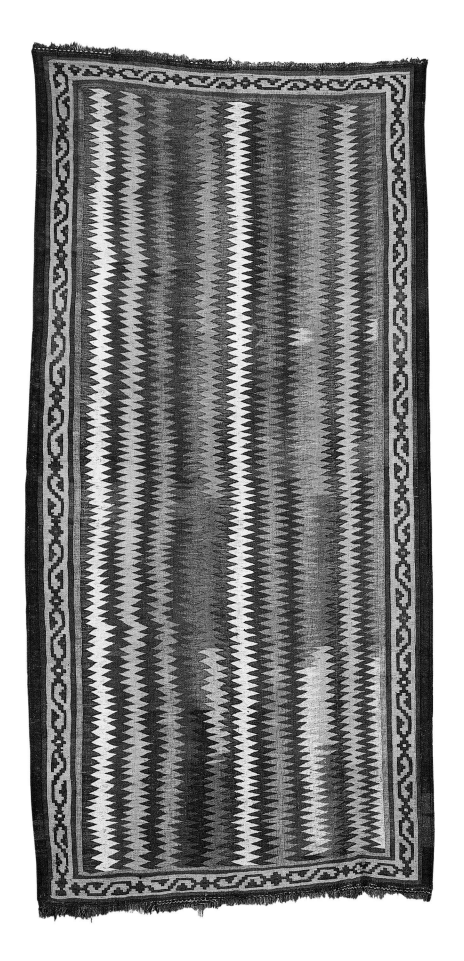

PLATE 107. Gelim, Bakhtiari, Chahar Mahal. End 19th century. All wool. Inclined slit tapestry, dovetailed and interlock weave. 310 x 152cm (10ft.2in. x 5ft.).

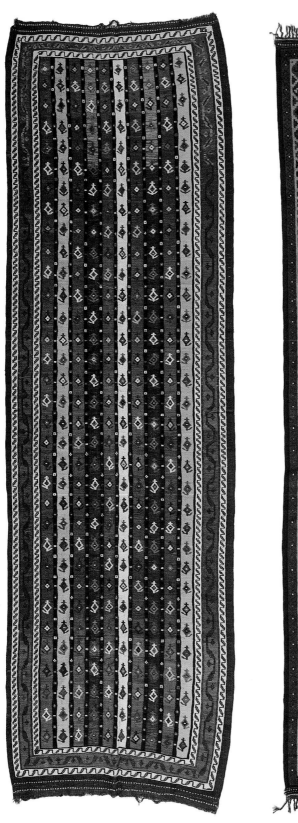

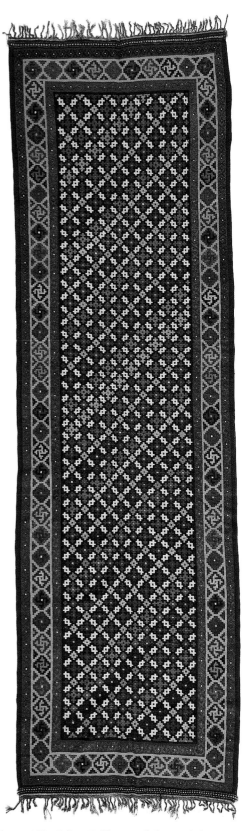

PLATE 108. *Gelim, Bakhtiari, Chahar Mahal. End 19th century. All wool. Dovetailed weave. 425 x 130cm (13ft.11in. x 4ft.3in.).*

PLATE 109. *Gelim, Bakhtiari, Chahar Mahal. c.1900. All wool. Dovetailed weave. 466 x 136cm (15ft.3in. x 4ft.6in.).*

FIGURE 27. *Map of Khuzestan, showing Karun river, Persian Gulf and the cities of Qarqub, Basna, Shush, Ramhormoz and Izeh. From Estakhri,* Masalik va Mamalik, *mid-10th century.*

NATIONAL MUSEUM OF IRAN, TEHRAN FOLIO 43B

Khuzestan

The traveller entering Khuzestan and encountering its multitude of oil derricks may find it difficult to believe that this was the one land of the Elamites and the cradle of Iranian civilization. But if one delves further and visits the towns and historical ruins of Shush (the ancient Susa), the ziggurat at Chogha Zanbil or other ruins, this view of Khuzestan will change. Khuzestan is not simply a land of history, however; it is also the source of some of the most important weavings of Iran. The early chapters of this book quoted travellers and historians who mentioned the weavings of Khuzestan. Here we examine the extant specimens, which go back a couple of centuries. Three of the most important varieties of Persian *gelims* originated in Khuzestan. Two of these are produced by the Lors and the third by the Arabic-speaking tribes of the province. It is also possible that other ethnic groups, such as the Afshars, may have played a role in the weavings and *gelims* of Khuzestan.

Khuzestan is an expanse of plain with the Zagros Mountains on one side and the Persian Gulf and Iraq on the other. Summer temperatures can be quite unbearable, often exceeding 45°C. In winter, however, the temperatures are moderate and the province is an ideal home for animal herders and tent-dwellers, especially with the Karun river and its numerous tributaries which water the land. It is at this time that Khuzestan becomes a home to several Lor clans who migrate here from Lorestan, Fars and Chahar Mahal. The largest of these is that of the Bakhtiari or Great Lors. It is they who have produced the most important Khuzestan *gelims* and left them as a legacy to posterity.

155

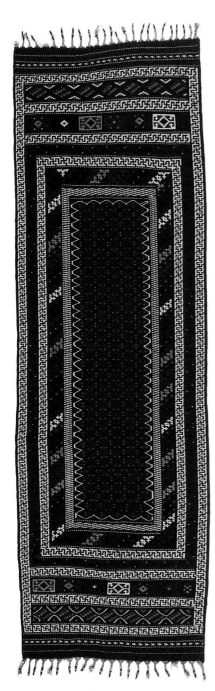

PLATE 110. *Gelim, Mir group, Lors of Bakhtiari, Izeh, Khuzestan. End of 19th century. Wool and cotton wefts on wool warps. Double interlocking weave. 403 x 129cm (13ft.3in. x 4ft.3in.).*

Izeh (Mir)

On the slopes of the Zagros Mountains in north-western Khuzestan is a cluster of villages that has long been the home of the Lors. These villages are considered Khuzestan's summer resort. The most famous of these villages is Izeh. Not only is Izeh the summer home of the Lors, it is also their last waystation as they prepare to pass the Karun and scale the slopes of Zard Kuh (4,221m/13,845ft.) on their way to Chahar Mahal. For these reasons, Izeh has long enjoyed a special status and served as a centre for the Lor khans.

The other name for Izeh is Malmir. It is not clear when this name came into use or how it supplanted the name Izeh. In the fourteenth century, Ibn Battuta, who was then in the village, referred to it as Izaj,[137] while in nineteenth century travelogues the name appears as Malmir. The latter name, which means belonging to the Amir, probably dates to the time when Izeh came into the possession of the Bakhtiari khans.[138] In the early part of the twentieth century, in line with a government policy of weakening the Lors, Malmir reverted to its earlier name of Izeh. But the Malmir name survives in the context of Lori and Bakhtiari rugs, in the form of the word *mir*.[139]

Mir, very probably a shortened form of Malmir, applies to a variety of the best Bakhtiari rugs. The word, now used only by older rug experts, has no precise definition. So far as I am able to determine, it refers to the finest Lori and Bakhtiari rugs with *botteh* patterns. These rugs were probably woven in Izeh/Malmir at the behest of Bakhtiari khans. If we suppose that the best *gelims* in Izeh were woven for the khans, I see no objection to referring to them also as *mir*.

In the early 1970s the first batch of *mir gelims* arrived in Tehran and stunned many rug *aficionados*, myself included.[140] These *gelims* were almost entirely unblemished, and their exquisite weave, colour schemes and designs were indications of their aristocratic pedigree. All of them were of the double-interlock structure; their designs were varieties of repeating *bottehs* and they featured a greater number of borders than the typical Bakhtiari *gelim*, so much so that the borders made significant inroads into the field. One or two of the borders were reminiscent of the brick Kufic script, not unlike the border of the rug or *gelim* now preserved in the Topkapi Museum in Istanbul. The best of these *gelims* exhibited another structural feature that was not immediately apparent. This was the presence of repeating raised lines, produced by the multiplicity of warps, 10cm (4in.) apart throughout the field. In the *gelim* in Plate 110, which belongs to this group, five raised lines are visible – a structure not seen elsewhere.

The use of colour in the aristocratic *mir gelims* is gentle and devoid of the typically sharp colours found in most Bakhtiari weavings, such as yellow, pink

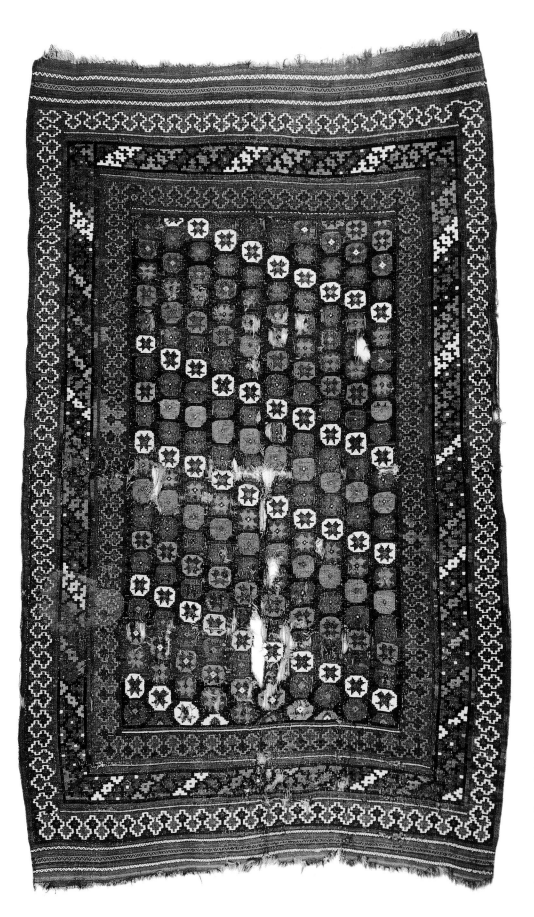

PLATE 111. Gelim,
Mir group, Lors of
Bakhtiari,
Khuzestan. Mid-
19th century. Wool
and cotton wefts on
wool and goat hair
warps. Double inter-
locking weave. 274
x 162cm (9ft. x
5ft.4in.).

157

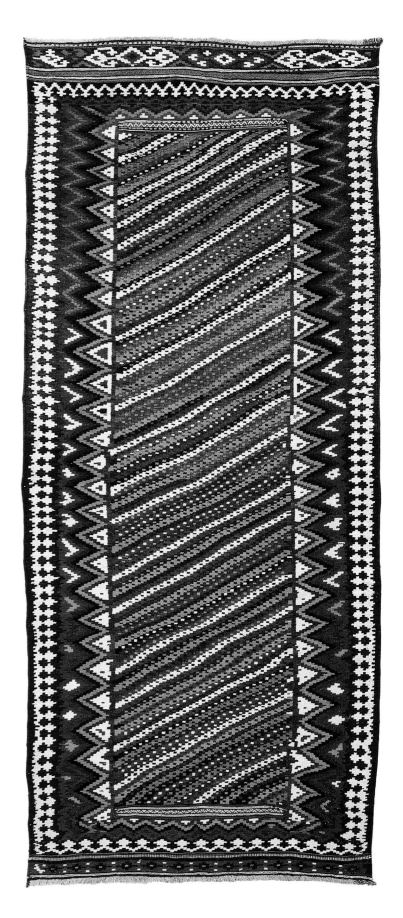

PLATE 112. *Gelim, Mir group, Lors of Bakhtiari,*
Khuzestan. End 19th century. Wool and cotton
wefts on wool warps. Double interlocking weave.
320 x 138cm (10ft.6in. x 4ft.6in.).

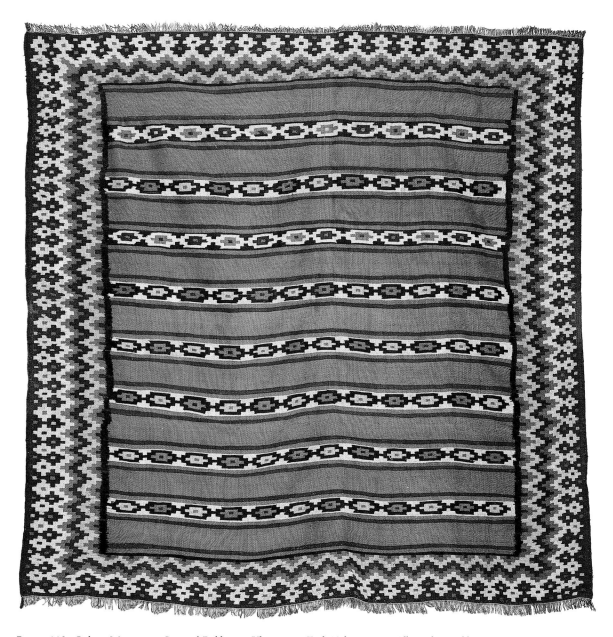

PLATE 113. *Gelim, Mir group, Lors of Bakhtiari, Khuzestan. End 19th century. All wool. Double interlocking weave. 216 x 217cm (7ft.1in. x 7ft.1in.).*

and green. Generally, more settled colours such as light crimson, dark blue, green and white – the hue of Khuzestan cotton – are used.

Aside from Izeh, throughout Khuzestan's eastern part the double-interlock *gelim* is woven by the area's Lor inhabitants. Among these one can see relatively greater diversity of design and colour scheme. One of the oldest of them bears a repeating eight-pointed star design (Plate 111). There is also a diagonal *moharammat* design (Plate 112); chain-like stripes (Plate 113); and a double-lozenge design (Plate 114). Double-interlock *gelims* must be called a speciality of the Bakhtiari Lors of Khuzestan and not of Chahar Mahal, because I have never seen such a structure in Chahar Mahal or with that region's colour schemes.

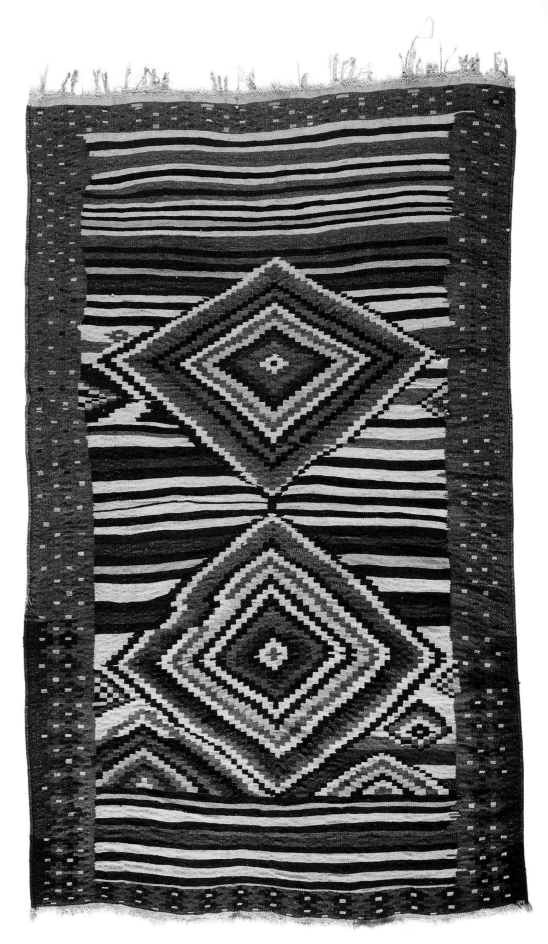

PLATE 114. *Gelim, Mir group, Lors of Bakhtiari, Khuzestan. End 19th century. All wool. Double interlocking weave. 231 x 139cm (7ft.7in. x 4ft.7in.).*

160

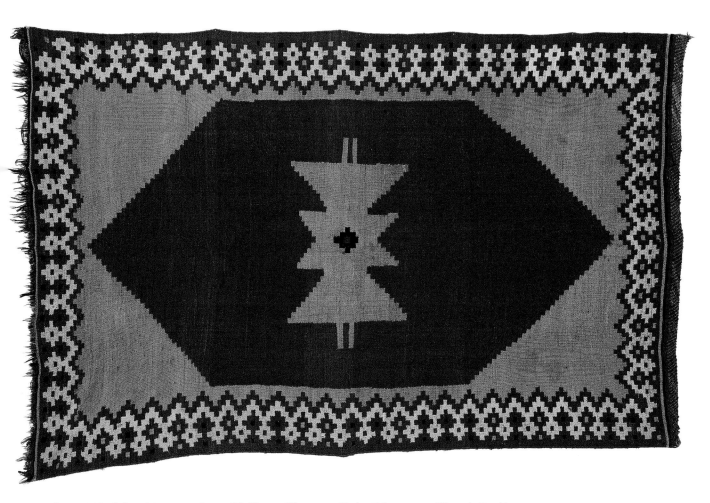

PLATE 115. *Gelim, Mir group, Lors of Bakhtiari, Khuzestan. Early 19th century. All wool. Double interlocking weave. 197 x 122cm (6ft.6in. x 4ft.).*

The most interesting *gelim* in this group is shown in Plate 115. Its weave is double-interlock and, while its colours are few – barely four – the generous use of yellow hints at the work of the people of Chahar Mahal, albeit the presence of colours in the Chahar Mahal *gelim* is much more diverse. Besides, the Chahar Mahal weavers do not produce the double-interlock *gelim*. The design on this *gelim* is unique and somewhat strange. Its central pattern is suggestive of a female sculpture, rather than of a medallion or eight-pointed star. The age of this *gelim* is another criterion which sets it apart from other Lori *gelims*.

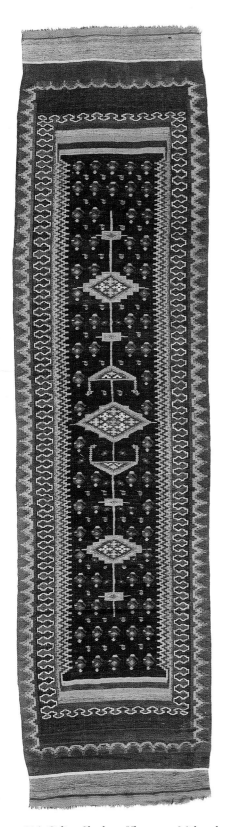

PLATE 116. *Gelim, Shushtar, Khuzestan. Mid- to late 19th century. Wool wefts on goat hair warps. Double interlocking and interlocking weave. 375 x 97cm (12ft.4in. x 3ft.2in.).*

Shushtar

The second batch of Khuzestan *gelims* comprises those known as the Shushtari, which have long enjoyed a high reputation. It is not certain that these Shushtaris are the same as those mentioned in historical texts from a thousand years ago. What is certain is that Shushtar has been an important centre of weaving from time immemorial.

This ancient city, built on the banks of the river Gargar (one of the tributaries of the Karun), houses Afshar tribes in addition to the Lors. These Afshars have been absorbed into the native population.

The *gelims* of Shushtar, while exhibiting the double-interlock structure, differ in many ways from the *mir gelims* and form their own independent category. One of the most tangible features of these *gelims* is their fineness; they are as thin as a piece of fabric. Although the wool used in these *gelims* is stiff and relatively dry, as in the Bakhtiari *gelims*, their warp and weft are spun several times thinner than those in other *gelims*. In terms of design and composition, too, the *gelims* of Shushtar are distinct. Most of them feature three delicate medallions linked together with a thin line, with a field framed by several borders (Plate 116). Some of them have wide borders at the upper and lower ends, with plain stripes used to increase the length of the *gelim* (Plate 117). Some use a considerable amount of unadorned plain weave around the edge; at times so much so that it appears that a small, patterned rug has been spread over a larger one (see pages 302 and 309 to 310 for a discussion of *masnad*). Colour schemes, too, differ little from other Bakhtiari *gelims*. The colour brown, or undyed brown wool, is used more frequently, while in one batch a considerable amount of dyed blue cotton, as well as other Lori colours, is used.[141]

In my opinion, these Shushtar *gelims* were not floor coverings for everyday use. Rather, they had a ceremonial function. Either they were rolled out for guests, or they were commissioned by khans to be sent as gifts to the shah, courtiers, or government officials, somewhat akin to the commissioned *gelims* of Seneh (see page 95ff.).

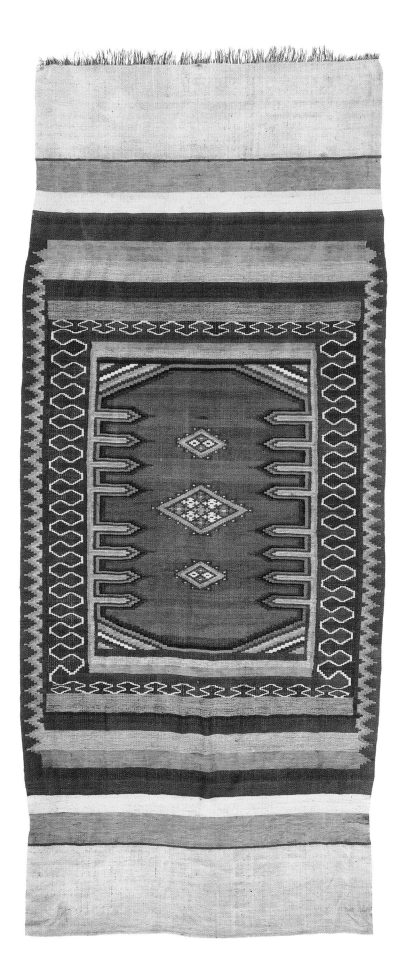

PLATE 117. *Gelim, Shushtar, Khuzestan. Late 19th century. Wool and cotton wefts on wool warps. Double interlocking weave. 333 x 142cm (10ft.11in. x 4ft.8in.).*

The Gelimchehs of Shushtar

The term *gelimcheh,* or little *gelim,* is used for those small *gelims* that serve different uses. Women generally weave these *gelims* for their personal use as prayer rugs, bundles or floor coverings for the bath. *Gelimchehs* are woven in Khuzestan more than anywhere else, and particularly in Shushtar. They are also known as *shushtari,* for they exhibit the same thinness and delicacy as the *gelims* of Shushtar. The main difference is that their weave is based on a cotton warp, while the *gelims* are on a woollen one. Another difference between the larger and smaller *shushtaris* is their pattern. *Gelimchehs* do not have borders, at least not on the sides. Their only pattern is a large comb-like shape placed in the centre of a plain field. At the top and bottom there are several broad and narrow stripes (Plate 118).

The design and composition of the *gelimchehs* of Shushtar, even their dimensions and size, are close to the variety known as *bozvashm* (see below). They are also woven in the vicinity of Shushtar.

Bozvashm or the Hairy Gelims

I have borrowed the term *bozvashm* from Estakhri, who used it in reference to the *gelims* that he had seen in Qazvin in the tenth century.[142] My guess is that the *gelims* mentioned by Estakhri must have been of the kind produced in Khuzestan, Azarbaijan, Kurdestan and eastern Turkey, and I have therefore given this name to the variety under discussion.

Bozvashm is a Persian word meaning goat-like. The *bozvashm gelims* of Khuzestan not only resemble goat pelt but are actually woven from goat's hair and are the only *gelims* of the pile variety. In these *gelims* no colours other than natural goathair, such as black, white, brown and grey, can be seen. Their pattern, design and even size are often similar to the *gelimchehs* of Shushtar.

The *bozvashm,* or *faux* pile, *gelims* must once have been found over a larger area than today.[143] Among their powerful admirers were the Ottoman sultans, who had in their possession the best specimens, known as *velense.* Hulya Tezcan has compiled a fairly complete list of collections of *velense* that still remain in Turkish museums.[144] Some of these *velenses* date back to the sixteenth century. One variety of *velense* or *bozvashm* was, and still is, the robe or *aba.* This is probably what attracted the attention of the Moroccan traveller Ibn Battuta (1303-77). Of his audience with Shaykh Qotb al-Din in Isfahan he wrote:

> On that day they had washed the Shaykh's clothes and spread them out to dry in the garden. Among these was a loose white cloak *[jobbeh]* which in that region is called the *hazar-mikhi* [thousand-nail]. On seeing it, I thought to myself that I deserved such a cloak ... they brought the garment and the Shaykh put it on me, whereupon I fell at his feet and kissed them.[146]

The cloak mentioned by Ibn Battuta puts me in mind of the *aba* that until recently was worn by some dervishes (Figure 12). Despite variations between *velense, hazar-mikh* and *bozvashm,* they all share a faux pile look and an attempt

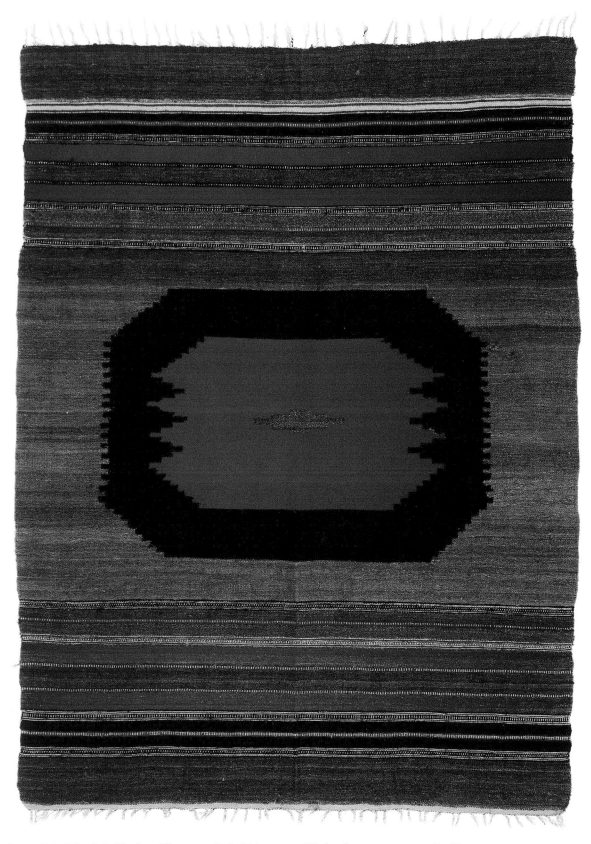

PLATE 118. *Gelimcheh, Shushtar, Khuzestan. Early 20th century. Wool wefts on cotton warps. Double interlocking and weft-faced plain weave. 125 x 97cm (4ft.1in. x 3ft.2in.).*

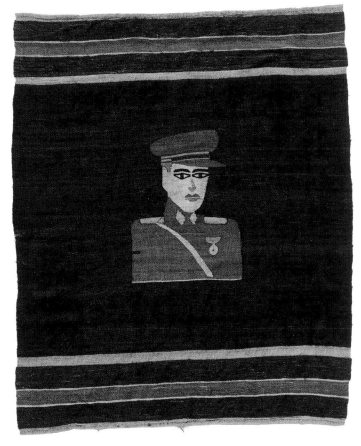

PLATE 119. *Faux-pile pardeh, Khuzestan, showing the portrait of the former Shah of Iran. c.1945. Goat hair wefts on cotton warps. Slit tapestry and weft-faced plain weave. 146 x 30cm (4ft.9in. x 1ft.).*

PLATE 120. *Faux-pile gelim, Khuzestan. End 19th century. Goat hair wefts on cotton warps. Slit tapestry and weft-faced plain weave. 200 x 132cm (6ft.7in. x 4ft.4in.).*

has been made in all of them to simulate animal pelts. These weavings, which have been (and in places still are) in use in every society including America, Europe and Asia are known in the jargon of weaving as the 'plush' group.

The *bozvashms* discussed here were used as floor coverings or blankets, and are woven from goat's hair.[146] These *gelims* were produced in the goat-rich wildernesses of Khuzestan, and probably even parts of Arabia. They are no longer produced in Khuzestan, however; the last ones were woven in the 1960s. The credit for producing these *gelims* generally goes to the Arabs of Khuzestan, who form a significant proportion of the population. Other tribes have also made a contribution, such as the Bani Ka'ab to the north of Khorramshahr, and the Bani Lam to the south of Ahvaz.

Although the weaving of *bozvashm gelims* has ceased in Iran, it still continues in eastern Turkey in some Kurdish villages, among them Siirt,[147] south of Lake Van and not far from the borders with Iran and Iraq. It is not easy to distinguish between the *gelims* of Siirt and those of Khuzestan. All of them are based on a cotton warp and both varieties have similar designs and structures. Amid this group of similar *gelims* there is one exceptional design showing the face of the shah of Iran in his youth, dressed in military uniform (Plate 119). This particular design must date to the late 1930s or early 1940s and must have been produced in Iran,

PLATE 121. *Faux-pile gelimcheh, Siirt, east Turkey. Early 20th century. Goat hair wefts on cotton warps.*
Slit tapestry and weft-faced plain weave. 170 x 126cm (5ft.7in. x 4ft.2in.).

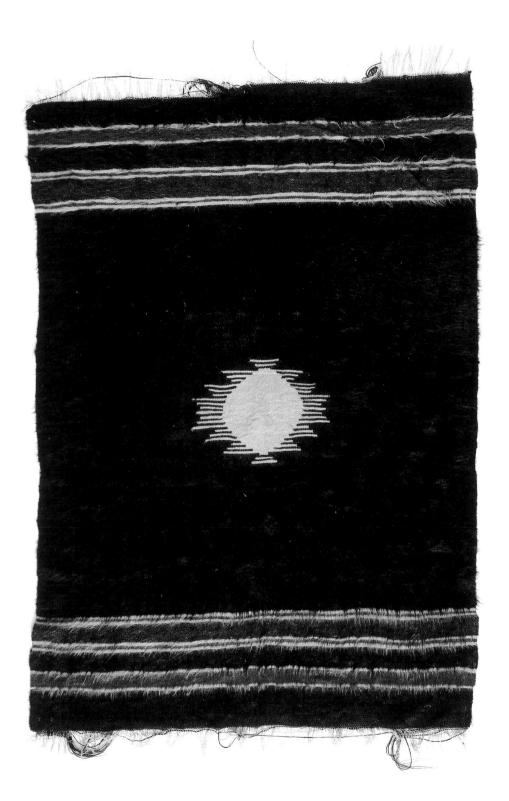

PLATE 122. *Faux-pile gelim-cheh, Siirt, east Turkey. Mid-20th century. Goat hair wefts on cotton warps. Slit tapestry and weft-faced plain weave. 176 x 123cm (5ft.9in. x 4ft.).*

most probably Khuzestan. On the basis of this *gelim* and the similarities that exist between the other group and the *gelimchehs* of Shushtar, I would venture to say that the *gelims* in Plates 119-120 were perhaps woven in Khuzestan and those in Plates 121-125 in Siirt.[148] The *bozvashm gelims* must be considered among the oldest floor coverings and weavings made by human hands, and the discovery of their method of weaving must be treated as an important one.

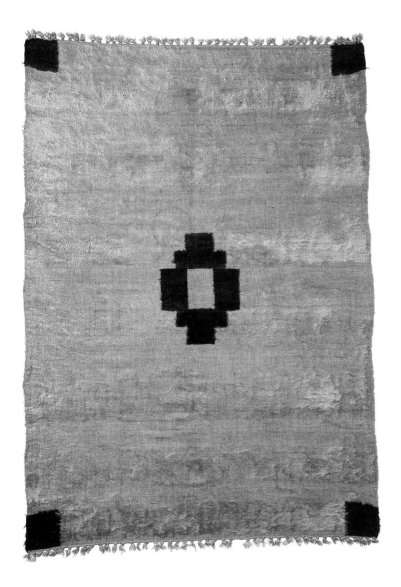

PLATE 123. *Faux-pile gelim, Siirt, east Turkey. Mid-20th century. Goat hair wefts on cotton warps. Dovetailed weave. 186 x 133cm (6ft.1in. x 4ft.4in.).*

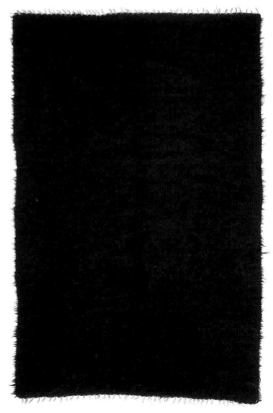

PLATE 124. *Faux-pile prayer gelimcheh, Siirt, east Turkey. Mid-20th century. Goat hair wefts on cotton warps. Slit tapestry and weft-faced plain weave. 117 x 79cm (3ft.10in. x 2ft.7in.).*

PLATE 125. *Faux-pile gelimcheh, Siirt, east Turkey. Mid-20th century. Goat hair wefts on cotton warps. Weft-faced plain weave. 178 x 119cm (5ft.10in. x 3ft.11in.).*

PLATE 126. *Gelim, Lors of Bakhtiari, Khuzestan. Late 19th century. All wool. Slit tapestry, weft-faced plain weave. 257 x 181cm (8ft.5in. x 5ft.11in.).*

The Bakhtiari Lors

I have attached the name Bakhtiari Lor to the last variety of Khuzestan *gelims*. The reason for this is that I do not have precise information about the place where they were woven. I do know, however, that they were made by the Bakhtiari Lors – not by the Bakhtiaris of Chahar Mahal nor even by the Lors of Fars. Furthermore, these *gelims* owe something to the two groups mentioned above. The design, pattern, composition and colour scheme of some of the *gelims* in this group bear a close resemblance to those of the *mir gelims*, but their weave is not of the double-interlock kind. Rather, it is slit tapestry, which is

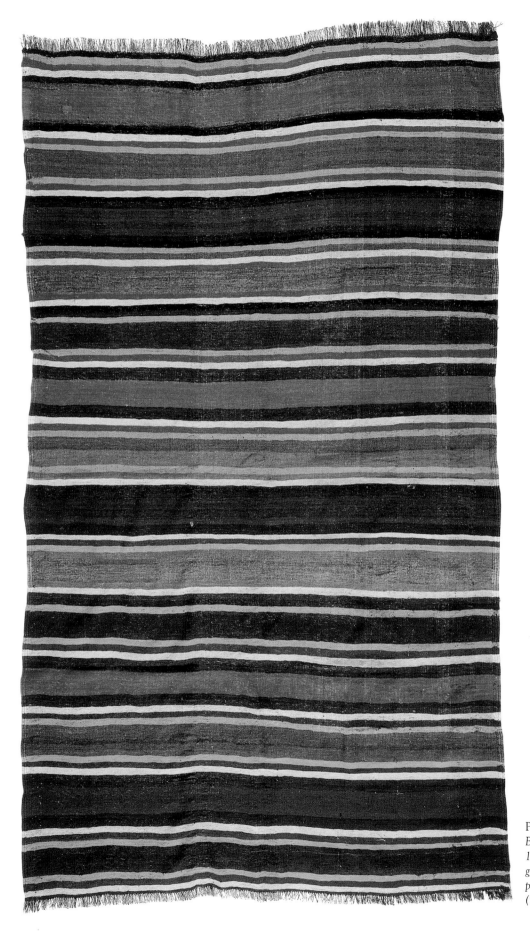

PLATE 127. Gelim, Lors of Bakhtiari, Khuzestan. End 19th century. Wool wefts on goat hair warps. Weft-faced plain weave. 296 x 170cm (9ft.9in. x 5ft.7in.).

171

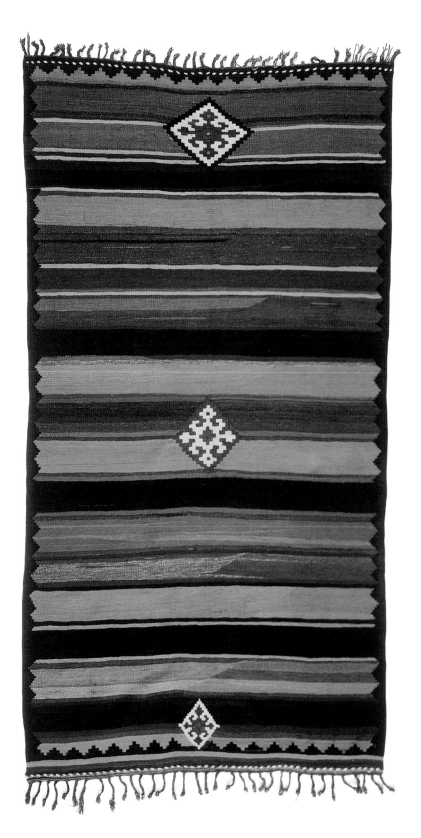

PLATE 128. *Gelim, Lors of Bakhtiari, Khuzestan. Early 20th century. All wool. Slit tapestry, weft-faced plain weave. 232 x 120cm (7ft.7in. x 3ft.11in.).*

more common among the weavers of Fars, such as the Lors. Plate 126 shows one such example which can be compared with Plate 114 from the *mir* variety. The three *gelims* in Plates 127, 128 and 129, all bearing a striped composition, have all the features of the Lori *gelims*, including the colour scheme.

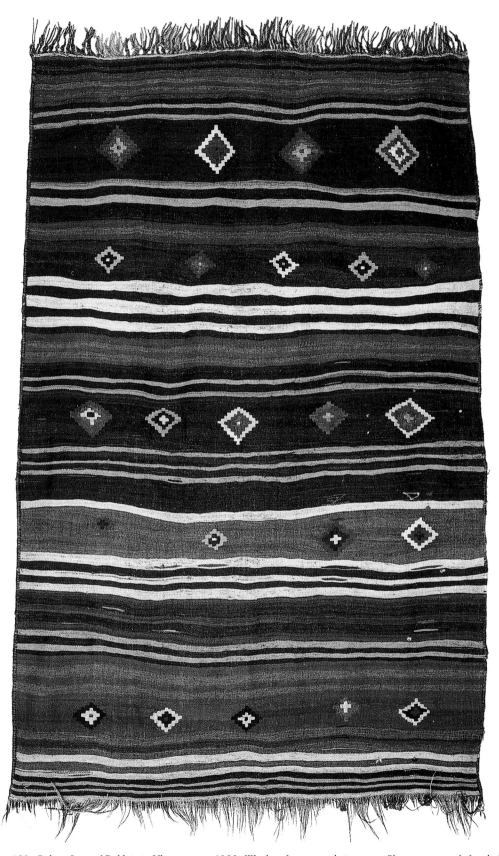

PLATE 129. *Gelim, Lors of Bakhtiari, Khuzestan. c.1900. Wool wefts on goat hair warps. Slit tapestry, weft-faced plain weave. 224 x 147cm (7ft.4in. x 4ft.10in.).*

FIGURE 28. *Map of Fars, showing Persian Gulf (in the south), Kerman and Sirjan (in the east) and some of the cities of Fars such as Eqlid, Abarquh, Kazerun, Jahrom, Fasa and Abadeh. From Estakhri Masalik va Mamalik, mid-10th century.* NATIONAL MUSEUM OF IRAN, TEHRAN, FOLIO 42B

Fars

The province of Fars is the second most important source of Persian *gelims*, outstripped only by Azarbaijan in terms of population diversity and variations in design. As with Azarbaijan, one of the factors responsible for the diversity and abundance of the Fars *gelim* is the mixture of Turk and Persian peoples. Wherever the Turks and Persians have mingled, their weavings have been more varied and abundant. Fars is one such place. The presence of the Turkish-speaking Qashqa'i people is the most important reason for the richness of the Fars *gelim*. The appreciation of such richness, however, would not have been possible had it not been for the Lors. The Lors are the spring through whom we can find the source, namely the Qashqa'i. Therefore, we must first turn our attention to the Lors.

The cooperation between Lor and Qashqa'i, which has been complementary and reciprocal, is worth examination. Pattern and design were provided by the Lors, but it was the Qashqa'i who nurtured them and lent them a certain panache. The selection of *gelims* chosen for this book includes the finest from each ethnic group, and the best *gelim* that the Lor have to offer is on a par with the best Qashqa'i *gelim*. But if we compare average *gelims* produced by each group, particularly those with similar designs and formats, the superiority of the Qashqa'i product becomes obvious. This is especially true in aesthetic terms, because everything in the former – weave, design, colour scheme – is more orderly and pleasing than in the latter. However, a look at the history of these two ethnic groups might help restore a balance in the evaluation of their work.

The decline of the Lors and rise of the Qashqa'i in Fars is not unrelated to the

accession of the Qajars in 1795 and the disintegration of the Zand dynasty. The latter dynasty was established by Karim Khan Zand, himself a Lor, although Karim Khan was not from Fars. During his reign, the Lors in the south and west of Iran enjoyed great influence and power. Aqa Mohammad Khan Qajar upset this balance. After Karim Khan's death, Aqa Mohammad Khan saw his opportunity and eventually succeeded in overthrowing his successors. Aqa Mohammad Khan's hostility towards the Zand led to the abandonment of Shiraz as the capital (which moved to Tehran), and the transfer of power in Fars from the Lors to the Turks. This power shift culminated, during the reign of Aqa Mohammad Khan's successor, Fath 'Ali Shah, in the appointment of Jan Khan Qashqa'i (1829-33) as the first ilkhan (chieftain) of Fars.[149] From then on the power of the Qashqa'i was on the ascendant. By the beginning of the twentieth century the Qashqa'i ilkhans had become so powerful that they could stand up to the central government. With their well-armed tribal forces they not only consolidated their power throughout Fars, but even went as far as claiming the throne.

It is difficult to believe that a tribe that had remained obscure prior to the Qajars could so rapidly rise to such a position of power. A number of factors contributed and in this regard it is useful to compare the Shahsavan and the Qashqa'i. What was true of the former in the seventeenth century and resulted in the unification of Turkish and Kurdish tribes happened in the case of the latter, resulting in a union between a great number of non-Turks including Lors with Qashqa'is.[150] It is this union that would explain why certain weavings from this region are every bit as much Qashqa'i as they are Lori; it is no easy task to label them. That is why I have occasionally preferred to use the label Lori/Qashqa'i for some of these *gelims*.

There are other tribes aside from the Lor and the Qashqa'i that live in Fars. The most important of these are the Arab tribes who primarily inhabit the western part of the province and who have been absorbed into the Khamseh confederation. Khamseh, which means five, was created from the union of five Turkish, Lori and Arab tribes to offset the steadily growing power of the Qashqa'i in the latter part of the nineteenth century. It was more a political confederation than a tribal union. For better understanding of Qashqa'i and Lori flatweaves, especially their *gelims*, or any detailed study, one should include a consideration of other weavings in Fars, in particular the *gabbehs*, which have exercised the greatest influence over the Fars school of *gelim*-weaving. As will be seen, the Fars school is distinct in every aspect from that of Azarbaijan, whether it be the size of the *gelim*, its pattern and design, or even the finish at the ends and sides.

The Lors of Fars

Although the Lors of Fars have ancient links with their cousins elsewhere, their weavings and especially their *gelims* differ markedly from those made by the other Lors already discussed. The double-interlock structure, prevalent in the *gelims* made by the Lors of Khuzestan, is unknown in Fars. Here the dovetailing and slit tapestry structures are more common. We could perhaps attribute the dovetailing structure of their *gelims* to the Lors of Chahar Mahal and Lorestan and consider

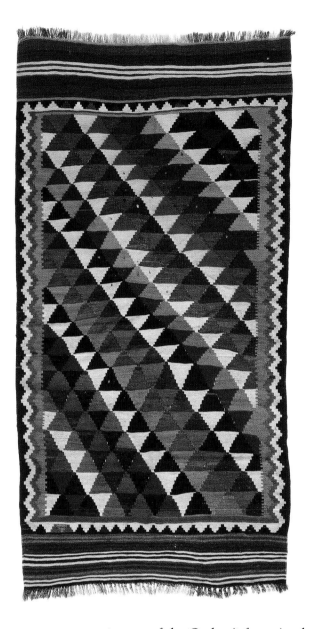

PLATE 130. Gelim, *Lors of Mamasani or Shulestan, Fars. c.1900. Wool wefts on goat hair warps. Slit tapestry weave. 262 x 135cm (8ft.7in. x 4ft.5in.).*

the slit tapestry structure as an import of the Qashqa'i from Azarbaijan. As we shall see, some of the *gelims* of the Lors of Fars resemble those of Zanjan and Qazvin in that they exhibit the dual structures of dovetailing and slit tapestry.

Leaving aside structure, the design and composition of Lori *gelims* are their most important features and liken them most closely to the *gabbeh*. Between Fars and Chahar Mahal and Bakhtiari, it is hard to know which to choose as the birthplace of the *gabbeh*. Whatever the case, it is generally agreed that the first makers of the *gabbeh* were Lors. Even if this theory is disputed by some, one point is certain: the Lori *gabbehs* of Fars far outnumber those made by the Qashqa'i. If the Qashqa'i have made Fars a bountiful source of *gelims*, the Lors have done the same with *gabbehs*. Although the Lors are scattered throughout the province of Fars, their home is the province of Kohkiluyeh, particularly the Mamasani district. Five of the finest *gelims* by these Lors have been selected for this book, all of them *gabbeh*-like.

Plate 130 bearing a zigzag *moharammat* design, and Plate 131, a lozenge grid, were probably produced by the Lors of Mamasani or Shulestan, whose winter

176

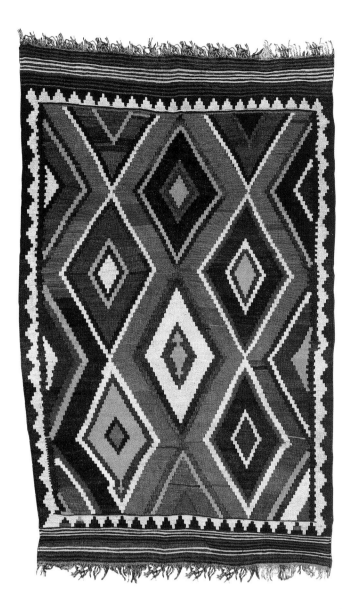

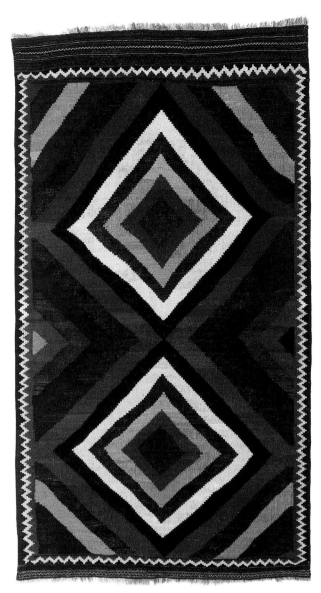

PLATE 131. *Gelim, Lors of Mamasani or Shulestan, Fars. Late 19th century. All wool. Slit tapestry weave. 230 x 145cm (7ft.7in. x 4ft.9in.).*

PLATE 132 *Gelim, Lors of Fars. Mid-19th century. All wool. Dovetailed weave. 270 x 151cm (8ft.10in. x 4ft.11in.).*

quarters are no great distance from the Lors of Khuzestan. Their work consequently bears the trace of the latter's influence, such as multiple borders, or so-called skirts, at the two ends of the *gelim*.

Plates 132 and 133, on the other hand, which resemble the work of the Qashqa'i, must be the product of the Lors of Kohkiluyeh. While their designs are to be found among the Qashqa'i, their dovetailing weave structure and more muted colours make them akin to Lori products. A comparison between Plate 132 and *gelims* bearing the same design by the Qashqa'i (Plate 141), is useful. Plate 133, however, bears a different design from the other Lori and Qashqa'i *gelims*, though it does not differ greatly from the *gabbeh*.

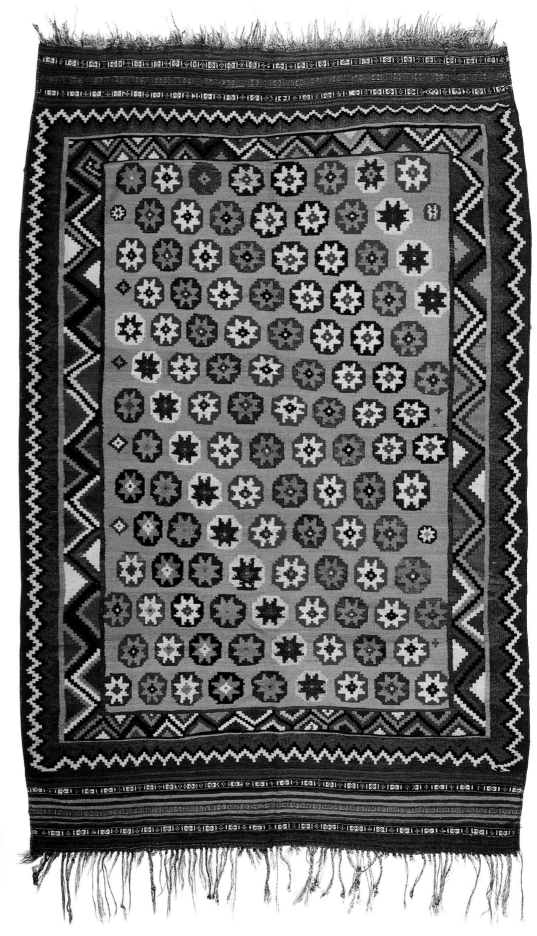

PLATE 133. Gelim,
Lors of Kohkiluyeh.
Late 19th century. All
wool. Dovetailed and
slit tapestry weave. 280
x 187cm (9ft.2in. x
6ft.2in.).

178

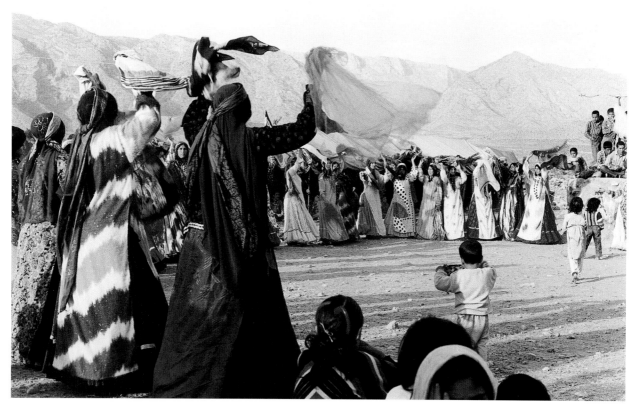

FIGURE 29. *Qashqa'i women dancing, Fars.*

Qashqa'i

Among all the various ethnic groups I know of none in which the women are as captivated by colour as are the Qashqa'i. They drape themselves in the brightest of colours: green, yellow, orange, purple, or anything else that takes their fancy. When they perform their folk dances, it seems as if every possible colour has been set in motion.

The love of colour manifests itself not only in the clothes of Qashqa'i women but also in their weavings. When chemical dyes entered Iran and reached the hands of the Qashqa'i, they chose the brightest among them. The bright orange eschewed by rug lovers and collectors found the greatest favour among these women who used it to weave hundreds of *gelims* and *gabbehs*. These *gelims*, which are flawless in terms of weave, are not desirable by Westerners because of their bright hue. Pink and purple were two other chemical dyes which the Qashqa'i preferred to their natural counterparts, because the chemical variety was much brighter and more eye-catching.

The *gelims* selected for our purposes here predate the use of chemical dyes and were woven mostly towards the end of the nineteenth century or early in the twentieth. They lack the sharp, bright tones of the chemical dyes, but the brightest vegetable colours have gone into their making, so that they are easily distinguishable from *gelims* made in neighbouring areas. This colour scheme is an important factor in the identification of Qashqa'i *gelims*. The examples shown here share various characteristics – a delicate and accurate weave structure that is almost exclusively of the slit tapestry kind, and the finish on the sides and ends – but also have features specific to themselves.

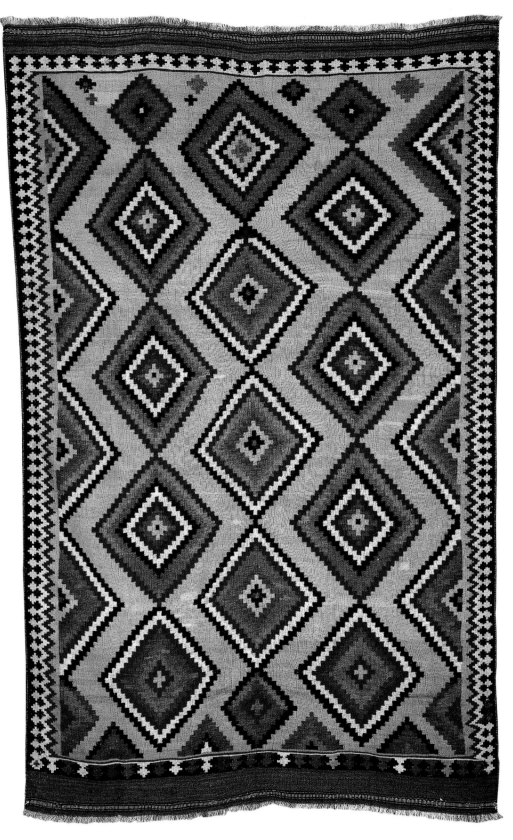

PLATE 134. *Gelim, Qashqa'i, Darreh Shuri, Fars. Late 19th century. Slit tapestry weave. About 230 x 170cm (7ft.7in. x 5ft.7in.)*

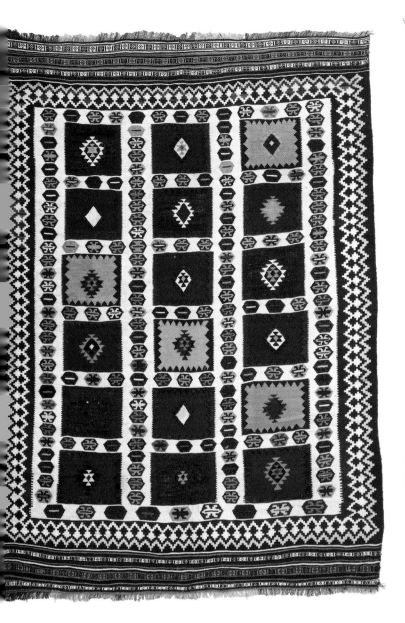

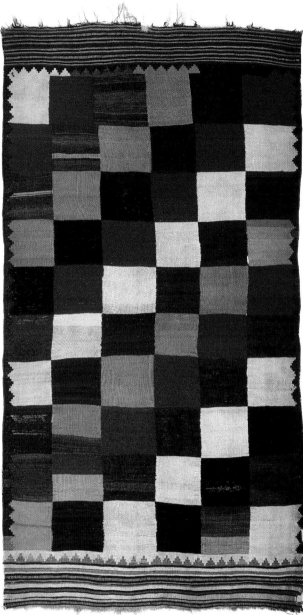

PLATE 135. Gelim, Qashqa'i, Kashkuli, Fars. Late 19th century. All wool. Slit tapestry weave. 228 x 159cm (7ft.6in. x 5ft.3in.).

PLATE 136. Gelim, Qashqa'i or Lors of Kohkiluyeh. 19th century. All wool, dovetailed, slit tapestry and weft-faced plain weave. 274 x 145cm (9ft. x 4ft.9in.). VOK COLLECTION

The Qashqa'i is a large tribe, scattered throughout the area which begins south of Isfahan and continues almost to the Persian Gulf coast. It comprises various clans, all of whom are proficient weavers, although sorting among the Qashqa'i *gelims* is no easy matter, whether through pattern or structure. There are no limits to their use of pattern and design. Whatever has been used by the Lors and the Bakhtiaris is also found in the work of the Qashqa'i. The mingling of tribes and their close relations have rendered the task of distinguishing among their weavings by structure very difficult. None the less, there are certain signs to look for.

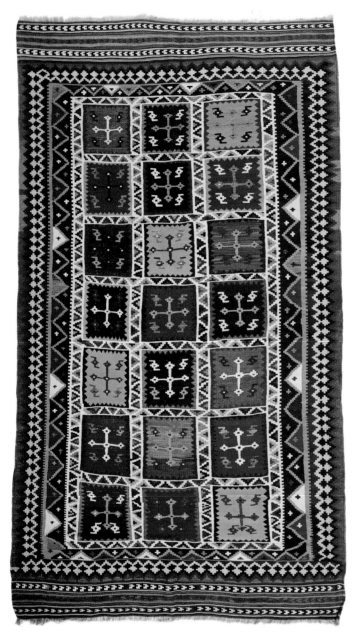

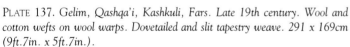

PLATE 137. *Gelim, Qashqa'i, Kashkuli, Fars. Late 19th century. Wool and cotton wefts on wool warps. Dovetailed and slit tapestry weave. 291 x 169cm (9ft.7in. x 5ft.7in.).*

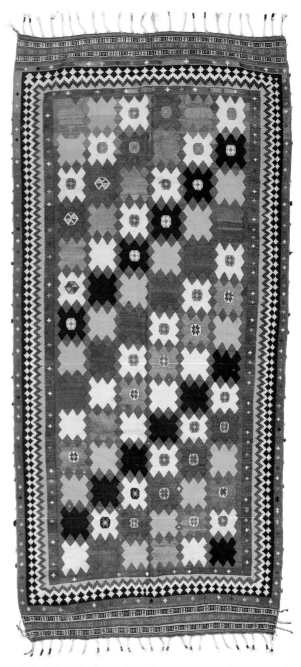

PLATE 138. *Gelim, Qashqa'i, Amaleh, Fars. Late 19th century. All wool. Slit tapestry weave. 330 x 153cm (10ft.10in. x 5ft.).*

The categorization of Qashqa'i *gelims* is by pattern. Seven general varieties have been identified.

The first group of Qashqa'i *gelims* bears the design known as the bricks *(kheshti)*, square grid and lozenge grid. As evident in their name, these *gelims* take their design from the repetition of square bricks placed alongside one another in an orderly fashion. While they appear similar at first glance, each *gelim* with this design has an order specific to itself. Some bear plain squares, while others feature motifs in them (Plates 134-139). This group is the closest to the *gabbeh*.[151]

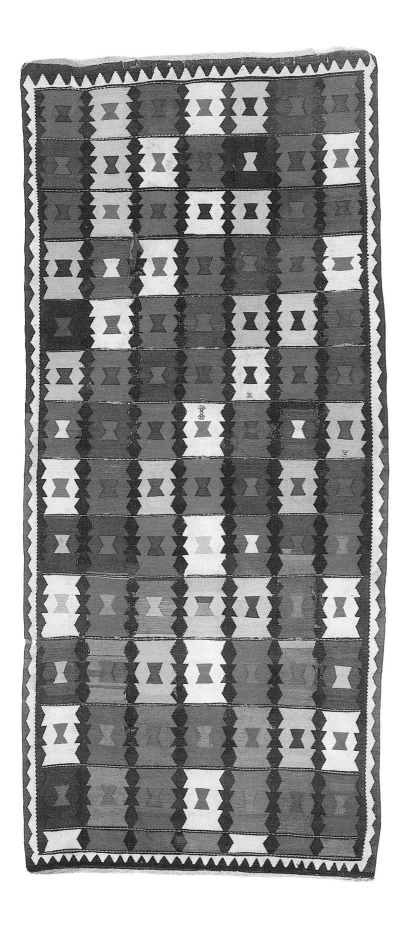

PLATE 139. Gelim, Qashqa'i,
Fars. Late 19th century. All wool.
Slit tapestry weave. About 337 x
120cm (11ft. x 4ft.).

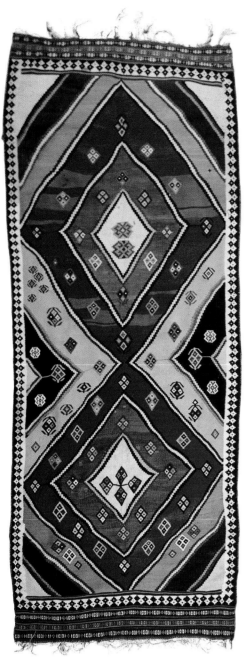
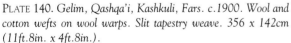
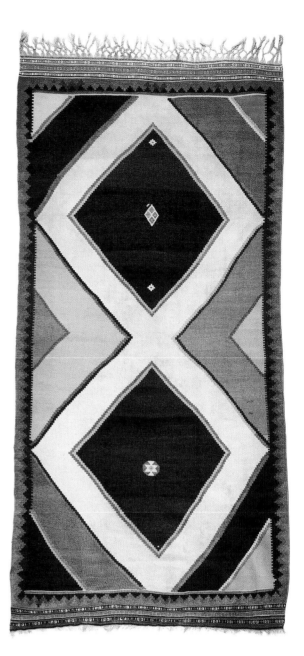

PLATE 140. *Gelim, Qashqa'i, Kashkuli, Fars. c.1900. Wool and cotton wefts on wool warps. Slit tapestry weave. 356 x 142cm (11ft.8in. x 4ft.8in.).*

PLATE 141. *Gelim, Qashqa'i, Shekarlu, Fars. c.1900. All wool, slit tapestry weave. 304 x 146cm (10ft. x 4ft.9in.).*
VOK COLLECTION

There is a small group of these *gelims* in which the lozenges are diamond-shaped rather than square; the field is covered with a repetition of these lozenges, although with varying orders. Another larger group of Qashqa'i *gelims* goes by the name of double or triple lozenges. In these *gelims* the pattern begins with two or three large lozenges which are then engulfed by larger lozenges radiating outwards until the entire field is covered (Plates 140, 142 and 143). Some examples in this group feature triple lozenges or even quadruple lozenges instead of the double. The broad, colourful stripes from which these lozenges take their shape give these *gelims* a special unity of appearance.

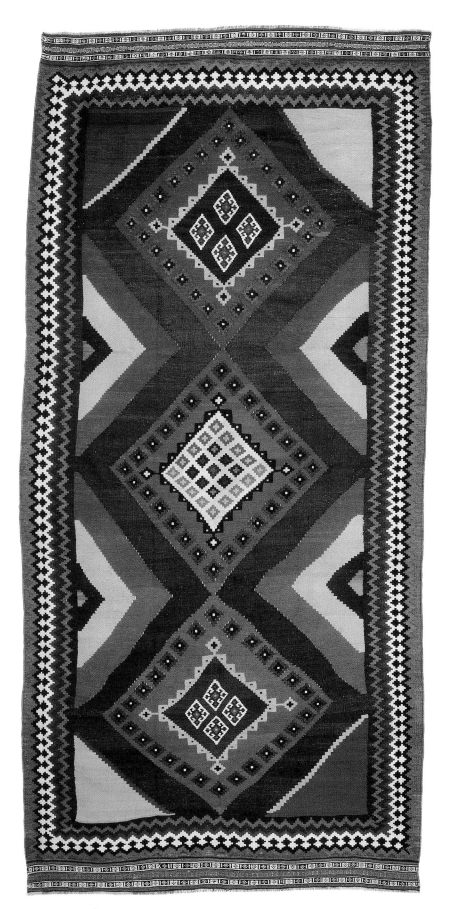

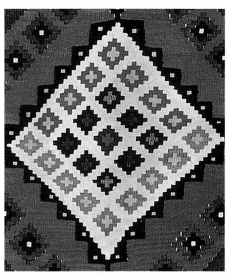

PLATE 142. *Gelim, Qashqa'i. Late 19th century. Wool and cotton, slit tapestry weave. 318 x 150cm (10ft.5in. x 4ft.11in.).* VOK COLLECTION

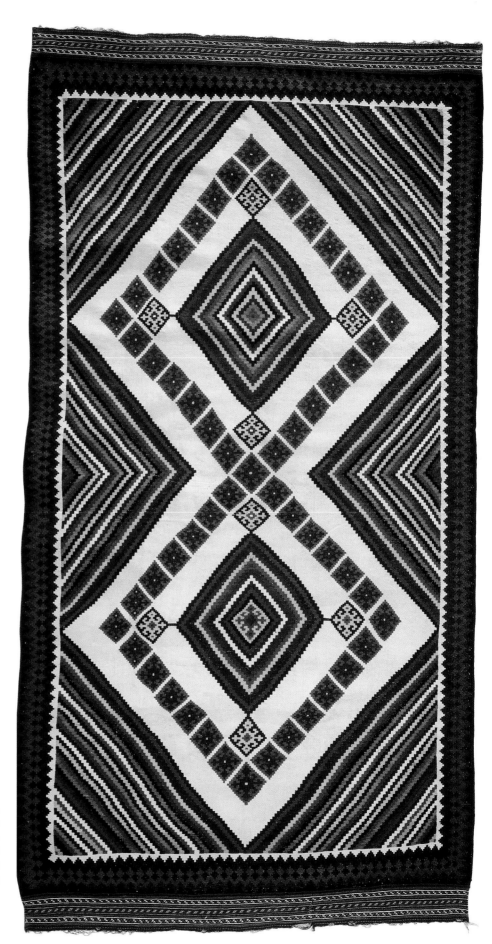

PLATE 143. Gelim, Qashqa'i, Darreh Shuri Fars. Late 19th century. All wool, slit tapestry weave. 322 x 163cm (10ft.7in. x 5ft.4in.). VOK COLLECTION

186

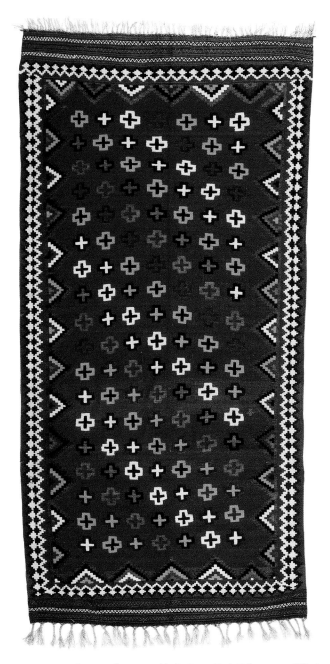

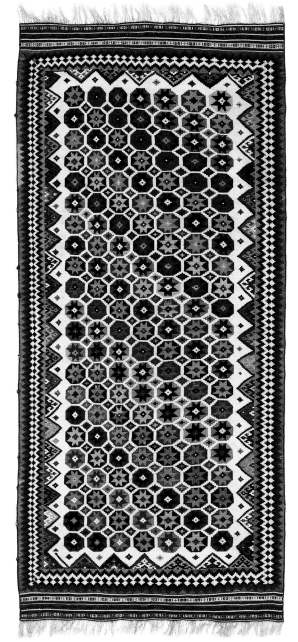

PLATE 144. *Gelim, Qashqa'i, Kashkuli, Fars. End 19th century. Wool and cotton wefts on wool warps. Dovetailed and slit tapestry weave. 315 x 155cm (10ft.4in. x 5ft.1in.).*

PLATE 145. *Gelim, Qashqa'i, Darreh Shuri, Fars. End 19th century. Wool and cotton wefts on wool warps. Slit tapestry weave. 276 x 127cm (9ft.1in. x 4ft.2in.).*

Another large batch of Qashqa'i *gelims* takes its design from repeating stars. The plain fields in these are covered by small stars of varying shapes, sizes and orders. Sometimes a small cross (+) defines their shape (Plate 144) and sometimes this is done by large eight-pointed stars (Plates 145 to 147). The colour of the fields varies also. Most are crimson or sometimes yellow (Plates 146 and 147). The white, all-cotton field in Plate 145 is especially effective in making the stars appear bright.

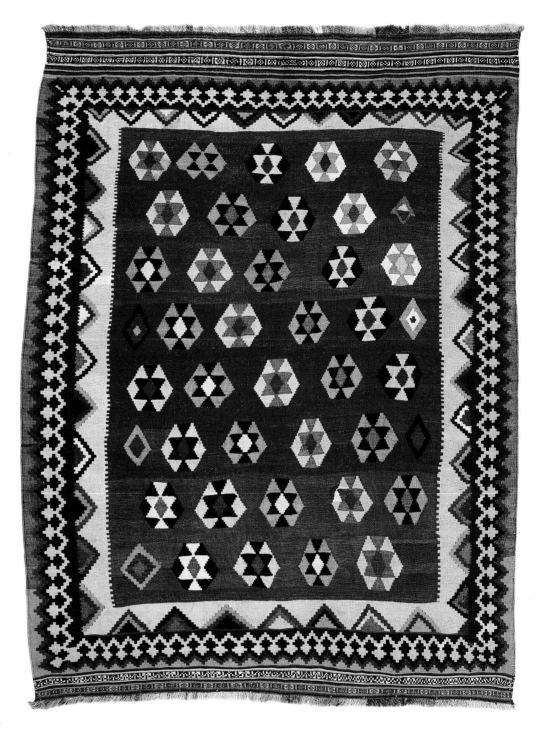

PLATE 146. *Gelim,*
Qashqa'i, Kashkuli,
Fars. End 19th
century. All wool.
Slit tapestry weave.
211 x 158cm
(6ft.11in. x 5ft.
2in.).

The Qashqa'i have also frequently used repeating motifs, such as the crab-like device. By placing the motif within a hexagon and repeating it, they have created different designs. Examples can be seen in Plate 149.

It is the striped design, however, that probably appears most frequently in Qashqa'i *gelims*. It can be seen in various forms, broad stripes, narrow stripes, stripes adorned with numerous kinds of motif. These designs generally appear 'busier' than the others. Plate 150 shows one of the most subdued among them.

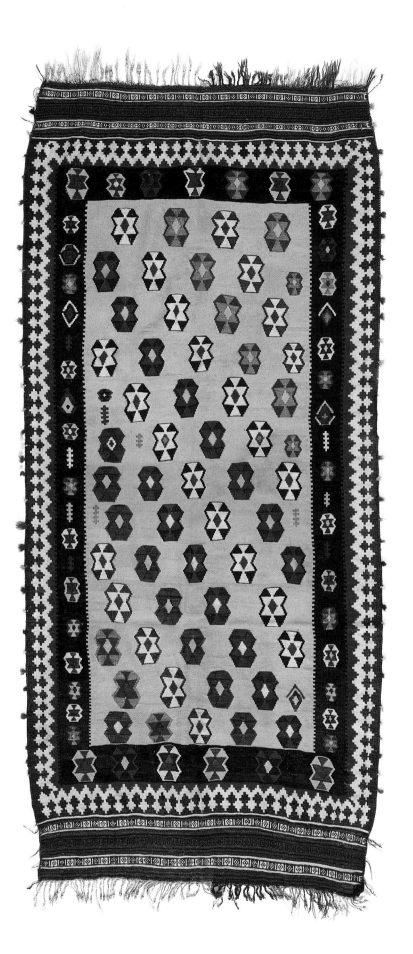

PLATE 147. Gelim, Qashqa'i, Amaleh, Fars. c.1900. All wool. Slit tapestry weave. 310 x 140cm (10ft.2in. x 4ft.7in.).

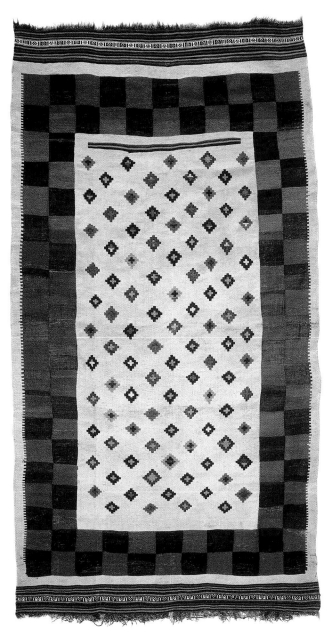

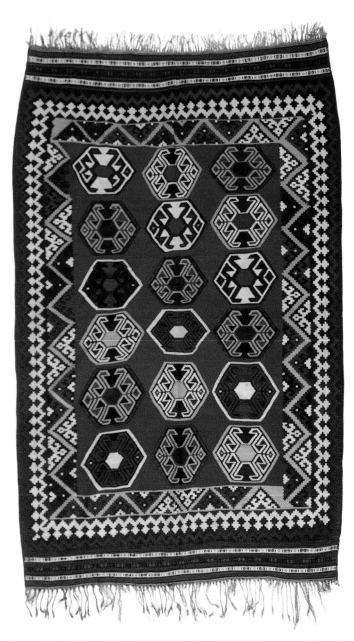

PLATE 148. *Gelim, Qashqa'i, Fars. Early 20th century. All wool, slit tapestry, dovetailed and weft-faced plain weave. 266 x 144cm (8ft.9in. x 4ft.9in.).*
VOK COLLECTION

PLATE 149. *Gelim, Qashqa'i, Kashkuli, Fars. End 19th century. All wool. Slit tapestry weave. 237 x 172cm (7ft.9in. x 5ft.8in.).*

Among other *gelim* designs preferred by the Qashqa'i and by admirers in the West is the plain-field variety. While I do not personally consider these as floor coverings and believe that they functioned as *sofrehs*,[152] I have nevertheless chosen a few as examples (Plates 152, 153 and 154).

The eye-dazzling design is another that did not escape the attention of Fars weavers. Although it is more common in Varamin than anywhere else, it has also been used in Fars and other places. The example here has a weave closer to the work of the Khamseh Baharlus, who are also Turkish-speakers (Plate 155).

190

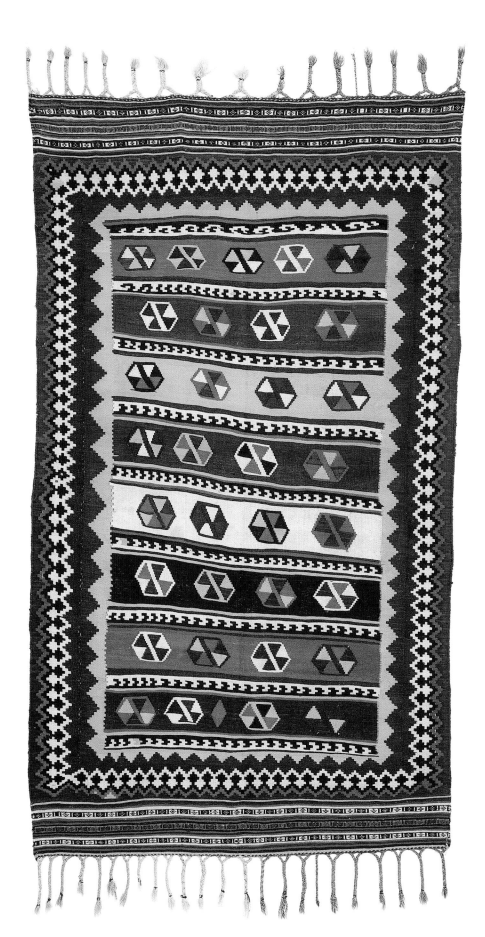

PLATE 150. *Gelim,
Qashqa'i, Kashkuli, Fars.
End 19th century. All wool.
Slit tapestry weave. 245 x
140cm (8ft. x 4ft.7in.).*

191

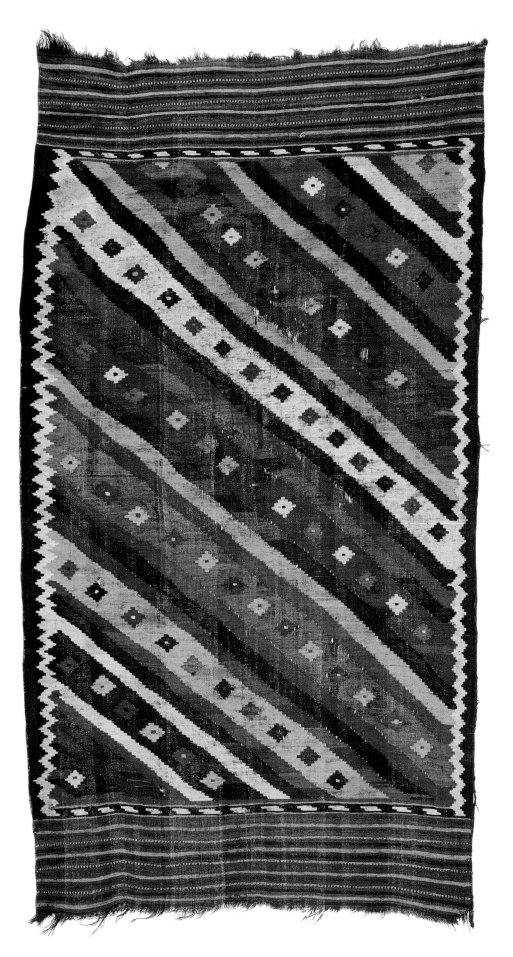

PLATE 151. Gelim, Lors of
Kohkiluyeh. 19th century.
All wool, slit tapestry and
weft-faced plain weave. 260
x 145cm (8ft.6in. x
4ft.9in.). VOK COLLECTION

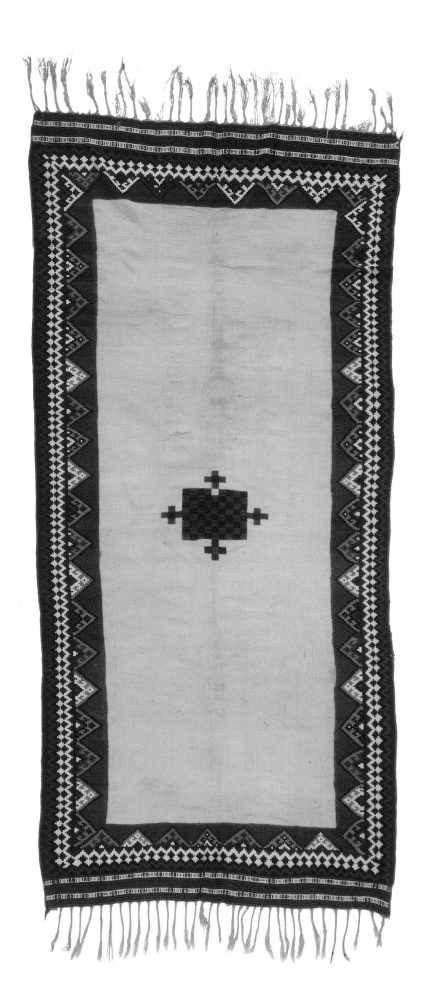

PLATE 152. Gelim or sofreh,
Qashqa'i, Darreh Shuri, Fars.
c.1900. Wool and cotton wefts
on wool warps. Slit tapestry and
dovetailed weave. 298 x 143cm
(9ft.9in. x 4ft.8in.).

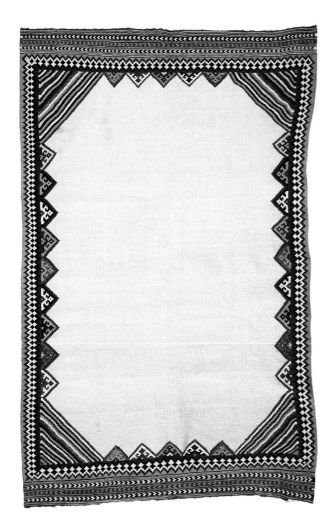

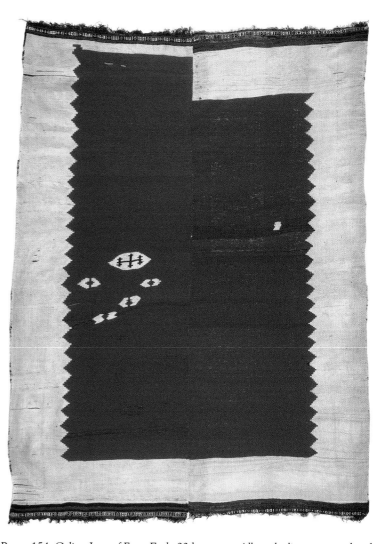

PLATE 153. *Gelim or Sofreh, Qashqa'i, Darreh Shuri, Fars. Late 19th century. Wool and cotton, slit tapestry, dovetailed and weft-faced plain weave. 244 x 144cm (8ft. x 4ft.9in.).* Vok Collection

PLATE 154. *Gelim, Lors of Fars. Early 20th century. All wool, slit tapestry and weft-faced plain weave. 265 x 200cm (8ft.8in. x 6ft.7in.).* Vok Collection

The Khamseh are the last group of gelim-weavers in Fars. The Arab members of this confederation have not made a significant contribution to *gelim*-weaving and, while the Persian constituents who comprise the Baseri, Nafar, Turkish, Imanlu and Baharlu clans have had some role in *gelim*-weaving, it is insignificant in comparison to that of the Qashqa'i. The home of these tribes in the easternmost corner of the province has made them neighbours to the people of Kerman, whose work has exercised considerable influence on their weaving. There the two cultures of Fars and Kerman are brought together, making these tribes all-round masters. This means that they know both the *gelim* and the *palas*. Although in terms of quantity their flatwoven products are overshadowed by their pile- rugs, they are of high quality.

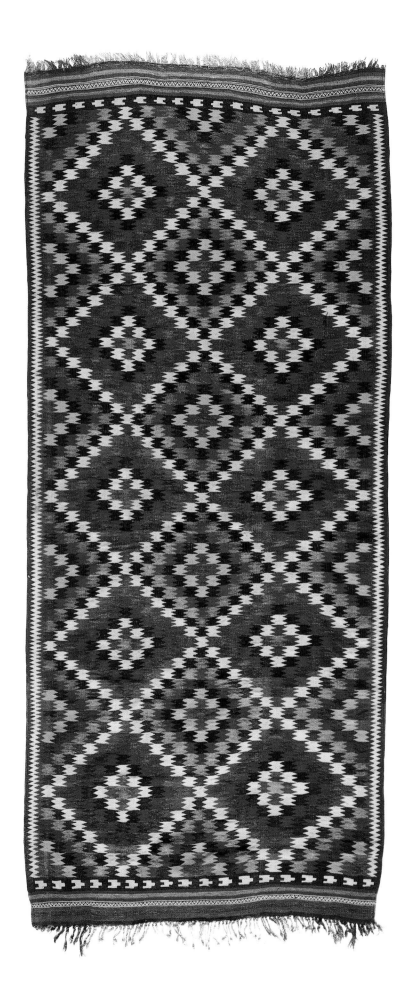

PLATE 155. *Gelim, Khamseh Confederation, Baharlu tribe, Fars. End 19th century. All wool. Inclined slit tapestry weave. 374 x 161cm (12ft.3in. x 5ft.3in.).*

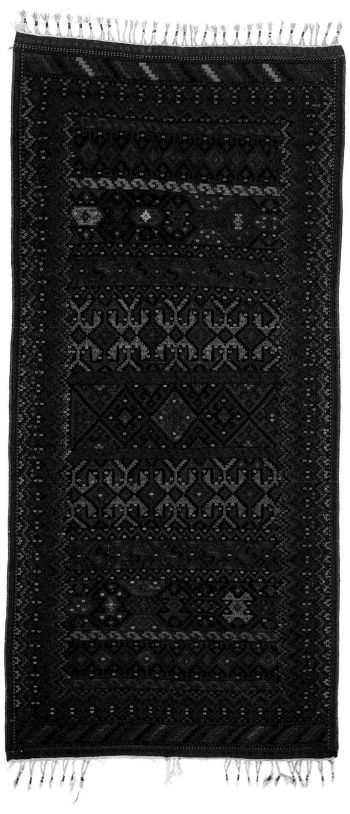

The Kerman Gelim

The *gelims* of Kerman form the smallest section in this book. The reason for this is clear. Kerman is not the land of *gelim*-weavers; it is the land of *palas*-weavers (see page 223). Nevertheless, in Kerman, particularly Sirjan, a large number of *gelims* are traded under various labels. A great many of these *gelims* were made by the Lors who migrated to Kerman from Lorestan and Fars. Ford has discussed some of these in his article.[153]

The *gelims* woven by the Lors of Kerman,[154] which comprise the largest category of *gelims* from this region, bear a close resemblance to the *gelims* of Lorestan and Fars. Their colour scheme is dark and they have the dovetailing and double interlock structure (Plate 156). Their dimensions are generally smaller than those of the *gelims* of Fars or other areas. Another *gelim* selected for this book was made by a group of mountain-dwellers known as Afshar-e kuhi (Plate 157). Their *gelims* are also small and their design and pattern resemble those of the rugs made here.[155]

With this *gelim* we come to the furthest extremity of the land of *gelim*-weavers. Further east the *gelim* disappears and is replaced by the *palas*.

PLATE 156. *Gelim, Lors of Kerman. Early 20th century. Wool wefts on cotton warps. Dovetailed weave patterned in certain area by weft substitution. 214 x 143cm (7ft. x 4ft.8in.).*

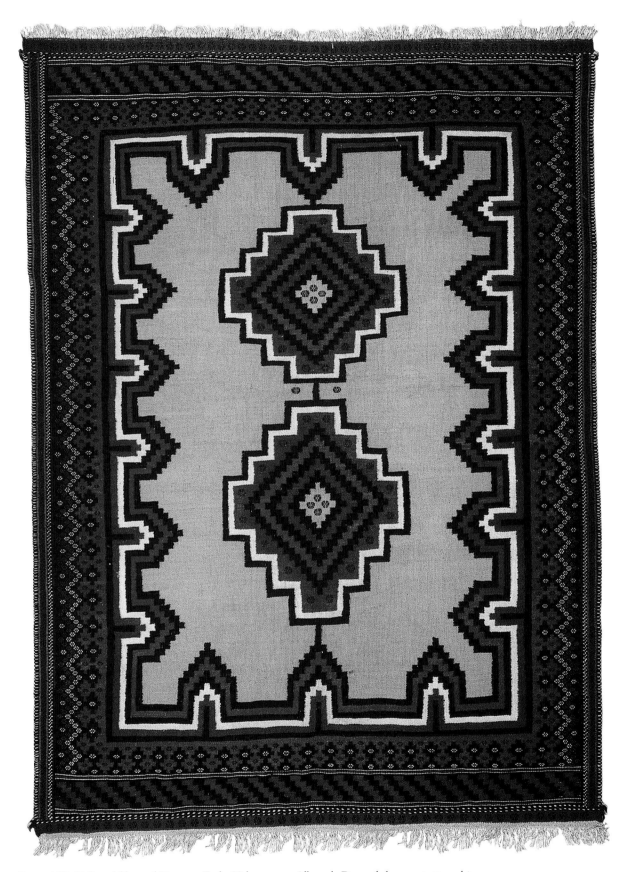

PLATE 157. Gelim, Afshars of Kerman. Early 20th century. All wool. Dovetailed weave patterned in certain areas by weft substitution. 196 x 145cm (6ft.5in. x 4ft.9in.).

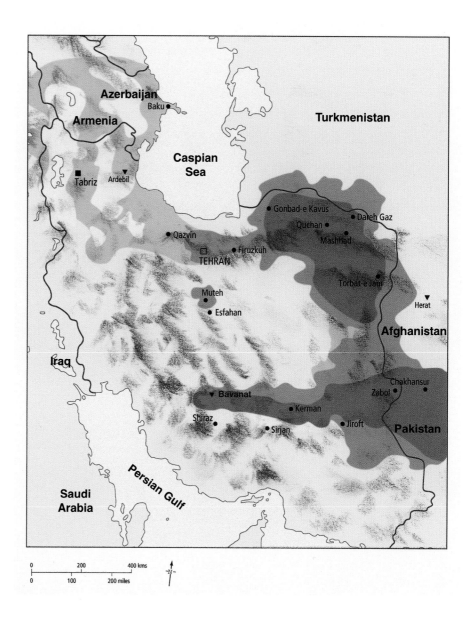

Map of Iran showing the extent of palas *weaving areas.*

Azerbaijan

Armenia

Baku

Turkmenistan

Caspian Sea

Tabriz Ardebil

Gonbad-e Kavus Dareh Gaz

Quchan

Mashhad

Qazvin

Firuzkuh

TEHRAN

Torbat-e Jam

Herat

Muteh

Esfahan

Afghanistan

Iraq

Chakhansur

Bavanat

Zabol

Kerman

Shiraz

Jiroft

Sirjan

Pakistan

Persian Gulf

Saudi Arabia

0 200 400 kms
0 100 200 miles

-N-

PALAS

Of all the flatwoven floor coverings, the least known is the *palas*. Aside from occasional mentions in rug literature, no serious effort has been made to study this group of floor coverings and no independent article has been published about them. This is despite the fact that as far as comparisons go, the *palas* is in no way inferior to the *gelim*. Even if there existed no consensus about their similarity in terms of quality, there could be little disagreement about their numerical parity.

The traditional land of the *palas*-weavers is more or less equal in size to the land of the *gelim*-weavers. In general, the west of the country is the land of the *gelim*-weavers, and the east is that of the *palas*-weavers. It has been centuries since this distinction lost its absoluteness, with the movement of the Turks from east to west and of the Kurds from west to east. Nevertheless, the flatwoven

198

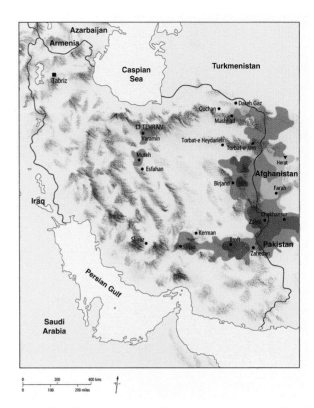

Map of Iran showing the extent of the palas *weaving areas with weft-float brocading structure.*

Map of Iran showing the extent of the palas *weaving areas with weft substitution structure.*

floor spreads of these two regions have preserved their distinctive characters. One would be hard-pressed to come up with a single *gelim* for every hundred *palases* found in the east; the reverse holds true, more or less, for the west. The rural masses in the east of Iran, from Khorasan to Sistan and Baluchestan, live on *palases*, call them exactly that, and are generally unaware of the word *gelim*,[156] while in the west the opposite trend prevails.

A more vivid testament to this contention is provided by Petsopoulos' book, *Kilims*, one of the first and most comprehensive on the gelim.[157] Petsopoulos points out the major *gelim*-weaving areas in Asia Minor and Iran, but he goes no further than western Iran and says nothing about the east and its contributions to *gelim*-weaving. This is not to say that he and his associates had no awareness of or access to Khorasan or Turkoman *gelims*. Rather, it indicates that they knew of the structural differences found in *gelims* woven in eastern Iran and, unlike some recent books on the *gelim*, elected not to include the *palas* in their discussion of the *gelim*. Another testimony to this contention is provided by the collectors of Turkoman rugs. These collectors – who are not only numerous but also rank among the most serious of rug *aficionados* – have never, as far as I know, paid much attention to Turkoman *gelim*.

Could the answer be the limitation of *gelim* weaving among the Turkomans?

Considering the numerous allusions made in Persian literature to the *palas*, the neglect and obscurity of this category of floor covering becomes all the more puzzling. It is no exaggeration to say that in Persian literature there are no fewer references to the *palas* than to the *gelim*. Like the *gelim*, the *palas* has been

mentioned everywhere as a floor covering and as an item of clothing for the poor, albeit one that is thicker and coarser.

The Persian lexicon, *Borhan-e Qate'* (1652), defines the *palas* as a stout *pashmineh* worn by dervishes and also as a kind of *pashmineh* (woollen weave) used as a floor spread.[158] *Ghayat al-loghat* (1826) and Anandraj's other Persian lexicons (1888) also define it as a thick, inexpensive floor covering and a garment for use by the poor.[159] Perhaps it is because of these references that subsequent lexicographers seriously devalued the *palas* and called it a coarse *gelim*, a stout *gelim*, or an inferior *gelim*.[160] Nor has the *palas* fared any better in the metaphors of everyday speech. People identified as *palas-neshin* (those who spread the *palas* under themselves) or *palas-push* (*palas*-wearers) are recognized as the poorest of the poor. The floor spreads or clothes of these people have sometimes been derogatively linked with the animal covering *jol*, giving rise to the expression *jol va palas*, meaning worthless possessions.

Except for the anonymous author of *Hodud al-'alam* (982), who mentions a few *palas*-weaving regions and refrains from making judgements on its virtues or imperfections,[161] all other writers and poets have attached to the *palas* the qualities of coarseness and unimportance. Ferdowsi (940-1020) makes several mentions of the *palas* in his *Shahnameh*, sometimes as a floor spread pleasing to God:

> Choose thou a house wherein there is a *palas*,
> [For] the master of that house is a grateful man.

He elsewhere makes reference to people whose clothes are inferior and *palas*-like, but who fail to praise God:

> Their garb is entirely of *palas*.
> In their hearts they bear no gratitude to God.

On another occasion he juxtaposes *palas* with silk, treating the two textiles as the twin poles of life's good and evil:

> This ancient firmament resembles a sorcerer,
> Appearing now like *palas* and now like silk.

Naser Khosrow (1003-88) also makes several references to *palas*. In one of his verses he declares the superiority of the pile-rug to the *palas*:

> Though wool be the origin of both,
> Yet is the qali better by far than the *palas*.

More interesting is his description of the cold and helplessness he experienced when he had nothing but a piece of *palas* on his back (see page 32). Rumi (1207-73) denounces the one who:

> …measures the redolent against dung,
> Water against urine, and satin against *palas*.

Nezami (1140-1217), likewise, places *palas* in opposition to silk and soft linen:

...until like those brides, the trees,
Thou now wearest [silk] brocade and now *palas*.

Sa`di has thus admonished those ascetics who made a show of piety by wearing *palas*:

Asceticism lies not in the wearing of *palas*:
Be a pure ascetic and wear satin.

In all these passages and in hundreds of others where *palas* is mentioned, this floor covering is referred to as a cheap, thick and low-quality fabric. The dictionaries, in addition to confirming these properties of the *palas*, are unanimous on its qualities as a *pashmineh*. There is no such consensus in the dictionaries on the uses of the *palas*, however. Some define it as a floor spread and others identify it as clothing. On its uses as a floor covering there is no disagreement, but the use of *palas* as an item of clothing raises questions.

It might be possible that the allusions to *palas* as clothing by great poets such as Ferdowsi, Naser Khosrow and Sa`di are in fact metaphorical rather than literal. Were *palas* clothes woven with the same structure as the *palas* floor spread? Is it not possible that the coarse and thick woollen garments worn by dervishes and the poor were referred to as *palas* by virtue of their resemblance to *palas*? In the discussion of the dervishes and Sufis we saw that their garb was variously called *pashmineh*, *gelimineh* or *palas*. The quality of weave in the *pashmineh* and the *gelim* is practically identical. Both have weft-faced plain weave, but the *palas* often has a compound weave not practical for the purpose of clothes. Could it be that by *palas-pushi* (the wearing of *palas*) some poets really meant *pustin-pushi* (the wearing of *pustin*, animal pelts)?

One of the items of clothing still prevalent in Afghanistan and northern Iran, particularly Khorasan, is the lamb pelt *(pustin)*. There is some resemblance between these lambskins and the *palas*. On the lambskin, or at least over a part of it, are embroidered various patterns. Its reverse, which is in contact with the body, is the woolly part. The appearance of the *palas* is similar. Its front is patterned, while its back, by virtue of consisting of a tangle of hanging wool, is fleecy. Dervishes, who often differ in their behaviour from the general populace, wear the lambskin inside out and display its woollen side. It may have been such an exterior that prompted the use of the word *palas* as a synonym for *pustin*. A verse by Nezam Veqari (d.1585) compares the *pustin* with the *palas*:

One he drapes in robes of wool and satin,
While to another he gives a patch of [animal] skin with *palas*.

In al-Ma`aref, too, the *pustin* and the *palas* have been treated as synonymous.

Not only is *palas-pushi* an interesting subject in itself, but a discussion on the geography of *palas*-weaving is also instructive. According to the available sources, the *palas* is the floor spread of choice for eastern Iranians, particularly the people of Khorasan, while the *gelim* is the floor covering in western Iran, especially those living in the Zagros foothills. This is not a recent phenomenon.

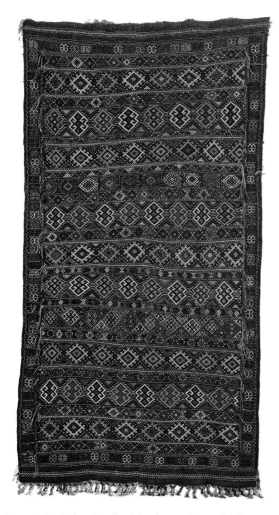

PLATE 158. *Palas, Kurds of Quchan or Bojnurd, Khorasan. Early 20th century. All wool. Weft-faced plain weave patterned extensively by weft-float brocading, knotted weft wrapping and reverse weft wrapping. 300 x 160cm (9ft.10in. x 5ft.3in.).*

The greatest number of allusions to *palas* in Persian literature come from poets and writers from Khorasan. Ferdowsi, Naser Khosrow and Sana'i (d.1131-50) are among these. Non-Khorasanis have also referred to the palas. These include Rumi, who was born in Khorasan and lived in the west and in Konya; and Nezami who was from Ganjeh in the north-west. These two poets, however, came after the poets from Khorasan, and it is reasonable to believe that palas-weaving could by this time have been carried by the Seljuk Turks from Khorasan to Azarbaijan and Konya.

But this theory does not hold up when we consider a claim by the author of *Hodud al-`alam* (latter part of the tenth century) from the same general environs and time as the Khorasan poets. While referring to *palas*-weaving in the cities of Guzakanan and Chaghanian in Khorasan, he also claims to have seen *palas*-weaving in Moghan (in Azarbaijan, the present-day territory of the Shahsavan tribe).[162] When Sa`di, the poet from Shiraz, also refers to the *palas*, the task of distinguishing between the *palas* and *gelim* areas is rendered more difficult. Or else we have to treat the words of the poets as generic and not specific references (see page 24). Perhaps we must consider it as one of the constraints of rhyme-making, or else accept the notion that floor coverings, among them the *palas*, were sent from one part of Iran to another (see page 35).

PROBLEMS OF DEFINITION AND THE DETERMINATION OF GEOGRAPHICAL AREAS

Until the structural bounds of the *palas* are fixed, its definition and the determination of its centres of production will not be easy. *Palas* is a Persian word, but in different areas and among different people its meanings are not always the same. The Turkomans of Iran use the term to refer to a large group of their floor coverings which have weft-float brocading on weft-faced plain weave (Plate 162). The Kurds and Afshars of Khorasan use the same name for floor coverings with the same weave or with reverse extra-weft wrapping on a weft-faced plain weave (Plate 160), while the people of Sistan and Baluchestan and certain sectors of the population of Kerman and Fars attribute the name *palas* to weft-faced substitution weave (Plates 166 and 167). Weavers in Azarbaijan consider weft-float brocading on weft-faced plain weave as *palas* (Plate 176). Some weaves, including floor coverings from Khorasan, have most of the structures referred to in alternating patterns and are also called *palas* (Plates 158 and 159**).**

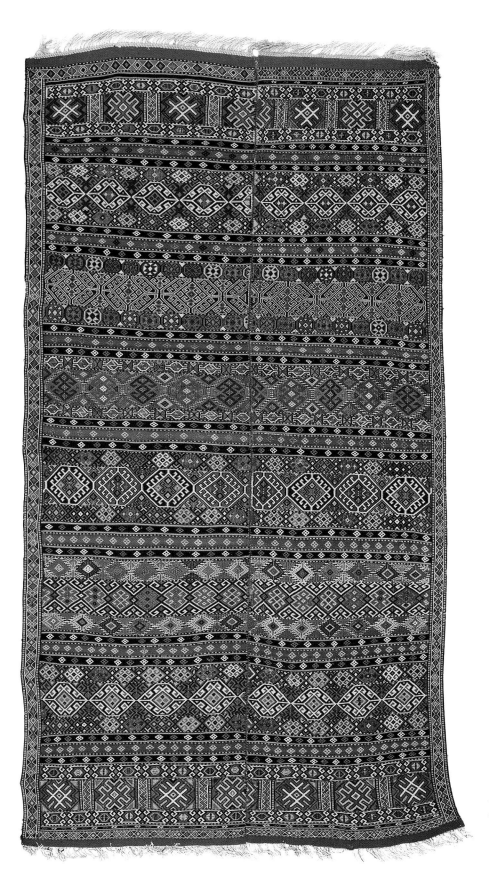

PLATE 159. *Palas, Kurds of
Quchan or Bojnurd, Khorasan.
Early 20th century. All wool.
Weft-faced plain weave
patterned extensively by weft-
float brocading, knotted weft
wrapping and reverse weft
wrapping. Two strips sewn
together. 370 x 200cm
(12ft.2in. x 6ft.7in.).*

Western sources have made half-hearted attempts to define *palas*. In a book on Turkoman weaves, *Turkmen Tribal Carpets and Traditions*, it has been defined simply as a large floor covering woven in weft-faced plain weave with supplementary weft patterning.[163] John Wertime has defined the *palas* as a *gelim* with weft-faced plain weave and a striped pattern,[164] while a work on the weavings of the Caucasus published in 1995, *Caucasian Carpets and Covers*, lists *palas* as a kind of *gelim* with weft-faced plain weave.[165] This by and large constitutes the material concerning the *palas* to be found in Western rug literature. While there are features of the *palas* in all these definitions, none is complete or telling.

Going by extant specimens, the descriptions of former writers still provide the best description of the *palas* as a stout, thick *pashmineh*. The first step, therefore, is to separate the *palas* from the *gelim*. Each is representative of a large and distinct cultural tradition. The *gelim* is the work of Zagros-area dwellers, while the *palas* belongs properly to Khorasan. The *gelim* is a simple weave, while the *palas* is made up of compound weave or weft substitution weave. The motifs that emerge from the structure of the *gelim* are markedly larger than those formed in the supplementary weft of the *palas*. For the same reason, the patterns and designs of the *palas* always appear finer and more elaborate than those of the *gelim*.

The diversity of structures found in the *palas* does not match that of the *gelim*. Regardless of whether the structure of the *gelim* is slit tapestry, dovetailed, interlock, or double-interlock, it is a *gelim* nevertheless, employing one set each of warps and wefts, with the pattern on both sides of the weave the same. However, in the *palas* the structure and the look differs from that of the *gelim*. Most palases are woven with one set of warps and two sets of wefts. In a large group, the foundation comprises the first set of wefts along with the warps; the second set makes up the supplementary, or pattern-making, wefts. This supplementary weft is interlaced with the ground weft via a process of floating or substituting. It is due to this or substituting weft that the two faces of the *palas* are not identical. Unlike the *gelim*, therefore, the *palas* is not two-faced. One side is patterned, and the other a mass of woven fibres which are the leftovers from the patterning wefts, and this side varies in different weaves or structures (see Figures 30 to 35).

Regardless of the structures outlined above, the visual effect of all *palases* are the same for the general viewer. There are three reasons for this: all *palases* are single-sided; all *palases* are thick and stout (at least in comparison with *gelims*); and the motifs used in all *palases* are small and fine (in comparison with *gelims*). With the *gelim*, single motifs are created by interweaving one strand of weft with a batch of warps. The motifs on the *gelim*, therefore, comprise a collection of coloured surfaces or patches of colour. The opposite is true of the *palas*, where motifs are generated by lines rather than the surface. The weaver uses the extra wefts, or a substitution weft, to embellish the ground with lines of thread; the result is somewhat akin to embroidery. In the *palas*, however, the process is performed with the fingertips, whereas in embroidery it is the needle that creates the pattern.

As to what constitutes a *palas*, suffice to say that the plain, striped *gelims* which go by the name of *palas* in Azarbaijan and the Caucasus are misnamed. Those with a few stripes in compound weave might be called *gelim-palas* or *palas-gelim* – a practice advocated in this book (see Plates 178-180). But the *gelims* that have only a striped pattern, with none of the stripes made of compound or substituting weft weave and the entirety of the *gelim* in weft-faced plain weave, do not qualify as *palas*. Such *gelims* are produced everywhere in Iran, and their design and pattern has little to do with their structure. In this book, in addition to the striped *gelims* of Azarbaijan (Plate 8), I have also shown *gelims* made by Bakhtiari Lors (Plate 127) and by the people of Mazandaran (Plate 100).

Another category of floor coverings which must be distinguished from the *palas* is that comprising the weft-wrapping products of the Shahsavan and Caucasus areas. These are called *sumak* and *verneh*, although they resemble certain *palases* in look and, like others, they are of compound weave. It is not fair, however, to call them *palases*, because these weaves are too delicate and fine; indeed, they were not so named in the past. In the west of Iran, therefore, there remains little more than a faint trace of *palas*. In the east, however, according to the evidence at hand, there are two types of weft-wrapping in *palas* weaving and, as we will see soon, they are considered a part of *palas* weaving.

VARIETIES OF PALAS

In order to identify the various kinds of *palas*, two factors must be considered: the area of weave, and the structure. A number of areas have played an important role in the production and presentation of the *palas*, namely Khorasan, Mazandaran, Sistan and Baluchestan, and Kerman. Each province has its own *palas*-weaving areas which are centred in clusters of villages and towns. As with the *gelim*, we can pinpoint centres of weaving for certain varieties. The influence of these centres may extend for hundreds of kilometres, or just a few.

Structure, more than anything, is crucially important in determining the constitution of the *palas*. It is through studying structure that I have been able to come close to the centres of weaving. As with the *gelim*, the structures of the *palas* are limited, amounting to no more than four. The relationship between structure and pattern in the *palas* is much closer than it is in the *gelim*; indeed the two are often inseparable.

The structures used in the *palas* are either compound weave or weft substitution weave, which means that they are created by one set of warps and two sets of wefts. While these structures share a common basis, in detail they differ from one another. The common feature among them is the presence of a supplementary or substituting set of wefts which plays the role of pattern-maker. These four structures are as follows: supplementary weft-float brocading (Figures 30 and 31); weft substitution weave (Figures 32 and 33); supplementary chequered

FIGURE 30. *The front face of supplementary weft-float brocading.* FIGURE 31. *Opposite face of Figure 30.*

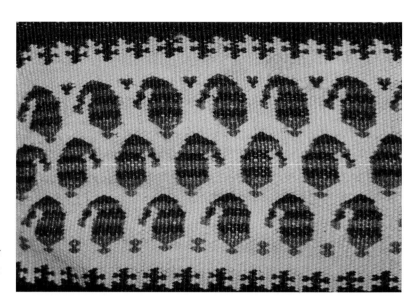

FIGURE 32. *Detail of Plate 174 showing strips of weft-faced plain weave patterned by weft substitution weave.*

FIGURE 33. *Opposite face of Figure 32.*

206

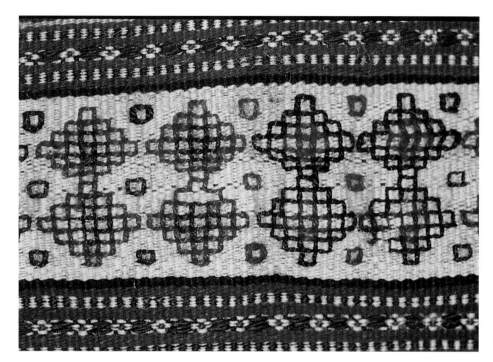

FIGURE 34. *Detail of* Plate 165 *showing weft-faced plain weave patterned by chequered weft wrapping.*

FIGURE 35. *Opposite face of* Figure 34.

weft-wrapping (Figures 34 and 35); and supplementary reverse weft-wrapping and knotted weft-wrapping (Figures 41 to 43). These will be referred to as brocading, weft substitution, chequered wrapping and reverse wrapping, respectively. In some areas only one of these weaves has been used, while in others two, three or all of them were employed.

The schools of *palas*-weaving should be divided into at least two major ones and several minor ones. The first of the major ones I have called the all-*palas* school and the second the half-*palas*. All-*palas* means those examples in which the entire surface of the fabric is in *palas*-weave and covered with patterns.

These *palases* are most commonly seen in Kerman and Khorasan. The half-*palas* school comprises those pieces in which certain sections are left as plain *gelim*, with no patterns. The design in these is generally striped, with the stripes alternately executed in plain *gelim* or patterned *palas*. I believe this school originated in Sistan and spread to Khorasan and other parts of the country. All the other schools of *palas*-weaving derive from one of these.

Khorasan

The province of Khorasan is the largest in present-day Iran. Situated in the country's north-eastern corner, it was once more extensive and reached the shores of the Amu Darya river.

Khorasan was the cradle of eastern Iranian civilization. The Parthians, who rose to power after the Medes and the Achaemenids, came from this land. The most important cultural renaissance in Iran took root here a thousand years ago, at which time the foundations of Muslim Iran's art and culture were laid. The special characteristics of Khorasan and the region's wealth must have stirred up greed amongst the northern tent-dwelling neighbours, such as the Seljuks, the Mongols and the Uzbeks, who repeatedly attacked Khorasan and sacked its treasures.

The idea of blocking the entry of the northern tribes into Khorasan was first realized in the sixth century by Khosrow Anushiravan, who built a long wall as a barrier. This wall, however, did not last. The wall placed before these tribes by Shah 'Abbas the Great in the early seventeenth century – namely, a human bulwark composed of Kurdish tribes – proved to be far more effective. Shah 'Abbas' idea in creating this barrier was to confront the Turk with the Kurd. While this appeared simple, in practical terms the resettlement of 40,000 households from the north-western corner of Azarbaijan to Khorasan[166] proved no easier than the construction of Anushiravan's wall. The resettlement of the large Chemeshgazak tribe from west to east had major historical and cultural ramifications. One of these was the greater balance created between the Kurd and the Turk; the Kurds now stood as the most powerful organized entity before the Turkomans and the Uzbeks.

In previous sections Khorasan has been called the land of the *palas*-weavers. In large part this refers to the work of the Kurds in the region. But other groups, too, such as the Baluch, the Sistani, the Taymuri, the Hazare'i, the Turkoman and the Afshar, have made an important contribution to *palas*-weaving in Khorasan.

The Kurds

Without doubt the largest volume of Khorasan *palases* are produced by Kurds; these are called Kurdish *palases* (as opposed to Turkoman ones).

From the time of the entry of the Kurds into Khorasan, the town of Quchan served as the capital and seat of the ilkhan for the Za`faranlu, the largest of their clans, while Bojnurd, Shiravan (not to be mistaken with Shirvan of the

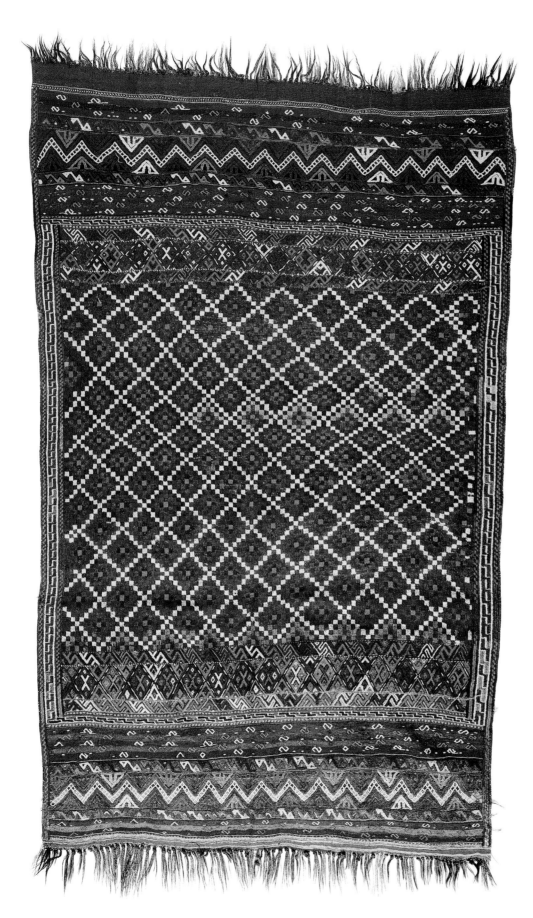

PLATE 160. *Palas, Kurds of Quchan or Bojnurd, Khorasan. Early 20th century. Wool and cotton wefts on goat hair warps. Weft-faced plain weave patterned extensively by reverse weft wrapping, weft-float brocading. 268 x 164cm (8ft.10in. x 5ft.5in.).*

209

Caucasus) and Chenaran became the seats of other important clans, such as the Shadlu, the Kovanlu and the `Amarlu.[167] Dozens of other Kurdish clans and sub-clans settled throughout the northern part of Khorasan. All these groups play a major role in *palas*-weaving and other kinds of weaving. Although these *palases* were produced by different ethnic groups, I will follow the lead of the people of Khorasan and refer to them as the *palases* of Quchan (rather than as the Kurdish *palases* of Khorasan).

The design and composition of Quchan *palases* are varied and diverse. A large batch of them bear the striped composition (Plates 158 and 159). In another group, the centre exhibits a lozenge or lozenge grid pattern, while above and below the central pattern run several narrow borders (Plate 160). These have been influenced by the *palases* of Mazandaran (Plate 165).

Almost all Quchan *palases* are heavily patterned; it may be more appropriate to call them all-pattern or all-palas, meaning that they are *palas*-weave all over (Plates 158-160). The colour schemes in Quchan *palases*, as with their other rugs and weavings, are varied. All colours are used but, as with the Turkomans, their colour base is the more eye-catching dark red.

The weave in Quchan *palases* is neither fine nor coarse; it is medium. However, in comparison with the Turkoman *palas*, it appears coarse. The structure of Quchan *palases* is more diverse than that of other *palases*, especially the Turkoman variety. A single *palas* can be executed with several different structures. A portion of these structures forms part of the ancestral legacy which they brought from Azarbaijan.

Two structures appear more than any others in the Quchan *palases*. One is supplementary weft-float brocading; the other is supplementary reverse weft-wrapping. The brocading is achieved through the use of a set of extra wefts and is only employed at the time of patterning. It may cover the entire piece or appear sporadically. Both kinds are found in Kurdish *palases*, while Turkoman *palases* only use the former kind (Plate 162).

The second kind of weave, or reverse wrapping, is favoured by the Kurdish weavers of Khorasan, who brought it with them from Azarbaijan. Seldom do any other tribes in Khorasan use this weave, but it flourishes among the Kurds of Azarbaijan and eastern Turkey. The difference between reverse wrapping and regular weft-wrapping used by the Turks is the appearance of the front and back of the fabric. What is the front for the Turks is the back for the Kurds (see Figure 41).

The percentage of use and appearance of this kind of weave in Quchan *palases* varies. Sometimes a balance of both weaves is found in a single piece, and some-times the second variety – namely, reverse wrapping – appears predominant.

Eastern Khorasan: Darreh Gaz, Kalat, Torbat-e Jam, Qa'en

As well as the Kurds there are other tribes and peoples living in Khorasan, for the most part in the eastern part of the province, away from the Kurdish area. Among these are the Baluch, the Sistanis, the Arabs and the Hazare'is. There

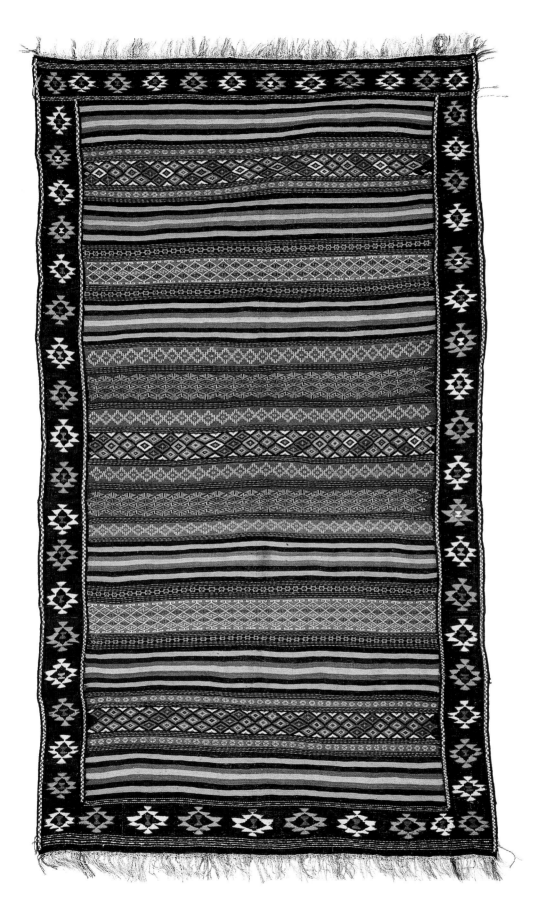

PLATE 161. Palas, Afshars of Kalat-e Nader, Khorasan. Early 20th century. All wool. Slit tapestry and weft-faced plain weave, with most of the stripes patterned by weft substitution. 307 x 173cm (10ft.1in. x 5ft.8in.).

is a great deal of reciprocity of influence among the *palases* of these peoples, so much so that it is sometimes difficult to distinguish among them. The most important of these groups are the Afshars, who live in the regions of Kalat and Darreh Gaz. In terms of both weave and structure, the *palases* made by these people bear a close resemblance to the Jiroft *palases* of Kerman (Plate 169). The structure of these *palases* is of the weft substitution kind, and their pattern is striped.

The Baluch in this area, principally centred around Torbat-e Jam and Torbat-e Haydariyeh, have also woven numerous *palases*. The design in these *palases* is generally provided by stripes, but it resembles the work of the Sistanis and southern Baluch more closely. The *palas* section in this batch of weavings is generally narrower and less important than the *gelim*-weave section. In the *gelim*-weave section, too, simple designs such as the herringbone can sometimes be seen.

The Kurds in this area have also woven many *palases*, but their work has not escaped the influence of their neighbours.[168]

Mazandaran

Regardless of the fact that the political division of the country leaves the Turkomans in Mazandaran, their *palas*-weaving belongs in the Khorasan category. These *palases* have the greatest number of shared characteristics with the *palases* of the neighbouring Kurds. The Turkomans are among the most prolific of Iran's rug-weavers. Although *palas*-weaving among them is no less common than rug-weaving, it serves their own uses, whereas rugs are woven for guests or sale. These people, who produce such delicate rugs, use felt or *palas* as their own floor coverings. Next to the Kurdish *palas*, the Turkoman variety is the most common in Khorasan (and, of course, Mazandaran). Turkoman *palases* are woven by the two tribes of Yomut and Guklan. These *palases* are generally larger than the Kurdish variety, with dimensions of 3m x 2m (10ft. x 6ft.6in.). While their patterns are varied, they appear uniform, perhaps because of the monotony of the tiny Turkoman motifs which are repeated in a limited range of colours.[169] In terms of weave, however, these *palases* are fine and often awe-inspiring (Plate 162).

The structure of Turkoman *palases* is of the all-over brocading variety. At the two ends of these *palases* are unpatterned plain *gelim* sections roughly 20cm (8in.) in breadth; these are referred to by the people of Khorasan as '*palas* ends' ('*sar-palas*'). The unadorned simplicity of this section has a soothing effect in contrast with the clutter of the field.

Turkoman *palases* share several features with western Iranian *palases* and must be from the same family and origin. As for why the western *palases* are so much more in demand than the eastern variety, we must look to the areas of design and colour scheme rather than structure, which is the same in both.

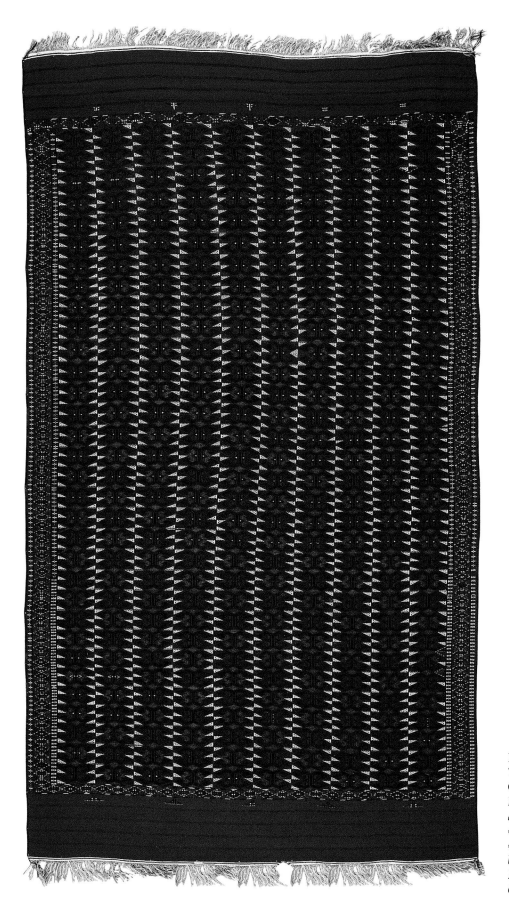

PLATE 162. *Palas, Turkoman, Yomut or Guklan, Mazandaran. Early 20th century. Wool and cotton wefts on wool warps. Weft-faced plain weave patterned extensively by weft-float brocading. 352 x 197cm (11ft.7in. x 6ft.6in.).*

Savadkuh

Among the *palases* commonly known as Kurdish *palases* are those which differ in many respects from them and together form a separate category. More than having a resemblance to the work of the Kurds, these *palases* appear similar to a category of Mazandaran *gelims* (Plates 100 and 101). The same delicate weave that marked those *gelims* is present in these *palases*, and they are alike in terms of colour scheme and use of wool as the material. The *palas*-end sections in both often exhibit the same patterns and structures as these *gelims* and, like them, are in two pieces – features that are rarely found in the Kurdish *palas*.

Most interesting of all is the structure of these *palases*, which is generally of the chequered weft-wrapping type. While this fundamentally qualifies as a variety of weft-wrapping, its appearance differs from that of all other weft-wrapping and therefore it is seldom placed in that category.[170] This combination of features sets these *palases* apart from the Khorasan, Kurdish and Turkoman *palas* varieties, despite the fact that there are signs of a connection between these *palases* and the Kurds of Khorasan and even of Azarbaijan.

One of the connecting links can be seen in Plate 179, which was woven either north-west of Iran or in the Caucasus. In terms of weave, it is more Turkish than Kurdish. With this evidence and connecting links, can a bridge be established between the weavers of these *palases* in Mazandaran and the Kurds and Azaris?

The *palases* in this group were produced in the villages of southern Mazandaran, situated in the northern valleys of the Alborz range, east of the Firuz Kuh-Sari road; village names include Sangdeh,[171] Pachim, Kelim and Savadkuh (the last of which was the home of Reza Shah Pahlavi). For this reason it seems illogical to refer to these woven pieces as Kurdish. The *palases* and even *gelims* of this region merit further study. This should take into account a comparison between them and the work of the Semnan weavers, who live not too far away, and the Kurds.

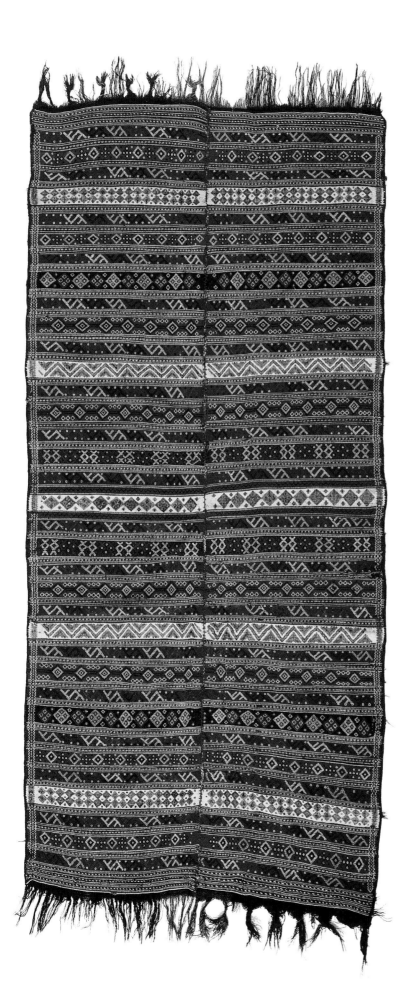

PLATE 163. *Palas, Savadkuh, Mazandaran. Late 19th century. All wool. Weft-faced plain weave patterned extensively by chequered weft wrapping. Two strips sewn together. 297 x 140cm 9ft.9in. x 4ft.7in.).*

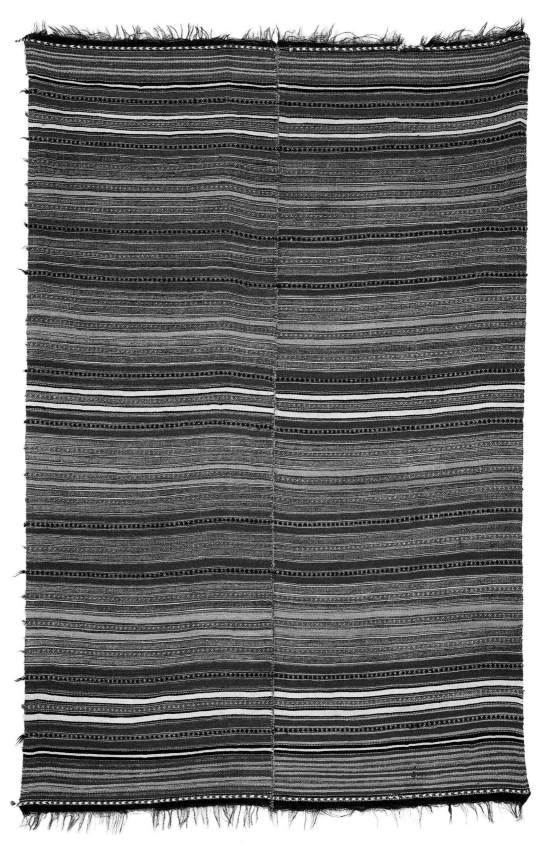

PLATE 164. *Palas, Savadkuh, Mazandaran. Early 20th century. All wool. Weft-faced plain weave patterned by chequered weft wrapping. Two strips sewn together. 216 x 145cm (7ft.1in. x 4ft.9in.).*

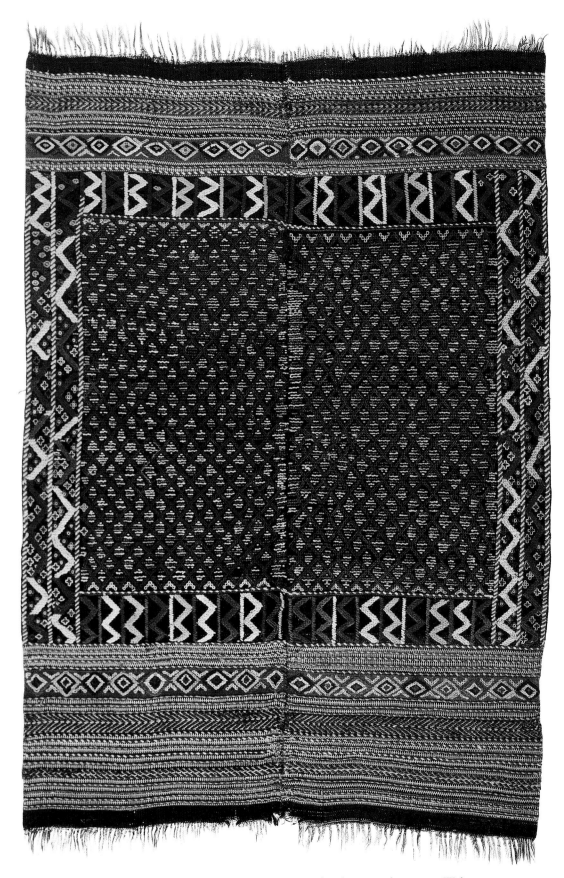

PLATE 165. *Palas, Savadkuh, Mazandaran. Late 19th century. Wool wefts on goat hair warps. Weft-faced plain weave patterned extensively by chequered weft wrapping. Two strips sewn together. 205 x 145cm (6ft.9in. x 4ft.9in.).*

Sistan

The name Sistan derives from *sagestan*, meaning the land of the Sakas. Prior to the arrival of the Sakas in the second century BC, Sistan was known as Zarang. The latter name appears on the rock inscriptions of Persepolis and Bisotun (Behistun), as well as in the Avesta. The Avesta also contains prophecies regarding the advent of the Saushyant (saviour) in Sistan on the banks of Lake Hamun.[172] To Iranians, Sistan was not only a land with sacred associations, it has also been a horn of plenty. The alluvial plain around the lake was unmatched in productivity and Sistan had a reputation as the granary of Asia. Despite all these precedents, however, fate has not been kind to the people of Sistan.

The Russo-Persian wars and the loss of large areas of northern Iran in the latter part of the nineteenth century had numerous repercussions. Among these was the beginning of border skirmishes along the Iran-Afghanistan frontier, resulting in a large portion of Sistan being annexed to Afghanistan. The present-day Afghan province of Nimruz, together with its capital Zaranj (Zarang), was a part of these territories. The partition of Sistan had disastrous consequences for the people. The dams that the Afghan government built across the Hirmand (Helmand) and other rivers in the area reduced the waters of Hamun to a trickle and destroyed the agriculture in the area. The people of Sistan were left with no choice but to abandon their land. A large group of them emigrated to Khorasan and Mazandaran; those who remained behind never recovered from the blow.

Sistan today comprises less than half the area of Sistan in the nineteenth century. It was joined to the province of Baluchestan to produce the province of Sistan and Baluchestan. Until not too long ago Sistan boasted a fairly credible weaving industry, and its rugs were traded under the name of Zabol (Sistan's present-day capital).[173] Nowadays, however, little remains of that industry. The flatwoven pieces and *palases* of Sistan have nevertheless managed to preserve their continuity. The term Sistan *palas*, used in this book, applies to weavings far beyond the present-day borders of Sistan and also encompasses some of the weavings of Pakistan and Afghanistan. In all three countries, the Baluch have a share in these *palases* alongside their Sistan neighbours. The intermingling of the Sistani and the Baluch have influenced their work greatly. It has sometimes made it impossible to tell apart Sistani *palases* from Baluchi ones.

Baluchestan

> When God was making the world, He made everywhere all the different countries for the people to inhabit. After He had nearly finished, God realized He had forgotten to make Baluchestan. So He put together all the darkness, the dust, the leftover and slapped them into shape with the very little water He had left, and thus we got our Baluchestan.[174]

The complaint of the people of Baluchestan, that nature has been less than kind to their land, takes nothing away from its history. This expanse of territory, extending from the mountains of Bam to Sind and the Punjab, and from Sistan

FIGURE 36. *Interior of a Sistani tent near Zabol, showing a Sistani palas.*

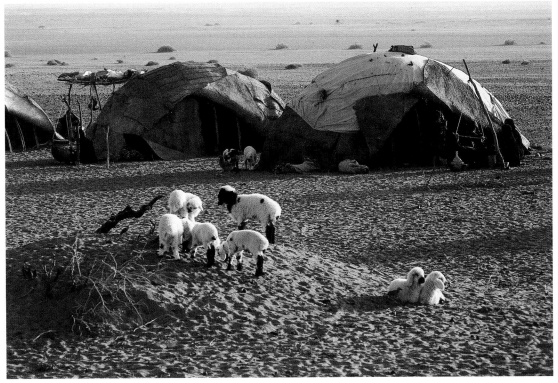

FIGURE 37. *Baluchi tents, between Iranshahr and Maskutan.*

to the Arabian Sea, has served as home to numerous peoples. Consequently there are conflicting theories about the origins of the Baluch people. Some consider them Semites and Arabs and believe that they moved east from the west.[175] Others agree that they migrated from west to east, but consider them an Iranian people, citing as their reason the similarities between the Baluchi dialect and the western dialects of Iran, all of which are of the Indo-Iranian family.[176] What is certain is that in the first post-Muhammadan century, at a time when Kerman was conquered by Muslims, there were desert-wandering tribes in the region known as the Baluch or the Balos.[177] Earlier, in the inscriptions at Persepolis and Bisotun, they were referred to as the Maka.[178] Based upon recent studies, particularly on their language, it would seem that the Baluch are of north-western Iranian descent.[179]

Little weaving takes place in Baluchestan today, especially in the southern regions. In the north there is some weaving by the Baluch, particularly in the areas where they live in the vicinity of the people of Sistan. There are distinct limitations in the structures and colour schemes of the weavings of the Baluch, and their work lacks the diversity of Sistan weavings. None the less, a considerable number of *palases* featured in this chapter were made by the Baluch.

Further south weaving is less common and straw mats take the place of *palases*. In the south of Iranian Baluchestan and around Khash we can find very finely produced embroidery, which is used on clothing, and various laces, but nothing of *palas*-weaving.

To distinguish between Sistan *palases* and Baluch ones is not easy. All have a similar structure, which is of weft-faced plain weave and the weft substitution variety – a structure used more in this region than anywhere else. Weft substitution is one of the simplest of the *palas* weavings. Like the *gelim*, the principles of weaving are simple. The weft is interlaced with the warp in a one-to-one ratio (one above, one below), but here the weaver has two sets or more of wefts, instead of one, and constantly substitutes the wefts for the purposes of patterning. This means that whenever she brings to the face of the fabric one of the wefts for patterning, she moves to the back of the fabric the other weft which is not being used and leaves it floating. With the next pass she does the reverse. One of the special features of this weave is the appearance of its face and back. The face is patterned, while the back is is a cluster of floating wefts (Figures 32 and 33).

The *palases* presented here represent an area of a few hundred square kilometres stretching across Iran, Afghanistan and Pakistan, and are the work of different ethnic groups in Sistan and Baluchestan.[180] It is not easy to attribute these *palases* to the correct ethnic group. In general we can say that the *palases* in which brighter, livelier colours are used such as yellow, orange and green, are produced by Sistan weavers, and those executed in darker, more muted colours are made by the Baluch. The important *palas*-weaving areas in the region are Zabol, Chakhansur and Nushki, situated respectively in Iran, Afghanistan and Pakistan.

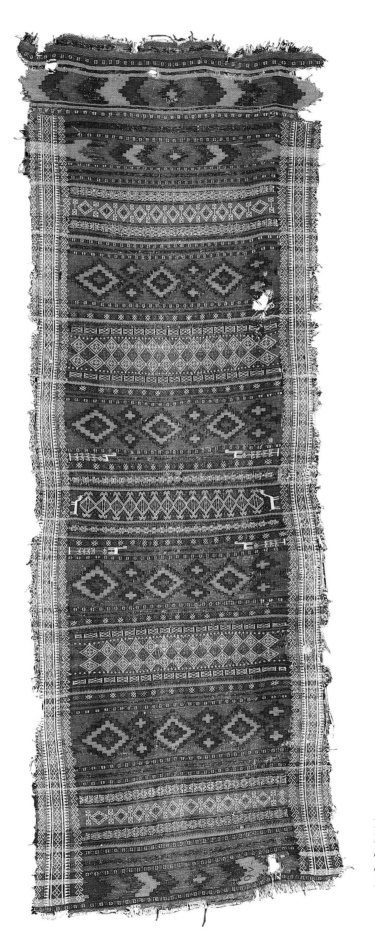

PLATE 166. *Gelim palas, greater Sistan. Late 19th century. All wool. Slit tapestry and weft-faced plain weave patterned extensively by weft substitution weave. 291 x 100cm (9ft.7in. x 3ft.3in.).*

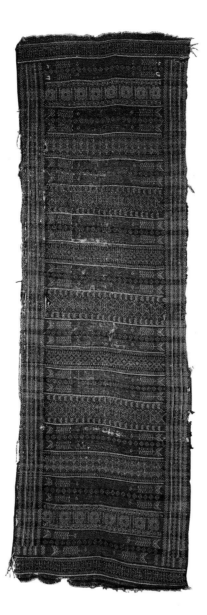

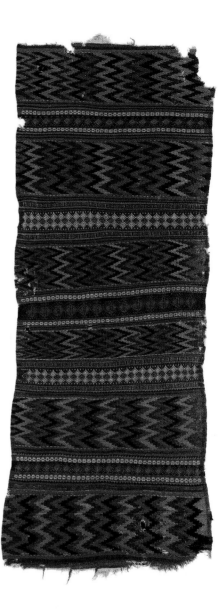

PLATE 167. Gelim palas, Baluchestan, Nushki. c.1900. Weft-faced plain weave patterned extensively by weft substitution weave. 363 x 119cm (11ft.11in. x 3ft.11in.).

PLATE 168. Gelim palas, greater Sistan. Early to Mid-20th century. All wool. Slit tapestry and weft-faced plain weave patterned by weft substitution weave. About 350 x 130cm. (11ft.6in. x 4ft.3in.).

No matter where they are from, the Sistan and Baluch palases bear geometric designs and patterns formed with repeating motifs and striped compositions. The most attractive are the bordered *palases*. The term *harir* 'silk', which they attach to these *palases*, is barely an exaggeration. The borders on these *palases* resemble certain silks, and it seems as if on both sides white, transparent silk lace has been sewn on. These borders are always in white (Plates 166 and 167). Some *palases* are very large, with lengths of up to 4m (13ft.). These *palases* are sometimes in two pieces and, in addition to serving as floor coverings, also function as counterpanes. Another group are without borders (Plate 168).

The most important feature of the Sistan and Baluch *palas* is the combination of *gelim* and *palas*-weave used in its composition, with plain *gelim* and *palas* placed side by side in alternating stripes. This composition, which I have called the half-*palas*, is the basis for the largest category of *palases*, some of which can be found in the north-east and the west. The influence of the Baluch and Sistan *palases* is most visible in north-eastern Khorasan, the land of the Baluch and Sistanis of Khorasan and of the Afshars.

Kerman

Kerman is undoubtedly one of the most productive areas of *palas*-weaving in Iran and makes no concession to Khorasan or Sistan. This large province, which has long been the home of various groups, has amalgamated within its borders the Turk, the Lor, the Baluch and the Arab and offered them all a home.

Kerman's ethnic diversity has had great influence on its weavings and has made it one of the richest areas of production. Each of the ethnic groups in Kerman has established a reputation for itself in one kind of weaving or another. The Afshars, for instance, are experts at the pile-rug and weft-wrapping fabrics, and the Lors and Laks at *gelim*-weaving. But the Kerman *palas* is the domain of no single ethnic group.

At least two completely distinguishable categories of Kerman *palases* can be determined and examined. The first are the *palases* of Jiroft, south of the city of Kerman, and the second the Shiraki *palases*, in the western part of the province. Whether eastern or western, the two kinds are clearly distinguishable in pattern, design, colour scheme and even structure, but both belong in the school of dense *palases*. This means that they are *palas*-weave from end to end (see page 205). By contrast, the *palases* of their Sistan and Baluch neighbours belong with the sparse *palases* and are a combination of *palas*-weave and *gelim*-weave.

Jiroft

Jiroft, also known as Sabzevaran, is situated in the southern part of Kerman, west of the Barez mountains. Like many other centres of rug-weaving, it is primarily a gathering place for different kinds of weavings rather than a major producer in its own right.

The Jebal-e Barez mountain range, at the tail end of the Zagros, is lush and high in this area and sometimes rises to 4,000m (13,000ft.) or more. Many different people have lived on the slopes over time. These tribes have been generically known as Jebal Barezi, or simply Kuhi or mountain folk. While they all speak Persian, it is possible to identify the Lori, Laki, Baluchi, Arabs and Kermani dialects among them.[181]

In general, regardless of all the common features of the *palases* made here and those of Baluch and Sistan *palases*, as long as the tribal identity of the weavers remains obscure we must call their weavings Jebal Barezi or Jirofti.

The composition of Jiroft *palases*, like most other *palases*, is striped. Their two sides, however, bear a special structure composed of several kinds of weft-wrapping (Figure 38) – something not found in the Sistan, Baluch or even Khorasani *palases*. Instead, the same white *harir* border that appears in the Sistan *palases* is also present in many of these. The colour scheme in these *palases* is generally more muted. Dark red and dark blue colours are most commonly found, and their presence alongside undyed wool or cotton results in a strong clash.

The structure of Jiroft *palases* is always of the weft substitution kind. The

FIGURE 38. Detail of Plate 169 showing the side finishing of the Jiroft palas.

PLATE 169. Palas, Jiroft, Kerman. Early 20th century. Wool and cotton. Weft-faced plain weave, patterned extensively by weft substitution. 236 x 123cm (7ft.9in. x 4ft.).

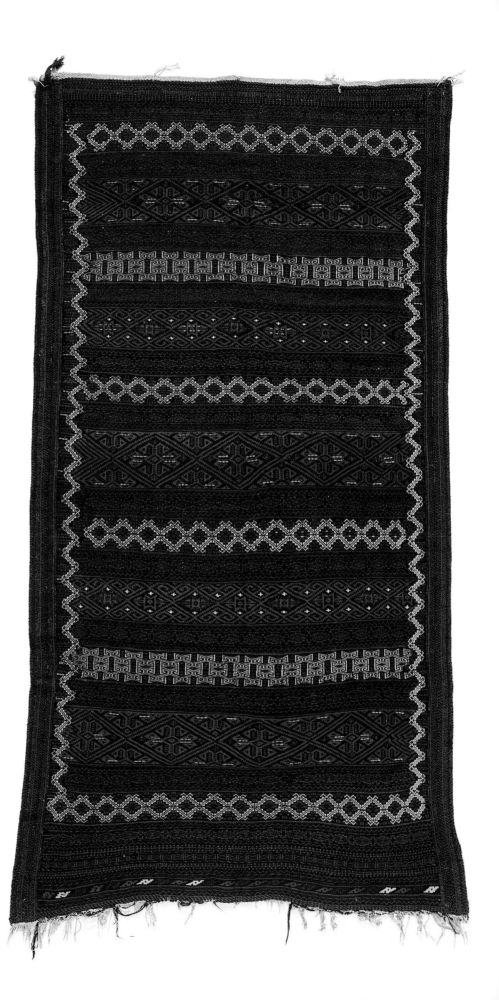

224

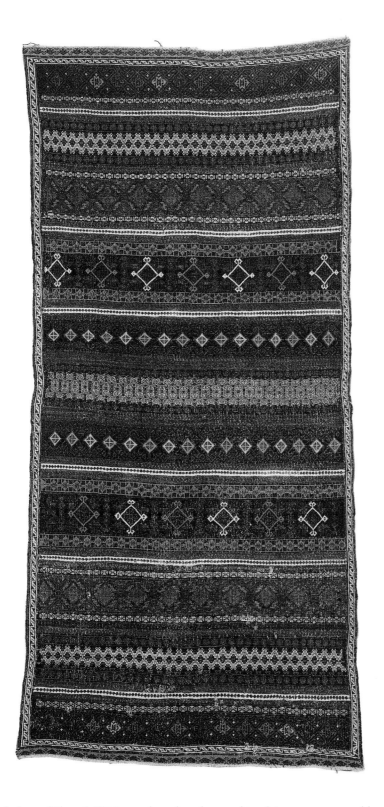

PLATE 170. *Palas, Afshars of Khorasan. Late 19th century. All wool. Weft-faced plain weave patterned extensively by weft substitution. 246 x 112cm (3ft.8in. x 7ft.9in.).*

example here (Plate 169*)* is produced end to end in this structure, and bears tiny repeating patterns. Outside Kerman, the *palases* closest to these are those of eastern Khorasan, and sometimes it is difficult to tell them apart.[182] It may be that the Khorasan *palas* made with all-over weft substitution is a sub-tributary of the Jiroft palas.

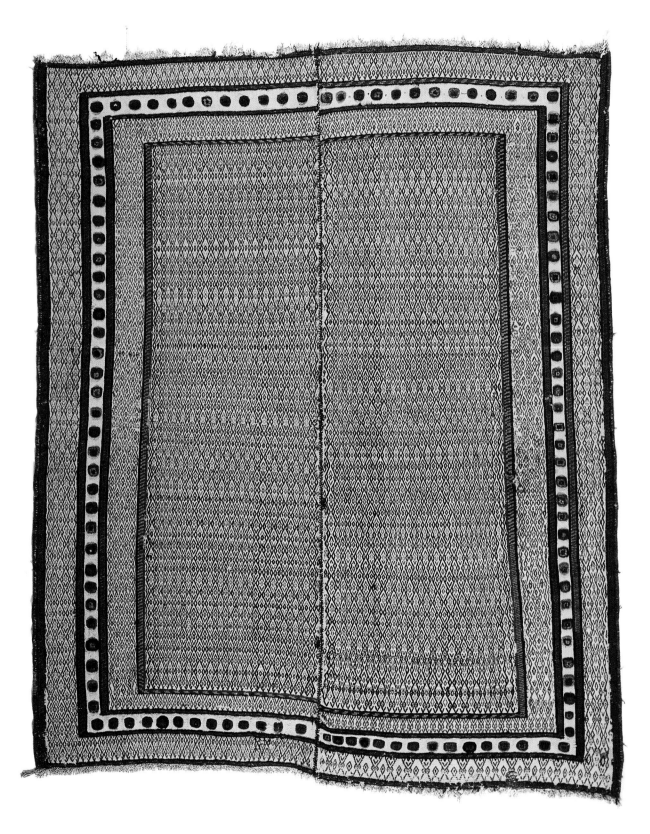

PLATE 171. *Shiraki palas, Khamseh Confederation, Arab tribe. c.1900. Wool wefts on cotton warps. Weft-faced plain weave patterned extensively by weft-float brocading. Two strips sewn together. 208 x 170cm (6ft.10in. x 5ft.7in.).*

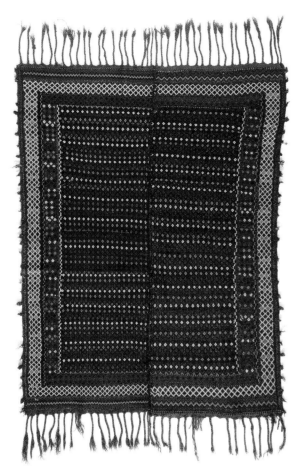

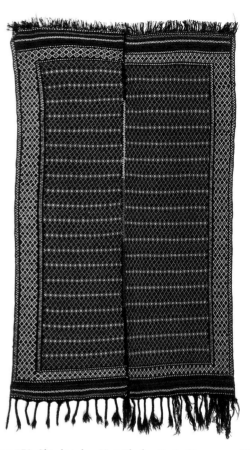

PLATE 172. *Shiraki palas, Haji Abad or Pariz, Kerman. c.1900. All wool. Weft-faced plain weave patterned extensively by weft-float brocading. Two strips sewn together. 210 x 162cm (6ft.11in. x 5ft.4in.).*

PLATE 173. *Shiraki palas, Haji Abad or Pariz, Kerman. c.1900. All wool. Weft-faced plain weave patterned extensively by weft-float brocading. Two strips sewn together. 240 x 152cm (7ft.10in. x 5ft.).*

Shiraki

The second category of Kerman *palases* are known as *Shiraki* or *Shiraki-pich*. *Shiraki* is neither a place nor a tribal name. It applies to a category of *palases* produced west of Kerman which share a great many features and are the work of different tribes. Apart from the people of western Kerman, these *shirakis* are made by the Khamseh, who include Turkish, Lor and Arab tribes. The home of these people is the eastern part of Fars, between Abadeh and Darab, but some of them travel as far as western Kerman and Minab.

The *shirakis* under consideration were produced by the Lors and the Khamseh in western Kerman (in the vicinity of Pariz) and in Fars, between Darab and Bavanat.

The format of the *shirakis* is alike. Most of them have dimensions of 2.1m x 1.6m (6ft.8in. x 5ft.6in.) or slightly larger. They are woven in two pieces sewn together at the centre (Plates 171 to 173), although sometimes they are in one piece.[183]

The pattern and design in all of them is provided by tiny repeating motifs and all have multiple borders. The warp in most of them is dyed dark blue or brown (Plates 172 and 173), which is a feature found more than anywhere else in the weavings of Azarbaijan and the Caucasus (Plate 191). Others are centred around an undyed warp (Plate 171).

All *shirakis* are of the all-*palas* variety, patterned by weft-float brocading, and there is a certain unity of pattern, design, colour and structure about them.

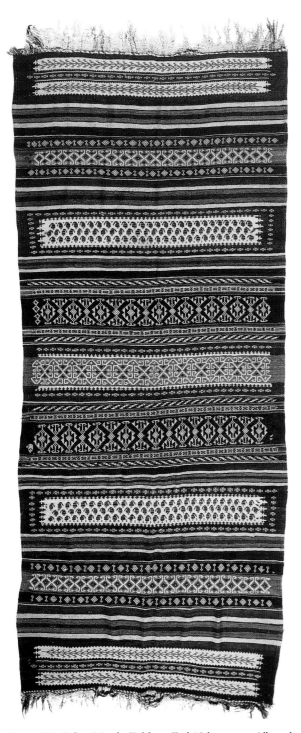

PLATE 174. *Palas, Muteh, Esfahan. End 19th century. All wool. Weft-faced plain weave patterned extensively by weft substitution. 320 x 135cm (10ft.6in. x 4ft.5in.).*

Muteh

Muteh must be regarded as the oddity in Iranian *palas*-weaving. This little village, situated some 130 kilometres (80 miles) north-west of Esfahan, has no roads leading to any of the rug-weaving areas. It is a remote village in the middle of a remote plain, the third point in a triangle formed with Khorasan and Kerman, but some thousand kilometres distant from each. As recently as the 1980s, few were aware of the village's existence. Muteh was 'discovered' late in the decade, at the time of missile attacks on cities in the thick of the Iran-Iraq war. Its floor coverings started appearing in the market as missile *gelims*.[184] What was most curious about them was their close resemblance to the *palases* of Khorasan. They also bore traces of the weavings of Varamin and Kerman. I am convinced that Muteh provides a model for carpet studies, especially in reference to the displacement of weaving prototypes through ethnic shifts. By now everything about Muteh is clear. People from Khorasan moved to Muteh about 100-150 years ago. They remember nothing other than that their forebears were from Khorasan. But their weavings, like the pages of a history book, can shed further light on their past. Muteh is one example of mass migration in Iran, and the weavings of the people serve as an indicator of their history.

The *palases* of Muteh are of the weft substitution variety, allied to the eastern Khorasan school, which itself is a subset of the Sistan school (see pages 205-207). Thus they are of the sparse kind, with a double structure of weft substitution and plain *gelim*-weave. The composition of this batch of *palases* is always striped, with alternating plain and patterned stripes.

One of the features of most Muteh *palases* that does not appear in those of Khorasan or Kerman is the plain border on both sides, executed in plain *gelim*-weave. The sharp, spear-shaped ends of the stripes in this category of *palases* are the reason they are called 'missile *palases*'. A smaller batch of Muteh *palases* are borderless (Plate 174). The *palas* seen in Plate 175 with a border all around is an exception, especially since the design on this *palas* is remarkably less busy than those on the other *palases*.

228

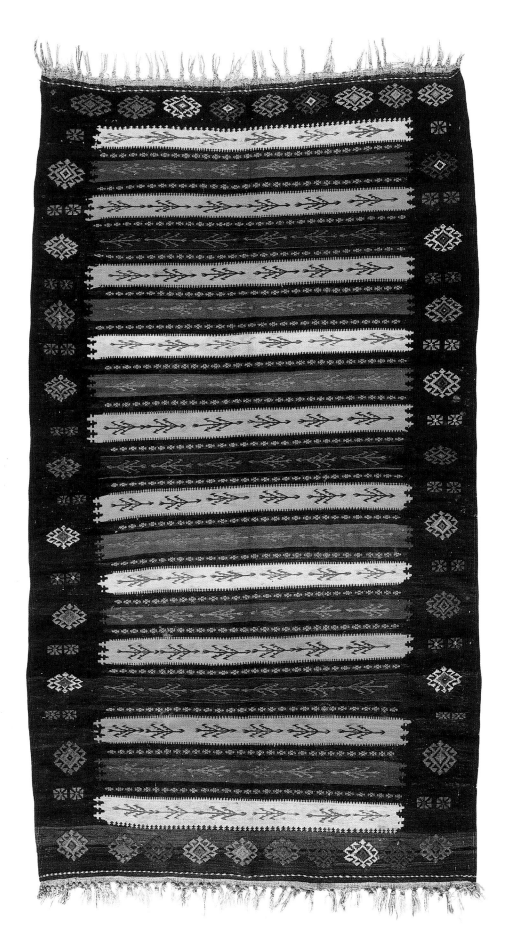

PLATE 175. *Palas, Muteh, Esfahan. c.1900. All wool. Weft-faced plain weave patterned by weft substitution and weft-float brocading. 266 x 152cm (8ft.9in. x 5ft.).*

The Northwest: Turkey, the Caucasus, Iran

I am truly at a loss what name to pick for the *palases* of the north-west, or even to which people or country to attribute them. At least four countries – Turkey, Republic of Azarbaijan, Iran and Iraq – have a share in the production of *palases* in this area. Their weavers are Kurds, Turks and sometimes Armenians. But how and on what basis should these *palases* be categorized?

A large number of the *palases* of Turkey have been represented in books and journal articles as *gelims* and *zilus (zilis)* in the past decades, and the *palases* of the Caucasus have been studied under the generic rubric of *gelims* or flatwoven textiles. Although the areas of production of these *palases* have been pinpointed, nothing has been said of the weavers, nor have there been any comparisons between eastern and western *palases*. It is a similar situation with the *palases* of the south-east, with specimens from Iran, Afghanistan and Pakistan, but there at least we know of the ethnic group or groups that made them (see pages 218 to 222). In the north-west we do not have that information.

The western *palases* generally fit into one of two major categories: chequered and striped. Both have a supplementary brocading structure or a combination of this with reverse chequered weft-wrapping. Weft substitution has not made its way to the north-west and no examples of it have been seen there so far. This must be a direct result of the total absence of any people from Sistan, Baluchestan or Kerman in the area.

The most important category of north-western *palases* is the chequered or square grid. The composition in most of these is not unlike chequered squares.[185] Even though the area within the squares is decorated with the finest colours and patterns, by and large they exhibit the dark-light aspect of the chessboard. Compare the examples from Iran and the Caucasus (Plates 176 and 177). Plate 176 comes from the north of Iranian Azarbaijan, in the vicinity of Qarachedagh, and was produced by the Turkish-speaking Arasbaran or Qaradaghi tribes. The other one derives from the Caucasus and both are of Turk-weave. As well as the chequered design, there are other compositions within this category. Despite the diversity of design, pieces in this batch belong to the all-*palas* branch (see pages 205 to 207) and have some connection to the Turkoman *palases* of Khorasan. The striped *palases* of the north-west, however, must be grouped into several categories. One category, produced by the northern Kurds, has features which are distinct in every respect. Petsopoulos has examined seven specimens of this variety under the name of *gelims* from Malatya (west of Lake Van and north of Diyarbekr),[186] while Housego has called one of them the work of the Jalali Kurds on both sides of the Iran-Turkey border.[187] The example in this book (Plate 178) must be from the same area. It is not very difficult to find such *gelim palases* in the rug bazaars of Tabriz. The *gelims* of the northern Kurds are often of combined weave, with supplementary brocading and plain *gelim*-weave or sometimes slit tapestry, and generally in two pieces.

In addition, there are other branches of north-western *palases* – or, more accurately,

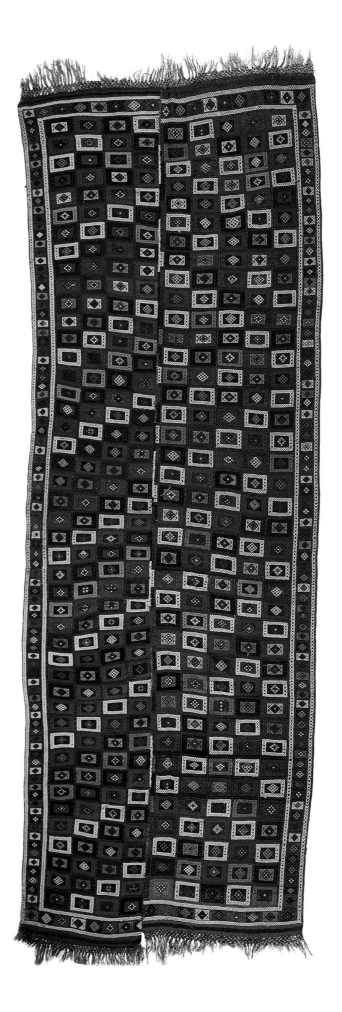

PLATE 176. *Palas, Qarachedagh area, Azarbaijan. Late 19th century. All wool. Weft-faced plain weave patterned extensively by weft-float brocading. Two strips sewn together. 535 x 191cm (17ft.7in. x 6ft.3in.).*

231

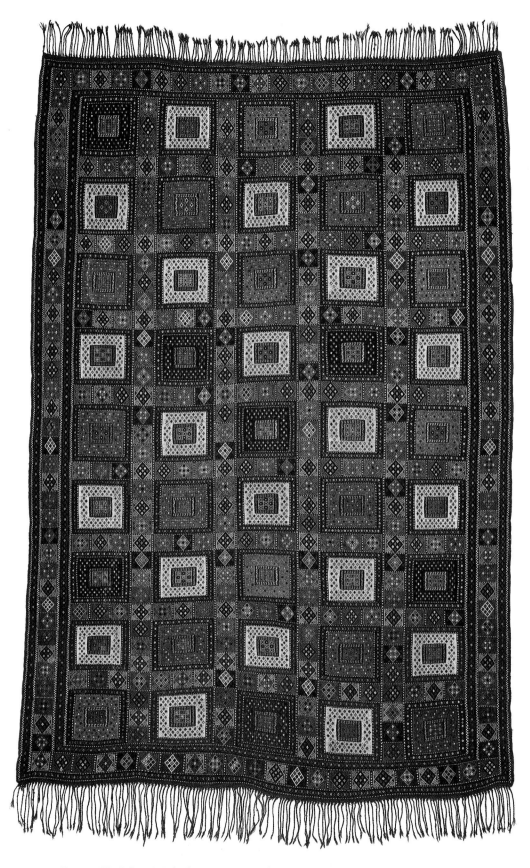

PLATE 177. *Palas, Qarabagh, Caucasus. 19th century. All wool. Weft-faced plain weave patterned extensively by weft-float brocading. 295 x 205cm (9ft.8in. x 6ft.9in.).*

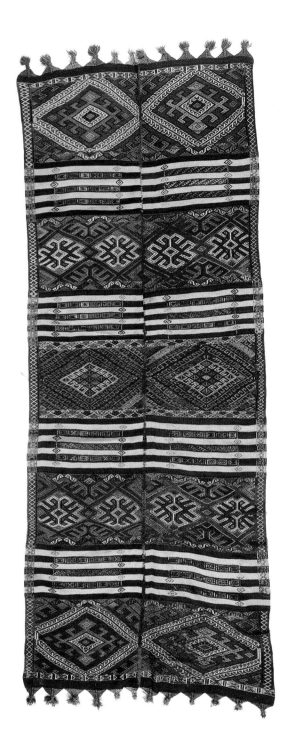

PLATE 178. *Gelim palas, Khoy area, Azarbaijan. All wool. Weft-faced plain weave patterned by weft-float brocading. Two strips sewn together. 345 x 135cm (11ft.4in. x 4ft.5in.).*

half-*palases*. In these *palases*, or *gelim-palases*, the percentage of *gelim*-weave is greater than *palas*-weave. The *palas* section in some of them is reduced to very narrow stripes. One such *gelim-palas* is shown in Plate 179, which could possibly be the work of the Hamamlu in northern Azarbaijan (see pages 56 to 58). This theory is based originally on the colour scheme rather than the structure, which resembles the work of Mazandaran weavers more closely (although it is not from that area).

The other *gelim-palas* (Plate 180) was made in northern Azarbaijan, either by the Shahsavan or by their neighbours the Arasbaran who live on the slopes of Qarachedagh.

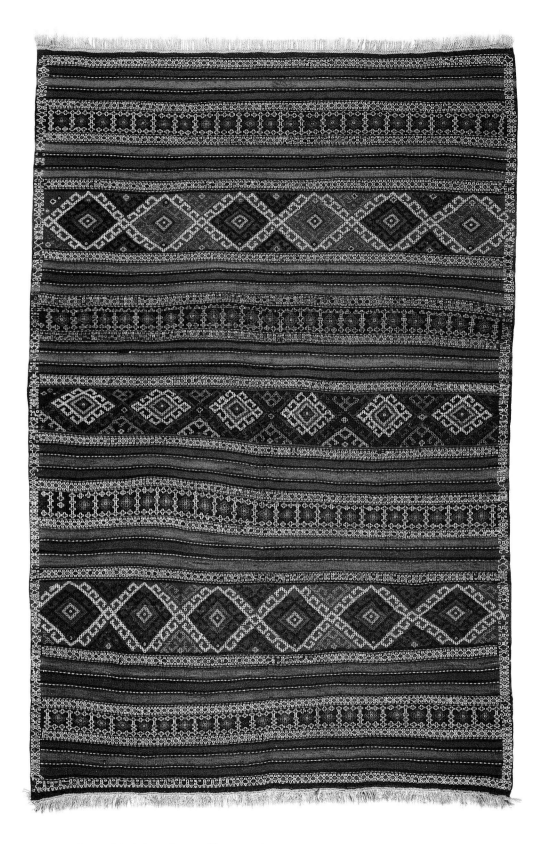

PLATE 179. *Gelim palas, possibly Hamamlu, Azarbaijan. Late 19th century. All wool. Weft-faced plain weave patterned by chequered weft-wrapping. 250 x 169cm (8ft.2in. x 5ft.7in.).*

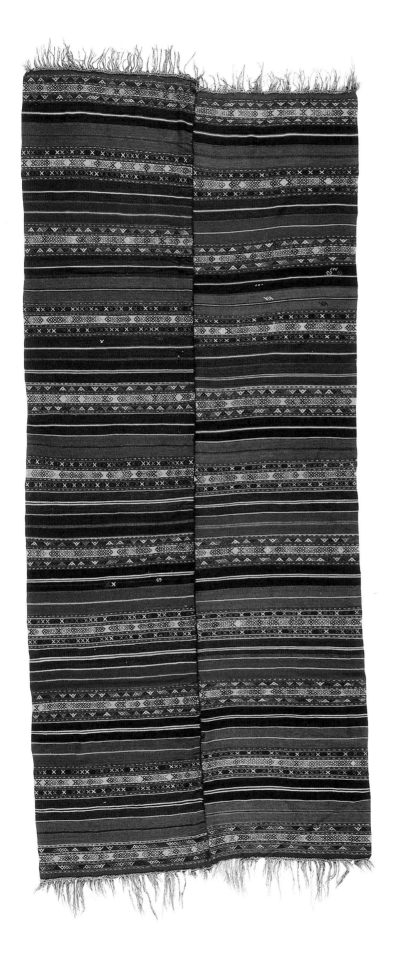

PLATE 180. *Gelim palas, Moghan, Azarbaijan. Late 19th century. All wool. Weft-faced plain weave patterned by weft-float brocading. Two strips sewn together. 405 x 149cm (13ft.3in. x 4ft.11in.).*

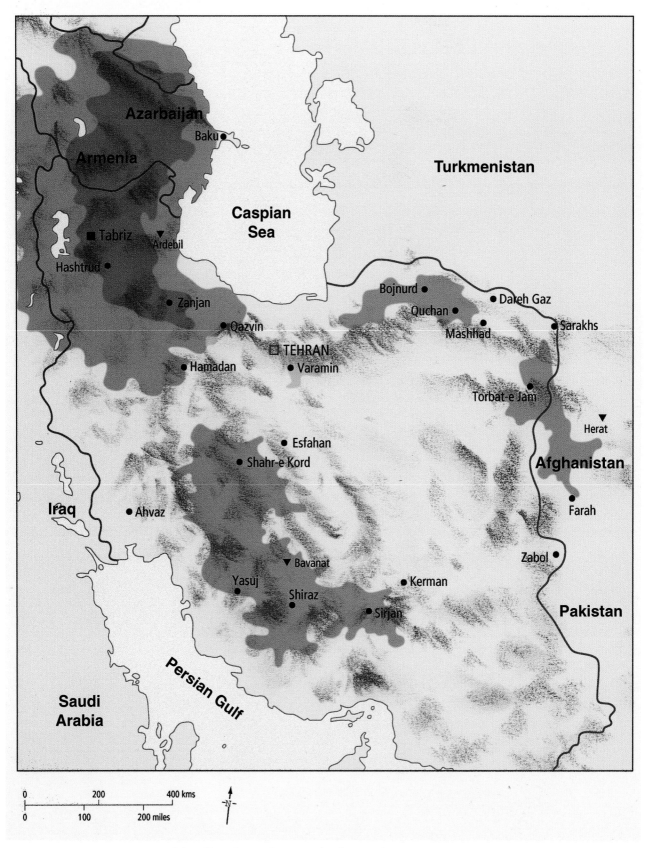

Map of Iran showing the extent of weft-wrapped weaving areas.

236

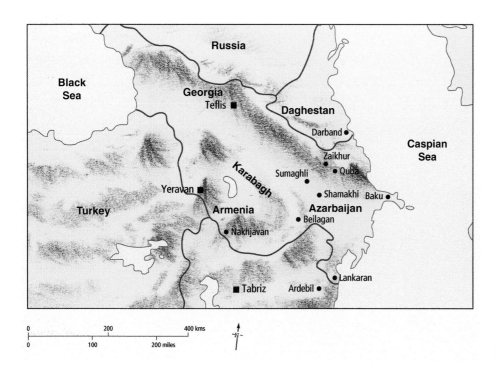

Map of the Caucasus.

WEFT-WRAPPING

There is a belief among some that the weft-wrapping floor coverings known as *sumak* are produced only in the Caucasus and that nothing comparable has been made in Iran. This is not so. In some areas of Iran, such as Kerman, Khorasan, Bakhtiari and Azarbaijan, similar floor coverings have been woven. The richness found in these floor spreads has its origins in the Caucasus.

The case of the Caucasus is similar to that of Sistan. To examine the rugs woven in these places we have to ignore boundaries and recreate the same environment that prevailed in the nineteenth century, with people going back and forth across borders.

At least three sections in this book are connected to the weavings of the Caucasus. While I could limit myself to the *gelim* and the *palas* of Iran in the last two chapters, that is no longer possible in this section. The Caucasus must be a part of the discussion here and temporarily joined with Iran. Any study of Iran's weft-wrapped textiles, *suzanis* or even *pardehs* (wall hangings) would be meaningless without taking into account the Caucasus region.

THE CAUCASUS

Beyond Iran's northern borders, between the Caspian and the Black Seas, lies a lush range known as the Caucasus Mountains whose southern slopes have long been the home of numerous tribes, with each area having its own name. Today this area is divided among four regions: Georgia, Daghestan, Armenia and Azarbaijan. Although each of these four countries has its own weaving industry, only Azarbaijan concerns us in this book.

As we have seen, Azarbaijan is the name given to Iran's north-western provinces. The selection of this name also to denote the south-east Caucasus occurred in 1918 for political reasons.[188] Despite the numerous tribal and ethnic links between the two Azarbaijans, the northern portion had in the past gone by other names. Initially it was called Aran, and there are numerous references to Aran in the works of Muslim and Christian geographers and historians in the Middle Ages. According to some, Aran lay in the area between the rivers Kor and Aras (Araxes). Its capital, Barda', which is located across the Aras river (Iran's present-day border) and north of present-day Baylaqan, was an important trade centre. Sunday was market day and the market was set up in the vicinity of the Kurdish neighbourhood, called Korki. Estakhri estimated the dimensions of this marketplace to be one league by one league (farsang). Indicating its reputation, he wrote: 'Most people, when enumerating the days of the week, speak of Saturday, Korki, Monday, Tuesday…'[189] He also stated that people came from all over, including Khorasan and Iraq. Among the products of Barda' and Baylaqan were silk, wall hangings and horsecloths.[190] Other important commercial towns include Khazar, also known as Darband-e Khazaran, in which all manner of goods were traded, including textiles. Merchants travelled there from Gorgan, Tabarestan, Armenia, Azarbaijan and Anatolia.[191]

It appears that during the reign of the Shirvanshahs, who ruled Shirvan and neighbouring areas, the name Aran was eclipsed by that of Shirvan. From the sixteenth century onwards, when the area came under the control of the Safavids and became a part of Iran, the name Aran gradually disappeared.[192]

The Safavids, having risen to the throne through the allegiance of Turkish-speaking tribes, now began to put their supporters in northern Azarbaijan and the Caucasus in positions of power. The influence of these tribes, among them the Shahsavan, continued until early in the nineteenth century, and they were free to travel to lands on both sides of the Aras river. As a result of the Russo-Persian wars, the defeat of Iran and the demarcation of the new border by the Aras river, and finally with the triumph of the Bolshevik revolution, relations between Iran and the Caucasus were severed.[193] In their weavings, however, the old ties continued.

SUMAK, SUZANI OR WEFT-WRAPPING

One of the floor coverings terms which has never been fully defined is the word *sumak*, or the weft-wrapped kind. These textiles are produced in the land bordered by the Black Sea at one end and the Caspian Sea at the other. In various centres of production they go by different names. The Turks of Anatolia call them *zili* or *sumak*,[194] the Caucasians and Armenians refer to them as *sumak* or *verneh*, the Shahsavan call them *qayaq* or *verneh*,[195] and the rest of Iran knows them as *suzani*. The same is true more or less in the West, but the more conservative observers refer to them by the generic term of 'flatweave'.

What is common to all these floor spreads is their structure. They are classified as compound weaves, and in all of them (except one group) two sets of wefts and one set of warps are employed. The set of wefts which, along with

the warps, constitutes the foundation of the weave, is called the ground weave. The other set of wefts has a supplementary and patterning function and creates the design and the pattern of the weave. While a variant of this structure also exists in some eastern Iranian *palases*, these have never been included with the weft-wrapping variety because the *palas* is not as fine or delicate as the weft-wrapped textiles of Azarbaijan and the Caucasus (see pages 202 to 208).

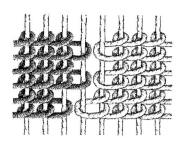

FIGURE 39. *Simple weft-wrapping.*

One of the basic problems with *sumak* is the selection of an appropriate name for it. The supposition in most references that *sumak* can be traced back to Shamakhi has no basis in historical truth; the word has appeared solely as a name for this fabric. Not only is Shamakhi pronounced and spelled differently from *sumak*, but also it is not a location to which these textiles are specific, for they are produced in most of Azarbaijan, the Caucasus and Anatolia.

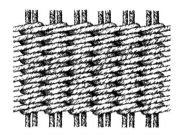

FIGURE 40. *Compact weft-wrapping.*

As for *suzani*, this term must also be questioned. Although it has roots and a pedigree in Persian language and literature (discussed on pages 314 to 315), and is current among rug experts and in the rug bazaars of Iran, this term is not appropriate for weft-wrapped textiles. Another group of floor coverings dealt with in this book goes by the name *suzani* (literally meaning needlework), which is entirely apposite, for their production involves needlework; the production of weft-wrapped textiles, meanwhile, involves the use of fingers rather than needles. The explanation for why these weavings are called *suzani* in Iran may be found in their similarity with the true *suzanis* (see pages 314 to 315). Weft-wrapped, which seemed an appropriate description for these fabrics, never really established itself in the hearts of rug *aficionados*. Instead, the term *sumak*, which was believed to be a misnomer, gained greater public acceptance and continues to do so.

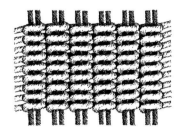

FIGURE 41. *Reverse weft-wrapping showing the opposite face of Figure 42.*

MAHFURI

I feel that weft-wrapping a fabric did, indeed, exist in the past and that it was called *mahfuri*, although this claim lacks the necessary evidence to buttress it. Nevertheless, there is evidence at hand to indicate that in Azarbaijan and the Caucasus, aside from the pile-rug (*qali*) and the *gelim*, another floor covering called the *mahfuri* was produced, and that it achieved renown throughout Iran. Unlike the *palas*, the *mahfuri* was an expensive floor spread reserved for royalty. Bayhaqi (995-1077) considered the *mahfuri* and the *qali* as akin to gold and silver vessels: '…so many clothes and such finery of gold and silver and pearls, so many mahfuris and qalis…that the emir and all those present were astounded.'[196] Again, when referring to wealth, Bayhaqi talks about a thousand set of *qalis* and *mahfuris*,[197] calling them the floor spreads found in kings' tents. Gardizi (d.1061) refers to the *mahfuri* as an expensive rug,[198] and Suzani-e-Samrqandi (d.1166 or 1173) invokes the memory of an old woman who, despite her ugliness, could weave *qalis* and *mahfuris*:

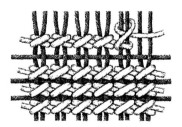

FIGURE 42. *Opposite face of Figure 41.*

That hairless, ghoul-faced hag, for all her ugliness,
Weaveth many a *qali* and likewise many a *mahfuri*.

FIGURE 43. *Working face of extra-weft knotted wrapping on a plain weave ground.*

239

Such allusions leave no doubt that the *mahfuri* and the pile-rug were not the same thing, although both were considered valuable. One might be led to suppose that since the *mahfuri* was not the *qali*, it may have been a kind of *palas*, but the following verse by Khwajeh Abdollah Ansari (1005-88), wherein he compares himself to the *palas* and the beloved to the *mahfuri*, thereby emphasizing the great distance that lay between them, settles the question:

> Great is the difference between me and thee.
> How can the *palas* vaunt itself over the *mahfuri*?

If the *mahfuri* was not the same thing as the *qali* or the *palas*, what, then, was it? It could certainly not have been the *gelim* because, aside from the silk and gold brocade variety, the *gelim* was used by the poor. Likewise we learned in the section on the *suzani* that it and the *mahfuri* were not the same thing. Could it be that *mahfuri* was nothing other than what is presently referred to as *sumak*, especially considering that its geographical area of production was delineated by travellers and geographers in the past?

The word *mahfuri* is derived from Mahfur, an Anatolian town on the shores of the Mediterranean Sea. This does not mean, however, that the production of mahfuris was limited to the town.[199] In fact, it was produced throughout Armenia, the Caucasus and Azarbaijan, and the finest varieties were those made by Armenians. Gardizi confirms this: among the gifts of superior value that Sultan Mahmud sent to Qadar Khan were Armenian *mahfuris*.[200] Mo`jam al-boldan in the thirteenth century reiterates the fact that the best *mahfuris* were woven in Armenia.[201] As for the three towns to which *Hodud al-`alam* attributes the best mahfuris stating that '...all the various *mahfuris* that exist throughout the world come from these three locations.'[202] They are located in Azarbaijan and the Caucasus. This receives further corroboration from Tabari (d.922): '...it is a large town which they call Khazar [on the Caspian], where they engage in all manner of commerce...and they weave these *Mahfuri zilus* in those towns and call it Darband-e Khazaran.'[203]

There are several interesting considerations raised by these quotations. The land of *mahfuri*-weavers was situated between the Black and the Caspian Seas, and present-day Armenia, the Caucasus, and Azarbaijan were the greatest centres of production, their work reaching all corners of the known world. Although Tabari's comparison of the *mahfuri* and the *zilu* is questionable, we can hardly lay the onus for distinguishing the various kinds of flatweave on the historians of the past (see page 24). An examination of the present status of these floor coverings shows that times have not changed. The best *mahfuris* (*sumaks*) are still produced within the same geographical boundaries.

How should we explain the disappearance of *mahfuri* as a name, and its replacement by *sumak*? And when did such a change occur? We know that the term *sumak* was coined as recently as the end of the nineteenth century and that *mahfuri* appeared for the last time in written sources in the thirteenth century. In the six centuries between *mahfuri* and *sumak*, what were these floor coverings called? Should we suppose that, subsequent to their settlement in the Caucasus,

the Turks found the term *mahfuri* unrepresentative and opted for *zili (zilu)* instead? If so, how did we get the term *sumak*?

The term *sumak* appeared on the scene in the waning years of the nineteenth century and the Frenchman D'Allemagne was among the first to use it. A lover of Persian art, D'Allemagne travelled to Iran three times to collect specimens. In a chapter in his extensive book, *Du Khorasan au Pays des Backtiaris*, he examined Persian rugs and also wrote briefly about *gelims*. He considered the *gelim* to be of two kinds: the double-face and the single-faced, which he called *soumak*. He considered the term to be of Hebrew origin, and the product to be the work of Shirvan (Shamakhi).[204] D'Allemagne's brief explanation raises several issues. The first is his reference to *sumak*-weaving in Shirvan. We know that the most important region in Shirvan was Shamakhi, its capital. The attribution of the *sumak* to Shamakhi was probably rooted in this very hint by D'Allemagne. I believe *sumak* is related to an area different from Shamakhi. Some 60 kilometres (37 miles) north of Shamakhi, on the slopes of Mount Babadagh, lies a village named Sumaklu. The name of this village appears nowhere in writings on rugs. It is possible, however, that it was an important centre of *sumak*-weaving in the past, for it lies within the radius of the work of *sumak*-weavers. It would not be far-fetched to imagine the products of this village being traded in Shamakhi, the centre for the trade of such rugs, under the label of *Sumaklu* or *Sumak*. Similar instances can be found elsewhere. *Sumak*, or *somaq*, is one of those few words whose pronunciation is almost uniform in several languages. Aside from Hebrew, to which D'Allemagne referred, this word appears in more or less the same form in Persian, Turkish, Armenian, English, French and German. This has been responsible for making the word a universal one.

So long as the word *sumak* is used to refer to floor coverings made in the environs of Shamakhi, I see no problem with it. But I am opposed to having Baluchi or Kermani floor coverings called *sumak* merely because of their weft-wrapped structures. Besides, in addition to weft-wrapped floor coverings, a large number of containers such as *khorjins* (saddlebags), *mafrashes* (bedding bags) and *jols* (horsecloths) also share the same structure.[205]

VARIETIES OF WEFT-WRAPPING

Weft-wrapped textiles can generally be divided into two categories, each of which can be further subdivided. One category is known as *sumak*. Its most important feature is its structure of end-to-end weft-wrapping, so much so that the ground weave is covered with *sumak*-weave and cannot be seen. I have named the second category half-*sumak*. This is the same thing that the people of the Caucasus call *verneh* or *varni*. In this category, sections of a rug are in *sumak*-weave and the rest in plain *gelim*-weave. In simpler language, the weft-wrapping serves a patterning function over a plain field.

Despite their contrasting structures, it is useful to compare the *palas* with *sumak*. As we have seen, *palases* are divided into the two major categories of all-*palas* and half-*palas* and are thus similar to the *sumaks*. The difference is that in

a large number of *palases* – namely, in those with weft substitution – the design is striped. As we have seen, in the *palases* all the stripes are covered in patterns, while in the half-*palases* only alternating stripes exhibit patterns (see pages 205 to 207). *Sumaks*, however, are far more diverse in pattern. If we were to classify them by design, we would come up with many kinds. Here we will concentrate on the two major areas of Shirvan and Qarabagh.

Shirvan

Based on the available evidence, we must consider the eastern Caucasus the home of most *sumak* floor coverings (Plates 181 and 183). This is borne out both by historical sources and by extant specimens. The three towns the author of *Hodud al-àlam* named (see page 240) were Shirvan, Khersan and Lizan.[206] Although today not even the name remains of the last two, according to this author these towns were in the vicinity of Shamakhi, Darband (Derbent) and Kuh Qobak (Quba, in rug literature known as Kuba)[207] – in other words, present-day north-eastern Azarbaijan where *sumaks* are produced. Although there are minor variations in the classification of these floor coverings, their areas of production fall within the same general bounds described by the author of *Hodud al-àlam*.

Raoul Tschebull has attributed a large group of them to Zeiykhur, a village 27 kilometres (16 miles) north of Kuba, on the basis of the pattern they share with the pile-rugs of this village.[208] Prior to Tschebull, too, Schurmann considered Zeiykhur an important centre for the production of delicate *sumaks*, though he did not identify any categories.[209] Kerimov, who has written one of the most comprehensive books on the pile-rugs of Azarbaijan, has largely ignored flatweaves, but he has cited a few sumak floor coverings which he has attributed to Kuba.[210] In addition to dozens of journal articles, two books have been published about these floor coverings,[211] but in none of them have they been classified. If we can agree with Tschebull about Zeiykhur as the origin of a category of all-*sumaks* from the eastern Caucasus, we would not be amiss to call them *zeiykhuris* (Plate 181). Thus, we would be perpetuating one of the great traditions of the past (see page 29) as well as identifying other related categories.

Several valuable studies have been done on this group of textiles. Among

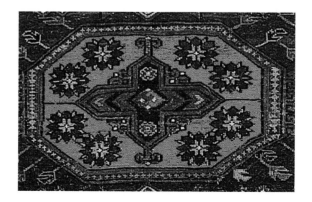

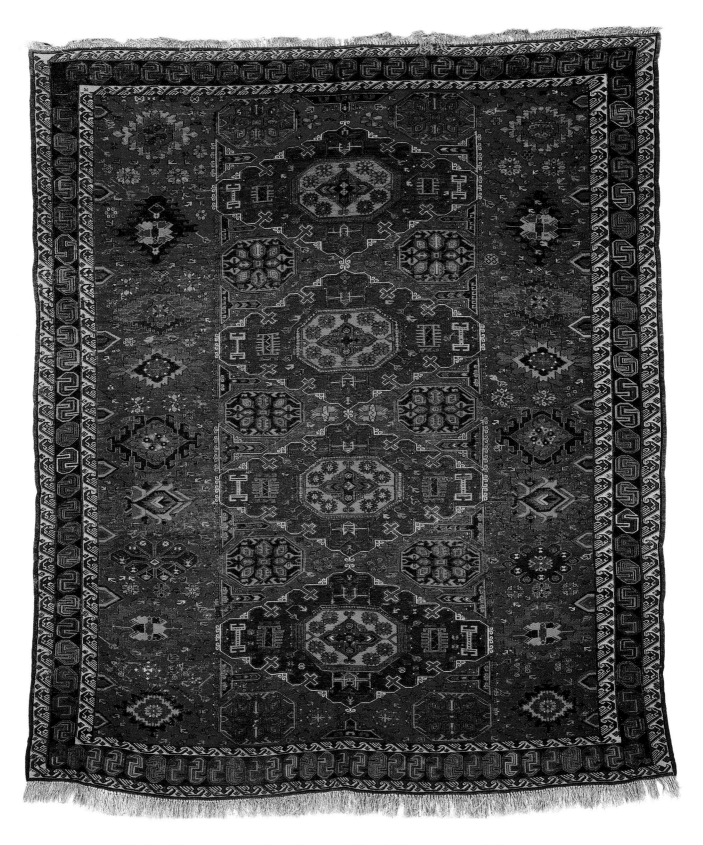

PLATE 181. *Sumakh, Shamakhi area, Caucasus. Late 19th century. All wool. Plain weave patterned all over by extra-weft wrapping. 310 x 240cm (10ft.2in. x 7ft.10in.).*

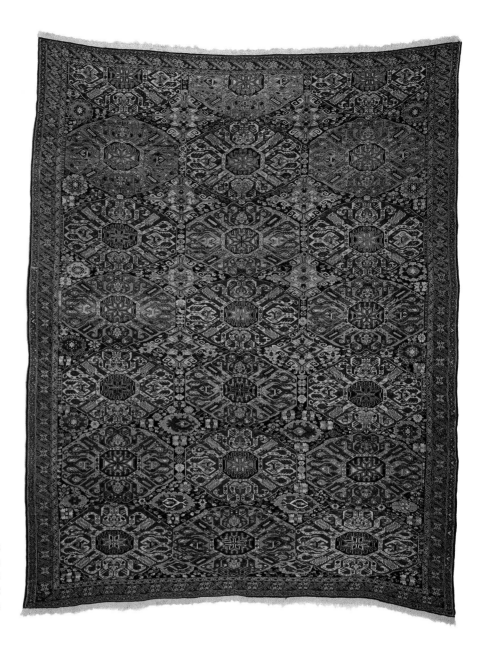

PLATE 182. Sumakh, Kuba area, Caucasus. Mid-19th century. All wool. Plain weave patterned all over by extra-weft wrapping. 390 x 315cm (12ft.10in. x 10ft.4in.).

these is the work by Carol Bier whereby she has classified the patterns on Caucasian rugs and compared them with those of *sumaks* and embroidered fabrics produced in the same area. Bier has concluded that the patterns on many pile-rugs are derived from sumaks and embroidered fabrics, which have served as prototypes.[212]

Not enough can be said about the patterns and designs of the *sumaks* of Shirvan-Kuba. Most of the designs appearing on the pile-rugs produced in the area can also be seen on the *sumaks*. In his classification table on the rugs of Azerbaijan, Kerimov lists 123 patterns, of which he considers sixty-six to be from the Shirvan-Kuba area.[213]

What appears of interest here is the use of designs with twists and turns and medallions on *sumaks*, which recall the *suzanis* and other textiles of the Safavid era. This in itself qualifies *sumaks* as classic Persian rugs rather than tribal or village weavings.

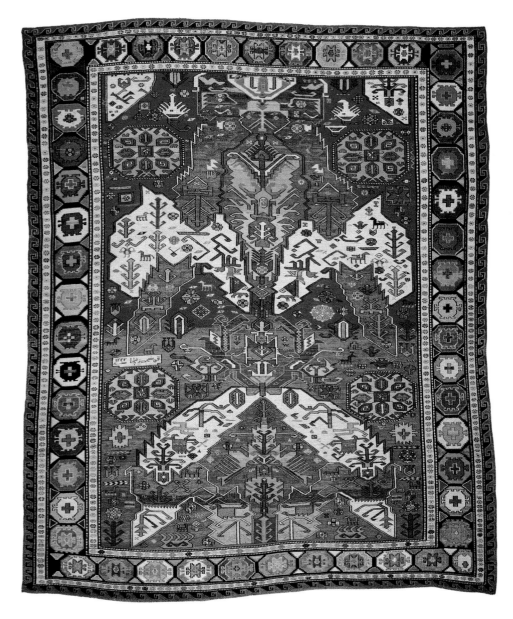

PLATE 183. *Sumakh,
South Caucasus. Mid-
19th century. All wool,
plain weave patterned all
over by extra weft-
wrapping. 310 x 190cm
(10ft.2in. x 6ft.3in.).*
VOK COLLECTION

Qarabagh

Qarabagh is situated in western Azarbaijan on the slopes of the Lesser Caucasus.
Today it falls within the borders of Azarbaijan, but in the past was shared by the
Armenians as well. Older geographical maps show Aran and Armenia as adjacent
to each other. In Estakhri's map, the border of Armenia is drawn from Barda' to
Tiflis. In the accompanying text, however, he assigned a greater area to
Armenia.[214] According to the available evidence, in subsequent centuries and up
to the early decades of the twentieth, various Armenian groups lived in Qarabagh.
Even today a narrow strip of their territory stretches into Qarabagh and splits
Caucasian Azarbaijan in two, a situation which has resulted in numerous wars.

I think it probable that some half-*sumaks* were produced in Qarabagh by
Armenians (see below). Their structure results from extra-weft wrapping on a
plain-weave ground. They can be divided into two major and several minor
categories. The two major categories are the *vernehs* and the so-called *sielehs*.

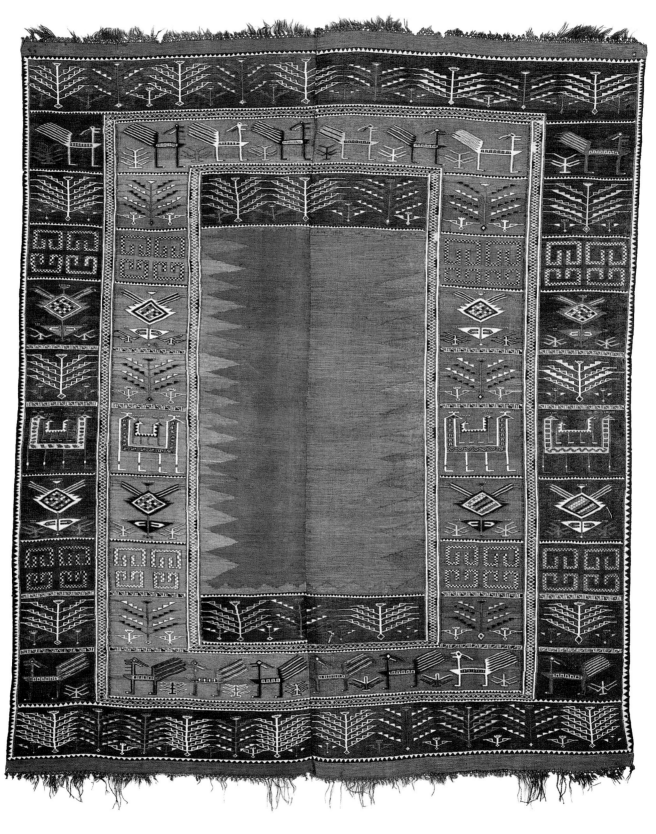

PLATE 184. *Verneh, South Caucasus. Mid- to late 19th century. All wool. Weft-faced plain weave patterned by extra-weft wrapping. Two strips sewn together. 221 x 190cm (7ft.3in. x 6ft.3in.).*

Verneh and Sieleh

The *vernehs* are one of the largest sub-groups within the category of weft-wrapped textiles. They are not limited by design, pattern or dimensions.[215] Some of them are quadrilateral and rectangular, with dimensions of roughly 2m x 2m (6ft.6in. x 6ft.6in.) (Plate 184). Others are larger and have the dimensions of the *gelim* (Plate 185). Both varieties are occasionally in one piece and more often two- or multiple-length pieces sewn together. In the square *vernehs* the borders often have weft-wrapping while the centre is plain and unpatterned, which is why they are sometimes mistaken for *sofrehs*. It would not surprise me if these were in fact *masnads* (see page 309ff.). The larger *vernehs* exhibit scattered patterns with animals and other motifs.

It is not clear where and when the word *verneh* originated. There are no references to it in older writings, nor even in the rug literature of recent decades. One of the first to begin collecting *vernehs* in the mid-twentieth century was McMullan; he, however, has made no reference to their name.[216]

Despite the dearth of information about the origins of the word, its use flourishes among weavers of these pieces, who are generally Caucasian and Shahsavan. Although *verneh* has meanings in Persian, Turkish and Armenian that correspond to its meaning varnish in the Latin group of languages,[217] the name has nothing to do with the product itself. I believe that the word originated in Armenia and that its form was somewhat corrupted. Many villages in Armenia bear *varin* or *verin* as prefixes to their names, meaning lower and upper respectively, as in Upper Artashat and Lower Artashat (south of Yerevan).

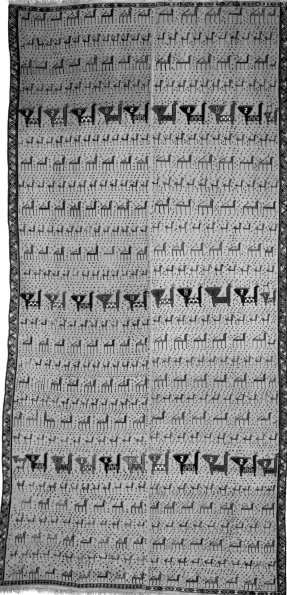

PLATE 185. *Verneh, possibly hanging, Shahsavan of Moghan. Late 19th century. Wool with some cotton. Balanced plain weave patterned by extra weft-wrapping. Two strips sewn together. 376 x 185cm (12ft.4in. x 6ft.1in.).* VOK COLLECTION

The *vernehs* mentioned were woven in most areas in the southern Caucasus, such as Qarabagh, Shirvan and, on the Iranian side, Moghan. Life forms such as animals, flowers and plants appear more in this category of Caucasian rugs and flatweaves than in any other. This must have been related to the ethnic origin of the weavers – Iranian people such as the Kurds, the Talesh, the Tats, the Moghani and of course the Armenians who, as Christian and by virtue of their practice of figural representation, placed themselves outside the tradition of mainstream Islam.[218]

247

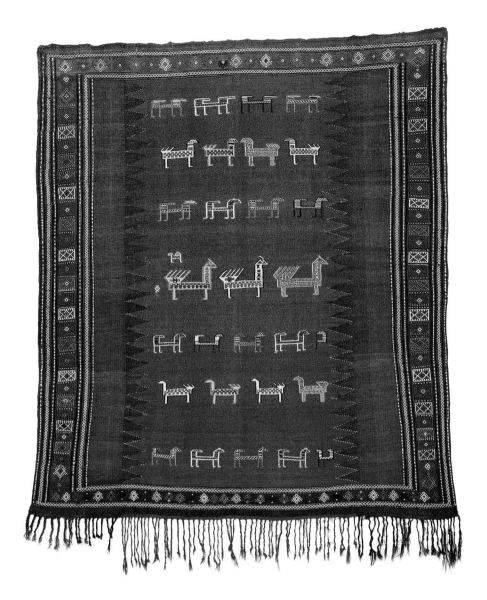

PLATE 186. *Verneh, South Caucasus. Mid- to late 19th century. All wool. Warp-faced plain weave patterned by extra-weft wrapping and weft-float brocading. 190 x 165cm (6ft.3in. x 5ft.5in.).*

Another category of *vernehs* comprises those decorated with an S-shaped 'dragon'. These are generally called *sieleh*. In terms of weave, they fall into the category of half-*sumaks*, since their structure is weft-wrapping on a plain-ground weave. The design usually consists of sixteen to twenty large dragons covering the field in four rows of four or five, surrounded by a narrow border (Plates 188 and 189). The origin and meaning of the word *sieleh* are not clear. There has been speculation that it was a town in the Caucasus, but the reality is quite different. There has been no town in the Caucasus known by the name of Sieleh, and the meanings and attributions offered lack any basis in reality. I believe that the word is none other than *zilu*. Most Turks pronounce 'lu' (an attributive suffix) as 'li', as in Moghanlu and Taleshlu which they refer to as Moghanli and Taleshli. Likewise, in keeping with this tendency, they pronounce the word *zilu*, which is not attributable to any particular tribe, as *zili* (see pages 25 to 26). If we suppose that the word 'sieleh' was first used by a German, or if we at least consider such occurrences as not impossible, we arrive at the solution to some of the puzzles in

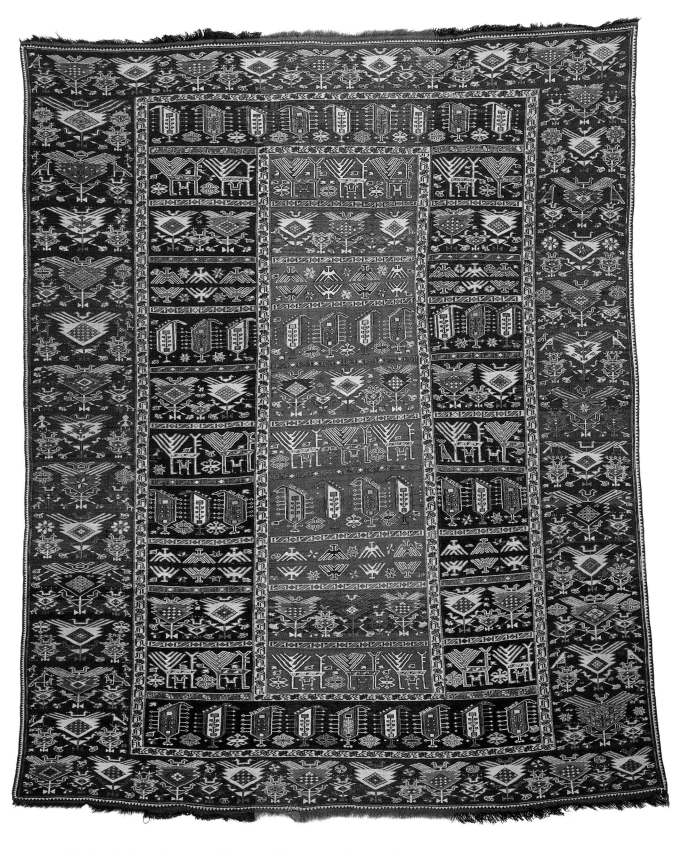

PLATE 187. *Verneh, South Caucasus. Mid- to late 19th century. All wool. Balanced plain weave patterned by extra-weft wrapping. 220 x 182cm (7ft.3in. x 6ft.).*

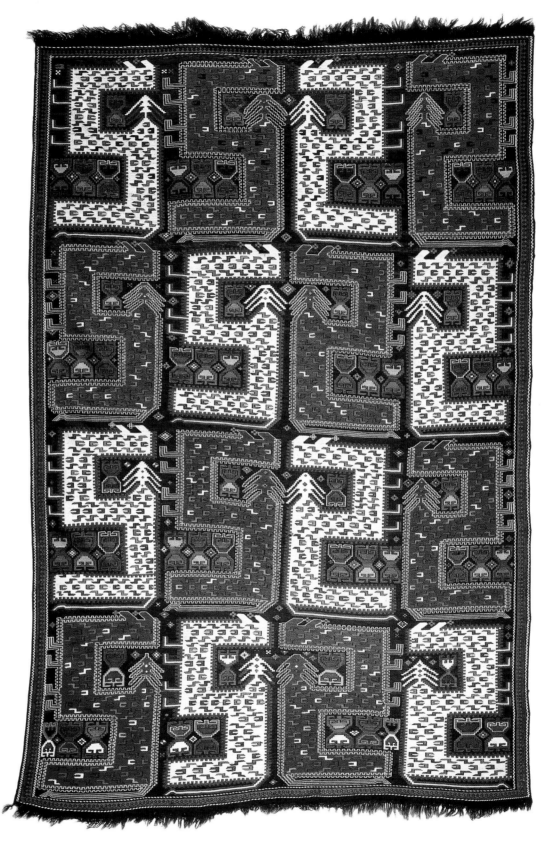

PLATE 188. *Pardeh (hanging), Qarabagh. Late 19th century. All wool, weft-faced plain weave patterned all over by extra weft-wrapping. 282 x 188cm (9ft.3in. x 6ft.2in.).* VOK COLLECTION

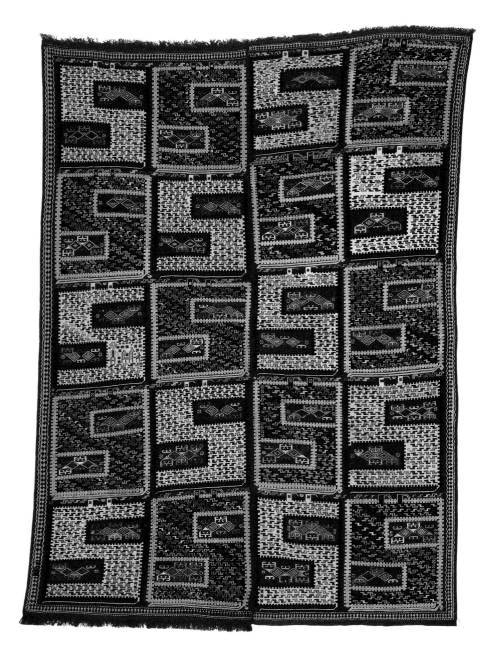

PLATE 189. *Verneh, South Caucasus. Late 19th century. All wool. Plain weave patterned all over by extra-weft wrapping. Two strips sewn together. 265 x 200cm (8ft.8in. x 6ft.7in.).*

carpetology, among them that of *zilu* and *sieleh*. The minor changes in the spelling and pronunciation of these two words can be traced to the German language in which 's' and 'z' are pronounced with the opposite sounds to in English.

More picturesque than *sielehs* are the camel-patterned *vernehs*, dealt with in the section on *pardeh* (see pages 320 to 322). The warp in nearly all these *vernehs* is dyed wool. Some are uniformly dark blue or brown, like *shirakis* (Plate 172). Others, whose fields are warp-faced, have warps with different colours, like *jajims*. It is as difficult to pinpoint the area of weave of the *vernehs* as it was easy to pinpoint that of the *sumaks*, because the former *vernehs* are far more varied than than the latter. Based on the above, it is not easy to assign them to the Caucasus or Iran. There exists another group of *verneh*, too. The look of these *vernehs* is somewhat similar to the previous ones, but their structure is of a *palas*-weave with weft-float brocading rather than weft-wrapping. I have called this group *verneh-palas* (Plates 190 and 191).

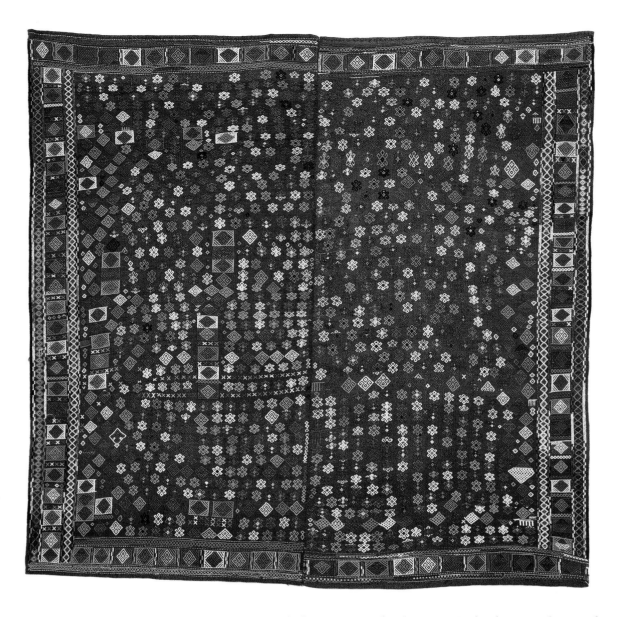

PLATE 190. *Verneh palas, Qarabagh, Caucasus. End 19th century. Wool and cotton wefts on wool warps. Weft-faced plain weave patterned by weft-float brocading. Two strips sewn together. 189 x 180cm (6ft.2in. x 5ft.11in.).*

OPPOSITE: PLATE 191. *Verneh palas, Qarabagh, Caucasus. End 19th century. All wool. Warp-faced plain weave patterned by weft-float brocading. Two strips sewn together. 189 x 150cm (6ft.2in. x 4ft.11in.).*

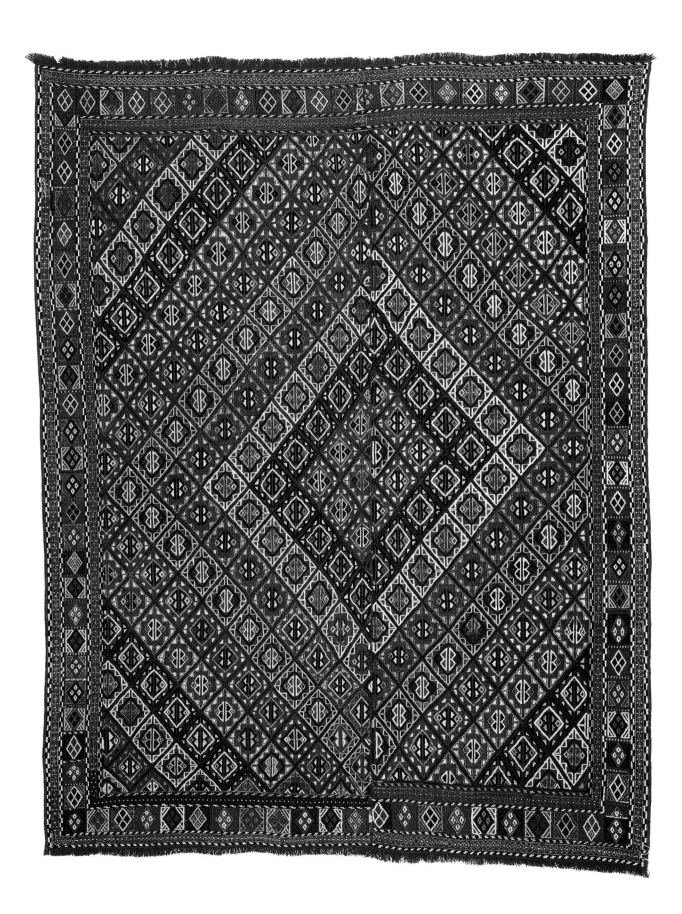

253

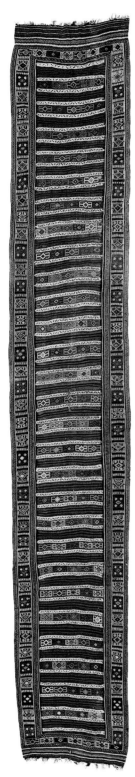

PLATE 192. *Weft-wrapping, Lors of Khuzestan. Late 19th century. All wool. Weft-faced plain weave patterned extensively with spaced weft-wrapping. 825 x 125cm (27ft.1in. x 4ft.1in.)*

WEFT-WRAPPING IN IRAN

If we were to calculate the volume of all weft-wrapped textiles such as *khorjin* and *mafrash* produced in Iran and the Caucasus, Iran would probably considerably outstrip the Caucasus. By the same token, the Caucasus would be far ahead of Iran in the production of weft-wrapped floor coverings.

It is not clear why Iranians did not choose this kind of weave for their floor spreads. Wherever they did, it was for specific purposes. Did they consider it too fine a weave to tread on, or did they weave it only for use when serving guests? Perhaps this might have been the case in the Caucasus in the more remote past; here, too the *mahfuri* and the *sumak* might have once been far more valuable than other floor coverings, such as the *gelim* and the *palas,* and considered the most aristocratic of floor coverings after the *suzani.* Or perhaps the bulk of the remaining *sumaks* of the Caucasus was produced during the rug market's boom years in the region, at the close of the nineteenth century and the beginning of the twentieth, with the intention of trading and exporting them. In Iran, however, they were not items of commerce until very recently.

In connection with these points it is instructive to examine the weft-wrapping-rich areas of Iran. Among these areas one must undoubtedly include Lorestan, Khuzestan and Chahar Mahal and Bakhtiari – the territory of the Greater Lors and the Lesser Lors. Weft-wrapping is the most common type of weaving among these people and almost all their *khorjins* are woven thus.[219] Should anyone, however, attempt to find a few weft-wrapped floor coverings in these areas as opposed to the thousands of weft-wrapped *khorjins,* not only would they wear out several pairs of shoes but also they would come back empty-handed. In the past thirty years, I have seen no more than three specimens, Plate 192 being one of them.[220]

The same situation – perhaps an even more extreme one – prevails with the Shahsavan of Azarbaijan. For the women of this tribe weft-wrapping is a form of self-expression, as evident from their weft-wrapped *khorjins* and *mafrashes.* Why, then, have they not woven even a single floor covering fully in weft-wrapping structure?[221] Could this mean anything other than that they did not want to tread under foot such delicate and beautiful weavings? In their *vernehs,* of course, they have used this structure in executing scattered motifs, as shown in Plate 185.

The weaving of all-over weft-wrapping floor coverings by the Shahsavan goes back no more than a couple of decades. The age of the oldest such weaving is no more than thirty years. These floor coverings, whose first designers were the merchants of Tabriz, are now woven in Ardebil and Meshkin. According to the dictates of the export market, they are replete with varieties of animals and birds and woven in silk as well as in wool.[222]

What is true of the Shahsavan is equally true of the Kurds and the Qashqa'i. All of them are aware of this kind of weave, but have not used it in floor coverings.

Map of Kerman showing Persian Gulf in the south and some of the well-known cities of Kerman such as Sirjan, Bardsir and Zarand. From Estakhri, Masalik va Mamalik mid-10th century.

NATIONAL MUSEUM OF IRAN, TEHRAN, FOLIO 68a

Kerman

One of the few places in Iran that has paid attention to weft-wrapped floor coverings is Kerman. The presence of older examples of such floor coverings, as well as more recent ones, is an indication of the continuity of this tradition over the last two centuries. Had it been only the Turkish-speaking tribes of Kerman and the Afshars who had woven these floor coverings, it could be imagined that they had brought them along from Azarbaijan. But these floor coverings have been made by tribes other than the Afshars, such as the Lors and Qoraba'is, all living in the vicinity of Sirjan.

Practically all the designs of the Sirjan rug are also found in the weft-wrapped textiles of this area. Since the Afshars are concentrated more around Sirjan than other areas in Kerman, it is possible that they were the producers of the best weft-wrapped fabrics.

I have selected two of the finest weft-wrapped specimens from this area. One bears the *botteh* design (Plate 193*).* The precise repetition of this design on the field of this rug is reminiscent of certain Kerman shawls.[223] The delicacy expended in the weaving of this floor covering and the precision and refinement that have gone into the tassels at its two ends are admirable. Another interesting feature is the presence of dyed warps, which recalls the floor coverings of Qarabagh.

Plate 194, by contrast, is based on a cotton warp, which is common in the flat-weaves of Kerman. The pattern on this rug, its large medallion which is divided into equal-sized lozenges, and the *gols* within these lozenges all mark it as closer

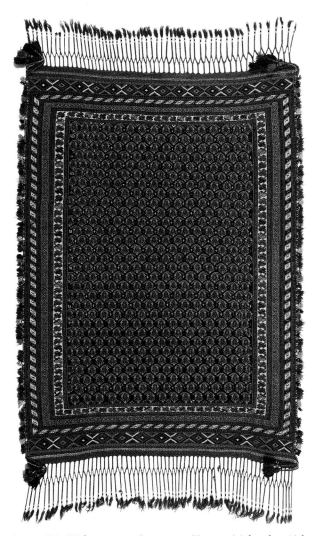

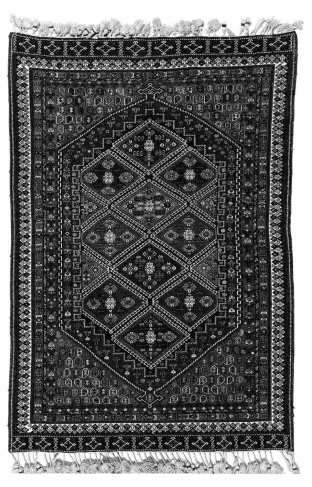

PLATE 193. *Weft-wrapping, Sirjan area, Kerman. Mid- to late 19th century. All wool. Weft-faced plain weave patterned extensively with extra-weft wrapping. 190 x 140cm (6ft.3in. x 4ft.7in.).*

PLATE 194. *Weft-wrapping, Sirjan area, Kerman. c.1900. Wool wefts on cotton warps. Weft-faced plain weave patterned all over with extra-weft wrapping. 189 x 131cm (6ft.2in. x 4ft.4in.).*

than ever to the work of the Afshars. In the past two decades there has been an attempt to revive the weft-wrapped rugs of Kerman for export. Although the recent products lack the creativity of the older ones, the quality of their weave is unimpeachable.

Torbat-e Jam

The last batch of Iranian weft-wrapped floor covers is woven in a remote place and by people that one would not expect (Plate 195). The place is around Torbat-e Jam and the weavers are the Baluch. Torbat-e Jam is one of the last outposts of north-eastern Iran, near the border with Afghanistan, and for a long time the area has been the home of various Baluch clans. We can confidently say that, rather than Sistan and Baluchestan, it is in the area between Torbat-e Jam, Qa'enat and Sarakhs that the most accomplished Baluch weavings are produced. The *palases* and weft-wrapped textiles woven here, although they are far fewer in number than their pile-rugs, are no less fine in quality. If ever a comparison is undertaken between the warp count of the best Baluch weft-wrapping and the best *sumaks* of Zeiykhur, I am not at all sure that the products of the Zeiykhuris in the Caucasus would prove superior to those of the Baluch of Khorasan.

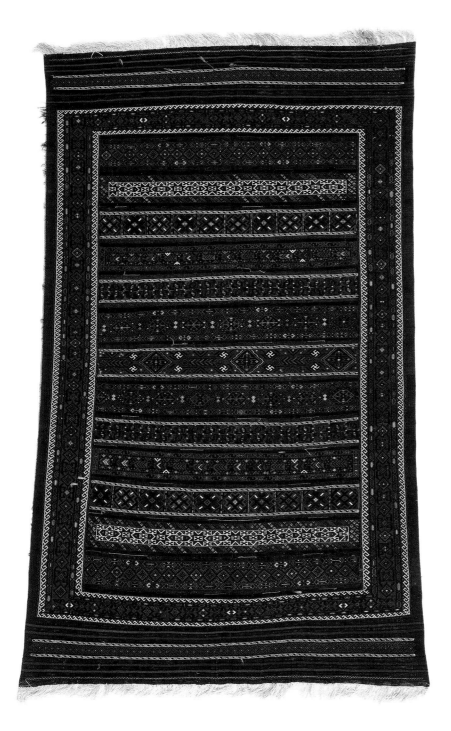

PLATE 195. *Weft-wrapping, Torbat-e Jam, Khorasan. End 19th century. All wool. Weft-faced plain weave patterned extensively by extra-weft wrapping. 270 x 160cm (8ft.10in. x 5ft.3in.).*

The pattern on Baluch weft-wrapping is striped and, more than anything else, resembles the *palases* of Kerman (see Plate 169). Can we take this as justification for the theory that the Baluch of Khorasan, or certain sectors of them, had origins in Kerman? Or should we seriously consider Kerimov's comparison of the *sumaks* of Shirvan-Kuba with the weavings of Khorasan in the Bojnurd and Torshiz areas?[224] What is evident is that the southern Baluch did not have weft-wrapped rugs. Instead, they wove, and indeed still weave, very delicate *suzanis*[225] that differ little in pattern and colour scheme from the weft-wrapped textiles of Khorasan.

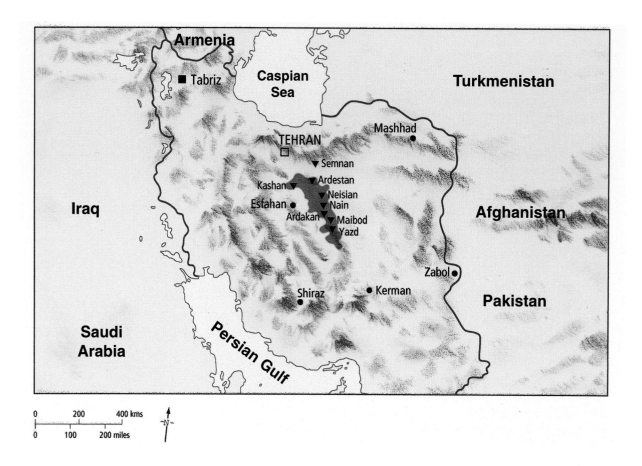

Map of Iran showing the zilu
weaving areas.

ZILU

Another variety of floor covering that must occupy an important place in this
book is the *zilu*. However, unlike the *gelim* and other flatweaves which found
their way into the hearts of rug *aficionados* and attracted a great deal of attention
– albeit belatedly – the *zilu* has never proven attractive to anyone. Merchants have
never made any attempt to export it, nor did collectors evince any interest in
collecting or studying it. Even in Iran's domestic markets the *zilu* has met with
little success. It has travelled little beyond its area of production – the Kavir region
– and, as we shall see, seems to be on its way to extinction even there.

There must be reasons for the *zilu*'s lonely plight in the carpet world. Or,
perhaps, we must contrive such reasons, one of which must be the *zilu*'s all-cotton
material. Although cotton is pleasantly appealing to the inhabitants of hot desert
areas as a material for floor coverings, it holds little interest for people in other
places such as the Zagros foothills or Europe, where warm woollen floor coverings
are preferred. The *zilu*'s blue-and-white colour scheme exudes the aura of clouds,
water and coolness for desert-dwellers, but appears cold and monotonous to lovers
of colour. Thus, the *zilu* has never found its way into the rug markets and has
never been exported. Perhaps for the same reason, the markets of *zilu* traders have
always lain away from the paths of other rug-sellers. The criteria for its sale,
likewise, differed from those that marked rugs: *zilus* were and are traded by weight,
not by *qavareh* (size, dimension or format).[226]

258

Despite all these disadvantages, the *zilu* stands as a unique floor spread. It is the only one woven entirely from memory, with the pattern established and memorized before weaving. It would be no exaggeration to call it the most intellectually demanding of flatweaves. For roughly a thousand years *zilu*-weaving has flourished along the perimeter of the Kavir (desert), with the area's hot and arid climate rendering the cotton *zilu* an ideal floor covering. Not only would a wool rug be inappropriate here, but also finding its raw materials would be difficult for desert-dwellers. Cotton was cultivated in the Kavir area until recently and indigo, which provided the dye for *zilus*, was not hard to obtain. The oldest mention of *zilu*-weaving along the rim of the Kavir is by Naser Khosrow (1003-88), who refers to four hundred *zilu*-weaving looms in the town of Tun.[227]

FIGURE 44. *Zavareh, a town on the edge of Kavir-e Namak, Salt Desert.*

Whatever *zilus* remain today were all produced by weavers in the western part of the central desert, between Kashan and Yazd, and some of these go back to the early years of the sixteenth century. Although the *zilu* had, and still has, a use within the home, one must visit town and city mosques in the desert in order to find good examples. The floors of these mosques are still carpeted with *zilus*. The Friday mosque of Zavareh, a town bordering the Kavir, is one such place. Its floor and the floors of the porticoes on both sides, as well as the 'ivan' (veranda) and 'shabestan' (prayer room) are covered with *zilus* (Figures 44 and 45).

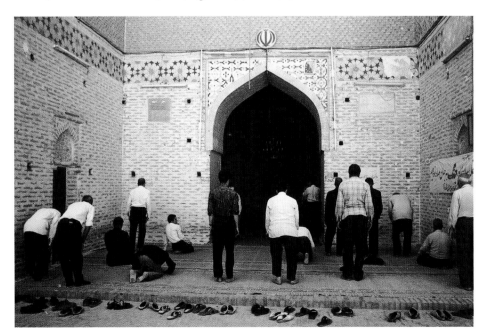

FIGURE 45. *Men praying on zilus at the Friday Mosque of Zavareh.*

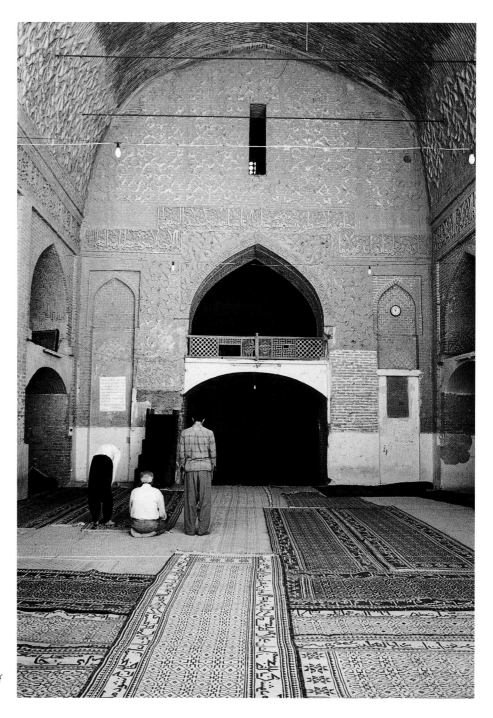

FIGURE 46. *Friday Mosque of Ardestan.*

In the mosque of Ardestan, built during the reign of the Seljuks, are spread more than sixty *zilus* of various dimensions (Figure 46). The floor of Na'in's Friday mosque, likewise, is covered with many *zilus*. Alongside the beautiful minbar in this mosque lies one of the loveliest. Bearing the *saf* design, this piece exhibits twenty-four mehrabs in two rows, each of which has a different pattern (Figures 47 and 48). Close to Na'in is the village of Mohammadiyeh. The mosques in this village are replete with beautiful and old *zilus*. In the Sar-e Kucheh mosque is spread a *zilu* that bears the date 1618 (Figure 49). This mosque, which dates from the early Islamic centuries, has a pre-Islamic

FIGURES 47 AND 48. *Details of a* saf zilu *at the Friday Mosque of Na'in. Dated AH 1225/AD 1810.*

FIGURE 49. *Detail of a* saf zilu *at the mosque of Sar-e Kucheh. Dated AH 1027/AD1618.*

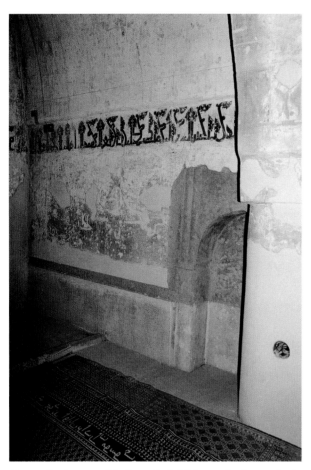

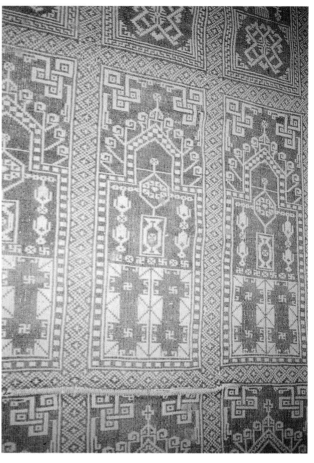

FIGURE 50. *Interior of the Sar-e Kucheh Mosque, Mohammadiyeh.*

FIGURE 51. *Detail of a zilu at the mosque of Amir Chakhmaq. Signed: work of Maibodi, dated AH 1183/AD 1769.*

foundation (Figure 50). The Friday mosque of Mohammadiyeh is equally old.

In hundreds of mosques in Yazd and its vicinity are to be found some of the most beautiful *zilus*. One of the most attractive is in the Amir Chakhmaq mosque. Some of the designs on this *zilu* recall Zoroastrian fire temples and are similar to the fire-temple-like base of the Kirchheim Azarbaijan rug (Figure 51).[228]

The Kabir Friday mosque in Yazd is similarly full of *zilus*. In the prayer room is a *zilu* wall hanging woven in red and dark blue adorned with the Tree of Life,[229] one of the common themes in *zilu* wall hangings or portières (Figure 52). Other *zilu* hangings bearing tree patterns are found in this mosque. Some 25 kilometres (15½ miles) south-west of Yazd is the small town of Taft. Here we find the khanaqah called Shah Vali, which houses some of the oldest *zilus*. Two of the *zilus* from this khanaqah which found their way to the Cairo Museum[230] and The Carpet Museum of Iran date from the mid-sixteenth century.

In dozens of villages and towns around Yazd, such as Ardakan, Fahraj and Bidakhvid, there are *zilus* from the sixteenth century and later. Mosque *zilus* are generally woven in larger sizes, with a length of up to 12 or 14m (40 or 45ft.). Such *zilus* are less than 3 to 4m (10 to 13ft.) in width. These dimensions are closely related to the architecture of mosques. One of them can easily cover the floor of a portico, while three or four are sufficient to carpet the hall under the dome or the veranda in front. Of course, larger mosques such as Yazd's Kabir

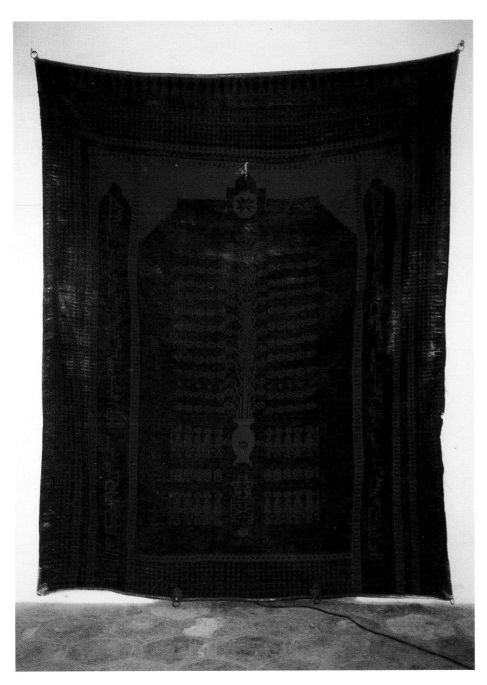

FIGURE 52. *A hanging* zilu *pardeh in the Great Friday Mosque at Yazd. The inscription on the border, repeated twice, reads: Endowed by the means of the board of supporters of the Great Friday Mosque of Yazd and the effort of Haji Khalesi, dated AH 1380/AD1960. The inscription under the vase reads: Work of Puya, dated AH1380/AD1960.*

Friday mosque would require more. The same would apply to the prayer rooms ('shabestan') of mosques, whose ceiling is supported by several columns. And yet it is not rare to find *zilus* in smaller dimensions, with lengths of between 3 and 6m (10 and 20ft.) and widths of between 1.5 and 2m (5ft. and 6ft.6in.). There are numerous uses to which these smaller *zilus* can be put. They are more practical than the larger ones for the empty spaces around the columns, for the minbar, and for the verandas and courtyards of mosques where they have to be carried back and forth (Plates 196 and 197).

The pattern on most *zilus* is of the *saf* kind, formed by the repetition of mehrabs or mihrabs (prayer niches) placed alongside each other. In most *zilus* are two rows of mehrabs; the number of rows being proportionate to the size of the *zilu*. In larger

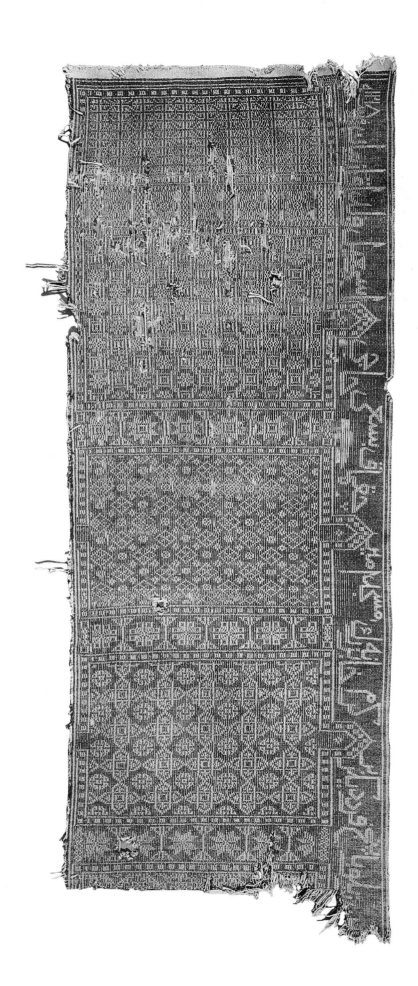

PLATE 196. *Zilu fragment, Yazd
area. Warp: cotton, Z10S.
Weft: cotton, Z4. Structure:
weft-faced compound weave
alternating-float weave; in
variant numerical 3/1, 2/1 and
3/2. About 215 x 90cm (7ft. x
3ft.). Inscription: 'This zilu
with five others [was given] to
the generous house of the great
mosque of Amir Chakhmaq, by
the effort of Haj Esma'il son of
Aqa Zaman date AH 1218
[1803]'.*

zilus we see twenty-four mehrabs in two rows. While all these mehrabs are of equal size and each is enough for one worshipper, their patterns differ. The surface of each mehrab is covered with a geometric motif around which runs a border. The repeating motifs and their structure are reminiscent of the brick-work of the Seljuk era. In the niche of the mehrab, which marks the place of prostration for the worshipper, we often find the motif of the swastika, an ancient Aryan motif and a symbol for the orbit of the sun, or else the eight-pointed star.[231] Other patterns are derived from trees, and the *zilus* bearing them are generally used as wall hangings.

Along the two lengths of the *zilu* are inscriptions woven into the field at the behest of the person who commissioned it. These generally bear the name of this person, the mosque to which the *zilu* was endowed, and sometimes the name of the weaver and date of completion. In most instances, the endower has forbidden the removal of the *zilu* from the mosque unless for purposes of cleaning, often cursing anyone who would presume to remove the *zilu*. Perhaps this accounts for the permanence of zilus and the absence of theft.

Few were the endowers who donated a single *zilu*. The number of endowments by one person generally ranged between four and thirteen, but it could be as high as forty-nine. These figures are directly related to the loom of the *zilu*-weaver. Similarly, the commissioning of more than one *zilu* did much to lower its price, for implementing the design programme and loading it on to the loom constituted a major part of the cost.

The fixing of a *zilu*'s age, or even its place of production and ethnic origin, is not as difficult as it is with other flatweaves, as most of this information appears

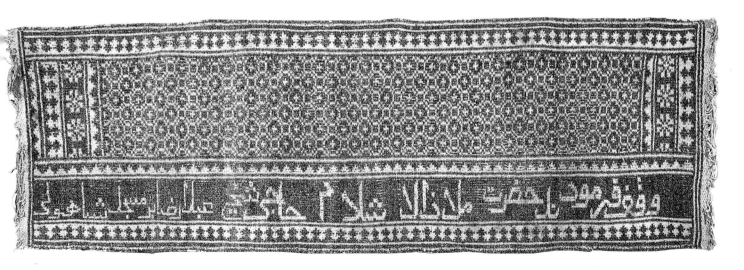

PLATE 197. *Zilu, Yazd area. Warp: cotton, Z3S. Weft: cotton Z2. Structure: weft-faced compound weave alternating-float weave; in variant numerical 3/1, 2/1, 3/2. 222 x 73cm (7ft.3in. x 2ft.5in.). Inscription: 'Endowed by His presence Mulla Zell al-Islam Haji Sheikh Abdolreza to the mosque of Shah Vali. Mid-19th century'.*

in the inscriptions on the surface of the weave. The oldest *zilus* found in mosques go back to early in the sixteenth century. One of these is spread on the floor of the khanaqah of Shaykh 'Ali Bidakhavidi, one of the villages around Yazd. The date it bears, 1520-21,[232] is nineteen years earlier than the date on the Ardebil rug, the oldest extant date-bearing rug of Iran. There are two other *zilus* in this khanaqah, bearing the dates 1523 and 1563 respectively. In the khanaqah of Shah Vali in Taft there were once three *zilus* all dated 1556. One is now in Cairo's Islamic Museum, one in Tehran's Carpet Museum, and the third is missing.[233]

Many seventeenth-century *zilus* remain in the areas surrounding Yazd and Iraj Afshar has provided a list of these. To this list must be added the *zilu* of Mohammadiyeh, dated 1618, and the *zilu* of Zavareh's Friday mosque, dated 1691. The *zilu* in the Amir Chakhmaq mosque, bearing the date 1769 (Figure 51), and the *zilu* of Na'in's Friday mosque, dated 1839, serve as representatives of the eighteenth and nineteenth centuries.

As well as the *zilus* found in and around Kashan, Ardestan, Na'in and Yazd, others that were transported somewhat further. In the khanaqah of Shah Ne`matollah Vali in Mahan are dozens of nineteenth century *zilus*. East of the Kavir, too, in some Khorasan mosques there are *zilus* made in Yazd, Maibod and Ardakan, which proves that the commodity was exported until fairly recently.

MAIBOD

Until recently, when *zilu*-weaving flourished in the towns west of the Kavir, the *zilus* of Maibod enjoyed a reputation superior to those of other places. While *zilus* were produced in Kashan, Naysian, Maibod, Ardakan and Yazd, it was primarily in Yazd that they were bought and sold. The centres of *zilu* sellers were the Khan bazaar and caravanserai. Anyone from any part of Iran who wanted a *zilu* would approach the merchants of the Khan bazaar and place their order. Today there is only one store left that still sells *zilus* and half of its merchandise consists of machine-made rugs. According to the shopkeeper, the demand for *zilus* has reached its lowest level ever, and this cool, soothing floor covering no longer has any takers. Maibod, the most important centre of *zilu*-weaving in Iran, has suffered a similar fate. This town, situated 50 kilometres (30 miles) north of Yazd, housed several hundred *zilu*-producing workshops until the middle of the twentieth century; today the number of workshops can be counted on the fingers of one hand.

Although many of the *zilus* found in the mosques in the Kavir area bear the name of the weaver and some of them date from the middle of the sixteenth century,[234] today the *zilu*-weavers of Maibod can barely make ends meet. Should the present situation continue, they will have little recourse but to close their workshops.

We do not know how old Maibod is. On a hill that was the site of the old town of Maibod sits a fort that may date back more than a thousand years. On the lower slopes of this hill are little caverns that may be human dwellings from the Neolithic age. No worthwhile study has yet been done on this ancient fort which

Figure 53. The city of Maibod.

has miraculously survived, and therefore no sound conclusions can be reached.

Although the town of Maibod is young by comparison with the fort, it is not too young to house the *zilus* of Maibod that go back several centuries. A caravanserai from the reign of Shah 'Abbas, an inn dating to a former age (perhaps between the twelfth and fourteenth centuries), and several cisterns and mosques in Maibod attest to its historical past.

Until a few decades ago, most of the townspeople of Maibod worked in some capacity to do with art and creativity. One could easily have dubbed it the town of artisans, or of 'blue-and-white producers', for in addition to blue and white *zilus* they also had a renowned blue and white ceramics industry.[235] The present town, with a population of 50,000, has seen many changes in the working life of its people, but there are still many older men in Maibod who remember having spent a portion of their youth in ceramics or *zilu*-weaving workshops.

One of the few *zilu*-weaving workshops still in operation in Maibod belongs to Haj Mohammad Baghestani (Figures 54 and 55). This man, now in his sixties, has been in the *zilu*-weaving trade from the age of ten and has reached the rank of a master craftsman. There are two *zilu*-weaving looms in Baghestani's workshop; one lies idle, while he supervises work on the other.

Each loom has to be operated by two workers.[236] The apprentice sits before the loom and is engaged in comb-beating. Every time a shoot of weft passes through the warps, he pounds it down with a heavy comb. The master weaver stands behind the loom in a narrow passageway contrived specially for the purpose and manipulates the warps with the use of levers.

Like any other rug, the *zilu* has a pattern, but this is not put to paper or a *vagireh* or any other sampler. The pattern of the *zilu* is programmed beforehand and set in a place that we can only call the 'memory' of the *zilu*. This memory resembles a set of electric cables that have been stripped of their insulation, so that the thin wire appears naked. The difference is that with the *zilu* these cables are strands of cotton, which are known as *majes* (the light blue strands appearing above the head of the weaver in Figure 54). The strands within the *maj* are connected to some of the warps and move them back and forth. The master weaver separates the *maj* into batches before weaving commences. In the *zilu* that appears in Figure 54), seven *majes* operate at once to divide the warps from one selvedge to another. This occurs through the release of the lever known as the *kamaneh* 'hoop'. Once the warps have been divided, the apprentice shoots a strand of weft through the space created between them and immediately begins to pound it down. When this is finished, the master weaver returns the warps to their original place by way of the *maj* through the use of a double-prong named a *kali*. To continue with the pattern, he then puts another set of *majes* to work.

The *zilu* in this illustration is a simple one with around twenty *majes*. Complex designs that do not follow a set order, such as calligraphy, increase the number of *majes* and sometimes bring them up to seventy strands. In this case, the planning, implementation and execution of the weave require a complete mastery of the craft.

One of the most important steps in the weaving of a *zilu* is the programming of its pattern. Like a computer program, this has to be flow-charted fully and stored to memory. The time that goes into organizing and implementing the pattern is more important and greater than that taken to weave only one or two *zilus* with it. Therefore, with one pattern, several *zilus* of one shape and size are woven. Consequently, the warps are made as long as possible, sometimes over 50m (165ft.), and wrapped around the upper loom beam. With the weaving of every half-metre (1ft.6in.) of rug on the lower beam, both beams are turned and the warps are transferred from the top to the bottom.

The width of the *zilu* in Baghestani's hands is 2m (6ft.6in.), even though the beam on which it was woven could have accommodated a width of over 3m (10ft.). Baghestani is now engaged in weaving 3m x 2m (10ft. x 6ft.6in.) *zilus* which are in greater demand these days. With the looms and warps that he has in storage, he is capable of weaving eighteen pieces at a time, each with these dimensions. For greater numbers he would have to wind new warps again. A *zilu*-weaver typically weaves between 1.5m and 2.5m (5ft. and 8ft.) of *zilu* per day.

Wulff, who wrote the first studies published on the *zilu*, made a slight error about its structure. He believed there to be double warps of two different colours[237] – an error that was perpetuated by a few other writers on the *zilu*. The *zilu* is a particular

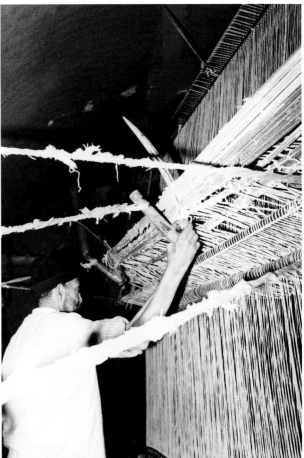

FIGURE 54. *Haj Mohammad Baghestani, master of zilu weaving, Maibod, 1994.*

FIGURE 55. *Mohammad Baghestani at work in his shop.*

type of weft-faced compound tabby weave.[238] The warps are made of multi-ply cotton yarn, generally between five and ten ply, and the wefts are two unplied yarn.

The *zilu* is a unique floor covering in every way. Aside from the features discussed above, another distinguishing mark is that women play little role in its production. The moving of the heavy beams of the *zilu*-weaving loom and the pulling of levers for moving the *majes* require the upper-body strength of a man. The women's role in *zilu* production has been in the making of its raw material, which entails spinning the yarn.

Considering the above points, it would be difficult to place too much reliance on the words of historians and travellers who pointed to *zilu*-weaving in colder areas such as Khoy and Vaznan (both in Azarbaijan). I believe they were using *zilu* as a generic term, which happens even today (see page 24). One reason for this is the use of *zilu* in compound words that denote other weavings completely different from the *zilu*. Tabari (d.922), for instance, refers to *zilu-ye mahfuri*,[239] possibly weaving weft-wrapping, and Hamdullah Mostawfi (d.1349) mentions *zilu-ye qali*,[240] which could also mean scattered pile-weave on plain-weave ground. Such terminology and its generic use were not limited to the writers of the past. Throughout Turkey and the Caucasus, Turkish-speaking people still use the word *zilu* to refer to a group of floor coverings that have nothing in common with the *zilu*,[241] and Westerners have followed this trend.

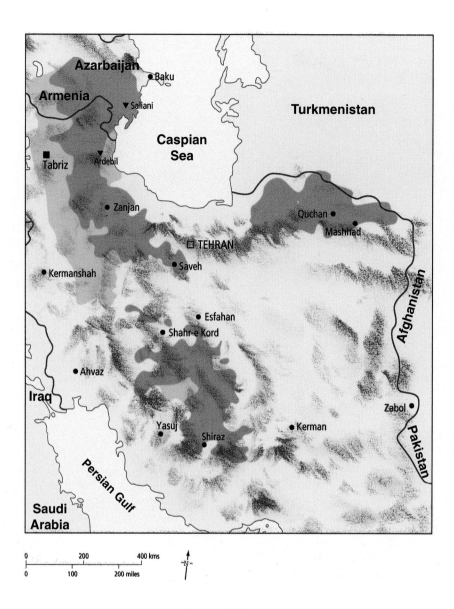

Map of Iran showing the jajim *weaving areas.*

JAJIM

So far in this book all the floor coverings have been of one family or one nature. With these pieces, which include the *gelim*, the *palas*, and the weft-wrapped and the *zilu* varieties, the weft was active, creating the design, and the warp passive. In this new group of floor spreads, classified under the name *jajim*, everything is the reverse and it is the warp that is the primary agent of patterning. That is why the *jajim* is called a warp-faced weave (as opposed to the weft-faced weaves discussed earlier).

Unlike the words *gelim*, *palas* and *suzani*, all of which have ancient roots in Iran and which have been recorded in Pahlavi texts (the language of the Sassanians), the origin of the word *jajim* has never been determined.[242] We know for certain that the word does not appear in the earliest of Turkish dictionaries, *Divan-e Lugat-e Turk*, compiled in the eleventh century. Neither does it appear in the works of early Muslim travellers, although Ibn Hawqal may have seen some specimens in Fars in the middle of the tenth century.[243] But the word does appear

frequently in texts and dictionaries from Safavid times onwards, although in terms of clarity and precision these definitions leave something to be desired.

Among Iranian weavers and sellers, and in Iran's rug markets, the *jajim* is a recognized and distinct floor covering due to its striped pattern. Besides its universal presence in Iran, this floor cover is produced in Central Asia and south-east Turkey. The term *cicim* (pronounced 'jejim'), however, refers to a group of Anatolian floor covering which have nothing in common with the *jajim* in either structure or appearance.[244] Iran's Turkish-speaking north-eastern neighbours, such as the Turkomans and some Afghans, use this fabric for tent-wrapping or animal and floor coverings.

The appearance of most *jajims* is more or less the same; one does not find the diversity of composition and pattern seen in the *gelim*, the weft-wrapping or the *palas*. The chief reason for this limitation is the concealment of the weft in these weaves. The fixed position of the warps on both ends of the loom precludes any movement and, despite their visibility, they cannot produce any patterning unless another method is used (see below). The stripes result from the colours of the warps, which means that the colours of the field must match those on the warps perfectly. Furthermore, the width of the stripes is determined by the manner in which coloured warps are clustered together (Plate 205). Not all *jajims*, however, meet this description. In addition to plain coloured stripes, some *jajims* also bear patterns. In these varieties, two sets of warps are engaged instead of one, with the substituting warps serving the purposes of patterning. Another difference between the plain striped *jajim* and the patterned variety is the appearance of the face and the back of the fabric, which in plain *jajims* is the same. Patterned *jajims*, however, look different on the back and the front. There, the substitution warps that create the patterns on the front are left floating in the back, concealing the patterns there (Figures 56 and 57). This

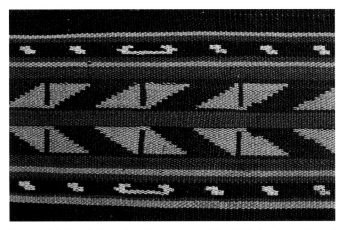

FIGURE 56. *Detail from the jajim shown in Plate 198 showing stripes of warp-faced plain weave alternating with strips of warp-faced plain weave patterned by the substituting warps.*

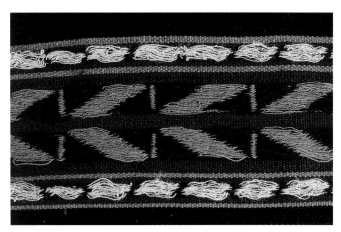

FIGURE 57. *Opposite face of Figure 56.*

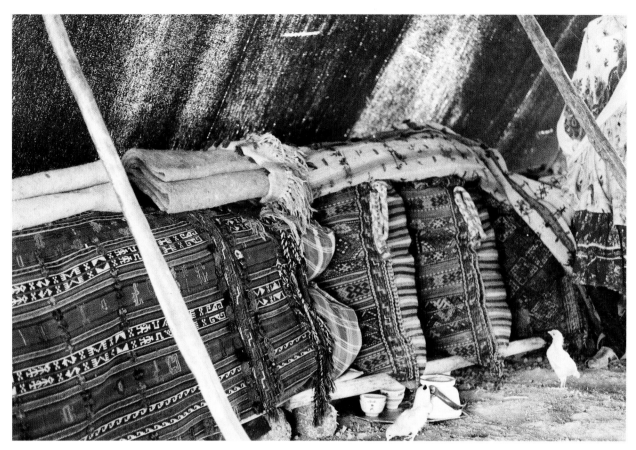

FIGURE 58. *Jajim used as bedding and bag covers. Interior of a Kurdish tent around Quchan, Khorasan.*

kind of weave, called the patterned *jajim*-weave in Iran, is none other than the warp-faced plain weave patterned by warp substitution.[245] It is not unlike a variety of *palas* in weft-faced plain weave patterned by weft substitution, with the difference that the stripes on the *palas* are generally broader than those on patterned *jajims*. Their backs, however, are the same (Figures 33 and 57).

There are other features to the *jajim* that set it apart from weft-faced floor coverings. It usually has no borders, a feature that results from the limits of the weave. To compensate for this shortcoming some tribal weavers sew or weave a narrow border strip into their *jajims* (Plate 200).

The descriptions of the *jajim* offered so far relate to the variety found in north-western Iran, especially Azarbaijan. However, there are at least two other schools of *jajim*-weaving in Iran: the Fars school and the Khorasan school. The dimensions of the Azarbaijan *jajim* are smaller than those of the Fars variety. The Azarbaijan type is almost square, the Fars type rectangular. The two ends of the Azarbaijan *jajim* are turned back and sewn, with no fringe or braiding. The Fars *jajims* have tassels which are braided together (Plates 215 and 216). Azarbaijan *jajims* are between six and ten lengths sewn together, whereas the Fars *jajims* are generally of two lengths and sometimes just one piece. Khorasan *jajims* too have certain other characteristics (see page 298), which set them apart from the Azarbaijan and Fars varieties.

It is no exaggeration to say that the *jajim* has the greatest number of uses

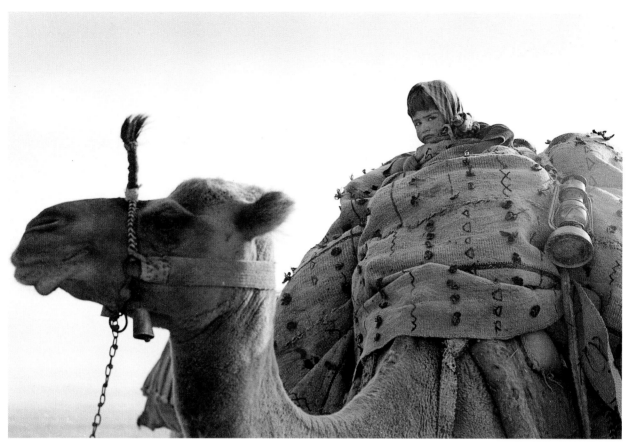

FIGURE 59. *Jajim used as a pack cover during migration. Kurds of Qahremanlu near Shirvan, Khorasan.*

among floor coverings. It is a multi-purpose fabric, serving as a floor spread, a blanket, a *rufarshi*, a bedcover, a quilt, a *korsi* cover, a wrap for belongings (during the migration season), a curtain and a bedroll (Figures 58 and 59). This is in addition to the use of animal coverings and containers in which the weaving pattern or fabric of the *jajim*, the weave, is used. The latter, however, fall outside the scope of this book.

Such multiplicity of uses is amply demonstrated by fifteenth-century paintings depicting the *jajim* (Figure 60). This variety is due to the particular weave of the *jajim* which lends itself to practically any purpose. The type and quality of the weave is linked to its purpose; *jajims* woven for use as bedcovers, blankets and wall hangings are considerably finer and more delicate than those used as floor spreads, and sometimes are even made of silk.

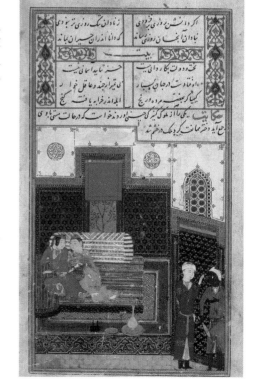

FIGURE 60. Jajim *used as a floor cover in the story of the Amorous Prince. Persian miniature painting from the Golestan of Sa'di. Herat 1426. Chester Beatty Library, Dublin, inv. no. MS 119, f.3a.*

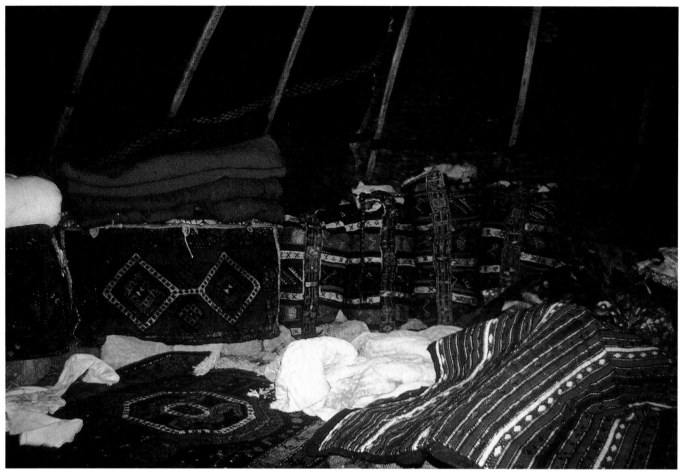

FIGURE 61. *Inside a Shahsavan tent with jajim as blanket. Sabalan 1975.*

AZARBAIJAN

Although this floor covering is recognized everywhere in Azarbaijan, it is to the eastern section of the province that we should go in search for it. The land of the weavers extends inland 200 kilometres (125 miles) from the water from the curve of the western shores of the Caspian Sea which reaches from Shirvan to Qazvin. The word *jajim* itself, like the word *gelim*, denotes both a kind of floor covering and a variety of weave, and the two should not be confused. In a large number of *vernehs*, for instance, the ground is *jajim*-weave or wrap-face plain-weave, but this does not make them *jajims* (Plate 186). Similarly, a large group of wall hangings are woven with a warp-faced structure (Plate 240); these, too, must not be called *jajims*. In the culture of Azarbaijan the *jajim* has specific characteristics which should be considered.

The Azarbaijan *jajim* is a rectangular piece comprised of six, eight or ten bands sewn together. The width of these bands differs according to its place of production, but it is generally between 20cm and 30cm (8in. and 12in.). To make a *jajim*, the weaver first weaves one band of about 20m (6ft.6in.) in length This is then cut up into six to ten equal-sized parts which are sewn together

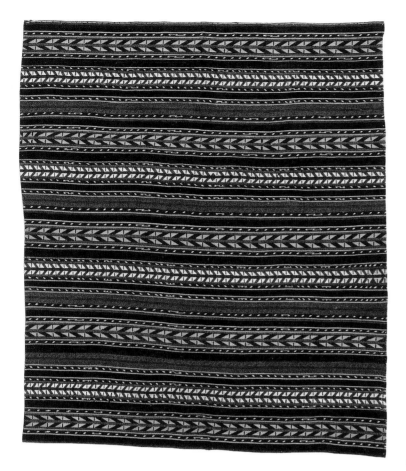

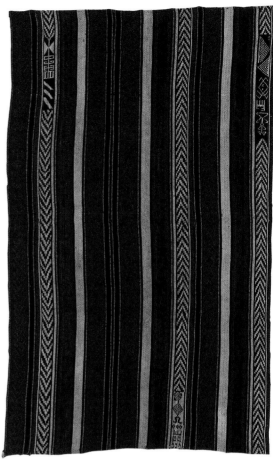

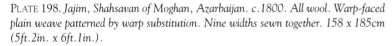

PLATE 198. *Jajim, Shahsavan of Moghan, Azarbaijan. c.1800. All wool. Warp-faced plain weave patterned by warp substitution. Nine widths sewn together. 158 x 185cm (5ft.2in. x 6ft.1in.).*

PLATE 199. *Jajim, Shahsavan of Moghan, Azarbaijan. Mid-19th century. All wool. Warp-faced plain weave patterned by warp substitution. Four widths sewn together. 167 x 106cm (5ft.6in. x 3ft.6in.).*

along the length. Sometimes, in order to produce more diverse colours and patterns, two bands are woven instead of one, each with different patterns and designs. The cut pieces of these two bands are then sewn together alternately to produce a pair of *jajim*. Once the bands are sewn together, the weaver either sews a narrow, 2cm (¾in.) band along the edge of the *jajim*, or simply hems the two ends. In some of the colder areas of Azarbaijan *jajims* are lined with felt so that the blanket or floor covering will be warmer.

The Azarbaijan *jajim* always has a striped design. The stripes are sometimes less than 1cm (⅜in.) in width (Plate 210) and sometimes as broad as 10cm (4in.) (Plate 205). Despite the design limitations, the Azarbaijan *jajim* exhibits a remarkable diversity. As explained on page 271, *jajims* can be divided into the two categories of plain and patterned. On the surface it seems that there is not much variation within these two categories, with all plain *jajims* seeming alike and likewise the patterned *jajims*. On closer examination, however, it will be seen that in each of these categories dozens of different colour scales and patternings have been used, with the quality of the weave also setting them apart from one another. Based on these principles and, of course, a familiarity with the

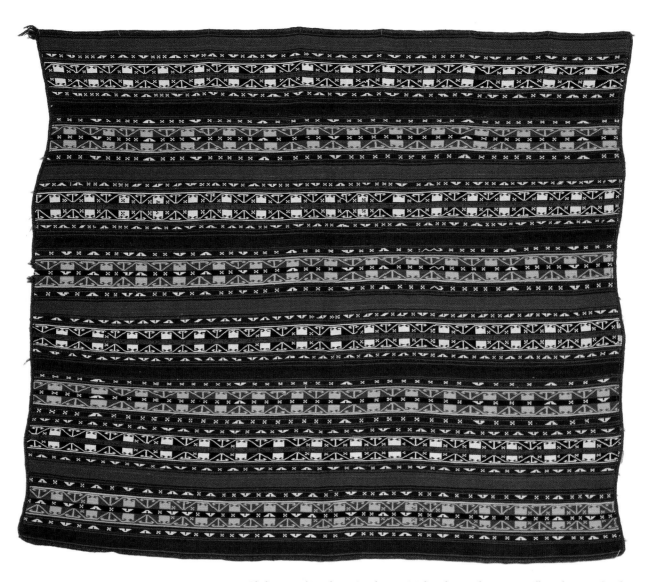

PLATE 200. *Jajim, Shahsavan of Moghan, Azarbaijan. Mid- to late 19th century. All wool. Warp-faced plain weave patterned by warp substitution. Four widths sewn together. 188 x 165cm (6ft.2in. x 5ft.5in.).*

other textiles of Azarbaijan, it becomes possible to identify and label the *jajims*.

The most important areas of Azarbaijan *jajim*-weaving are Moghan, Hashtrud, Mianeh, Takab and Zanjan. The Shahsavan play the largest role in the production of Azarbaijan *jajims*, particularly the patterned variety (Plates 198-204).[246] Some of the oldest *jajims* that have come to light were also made by them (Plate 198). The Hamamlu, meanwhile, have left behind plain *jajims* with the finest weave. Two examples of their work are shown in Plates 205 and 206. The colour scheme in Plate 206 and the tiny motifs worked into it raise it from the level of a handicraft to a work of art.

In Hashtrud and Mianeh, too, large numbers of *jajims* have been woven and the quality of weave is exquisite. There the stripes are somewhat narrower (Plates 207 and 208). The weavers of Takab, meanwhile, have stolen a march over the others in collecting together different colours while producing plain *jajims* (Plate 209).

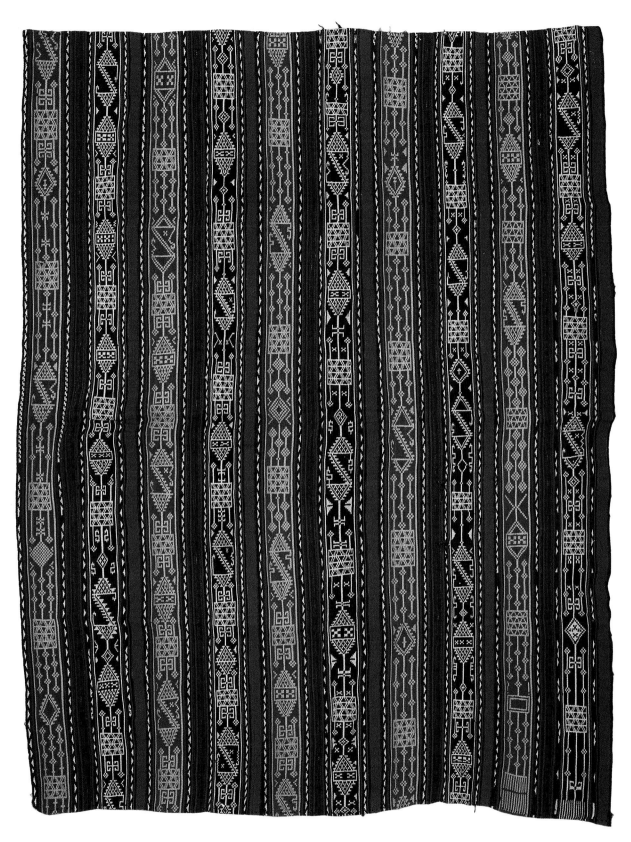

PLATE 201. *Jajim, Shahsavan of Moghan, Azarbaijan. Late 19th century. All wool. Warp-faced plain weave patterned by warp substitution. Five widths sewn together. 202 x 150cm (6ft.8in. x 4ft.11in.).*

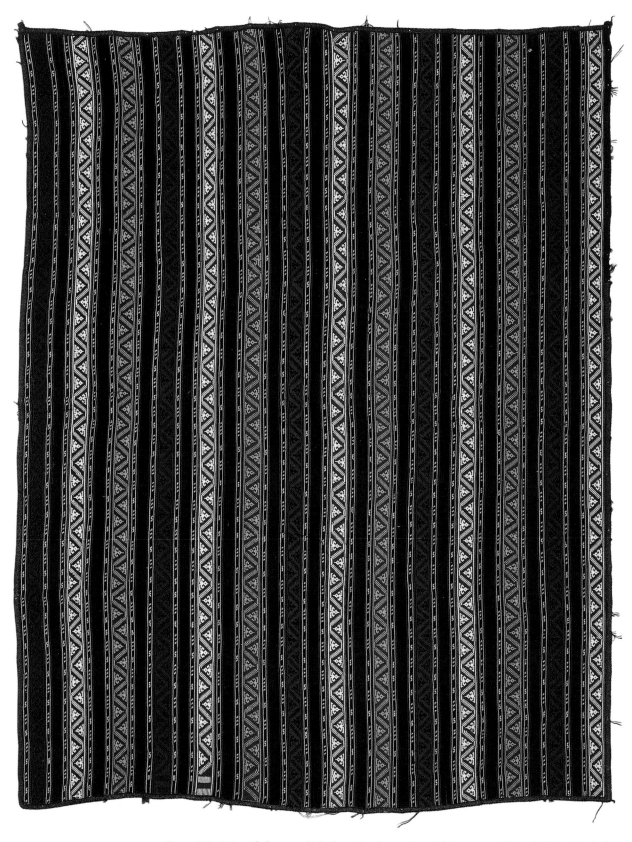

PLATE 202. *Jajim, Shahsavan of Moghan, Azarbaijan. Late 19th century. All wool. Warp-faced plain weave patterned by warp substitution. Nine widths sewn together. 213 x 170cm (7ft. x 5ft.7.).*

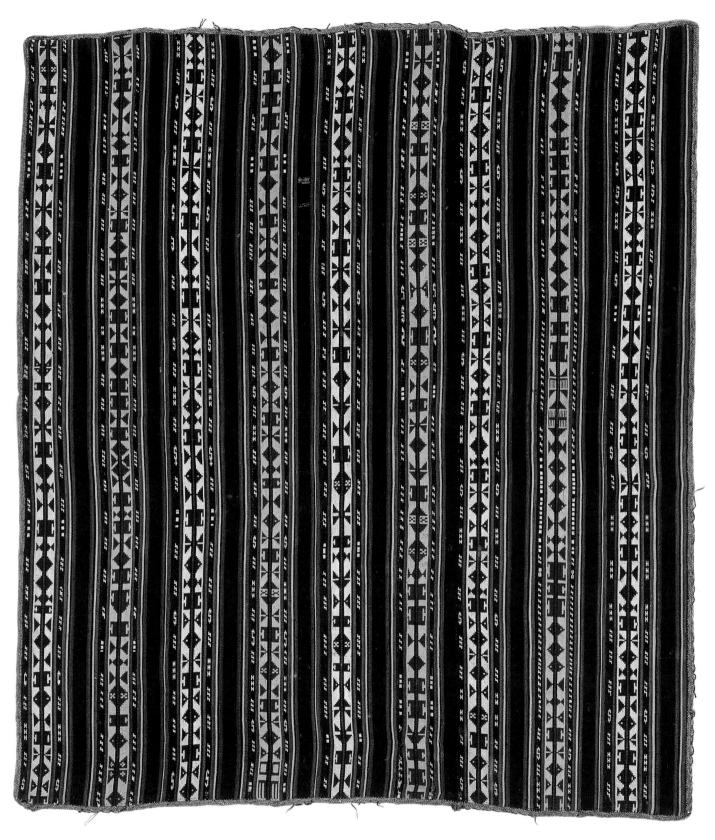

PLATE 203. *Jajim, Shahsavan of Moghan, Azarbaijan. Late 19th century. All wool. Warp-faced plain weave patterned by warp substitution. Nine widths sewn together. 178 x 160cm (5ft.10in. x 5ft.3in.).*

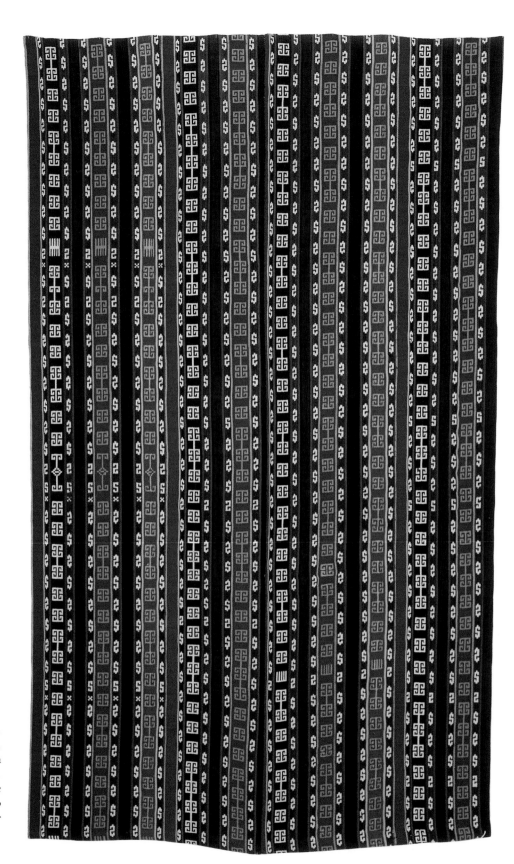

PLATE 204. *Jajim,*
Shahsavan of Moghan,
Azarbaijan. Late 19th
century. All wool.
Warp-faced plain weave
patterned by warp
substitution. Four
widths sewn together.
181 x 108cm (5ft.11in.
x 3ft.7in.).

280

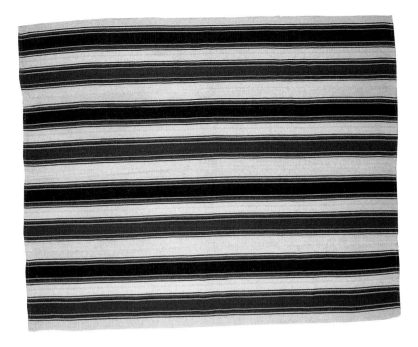

PLATE 205. *Jajim, Hamamlu, Azarbaijan. End 19th century. All wool. Warp-faced plain weave. Four widths sewn together. 230 x 184cm (7ft.7in. x 6ft.).*

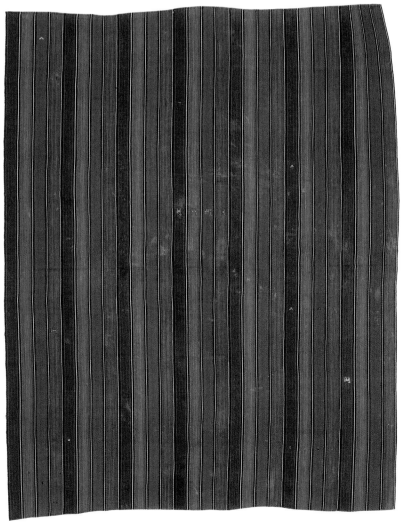

PLATE 206. *Jajim, Hamamlu, Azarbaijan. Mid- to end 19th century. All wool. Warp-faced plain weave with scattered weft wrappings. Seven widths sewn together. 227 x 174cm (7ft.5in. x 5ft.9in.).*

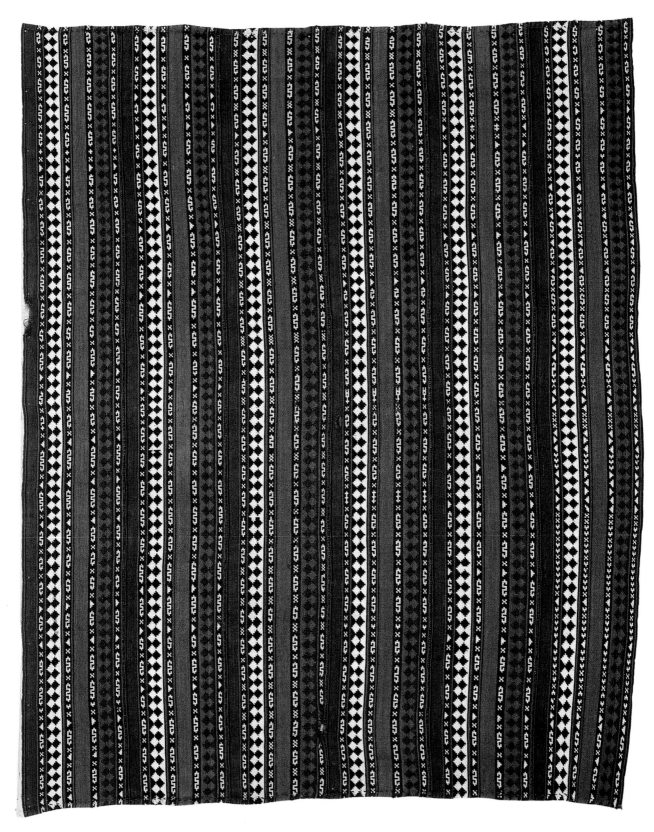

PLATE 207. *Jajim, Hashtrud, Azarbaijan. Late 19th century. All wool. Warp-faced plain weave patterned by warp substitution. Six widths sewn together. 176 x 146cm (5ft.9in. x 4ft.9in.).*

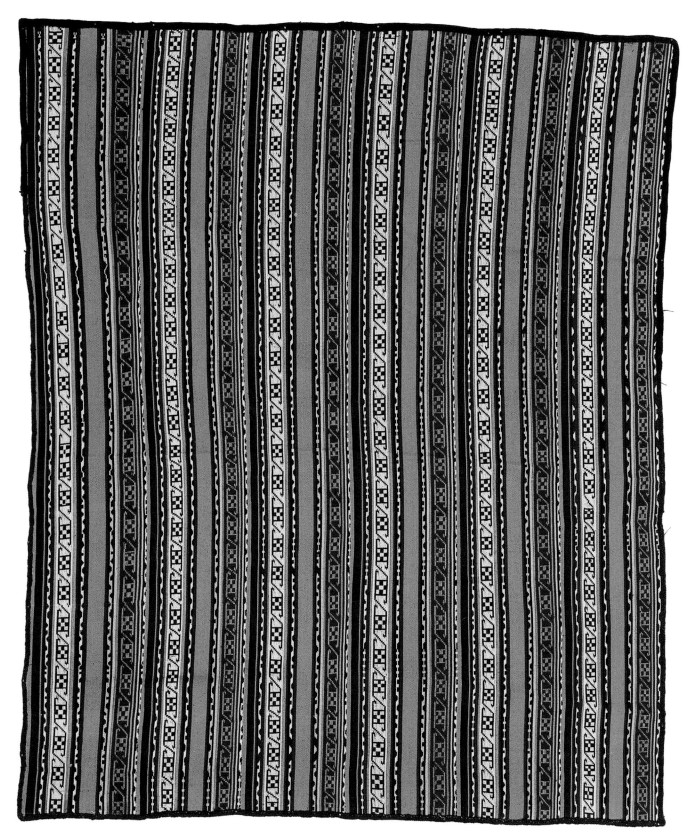

PLATE 208. *Jajim, Hashtrud or Mianeh, Azarbaijan. Early 20th century. All wool. Warp faced plain weave patterned by warp substitution. Eight widths sewn together. 172 x 143cm (5ft.8in. x 4ft.8in.).*

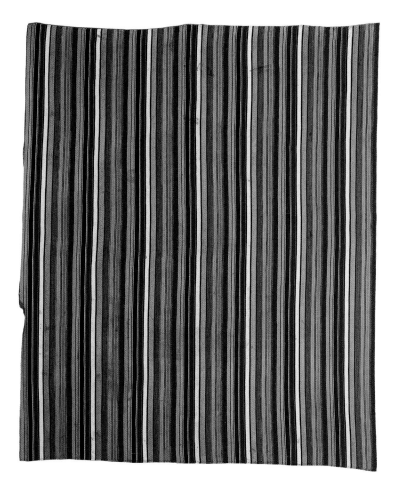

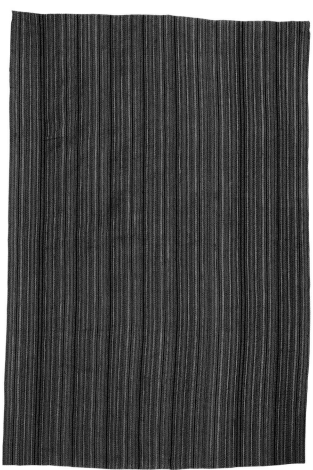

PLATE 209. *Jajim, Takab, Azarbaijan. Late 19th century. All silk. Warp-faced plain weave. Seven widths sewn together. 180 x 151cm (5ft.11in. x 4ft.11in.).*

PLATE 210. *Jajim, Zanjan. Late 19th century. All wool. Warp-faced plain weave. Nine widths sewn together. 256 x 175cm (8ft.5in. x 5ft.9in.).*

Zanjan has also played a major role in the production of *jajims*. One batch of Zanjan *jajims* which is remarkable in every way is the narrow-striped variety. In terms of delicacy and fineness of weave, these *jajims* are incomparable and their quality is akin to clothing fabric. They are also larger than other *jajims* (Plate 210).

Silk *jajims* have been woven in Azarbaijan, but only in very small numbers. In addition to Caucasian Azarbaijan, which has produced some silk *jajims*,[247] other places in Azarbaijan to have produced them include Moghan and Takab (Plate 209).

A small quantity of cotton *jajims* have also been discovered, but their place of production is not known. Their weave seems like the work of Mianeh (Plate 211), but they lack colour, the other factor in the recognition of *jajims*, or exhibit it only in very faint traces. These *jajims* are all based on the two colours of white and light blue and are reminiscent of some *rufarshis*. Blue and white textiles have been produced in several central, southern and eastern parts of Iran (see page 302ff.), but these do not have any connection with the *jajims*.

Despite the cotton products that have come out of Mianeh in the past, most of the *jajims* from here are of wool. Another area of *jajim* is Saveh where some of the pieces shown here were found.

284

PLATE 211. Jajim, Mianeh or Saveh. Early 20th century. All cotton. Warp-faced plain weave. Eight widths sewn together. 170 x 201cm (5ft.7in. x 6ft.7in.).

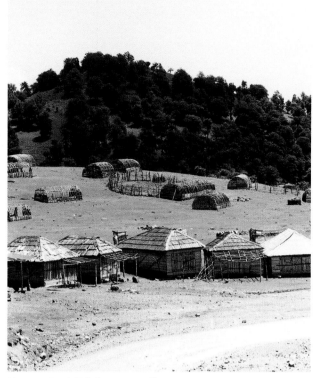

FIGURE 62. *A Talesh summer village.*

THE TALESH AND THE TAT

Talesh is another important area of *jajim*-weaving. Although Talesh is part of Gilan rather than Azarbaijan in Iran, its northern part lies in the Caucasus region and is considered to belong to Caucasian Azarbaijan. In Iranian, or southern, Talesh no floor covering other than the *jajim* is woven.[248] In northern Talesh, which lies outside Iranian soil, *mafrash* and *verneh* rugs and possibly *gelims* as well as the *jajim* are woven; this must be connected with the links between northern Talesh and Moghan.

Like the Tats, the Talesh are of Iranian descent and their language is a Persian dialect not too distant from Tati.[249] Their geographical situation, with the lush forests of Gilan in the western part of their territory and the waters of the Caspian in the east, has helped preserve them down the course of history, keeping them further out of the reach of Turkish and Mongol invaders than were other peoples. Nevertheless, they have plenty of contact with their Turkish-speaking neighbours and as a result almost all of them are bilingual.

Beyond ethnic and linguistic ties, there are similarities in the weavings of these two peoples. The Tats, while far fewer in number than the Talesh, have produced more weavings and *jajims* than them. In most Tat-inhabited areas, such as the villages north of Qazvin, Taleqan, Alamut and Khalkhal (the last within the territory of Azarbaijan), *jajims* similar to the products of the Talesh have been woven. For the most part these *jajims* are patterned, but their patterned sections have a structural weave different from those of the Azarbaijan jajims. This

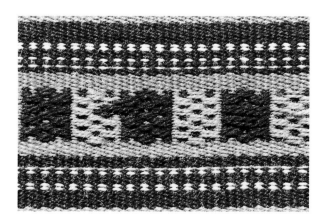

FIGURE 63. *Detail of jajim Plate 212 showing the strips of warp-faced plain weave patterned by warp-faced alternating float-weave.*

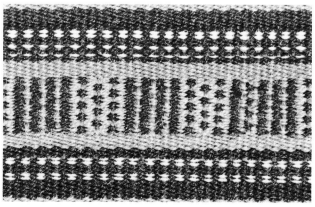

FIGURE 64. *Opposite face of Figure 63.*

286

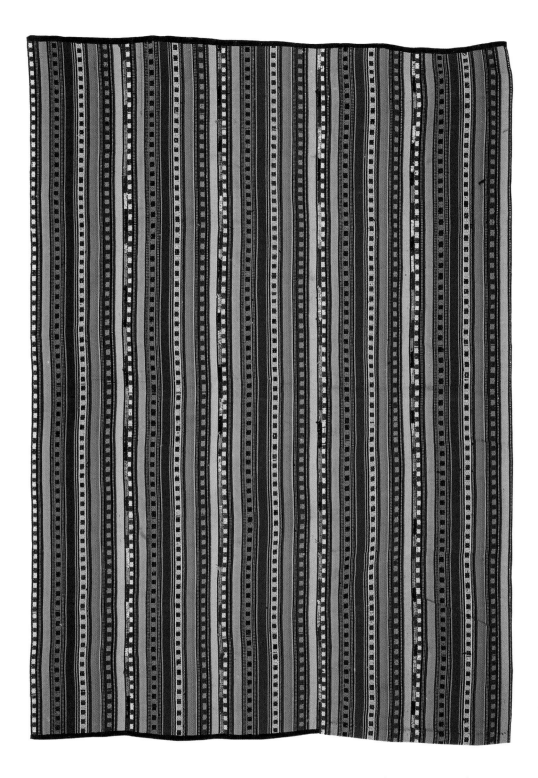

structure can be described as a warp-faced alternating float weave with two sets of contrasting coloured yarn (Figures 63 and 64), a structure which also appears in a large number of Fars weavings and Turkoman and Shahsavan bands. Among dozens of *jajims* with this structure, generally woven in Tat or Talesh territory, I have contented myself with a single example (Plate 212).[250]

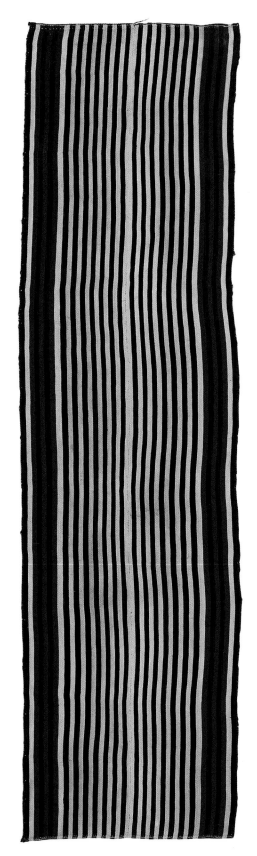

PLATE 213. *Jajim, Qashqa'i, Fars. Early 20th century. All wool. Warp-faced plain weave. Two widths sewn together. 440 x 118cm (14ft.5in. x 3ft.10in.).*

FARS AND BAKHTIARI

A thousand years ago the Arab geographer Ibn Hawqal appraised a variety of textiles produced in Fars, including a group which had achieved worldwide renown as the *jahromi*. One of these pieces, which was long and striped, he calls *nakhakh*. Perhaps it is due to this qualification that some have believed the Arabic *nakhakh* was nothing but *jajim*.[251] It is not easy to come up with any conclusion regarding the word *nakhakh* but, if we were to define the Fars *jajim* today, we could do little better than Ibn Hawqal's definition, as their fine quality and their long format have not been changed.

While Azarbaijan may be Iran's premier source for the *jajim*, Fars and Bakhtiari must undoubtedly be considered a close second and third. The *jajims* of Azarbaijan and Fars fall into two distinct schools. The Fars *jajim* has always been woven in a larger width, with stripes as wide as 60cm to 80cm (24in. to 31in.). Consequently, the Fars *jajim* is a two-piece product in which the two parts are sewn together after being woven. The length of these *jajims* is generally between 4m and 6m (13ft. and 19ft.6in.) and they always bear striped designs (Plate 213). The Fars weavers do not make patterned *jajims* with warp substitution as do their Azarbaijan counterparts. Instead, they weave patterns which are different in structure from their plain ones. While the Qashqa'i Turks call their patterned *jajims* 'jejim', their Lori and Bakhtiari neighbours call such weavings 'mowj'.

MOWJ

Mowj, which means wave, is the name given to a large number of floor coverings in western Iran. The name derives from the wave-like appearance of the structure of this group of textiles. This weave and this category of floor coverings must also be the legacy of Iranian descent, because they have roots and uses primarily among the Gilak, Talesh, Kurdish and Lori people.[252]

Different examples of this form of weaving can be found among the Talesh, Gilak and western Kurds. The dimensions of the pieces woven by the Kurds and the Talesh are generally small and in the range of the *gelimcheh* (see page 164). The most interesting specimens, however, have come from the Bakhtiari Lors and the Turkish and Lori people of Fars.

The most controversial aspect of the *mowj* may be its inclusion within the category of *jajims*. Despite the fact that weavers in Fars call them *jajims* or *mowj*, there are some who are opposed to the name *jajim* for these pieces and prefer to call

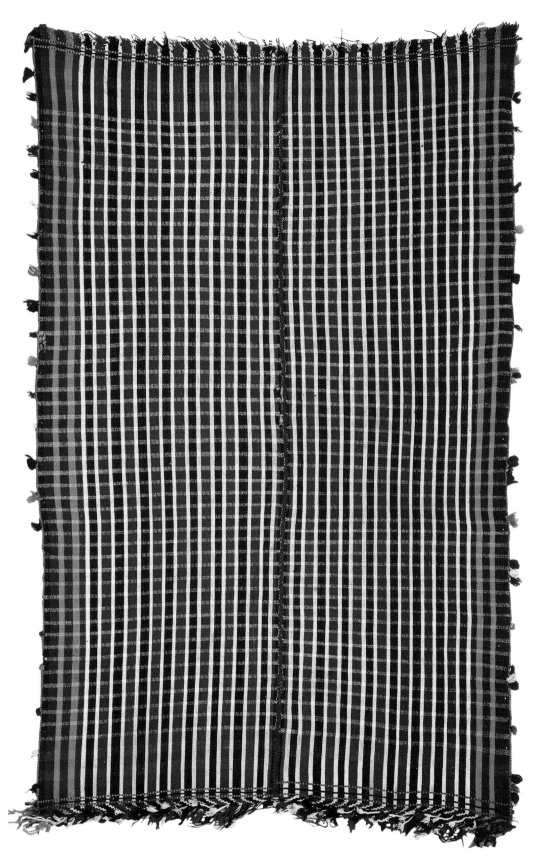

PLATE 214. *Mowj, Qashqa'i, Amaleh. Early 20th century. All wool. Balanced twill weave. Two strips sewn together. 224 x 149cm (7ft.4in. x 4ft.11in.)*.

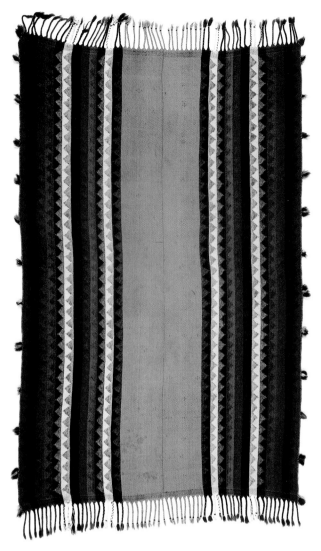

PLATE 215. *Mowj, Qashqa'i, Fars. Late 19th century. All wool. Balanced twill weave. Two strips sewn together. 250 x 164cm (8ft.2in. x 5ft.5in.).*

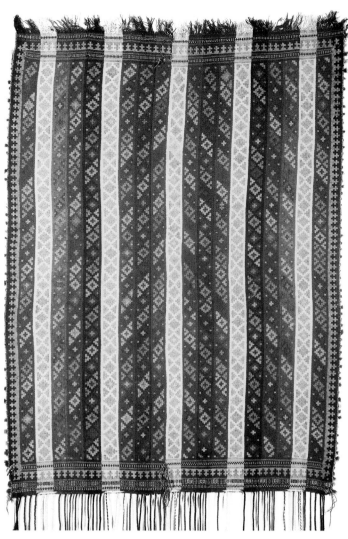

PLATE 216. *Mowj, Qashqa'i, Kashkuli, Fars. Late 19th century. All wool. Balanced twill weave. Two strips sewn together. 228 x 170cm (7ft.6in. x 5ft.7in.).*

them tapestry-like (quasi-*gelims*).²⁵³ The reason is that this weave shows warp and weft equally in the ratio of 2:2 and the patterns are created by both through a balance twill weave. Perhaps 'quasi-*jajim*' might be a more appropriate term than 'quasi-*gelim*'.

It is through this structure that the design and pattern on *mowjes* is far more diverse than that seen on *jajims*. As well as the *jajim's* striped pattern, which is the pattern most commonly used in the *mowj* (Plates 214 to 217), many of the *gelim's* designs have also been worked into the *mowjes* (Plates 218 and 219). The *mowj* could be called the offspring of the union between the *gelim* and the *jajim*.

The Fars and Bakhtiari *mowjes* have several features in common. Their dimensions are roughly 2.5m x 1.5m (8ft.6in. x 5ft.) and they all come in two pieces. The larger *mowjes* are for the most part woven by the Qashqa'i and serve as counterpanes. Unlike the *jajims* of Azerbaijan, the two sides of the *mowjes*, as with the Fars and Bakhtiari rugs and *gelims*, are weft-wrapped neatly and, like their *gelims* and the two ends, braided in net or web fringes.

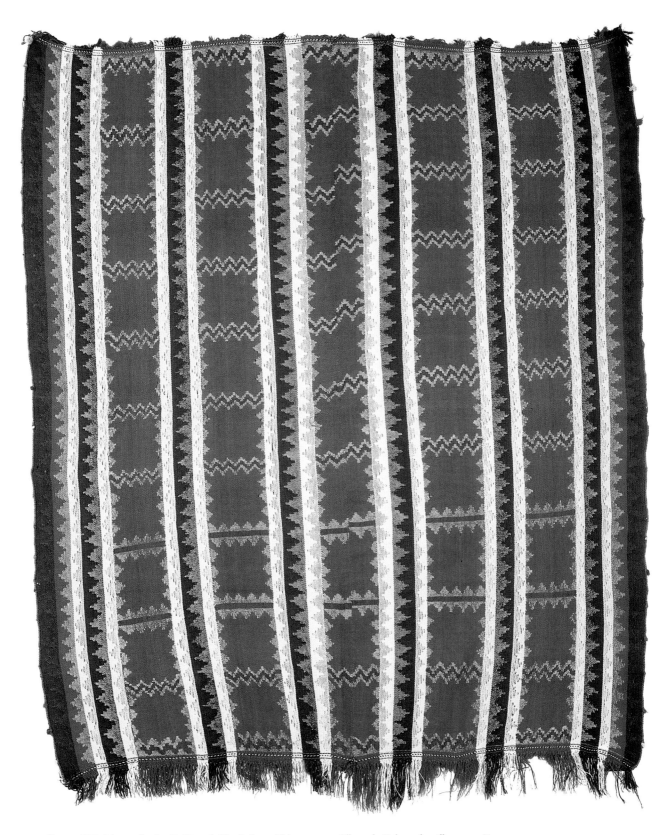

PLATE 217. *Mowj, Qashqa'i, Darreh Shuri. Late 19th century. All wool. Balanced twill weave. Two strips sewn together. 200 x 180cm (6ft.7in. x 5ft.11in.).*

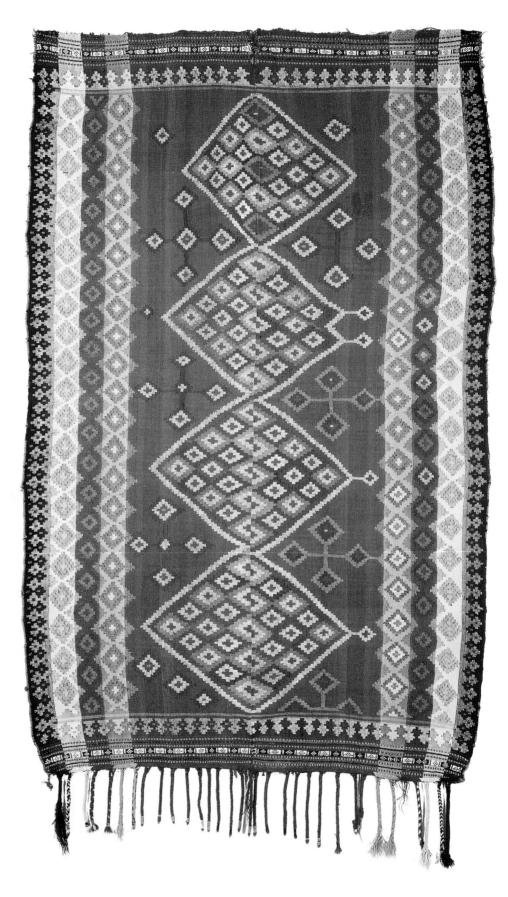

PLATE 218. *Mowj, Bakhtiari, Chahar Mahal. Late 19th century. All wool. Balanced twill weave. Two strips sewn together. 225 x 148cm (7ft.5in. x 4ft.10in.).*

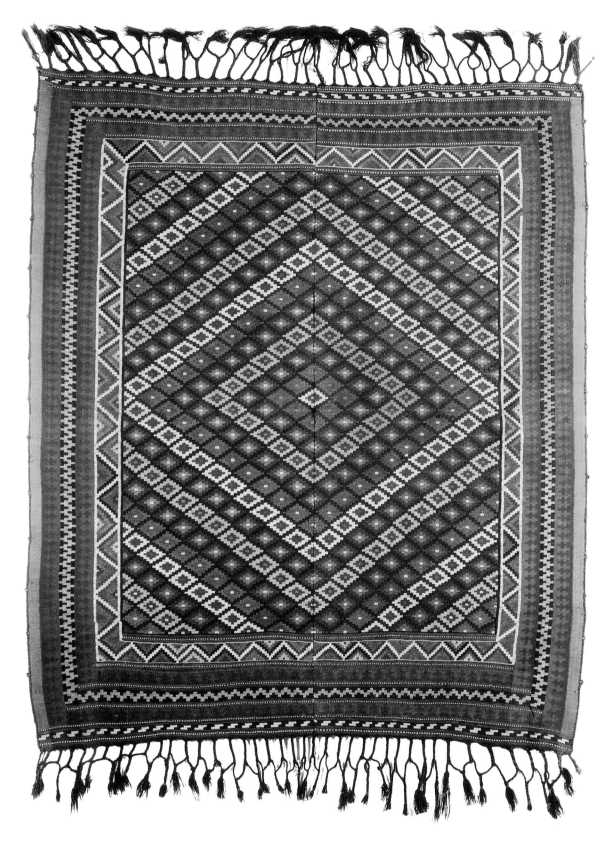

PLATE 219. *Mowj, Lors of Boyer Ahmad, Fars. Late 19th century. All wool. Balanced twill weave. Two strips sewn together. 220 x 198cm (7ft.3in. x 6ft.6in.).*

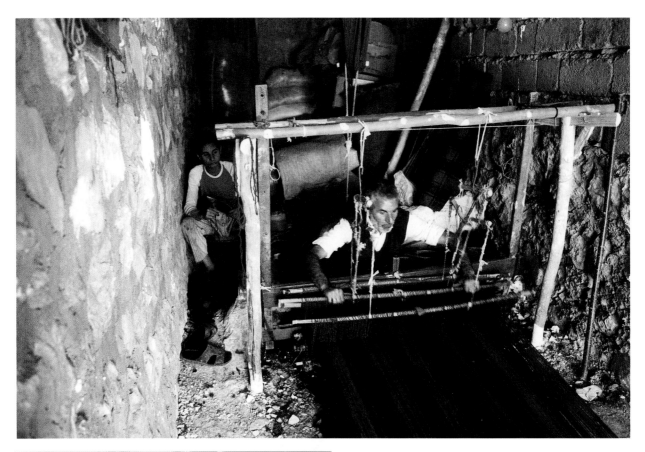

ABOVE: FIGURE 66. *Mowj weaving workshop. Chehelgerd, Chahar Mahal-e Bakhtiari.*

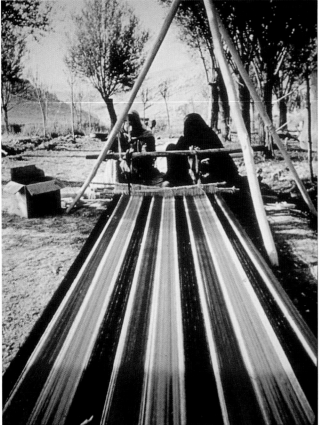

LEFT: FIGURE 65. *Qashqa'i women weaving a mowj, Fars.*

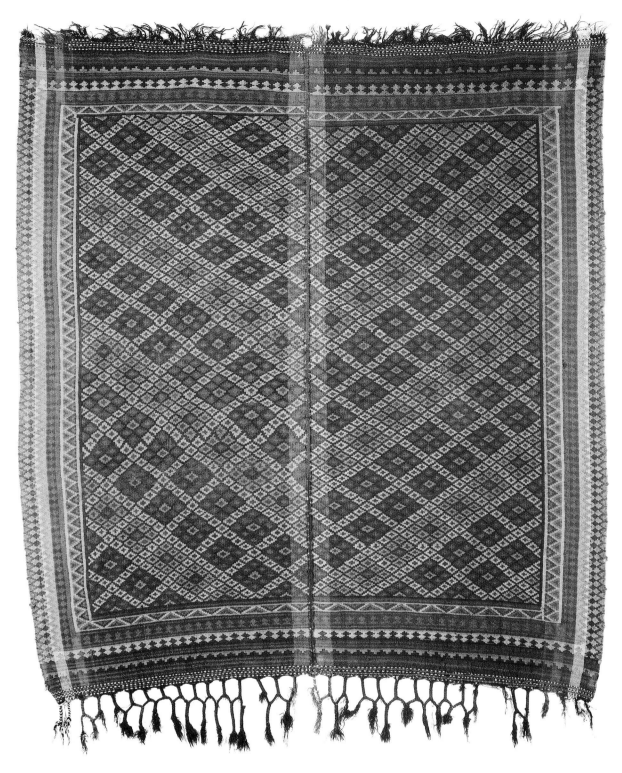

PLATE 220. *Mowj, Lors of Boyer Ahmad, Fars. Late 19th century. All wool. Balanced twill weave. Two strips sewn together. 220 x 210cm (7ft.3in. x 6ft.11in.).*

Another important point about the *mowj* is the fact that it is produced by both men and women. Women weave the *mowj* generally in the open (Figure 65), while men weave it in workshops in Kurdestan, Chahar Mahal and Khuzestan (Figure 66).

SHISHA-DERMA

Another variety of *jajim* is produced in Fars, going by the name of *shisha-derma*. This word, more commonly in use among the Turkish-speaking Qashqa'i, could possibly be a corruption of the Persian *shesh-termeh* (see page 25).

While this weave structure has also been found in Azarbaijan, Fars must be considered its true source. Hundreds and perhaps thousands of shisha-derma pieces have been produced in Fars. Virtually all these textiles are used as *khorjins* or horseblankets.[255] Over the years, as I have observed the weavings of Fars, I have seen only two *shisha-dermas* of the floor-covering variety. One of these is on display in the Carpet Museum of Iran, the other is shown in Plate 221.

Almost without exception, *shisha-dermas* are black and white, woven from very dark blue and undyed ivory wool. I have previously introduced a variety of these under the name of Iranian black and whites in *Hali*.[256] However, the yellow and red variety comprise a separate category. The *shisha-derma* floor covering discussed here must be considered as belonging to this group. This *shisha-derma* (Plate 221) has dimensions similar to those of the *mowj* and also comprises two pieces. The structure of the *shisha-derma* is a warp-faced alternating float weave with two contrasting colours.

The further east we go from Fars, the rarer *jajim*-weaving becomes. In Kerman and beyond there are no *jajims*.

OPPOSITE: PLATE 221. *Shisha-Derma, Qashqa'i, Amaleh, Fars. Late 19th century. All wool. Warp-faced alternating-float weave. Two strips sewn together. 245 x 160cm (8ft. x 5ft.3in.).*

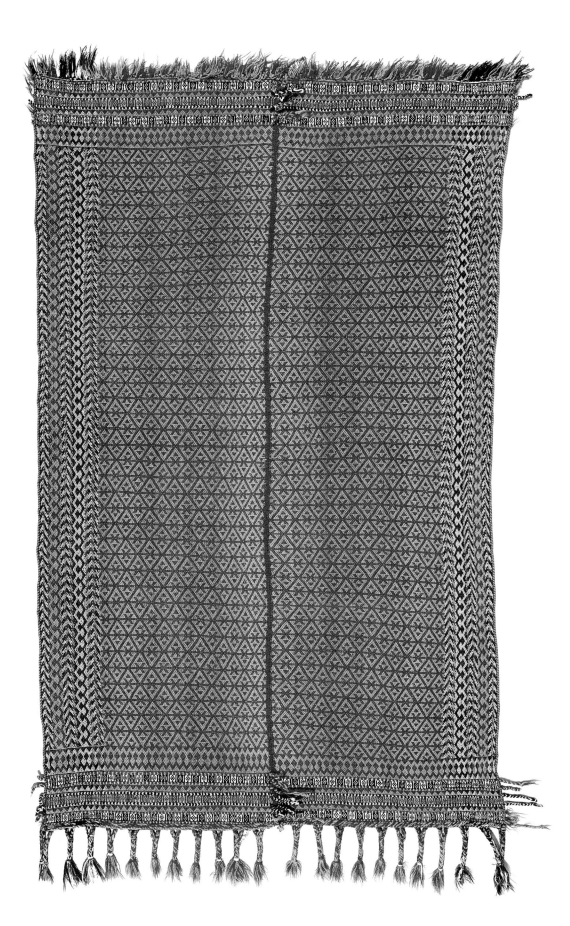

KHORASAN

In contrast with south-eastern Iran, where there is no *jajim*-weaving, Mazandaran, Khorasan and some areas in Afghanistan do produce these weaves. The Turkomans of Mazandaran are familiar with it and use it as a horsecloth. No Turkoman floor covering of the *jajim*-weave variety is known to exist. The Uzbeks of Afghanistan use this weave for a variety of *palas* and sew together bands of all-over patterned *jajim* in large dimensions and call them *ghujeri* (Qajari? – perhaps related to Qajar Turkoman?).[257]

It may be said that the eastern parts of Khorasan have more *jajim*-weaving than any other area due to the presence of the Kurds who emigrated from Azarbaijan (see page 208). At least two types are woven by the Kurds in this area. The first can easily be placed in the Azarbaijan school, since everything about it – size, design, pattern – resembles the Azarbaijan variety (Plate 222). The layperson would be unable to distinguish it from the Azarbaijan *jajim*, but it should not be forgotten that the weave in Kurdish *jajims* is coarser than the Azarbaijan variety, and experts will also recognize the difference in colour schemes.

The second variety is those *jajims* that must be considered part of the Khorasan school. These are generally larger than the *jajims* in the first group and their designs and colour schemes differ greatly. Generally they are produced by sewing together four broad bands. While these *jajims* are also striped, their stripes are broader than those in the first group and their colour scheme is limited to two colours, namely dark blue and dark red (Plate 223). The only ornaments in these *jajims* are scattered motifs executed in weft-wrapping.[258]

One other kind of *jajim* that comes to us from Khorasan differs in every respect from the Kurdish variety. The weave and colour scheme of this *jajim* (Plate 224) recall the workmanship of the Kurds and the plain sections are particularly reminiscent of Kurdish *jajims*. Its patterned section, meanwhile, has a structure similar to weavings (particularly *jols*) produced by the Kurds of Bijar and the weavers of Fars. The unanswered question is whether, after the passage of so much time, one can still rely on these features as criteria for tracing the origins of this group.

OPPOSITE: PLATE 222. *Jajim, Kurds of Khorasan. Mid-20th century. All wool. Warp-faced plain weave patterning by warp substitution. Five widths sewn together. 190 x 230cm (6ft.3in. x 7ft.7in.).*

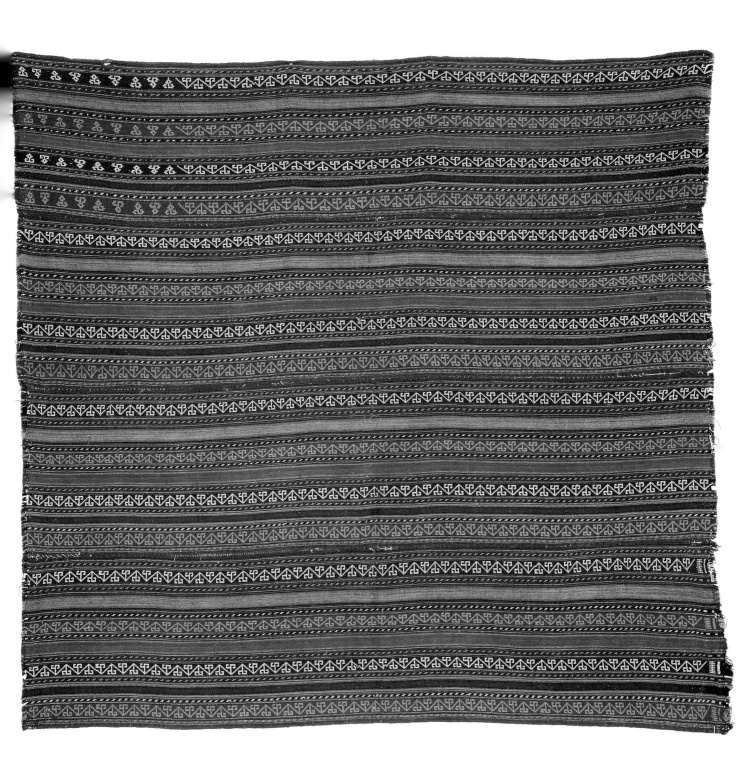

299

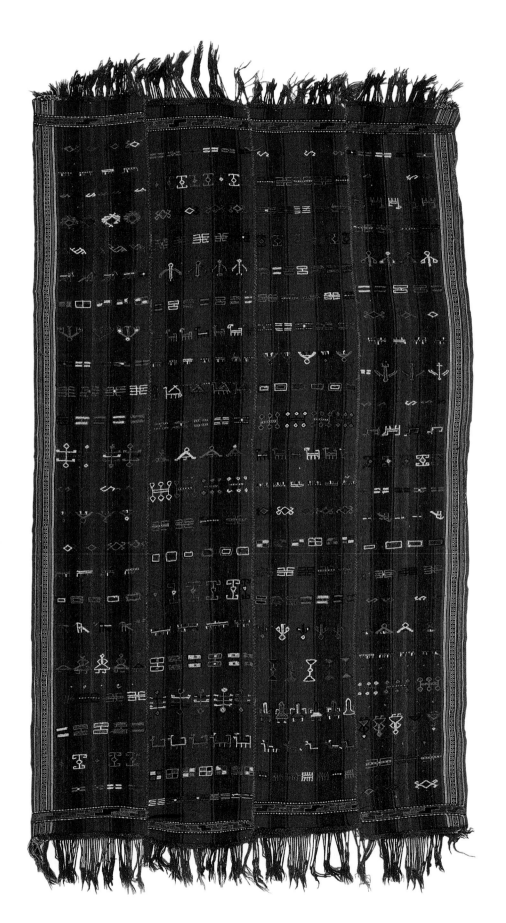

PLATE 223. *Jajim, Kurds of Khorasan. Early 20th century. All wool. Warp-faced plain weave patterned by weft wrapping. Four strips sewn together. 306 x 190cm (10ft. x 6ft.3in.).*

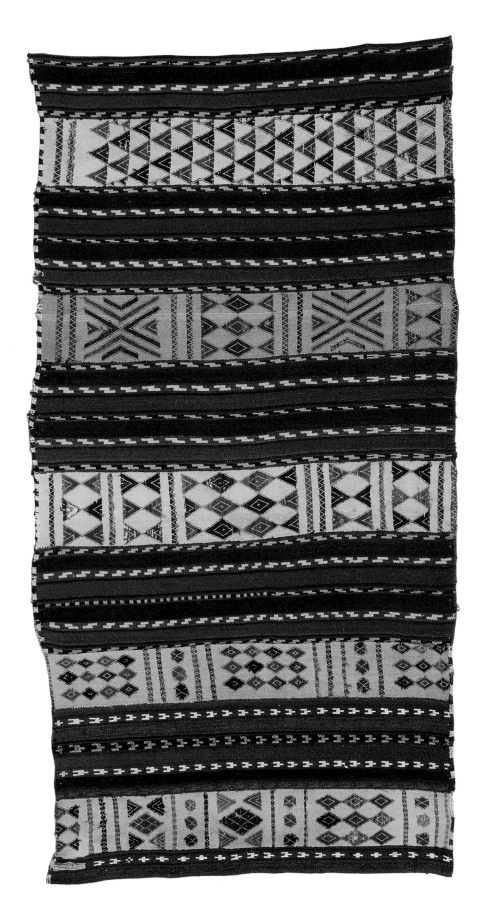

PLATE 224. *Jajim, probably Kurds of Khorasan. Late 19th century. All wool. Warp-faced plain weave patterned by weft substitution and weft-float brocading tied down on the face of the fabric. Ten widths sewn together. 122 x 234cm (4ft. x 7ft.8in.).*

301

CARPET ON CARPET

One of the fading traditions of Iran is the practice of spreading one carpet upon another. Not only will the demise of this tradition signal the termination of a variety of Persian rug, but it will also represent the end of the customs that accompanied this practice – customs generally related to hospitality and the reception of guests.

The special respect accorded to guests by Persians resulted in the creation of a separate rug from that on which the host himself sits. This rug, known as a *rufarshi* (carpet on carpet), was spread on the rug for the guest to sit on. There were several varieties of the *rufarshi*. One of these was the *masnad*, rolled out for kings and other notables (see page 309). The size, dimensions, material and weave of the *rufarshi* and the *masnad* varied greatly. The *masnad* was woven in a small size as a seating for one, whereas the *rufarshi* was a long runner spread along the side of the room, or tent, where the guests would sit. The *masnad* was often of silk and had a delicate and fine weave or stitch, whereas the *rufarshi* was either of cotton or wool and usually of a simple weave. The most exquisite patterns, in colourful tones, were executed on the *masnad*, while the rufarshi exhibited a plain design, generally striped, and with no more than a few colours.

Although the production of the *rufarshi* has ceased almost completely, the traditions and customs connected with it have endured. People who live without chairs and tables still fold a blanket or bedsheet and spread these at the edges of the reception room. Arriving guests are led to these floor coverings so that they will be seated on a softer and cleaner spot than usual and will also have a backrest to recline against. Once all the guests are seated and resting against the wall or cushions provided for them, the host sits at the end of the room near the door, in a spot devoid of a *rufarshi* or backrest, and bids his guests welcome. This tradition endures in some mosques and *hosayniyehs* in areas of southern Iran such as the Kavir region. Along walls and the edges of the mosque is spread a narrow *rufarshi* for guests to sit on.

The rufarshi has another use as well. During summer, when sunlight is bright, the *rufarshi* is spread over valuable rugs in order to protect their colour against damage from the sun. Dehkhoda has provided the best definition of the term: *Rufarshi* is a textile of wool, canvas or cotton, spread over the floor covering in a room to protect expensive rugs from exposure to sunlight and the tread of feet or to conceal their defects, and its uses can change according to the season.[259] The point that Dehkhoda has raised concerning the changing function of the *rufarshi* is an important one. The *rufarshi* can be either of cotton or of wool. The cotton variety is used in summer so that, in addition to the uses that Dehkhoda has pointed out, it can protect against moths attacking the rug. In desert areas, in the hot months the *rufarshi* is also spread over woollen carpets for it is far cooler and more pleasant than wool. In Azarbaijan and the Zagros area, on the

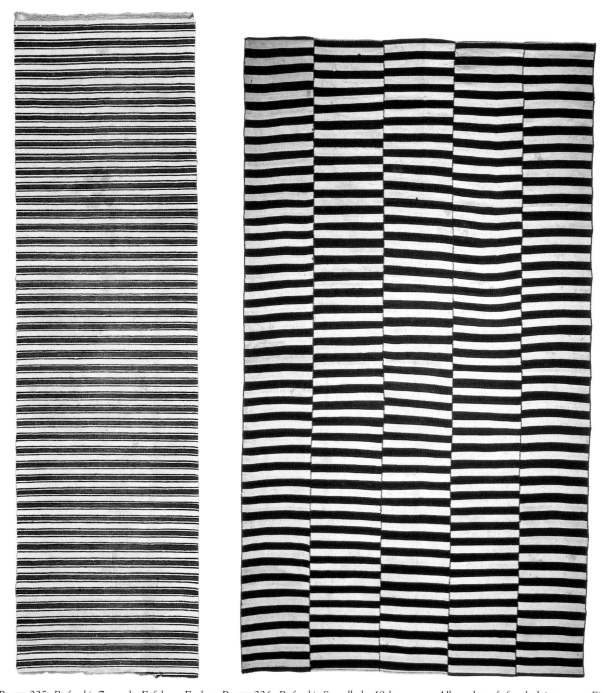

PLATE 225. *Rufarshi, Zavareh, Esfahan. Early 20th century. All cotton. Weft-faced plain weave. 229 x 65cm (7ft.6in. x 2ft.2in.).*

PLATE 226. *Rufarshi, Savadkuh. 19th century. All wool, weft-faced plain weave. Five strips sewn together. 403 x 226cm (13ft.3in. x 7ft.5in.).* VOK COLLECTION

other hand, the woollen *rufarshi* enjoys greater popularity (Figure 72).

The *rufarshi* has always had – and continues to have – a simple or striped pattern. The only writer to have drawn attention to the pattern of the *rufarshi* has been Shahri, who called it striped.[260] The *rufarshis* that survive, and those that are woven today, also bear such a pattern.

The structure in the limited number of *rufarshis* that remain from former times is weft-faced plain weave (Plates 225 and 226), the same structure used for

rufarshis today. The existence of some warp-faced plain-weave cotton *jajims* raises the possibility that some *jajims*, especially the cotton variety, functioned as *rufarshis*. A photograph from the late nineteenth century shows *rufarshis*, which appear warp-faced, spread end-to-end over the valuable and expensive rugs in one of the Qajar Palaces (Figure 67). Although it is not easy to judge the structure of these *rufarshis* from a photograph, their long stripes resemble the *jajim's* warp-faced plain weave. The existence of some cotton *jajims* can serve as additional evidence to substantiate this theory (see, for example, Plate 211).

In contrast to the *gelim*, the *palas* and the *masnad*, the writers of the past have not paid great attention to the *rufarshi*. The only textual source that this writer has been able to find is an allusion by Sadid al-Saltaneh, a Qajar notable, who observed this textile being woven in Qeshm in 1896.[261] It is probable that in the more distant past the term *rufarshi* was used in the same way as such generic names as *afkandani*, *gostardani* or *besat*, all three meaning 'floor covering'.

FIGURE 67. *Striped rufarshi covering the carpets of one of the Qajar Palaces, Tehran. Photographed at the turn of the 20th century by Anton Sevruguin.* ARTHUR H. SACKLER GALLERY, WASHINGTON DC

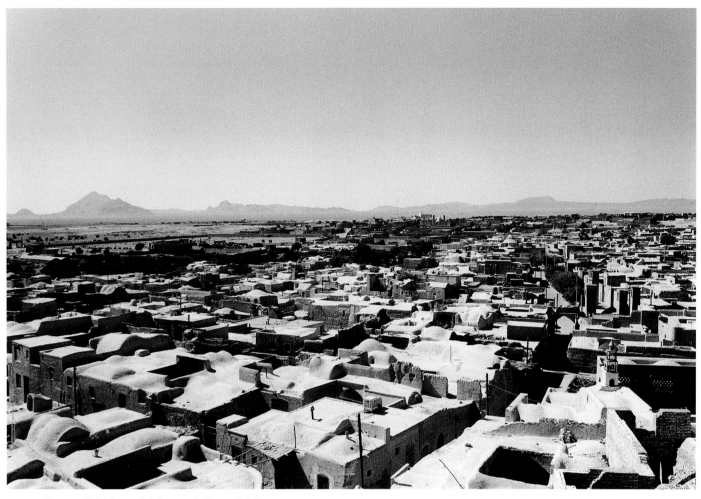

FIGURE 68. *Village of Mohammadiyeh near Na'in*.

ZAVAREH, MOHAMMADIYEH

In all probability, at one time the production of *rufarshis* flourished almost everywhere in Iran. Some places of course, acquired a greater reputation than others as producers of *rufarshi*. One of the regions that had a large share in their production was Zavareh (see Figure 44). This town, situated 15 kilometres (9½ miles) from Ardestan and at the edge of the Kavir, is an ancient desert settlement. Its Friday mosque was built in the twelfth century and is carpeted with *zilus* and a few *rufarshis*. The *rufarshis* of Zavareh are all of cotton and bear striped blue and white patterns. They were woven in long narrow cuts, 10m (33ft.) long and 60cm (24in.) wide, and would have been cut up and used according to the wishes of the purchaser. A fragment of a Zavareh *rufarshi* appears in Plate 225.

Another place famous for its production of the *rufarshi* was Mohammadiyeh, a village a few kilometres from Na'in (Figure 68). The enlargement of the town of Na'in in recent years has made the two adjacent. Mohammadiyeh must be called a textile village. Until recently most of its people were involved in weaving of various kinds. Now, however, there are no more than a hundred weavers left in the village, and of these only two weave *rufarshis* while the rest are engaged in

FIGURE 69. *Inside of an underground rufarshi and aba weaving workshop in Mohammadiyeh.*

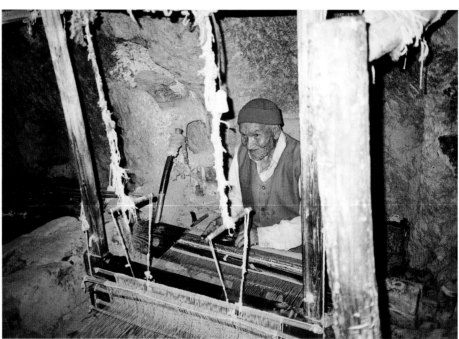

FIGURE 70. *Old master at work, weaving rufarshi, Mohammadiyeh.*

weaving robes *(abas)*. Of the thirty-five textile workshops in operation until recently, half have now been shut down; in the others old men sit behind the looms. These weavers must represent the last generation of *rufarshi*-weavers, for no young men are to be found among them. All are over sixty years old, and there are even eighty- and ninety-year-olds manning the looms.

The textile workshops are located by a hill called Gawdalu, in cavities dug into the hill. Each of these pits is the entryway to a workshop, which is reached by climbing down a stairway 4m (13ft.) into the ground. There, in a room carved into the earth, men work behind their looms (Figures 69 and 70). Each workshop is about 4m (13ft.) 5m to 8m (16ft.6in. to 26ft.) in length. This

306

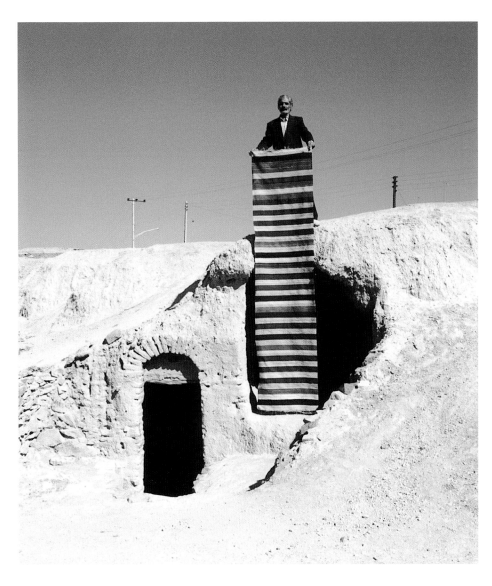

FIGURE 71. *Rufarshi made in Mohammadiyeh, 1995.*

limited space is put to optimal use, with several looms in operation. The smallest workshops contain four draw looms, while the larger ones can hold up to sixteen. Most of these looms now sit idle, and as each weaver dies another machine is abandoned.

Of the two weavers in Mohammadiyeh who weaved *rufarshis* in the mid-1990s, one was eighty-seven and the other over one hundred years old and blind and deaf. The *rufarshis* made by these two have undergone many changes over the years: now their material comprises left-over wool and snippets from Na'in rugs, and the pieces themselves are a combination of wool and cotton. Their weave, however, remains as delicate and precise as ever. These *rufarshis* are not put to the same use as those in the past were. After they are woven, they are sewn at the centre and sold like *gelims*, although they retain the name *rufarshi* (Figure 71).

Rufarshi-weaving is in its last gasp in most of Iran. The last *rufarshis* of Zavareh were woven during the past thirty years. In Mohammadiyeh, too, there is no demand for them and with the death of the last weaver the Mohammadiyeh *rufarshi* will die out as well.

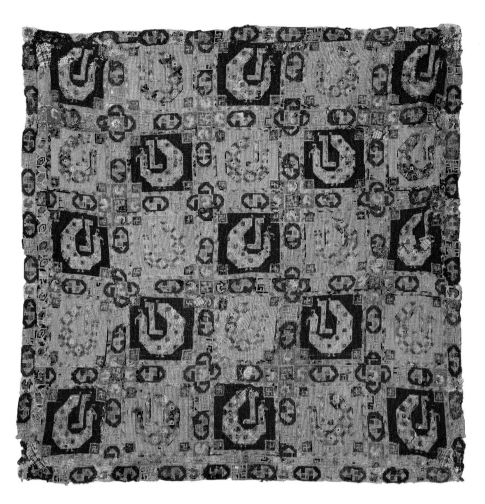

PLATE 227. *Suzani, masnad, Azarbaijan. 17th century or earlier. Silk embroidery. 56 x 55cm (1ft.10in. x 1ft.10in.).*
KIRCHHEIM COLLECTION

Several factors have been responsible for such a demise, one of which is the fact that women do not participate in *rufarshi*-weaving. They once produced the raw material for the *rufarshi*-weavers by spinning yarn, but have abandoned spinning for *rufarshi* since the Na'in rug became fashionable and a greater source of income. Another factor is the cost of the *rufarshi* in comparison to machine-made products such as blankets and other fabrics which can perform the same functions. And, finally, the uses to which the *rufarshi* was traditionally put no longer feature in most people's lives. Production of cotton goods in the Kavir area too has long ceased and the mode of living has changed as well.

FIGURE 72. *Rufarshi, Shahsavans of Moghan. Late 19th century. All wool. Slit tapestry weave. Width 43cm x about 10 metres (17in. x 33ft.).*

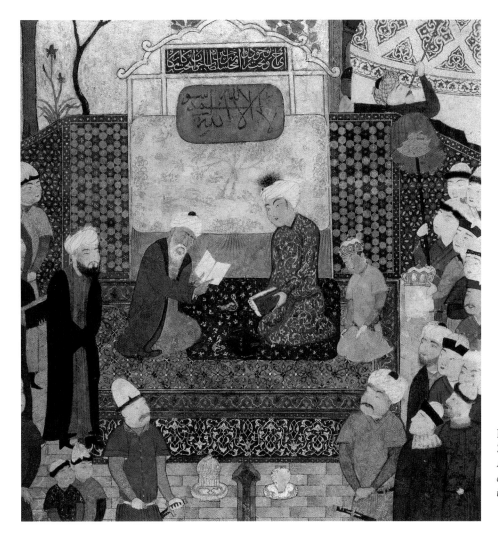

FIGURE 73. *Coronation of Sultan Hosayn Mirza Bayqara. Attributed to Mansur. Herat, c.1469. Opaque watercolour, ink and gold on paper.*

THE ART AND HISTORY TRUST
COLLECTION

In a few towns in Azarbaijan and Kurdestan *rufarshis* are still woven, but they are solely for local use; there is no demand in the towns or the rug markets. It should be noted that the Turks refer to their *rufarshis* as *palases*. As explained on page 202ff., they call any striped, unpatterned textile a *palas*, even as they use them as *rufarshis*. However, the existence of a single old *rufarshi* bearing striped patterns but various colours, and exhibiting a fine quality of weave, is a testament to the existence of this tradition among them in the past (Figure 72).

MASNAD

Older paintings which depict rugs associated with kings and princes often show a smaller rug spread on top of the larger one. This smaller rug was (and still is) called a *masnad* and was the seat of royalty (Figures 73 to 75). A verse from Khwajavi Kermani (1298-1352) refers to the placement of the *masnad* over the rug:

> He has spread the rug and [atop it] laid the *masnad*;
> He has reclined on the *masnad* as a flower upon the grass.

Persian dictionaries define the *masnad* as 'something upon which the king sits or against which he reclines'.[262] The word is synonymous with the Persian *shah-neshin* (Shah's seat), which is still used. Even today in Iran, whenever an

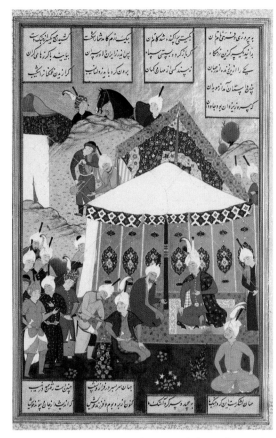

بر پروزی ودست منی قلم / بیک زمرم زن شکار زآن
برانیک پی کرزین زرنگا / پس نیز زایران لاوسپا
یک را ز ین نمدولتیاب / نه مندکسی زصاحی گمان
چنی پستان آمد وزموبدان / بیدرون کرد یا بزولتیاب
کرا زمین ملکنا نایب

جهان سربسربوزاره یوشت / خنی ست زلزغبه زرنسب
گون زنیبه روم وفزبیوش / کرایمیث ازجان یونذنجش
مان لشکر نست این کرد نگک / بمجید وسپکرد آنگک
مان لشکر نست این کرد نگک

FIGURE 74. *Preparing for the Joust of the twelve Rooks. Attributed to Mirza 'Ali. Tabriz c.1530. Opaque watercolour, ink gold on paper.*

THE ART AND HISTORY TRUST COLLECTION, FOL. 339 OF THE SHAH TAHMASB SHAHNAMEH

important visitor arrives he is led to the highest place in the room. Regardless of the size of the house, this is designated the *shah-neshin*. Depending on the owner's means this spot is decorated with cushions and wall hangings, while on the floor is spread a more valuable rug. Polak, who spent the years 1851-1860 in Iran, observed this custom.[263] There is a similar tradition among the tribes as mentioned further on (see page 312).

Masnad-weaving was commonplace as recently as the beginning of the twentieth century, before European décor (i.e. chairs) had supplanted traditional layouts of Persian homes. Some older rug salesmen still refer to smaller, more delicate rugs as *masnads*. Today, however, *masnad*-weaving has died out throughout Iran, with the exception of Azarbaijan.[264] The small, delicate pieces that appear in books and journals as Azarbaijan embroidery belong to this same group. Needless to say, the fact that *masnads* were intended for kings is fully borne out by Persian literature. Persian dictionaries, particularly the older ones, define the *suzani* as a small *masnad*, placed at the head of the room, the seat of kings and great men.[265] These pieces are distinguished by their small, suitable for one, individual size and by their patterns and superior execution.

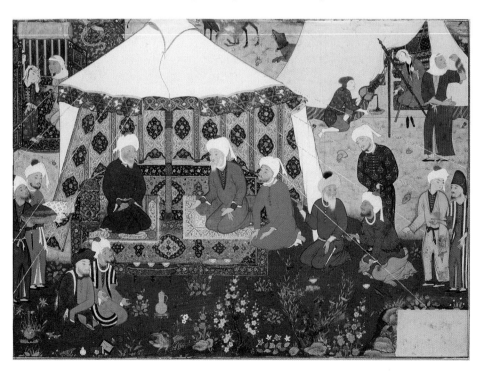

FIGURE 75. *Life in camps, detail from Nezami Khamseh, showing wise men sitting on a* masnad. *Persian miniature painting by Seyyed 'Ali, Tabriz 1540.*

FOGG ART MUSEUM, HARVARD UNIVERSITY, CAMBRIDGE, MASS.

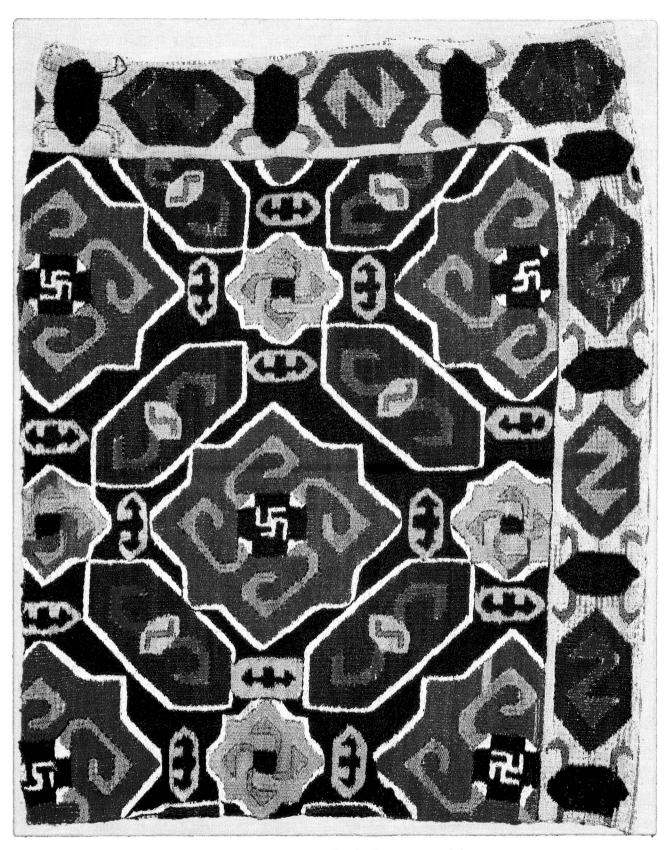

PLATE 228. *Suzani, masnad, Azarbaijan. 18th century or earlier. Silk embroidery. 64 x 60cm (2ft.1in. x 2ft.).*

KIRCHHEIM COLLECTION

Not all *masnads*, however, were for kings or of the *suzani* variety. It is not unlikely that some of the small tribal and Afshari rugs.[266] as well as a group of fine pile rugs known as *suf* and the square *vernehs* (Plate 229), played the role of the masnad for khans. We do not presently have complete information on these *masnads,* as research still continues. One puzzling detail is the discovery of several *masnads* with incomplete borders. The borders on the pieces found in this batch do not go all the way around the edges and seem unfinished. Although I have not examined these pieces myself, I believe they were not left incomplete but were intentionally made that way (Plate 228). Meanwhile, paintings from the past few centuries show *masnads* with unfinished borders. In one of these, a group of wise men and ascetics is shown gathered around a tent under two men of a higher status, while the two *masnads* are spread on the ground at some distance from each other. Both these *masnads* have unfinished borders, and it seems that the artist has deliberately stressed the unfinished aspect of the borders and the fact that they were not fragments. What we do not know is what is signified by these unfinished borders. Are the surviving unfinished *masnads* of the same kind as those in the painting? If so, what is intended by the incompletion of the borders? Were borders on *masnads* symbols of the throne and the realm, the sole prerogatives of kings? Or did men of religion, clerics and Sufis sit on *masnads* with unfinished borders as a mark of humility?[267]

Another noteworthy feature is a verse by Hafez that actually is woven in on one of the *masnads* (Figure 75). Here the poet rebukes those who boastfully occupy the seats of authority without possessing any of the requirements, save for physical symbols such as the *masnad:*

> Bravado is no qualification for reclining on the seats of the great [masnad],
> Unless one provide for all the means of greatness.

Bayhaqi (995-1077) seems to indicate that princes followed a certain protocol for sitting on *masnads* (Figure 75). He has given us the following description of how the Ghaznavid princes (sons of Sultan Mahmud) were seated:

> And in those days I saw them seated thus. Rayhan, Amir Mahmud's servant, led them in. He ushered in Amir Mas`ud first and seated him upon the *sadr [masnad]*. Then he brought in Amir Mohammad and placed him at the right hand of the first, such that one of his knees rested outside the *sadr* and the other knee upon the *nehali [masnad]*. And he brought in Amir Yusuf and seated him outside the sadr on the left.[268]

The *masnad* is best described as a small, square rug with a fine and superior weave that was designed for spreading on top of another rug. It was found primarily in the homes of the wealthy, especially those that witnessed greater activity, and was used only on special occasions. Royal *masnads* were of the *suzani* variety and made of silk.

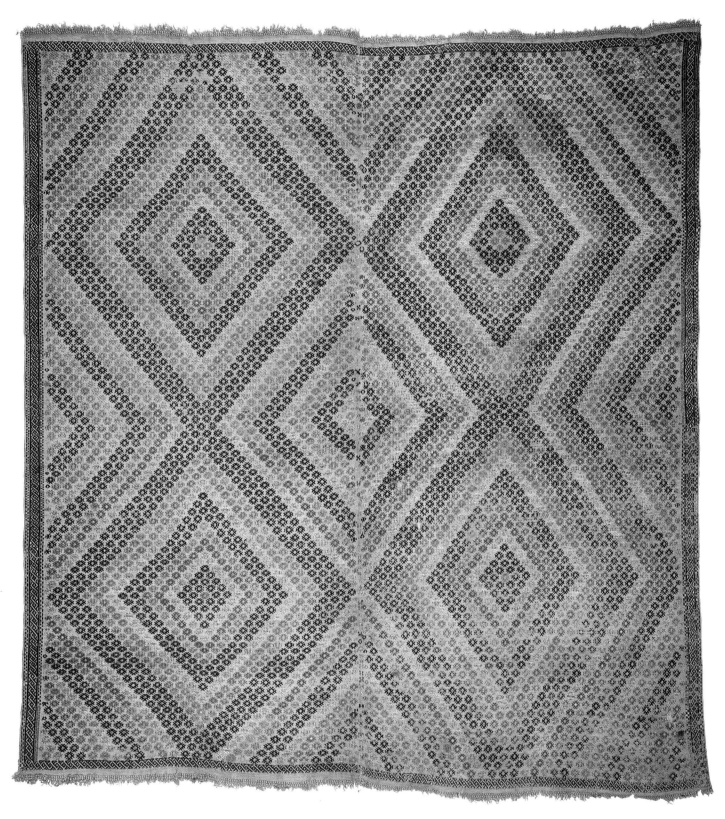

PLATE 229. *Masnad, south Caucasus or Shahsavan of Moghan. Late 19th century. All wool, balanced plain weave patterned by extra weft-wrapping. Two strips sewn together. 168 x 158cm (5ft.6in. x 5ft.2in.).* VOK COLLECTION

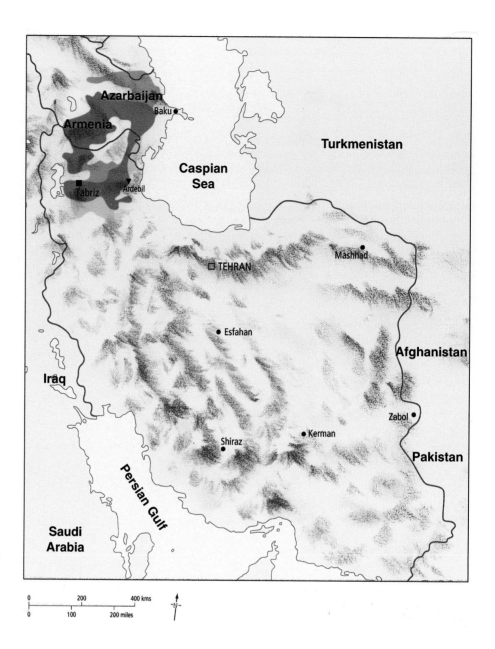

Suzani area.

SUZANI

Although these pieces do not technically fit in the category of weavings, being considered stitchings, I have devoted a section to them here because they are used as floor coverings. Besides, they provide a better understanding of a culture which uses flatweaves in the same manner.

Some Persian lexicons have defined the *suzani* as a small *masnad*, where men of status sit. At the same time, the term *suzani* is used more generally in Iran and refers to several varieties of needlework, as well as to a variety of weft-wrapped textiles, particularly the more delicate ones that resemble embroidery (see page 237ff.). In the West, however, *suzani* is the name given to the embroidered fabrics as well as those of Uzbekistan. Were it not for the historical sources which distinguish the various types of *suzani*, perhaps the status quo could be left undisturbed. But, as will be shown, renaming of certain textiles seems in

order. The term *suzani* appears in Persian sources from at least the tenth century onwards. From the details concerning the type of fabric, it seems that these references could only be the selfsame embroideries of Azarbaijan. It appears from the sources that these fabrics have long served royal needs, both as floor coverings and as clothing. One of the most telling of these references is found in a decree by the Safavid Shah Tahmasb, issued in 1540, concerning the reception of the Mughal emperor, Humayun. Shah Tahmasb stipulated what floor coverings were to be used for the royal tent where the Indian king would be entertained, and these include *suzani* rugs.[269]

Even older than Shah Tahmasb's decree are travelogues from the early years of Islam which refer to *suzani* as *suzankard* (meaning the same thing). One of these is *Hodud al-`alam*, which makes reference to the *suzankard* of Qarqub[270] (Khuzestan). Another is by Estakhri (first half of the tenth century) who has compared the *suzankard* weaving of Fasa (Fars) with that of Qarqub and found the former to be superior,[271] reminding his reader that the Fasa variety was worn by kings.[272] In both these works *suzankard* is mentioned as clothing material for royalty, but elsewhere *Hodud al-`alam* makes a distinction between the *suzankard* as fabric for apparel and another kind which may have been a floor covering: '…from the Khuzestan region…come various items of clothing and fabrics for wall hangings and suzankards…'[273] Other sources highlight the special partiality that kings had for this fabric. Some even had in-house workshops set up for its production. The allusions to silk *suzankard* are an important clue in learning more about them. The specimens that we have, dating from the seventeenth century onwards, are all of the superior, royal make. Among them are both clothing[274] and floor coverings. The designs worked into them reflect the interests and tastes of kings, such as images of cypress trees and princely captor and prey scenes (Plates 230 and 231).

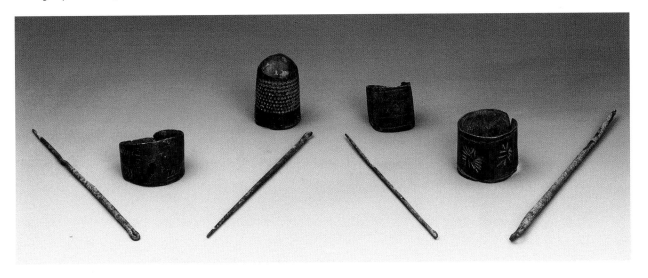

FIGURE 76. *Bronze needles and thimbles. Lorestan, first millennium BC.* PRIVATE COLLECTION

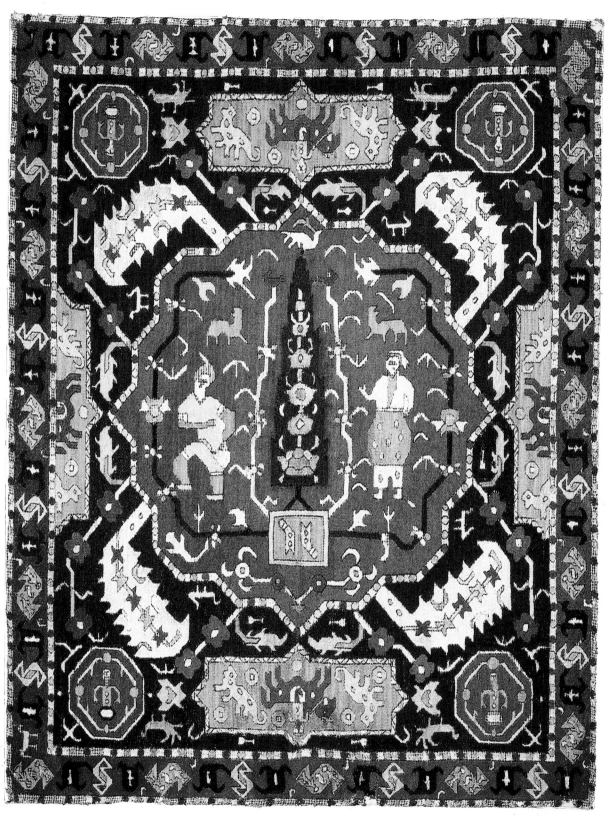

PLATE 230. *Suzani, probably masnad, Azarbaijan. 17th century or earlier. Silk embroidery. 93 x 72cm (3ft.1in. x 2ft.4in.).*

KIRCHHEIM COLLECTION

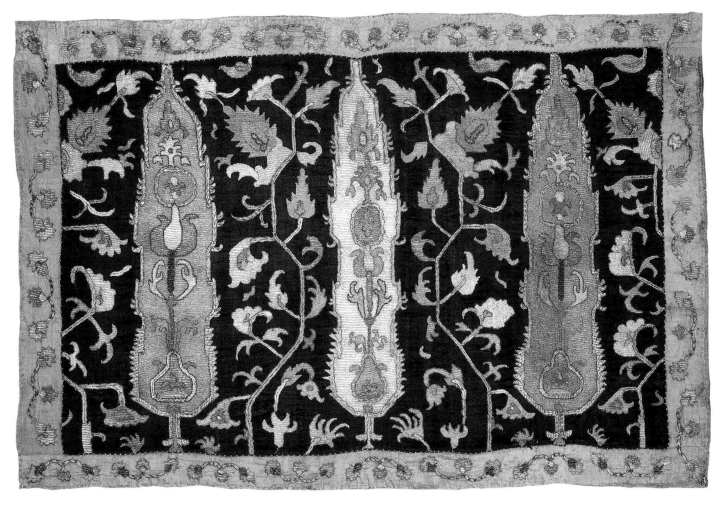

PLATE 231. *Suzani, probably masnad, Azarbaijan. 18th century. Silk and silver strip embroidery. 66 x 101cm (2ft.2in. x 3ft.4in.).*

KIRCHHEIM COLLECTION

Using size and dimensions as criteria, the *suzanis* used as floor coverings should be divided into two groups: *masnads*, which are squarish and intended for a single user (see page 309), and larger, more common non-*masnad* floor spreads which were smaller in dimension than rugs and *gelims*. In every respect *suzanis* have to be viewed as different from other flatwoven pieces, because in terms of quality, designs, patterns and execution they are superior, unsurprising given that they were intended for royal use. For more than a hundred years they have excited the interest of rug scholars and museums.

Jennifer Wearden examined the royal *suzanis* in depth in a comprehensive article.[275] These were made in the Caucasus and Azarbaijan and belong to the Safavid era (Plates 228 to 233). Continuity of the tradition can be found in eastern Iran and in Afghanistan. In northern Afghanistan, among certain groups of Uzbeks and Tajiks, the *suzani* rugs are still made and still bear that name.[276] These *suzanis* are distinct from their weft-wrapped rugs. Other than Afghans, some groups of the Baluch also make *suzanis*, especially the Baluch of the Khash area.

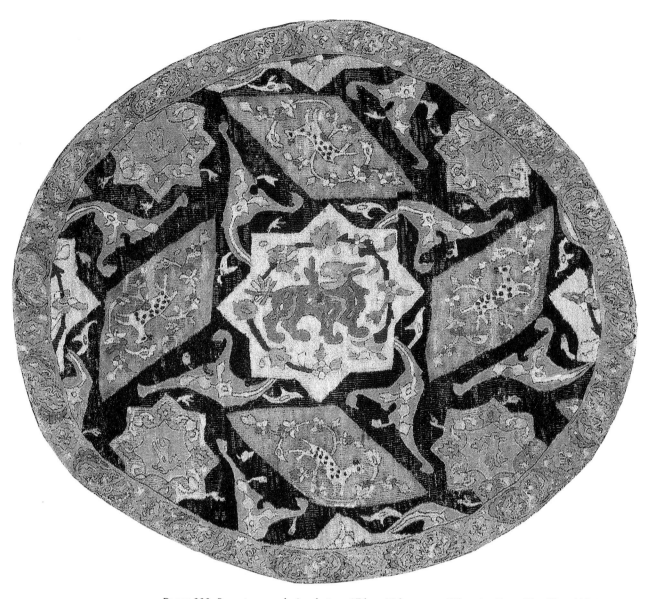

PLATE 232. *Suzani, masnad, Azarbaijan. 17th or 18th century. Silk embroidery. 88 x 77cm (2ft.11in. x 2ft.6in.).*
KIRCHHEIM COLLECTION

The use of the term *suzani* for weft-wrapped textiles must be attributed to the similarity between the two. Both are among the most delicate of textiles, and it seems that both were used by kings and people of wealth. They generally came together and, in today's parlance, were set together. If the tent, awning or *masnad* of the king was of the *suzani* variety, the floor covering in the tent of Khans and tribal chieftains would be of the weft-wrapping kind. It is not unlikely that such a use for the word *suzani* for weft-wrappings, which is current among all Persian-speakers, can be explained by these similarities.

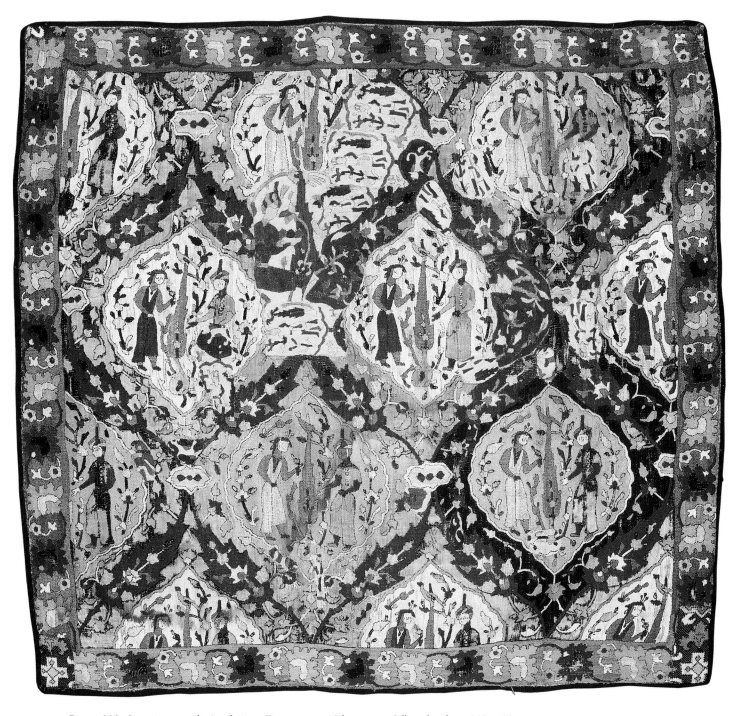

PLATE 233. *Suzani, masnad, Azarbaijan. First quarter 18th century. Silk embroidery. 112 x 99cm (3ft.8in. x 3ft.3in.).* VICTORIA & ALBERT MUSEUM, LONDON INV. NO. 975-1889

FIGURE 77. A Persian woman
behind a divider pardeh with a
Seneh gelim. Photographed
towards the end of the 19th
century and published in Dr.
Walter Schulz, Zustande im
Heritigen Persien wie sie das
Reisenbuch Ibrahim Begs
enthullt. Leipzig, 1903, p. 45.

HANGING FLATWEAVES

My intent in including this section is to discuss those flatweaves that served
as *pardeh* (hangings) prior to their use as floor coverings and those floor
coverings which were also used for other purposes.

PARDEHS

Although the *pardeh* does not fit into the category of floor coverings and is
generally used as a hanging on walls, I devote this section of the book to it
because in all probability some of the flatweaves which today we call floor
coverings were used as hangings or *pardehs* in the past. We know for certain that
some *gelims* and *jajims* served both as *pardehs* and as floor coverings (Figures 77
and 78). One variety of hanging that has come to us from the Caucasus has been
identified recently as the *shadda* (Plate 239).[277] Another group is generally
recognized by the slit or slits in the hanging, allowing for movement back and
forth (Plates 234 and 236). Not all *pardehs* are door hangings. A large batch
among them are shelf coverings designed to be spread over the niches worked
into interior walls. These niches are common in rural and small-town homes

PLATE 234. *Pardeh, Bijar, Kurdestan. Late 19th century. All wool. Slit tapestry, weft-faced plain weave.*
215 x 140cm (7ft.1in. x 4ft.7in.). Inscription: see page 326. COLLECTION OF THEO HABERLI

and are used for the storage of vessels and other objects, serving the same purpose as cupboards, closets and chests in city homes.

Among the flatweaves, those with pictorial quality were most probably used as *pardehs*. The production of pictorial *pardehs* and *gelims* has been specific to the Shi'ite Iranians. The making and weaving of pictorial hangings called for mastery, skill and familiarity with pictorial arts. The bringing together of all these elements was possible in city workshops. Tribal peoples, none the less, have also tried for certain pictorial *pardehs*. As pointed out in the introduction to this book, tribal and village weavings, and even their themes, were not far removed from their urban counterparts. Just as city-dwellers were partial to pictorial themes on their wall hangings, both because of the visual pleasure they afforded and the opportunities they provided for the narrating of interesting stories to children, so were villagers and tribespeople. Pictorial *vernehs* depicting herds of camels and goats, or *vernehs* depicting dragons, served such functions for them.

One of the places famous in the past for its *pardehs* was Barda'[278] (see page 238 and page 245). Although nothing now remains of it, the area in which Barda' was situated and which is called Qarabagh to this day remains the centre of pictorial *vernehs*. The continuity of this tradition can also be traced in Fars, in a category of rugs known as the thousand-bird variety which may also have served the functions of *pardehs*.[279]

There were many non-pictorial *pardehs*. A large number of them, attributed to the Caucasus, have been given the name

PLATE 235. *Pardeh, Qeydar, Khamseh of Zanjan. Early 20th century. All wool. Slit tapestry, weft-faced plain weave, patterned in lower end by weft-float brocading. 245 x 98cm (8ft. x 3ft.3in.).*

FIGURE 78. *Interior of a Shahsavan tent in the foothills of the Sabalan Mountains, showing a* pardeh *dividing the sleeping area from the rest of the tent. Photographed by Nasrolla Kasraian in the 1990s. This example is made of cloth, but flatweave dividers were used until recently.*

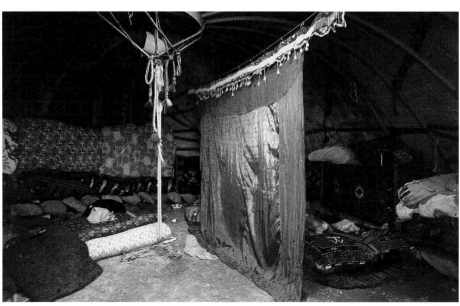

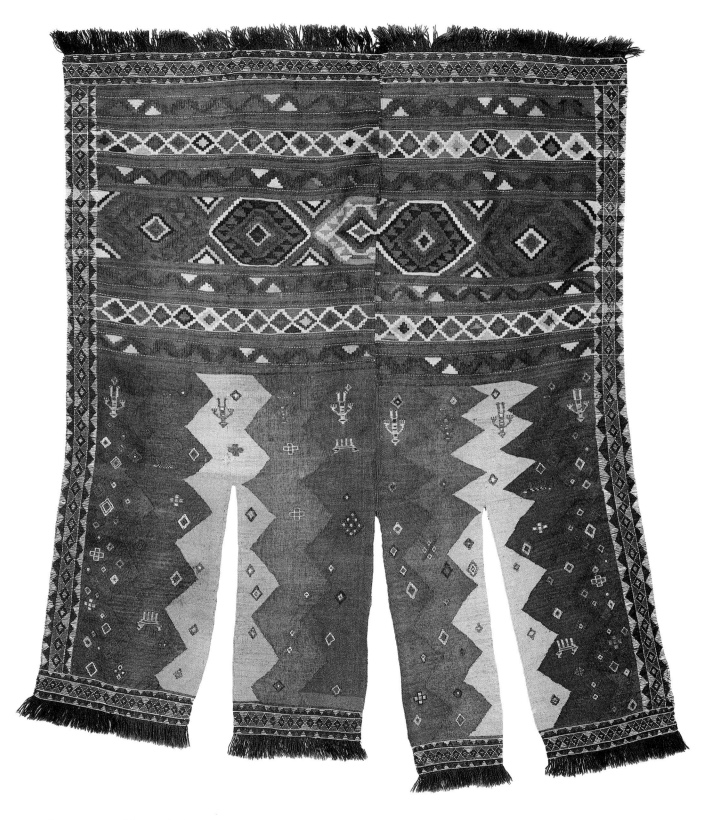

PLATE 236. *Pardeh, Qarabagh, Caucasus. c.1900. All wool. Slit tapestry and weft-faced plain weave patterned in certain areas by scattered weft-float brocading. Two strips sewn together. 155 x 130cm (5ft.1in. x 4ft.3in.),*

COURTESY ADIL BESIM

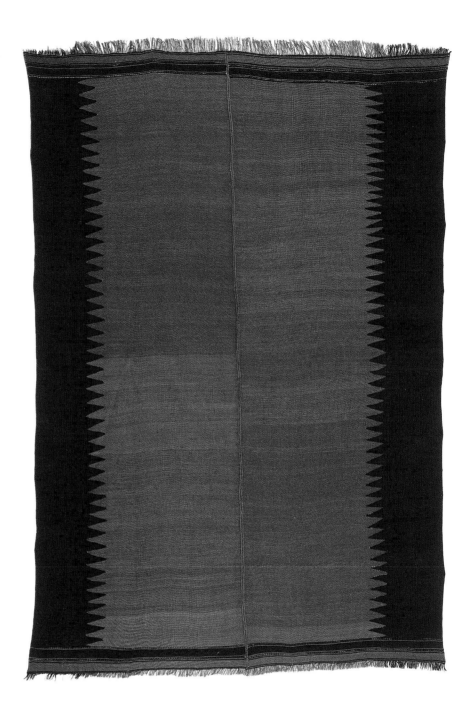

PLATE 237. *Pardeh, Moghan, Azarbaijan. Mid-19th century. All wool. Inclined slit tapestry, weft-faced plain weave. Two straps sewn together. 243 x 162cm (8ft. x 5ft.4in.).*

shadda, which is one of those corrupted words that the Turks have preferred over *pardeh* (see page 25). In Persian, *shadda* refers to the neatly braided tassels at the two ends of a rug.[280] The Azarbaijan and Caucasian *shaddas* or *pardehs* generally have this feature (Plate 235). These *pardehs* also exhibit simple geometric designs with bright, gay colours. If we take the neatly braided tassels at the two ends of this floor covering as a basis for identifying a *pardeh,* it is possible that the *mowjes* (Plates 215 and 216) and the *shisha-dermas* (Plate 221) were originally *pardehs.* Aside from these, it seems that any floor covering or *gelim* could be turned into a *pardeh* in case of need. There is an interesting quotation from Ghazzali (1058-1111) in this connection: 'Rabe'a said, Wait for an hour, and commanded that a *gelim* be hung as a *pardeh.*'[281] *Gelims* of the floor-covering

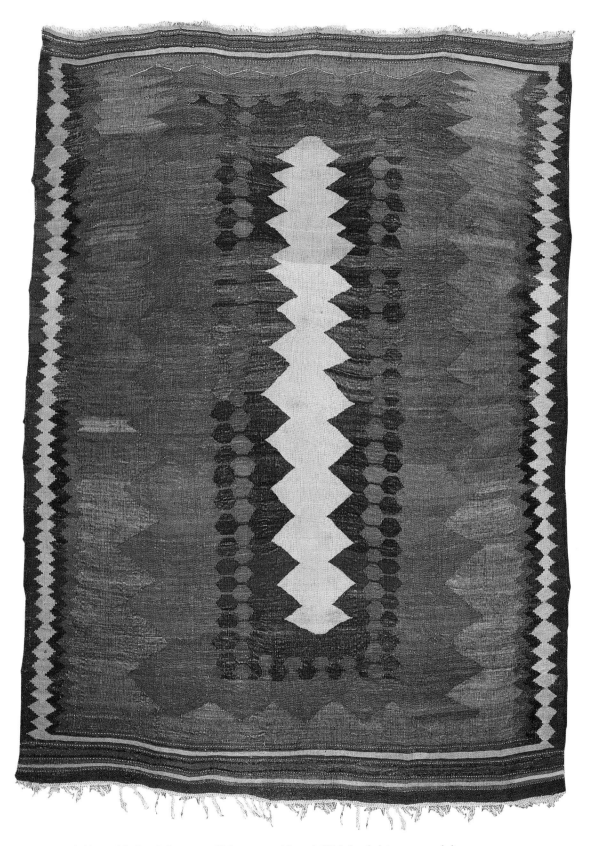

PLATE 238. *Probably pardeh, South Caucasus, 19th century. All wool. Weft-faced plain weave and slit tapestry. 290 x 202cm (9ft.6in. x 6ft.7in.).*

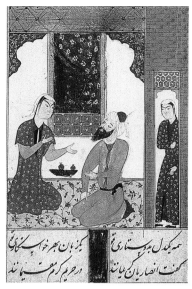

FIGURE 79. Asking for the Hand of Aynie. *Detail of a Persian miniature painting from a Selselatozzahab of Jami. Note the use of a* pardeh *on the window. Probably Khorasan c.1570-80. Opaque watercolour and gold on ink on paper.*
THE ART HISTORY TRUST COLLECTION.

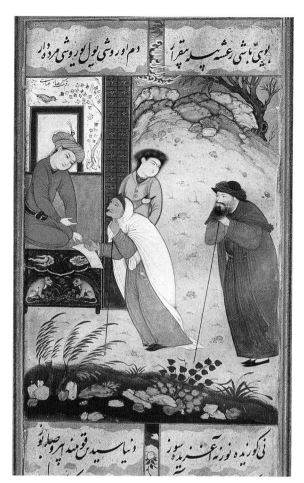

FIGURE 81. An Old Man Teaches a Divine Lesson. *Detail of a Persian miniature painting showing a* pardeh-*selling shop. Copied by Mir Emad, illustrations signed by Reza Abbasi. Esfahan, dated AH 1023 (1614).*
THE ART AND HISTORY COLLECTION

variety have also been hung as *pardehs* (Figure 77). There are numerous allusions to *pardeh*-hanging (*pardeh bastan*) in Persian literature. Most of these are in connection with the arrival of guests or strangers. It was for the peace and comfort of these people – as well to protect the women of the home – that a *pardeh* would be hung. Thus, *pardeh* began to assume more figurative meanings as well, and 'a woman within so-and-so's *pardeh*' marked her as belonging to that person's household or harem.[282]

Despite the different meanings and uses of the pardeh, there is one piece about whose functions as a *pardeh* there is no doubt, shown in Plate 234. This *pardeh* comes in a pair; at the upper end is a verse which confirms its function as a *pardeh*. It is possible that this *pardeh* once hung at the entrance of a khanaqah, because the verse is Sufi-like in language and sentiment:

The seat of my longing and the delight of mine eyes is thine abode;
Be thou kind and descend, for thine is the home.

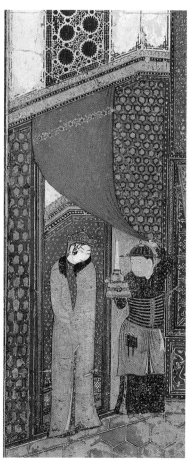

LEFT. FIGURE 80. Tahmina Enters Rustam's Chamber. *Detail of a Persian miniature painting. Note the use of a* pardeh *curtain on the door. Probably Herat, c.1434-40. Opaque watercolour, ink and gold on paper.*
HARVARD UNIVERSITY ART MUSEUMS (ARTHUR M. SACKLER COLLECTION).

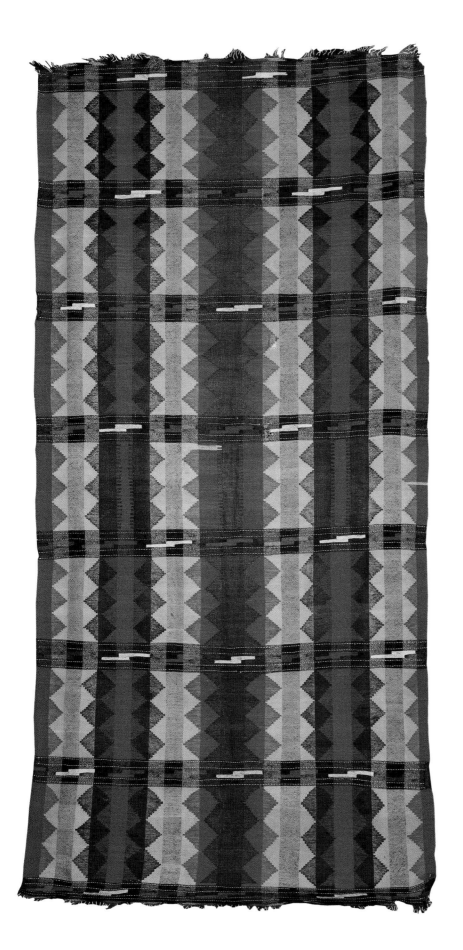

PLATE 239. *Possibly pardeh.*
South Caucasus. Late 19th
century. All wool, balanced
twill weave. About 270 x
150cm (8ft.10in. x 4ft.11in.).

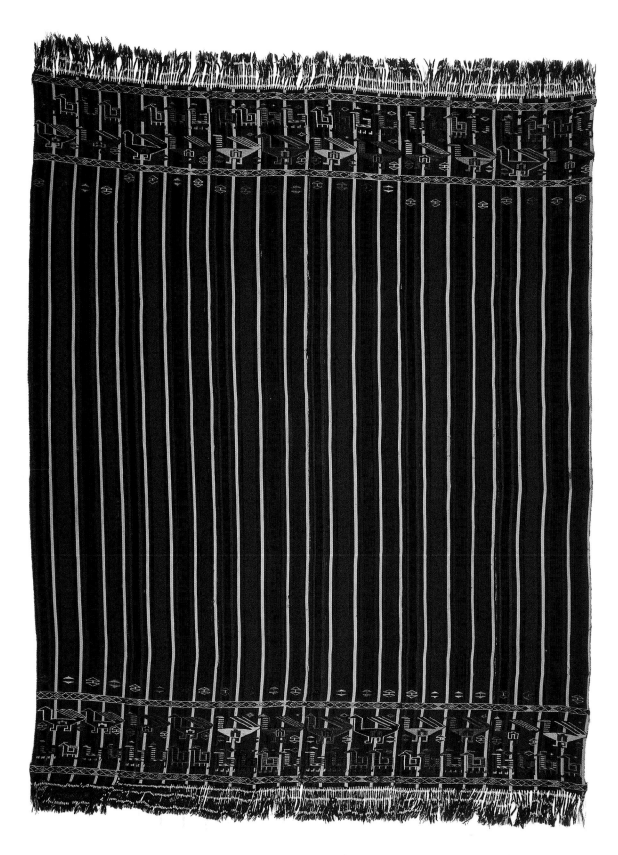

PLATE 240. *Probably pardeh, Hamamlu, Azarbaijan. c.1800. All wool. Warp-faced plain weave patterned in lower and upper areas by extra weft-wrapping. 260 x 215cm (8ft.6in. x 7ft.1in.).*

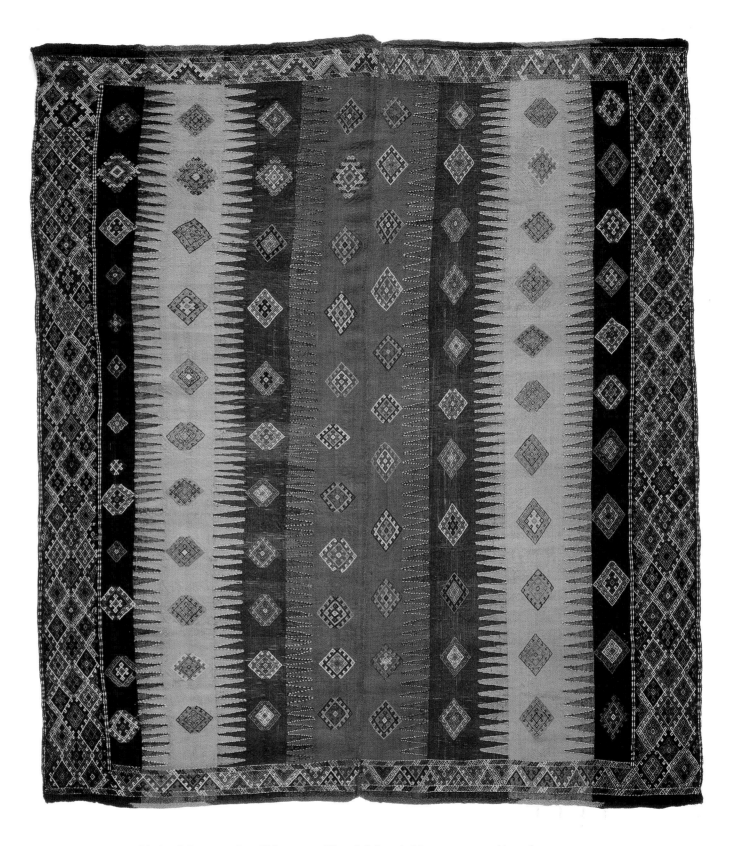

PLATE 241. *Pardeh, South Caucasus. Late 19th century. All wool, balanced plain weave patterned by weft-float brocading. Two strips sewn together. 216 x 189cm (7ft.1in. x 6ft.2in.).* VOK COLLECTION

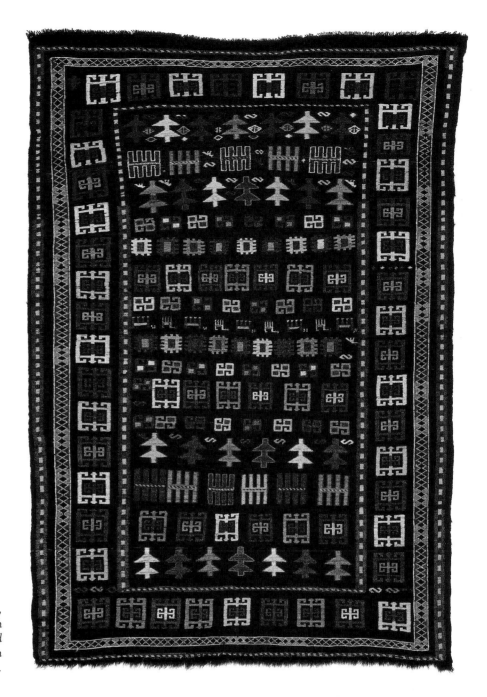

PLATE 242. *Probably pardeh, Qarabagh, Caucasus. Late 19th century. All wool. Balanced plain weave patterned in certain areas by extra-weft wrapping. 175 x 122cm (5ft.9in. x 4ft.).*

TOMB COVERS AND COFFIN COVERS

Flatwoven floor coverings served other functions as well as wall hangings. One such use was the covering of tombs; as discussed earlier, the Iranian kings set aside the most delicate of flatwoven pieces, and certain silk *gelims* as coverings for the tombs of the imams (see page 44). Another closely related use is that of a coffin cover.

Iranians make coffins in the simplest possible fashion, without the use of patterns. While the coffin is being moved, however, it is draped in the most beautiful of fabrics. Villagers and tribespeople, who have no access to such fabrics, usually spread a *gelim* or a *pardeh* over the coffin.

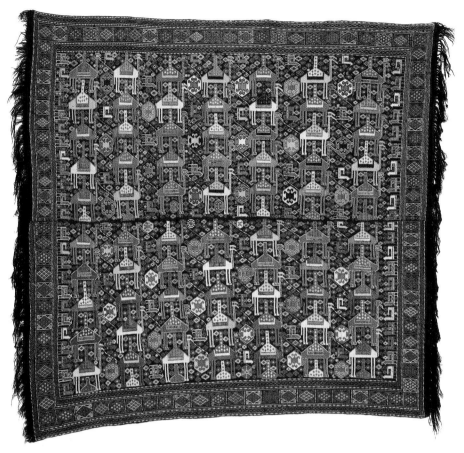

PLATE 243. *Probably pardeh, Qarabagh, Caucasus. Mid- to late 19th century. All wool. Balanced plain weave patterned in certain areas with extra-weft wrapping and weft-float brocading. Two straps sewn together. 187 x 177cm (6ft.2in. x 5ft.10in.).*

PLATE 244. *Pardeh (hanging), south Caucasus, possibly Qarabagh. Early 19th century. Wool and goat hair, weft-faced plain weave patterned by extra weft-wrapping. Two strips sewn together. 252 x 160cm (8ft.3in. x 5ft.3in.).* VOK COLLECTION

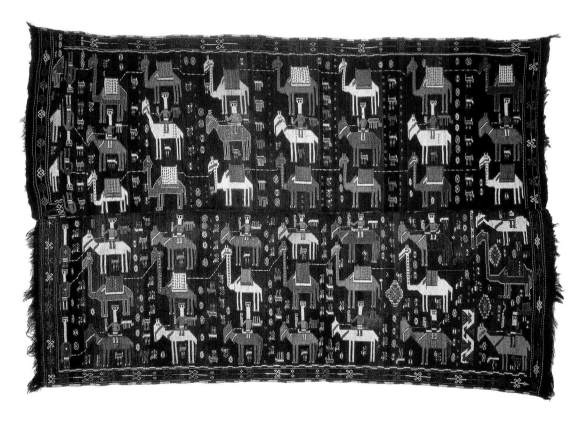

CONCLUSION

As we reach towards a conclusion, certain important points emerge from discussions in the earlier sections of the book. If a woven piece is read properly, it can serve as a means of joining together missing historical links and, even more importantly, provide a sketch of the character of the weaver and his or her tribe.

The first step in this endeavour is the discovery of the place of weave. Once the locations that have played the largest role in the production of certain weavings are pinpointed, it becomes possible to attain our objective of understanding the movements and migrations of people. Conversely, it can also increase our difficulties. I cite Takab as one instance. For several decades now the rugs and *gelims* of Takab have been appearing in the market under the label of Bijar. This confusion of sources, which appears a minor matter on the surface, has resulted in such complication surrounding the story of rugs of that area that we have no choice but to rewrite the area's history. This confusion between Takab and Bijar, located close to each other but with different ethnic histories and roots, seems inexplicable. The people of Takab are Turks while the residents of Bijar are Kurds, and they trace their roots to different cultural origins.

One must not minimize ethnic and tribal roots. We have seen instances in this book where remoteness in distance and time has failed to obliterate the character of the weavings of a certain group. We have seen how the Jiroft *palas*, together with its weavers, travelled to Khorasan, a thousand kilometres away, and how it subsequently appeared in a village not too far from Esfahan – another great distance. Likewise, we have seen how the passage of time did little to weaken the continuity of weaving among Kurds and Turkomans. We saw how after almost four hundred years, the Kurds of Khorasan still weave their reverse weft-wrapping and narrow striped *jajims* in the manner of their ancestors from Azarbaijan. Even more incredible is the endurance of the brocaded *palas* of the Turkomans, after eight centuries, in Azarbaijan, the Caucasus and Anatolia with all its features intact, save the colour.

We witnessed the appetite of Zagros-area dwellers in the use of colour. We also saw how and to what extent the people of the Kavir and Khorasan and Sistan were economical in their use of colour and how some of them preferred the darker and more muted shades. In terms of structure, too, we came across several interesting examples and saw how each was used in a specific area by a specific people. We found the Turks in the Zagros region to be more inclined towards the slit tapestry *gelim*, while we judged the Tats and the Lors in the same area to be associated with the dovetailed *gelim*. The weavings of certain tribes were found to be the mirror image of others. For instance, what would qualify among Turks as the face of their weft-faced fabric would be deliberately considered by the Kurds as the back of theirs, and the face of their fabrics would be the opposite of the Turks'. Similarly, we understood the relationship among people of Iranian descent such as the Kurds, the Lors, the Tats and the Talesh through their *mowjes* and *jajims*.

Ethnically speaking, we found the Turks to be more mobile and more likely to

migrate than the Iranian tribes, and we traced their footsteps all over the land. Among the Iranian peoples we found the dwellers of the Kavir to be more attached than any others to the land of their ancestors, with no examples of their *zilus* anywhere other than within their own area. We found no influence from the people of Kerman, Sistan or Baluchestan in Azarbaijan and the west.

Concerning origins and beginnings, I have come to no satisfactory conclusion. On the basis of the classifications in this book, we have drawn closer to the birthplaces of some of these weavings. Khorasan proved to be the birthplace of the *palas*, the Kavir of the *zilu*, the Caucasus of weft-wrapping, and Azarbaijan and Fars of the *gelim* and the *jajim*.

Finally, I admit to having used Estakhri's maps because of the personal allure they hold for me. In my opinion they are the most abstract paintings of Islamic Iran. That was not the sole reason for their use, however. The cities, towns and centres of weaving that appeared in history books a thousand years ago also appear in Estakhri's maps. Many of these towns have survived with the same names and the passage of time and the twists and turns of fate have not dampened the enthusiasm of their inhabitants for spinning and weaving. So today Shirvan is the centre of the best *mahfuris (sumaks)*, Barda' (Qarabagh) the source of the best *pardehs* and Fars the home of the loveliest *gelims* and *jajims*, a situation that has remained unchanged for a thousand years.

NOTES

1. Hole, 1967, p.149. See also Hole, 1977.
2. Bahar, 1362/1983, pp.138-8.
3. Ferdowsi, 1312/1933, vol.1, p.22.
4. Mashkoor, 1367/1988, p.111.
5. Kawami, 1992, p.7. See also Gluck and Firouz, 1977, p.177.
6. Xenophon, 1972,VII, 3, p.267.
7. Athenaeus, 1927, v 197, vol.II, p.393.
8. Rudenko, 1970, pp.297 and 298, pls.139 and 140.
9. Fujii, 1993, pp.35-46.
10. Kawami, 1991, pp.95-99.
11. Tabari, 1362/1983, vol.5, pp.1824-5.
12. Housego, 1989, p.118.
13. Qur'an 7: 31, 63: 9 and Hadith, quoting Shafi'e, 1369/1980, pp.337-8.
14. Dehkhoda, 1335/1956, vol.14, p.304.
15. Hasouri, 1996, pp.137-8.
16. *Takiyehs* and *hosayniyehs* are religious theatres and places of worship set up especially during the month of *Muharram* to mourn Imam Hosayn's martyrdom. For more on them see Chelkowsky, 1979.
17. *Hodud al-`alam*, 1372/1993, p.319.
18. Ibid, p.419.
19. Borhan, 1342/1963, vol.1, p.415 and vol.2, p.552.
20. Westerners who lived in Iran or were familiar with Persian language and culture used the correct term *gelim*. Among them were Polak, Benjamin and Housego, all cited in this list.
21. Hassouri, 1994, pp.9 and 11. This article is a summary of the author's paper in The 3rd Tehran Carpet Conference held in August 1994.
22. Kasravi, 1352/1973, pp.323 and 329.
23. In addition to Farrokhi and Naser Khosrow, Suzani of Samarqand also alludes to the *shushtari*. All these poems mention the *shushtari* as a carpet replete with colourful and floral patterns. It appears that the designs on *shushtaris* in the past differed from those today.
24. Ibn Hawqal, 1345/1966, p.66. Besides Jahromi, Ibn Hawqal mentions other renowned fabrics after their cities, '...from Shinz are brought Shinzi garments, from Djannab, Djannabi kerchief'. See Serjeant, 1972, p.50.
25. Estakhri, 1347/1968, p.120. Mo'in, 1342/1963, vol.5, p.1110. In Persian dictionaries Talisan or Tailasan is defined as a cloak worn by the orators. Dehkhoda, 1339/1960, vol.33, p.397. See also Marco Polo, 1926, p.41.
26. Polak, 1976, part II, p.113.
27. *Hodud al-`alam*, 1372/1993, p.398.
28. Ibid, p.387.
29. In the Bijar area 'sananbar' refers to a particular design. Rug-weavers believe Sananbar was a woman from Tabriz who became the wife of a khan from Bijar and promoted a Tabriz design in the area.
30. Sa'di, 1367/1988, p.16.
31. Zarrinkoob, 1357/1978, pp.31 f.
32. Mosahab, 1347/1968, vol.1, p.972, Dehkhoda, 1338/1959, vol.12, p.379 and Mo'in, 1364/1985, vol.1, p.799.
33. Attar, 1366/1987, p.22.
34. Mo'in, 1364/1985, vol.4, p.5136, Borhan, op.cit. vol 4, p.2334.
35. To dress Old Man Sky in his rags,
 I have, by the hand of the morn,
 Pulled off his head the thousand-nail robe.
36. Borhan 1342/1963, vol 1, p.415.
37. Naser Khosrow, 1366, pp.13 and 14.
38. Ibn Battuta, 1348/1969, vol 1, p.207.
39. Among the gifts Shah Abbas sent to Elizabeth I of England were 'six mules, each carrying four carpets, four of silk and gold, six clear carpets, the rest very fair crewel carpets'. (Housego, 1989, p.128 quoting *Sir Anthony Shirley and his Persian Adventures*, ed. Sir E. Denison Ross [London 1933]). The word 'gelim' is not mentioned by Shirley, but some European paintings depict royalty with Safavid gelims of the period. These were most probably gifts from Safavid kings. See Klose, 1993, pp.30 and 31.
40. Estakhri, 1347/1969, p.134.
41. *Hodud al-`alam*, 1372/1993, p.387.
42. Bayhaqi,1362/1983, p.30.
43. *Hodud al-`alam*, 1372/1993, p.373.
44. Ibid, p.397.
45. Gardizi,1347/1968, p.188.
46. Housego, 1989, p.118, pl.28.
47. Kirchheim *et al.*, 1993, p.15 and 351.
48. Maqdesi, 1906, pp.430-4.
49. Estakhri, 1374/1968, p.171.
50. *Hodud al-`alam*, 1372/1993, p.387.
51. Ibn Hawqal, 1345/1966, p.66.
52. Tanavoli, 1990, pp.14 and 15.
53. Naser Khosrow, 1366/1987, p.85.
54. Ibid, p.164.
55. Ibid, p.166.
56. *Hodud al-`alam* makes reference to 'the numerous merchants of Khoy, Nakhjavan and Bedlis' (Azarbaijan and Kurdestan). It also points out the major products from these towns, namely, *zilus*, pile rugs, wood, and so on. See *Hodud al-`alam*, p.419. Regarding the wealth of certain merchants in Fars, Estakhri says, 'I saw merchants in this town [Siraf], each with capital of sixty times a thousand thousand dirhans' (Estakhri, 1347/1968, p.134). Even by today's standards (two million pounds, Le Strange, 1996, p.181), this would constitute great wealth.
57. Aside from the basic materials of rug-weaving —such as yarn, cotton and silk, which were items of export — certain towns had also achieved a level of fame in the production of dyestuffs such as cochineal and madder (Estakhri, 1347/1968, p.158; *Hodud al-`alam*, 1372/1993, pp.415 and 422).
58. Keyvani, 1982, pp.446 f.
59. Habish-e Teflisi, quoting by Dehkhoda, 1345-1352/1966-1973, vol.41, p.411.
60. Olearius, 1669, pp.791 f.
61. Benjamin, 1887, p.426.
62. For further information see the annual reports of Markaz-e Toseíe-ye Saderat (The Centre of Promoting Export) published every year in Tehran.
63. Black and Loveless, 1977.
64. Enay and Azadi, 1977.
65. Edwards, 1975.
66. Ibid, p.186.
67. Pickering and Yohe, 1993, p.6.
68. *Hali*, 1990, p.83.
69. The literature on *gelims* and flat-weaves lists the titles of some 40 books and catalogues on Anatolian (Turkish) 'kilims' or flat-weaves. Titles on Persian *gelims* number only a few. See O'Bannon, 1994, pp.704-715.
70. Mellart, 1989, vol II.
71. Davies, 1993, pp.78-83.
72. Ibid, pp.71-8.
73. At the time, the author wrote a brief article disputing the 'goddess' theory and pointing to the non-consideration of the Kurds and the Armenians. See Tanavoli, *Hali* 52, 1990, pp.95-6.
74. *Hodud al-`alam*, 1372/1993, p.398.
75. Davies, 1993, p.66.
76. Dehkhoda, 1339/1960, vol.3, p.1122.
77. Dehkhoda, 1339/1960, vol.3, p.1122.
78. Bahar, 1362/1983, p.102, quoting Zatsparam.
79. Petsopoulos, 1984, p.274. In addition to the sources cited, the author saw silk *gelims* in the Mashhad Museum of Astan-e Qods-e Razavi in the years immediately preceding the Iranian revolution (c.1976-77).

80. Housego, 1989, pp.128-9, quoting *Chronicles of the Carmelites* and Tadeusz Mankowski 'Some documents from Polish sources relating to carpet making in the time of Shah Abbas I, in A.U. Pope, *Survey of Persian Art*, vol.III.
81. Pope, 1977, vol.XII, pp.1262-9.
82. Khwand Mir, 1333/1954, vol.4, p.494. This reference is courtesy of John Wertime.
83. Ibid.
84. Naser al-Din Shah, 1363/1984, p.125.
85. Pope, 1977, vol.VI, p.2402.
86. Ibid.
87. As an example see Pope, 1977, vol XII, pp.1172, 1173.
88. Eiland, 1981, p.239, pl.216.
89. Tanavoli, 1985, pp.97-103.
90. Kasravi, 1352/1973, p.341.
91. Hinz, 1936, pp.76 f.
92. Malcolm, 1951, vol.1, pp.556 f.
93. Tanavoli, 1985, p.28, map 3.
94. Ibid, pp.45-51.
95. For an example of a later Namin *gelim* see, Housego, 1978, p.45, pl.21.
96. For another example of this rare group see *Hali* 68, 1993, p.137, and for *boteh gelims* see Petsopolous, 1986, *Hali* 31, pp.42-47.
97. In the late 1970s, after Shahsavan weavings began to appear in the bazaars of Tehran and I had started work on my book *Shahsavan*, I sometimes heard the name Hamamlu, though I never encountered it during field trips. Consequently, I made no reference to it in my book.
98. Edwards, 1953, pp.62-63
99. Minorsky's list of Shahsavan clans, as well as that of Keyhan which subsequent writers followed, does not include the Hamamlu. See Minorsky, 1934, vol.IV, pp.267-8 and Keyhan 1311/1932, pp.106-110. See also Tapper, 1996, pp.61-84.
100. *Iranshahr*, 1344/1965, p.118.
101. The references in historical sources to the numerous baths of Barda' (LeStrange, 1966, p.177) suggest the possibility that the present-day Hamamlu are descended from the bathkeepers of Barda' and that they moved from the northern bank of the Aras river to the southern, which is their present location.
102. Tschebull, 1995, pp.89-97. 103. Tanavoli, 1985, pp.106-7, pls.8,9.
104. Ibid, p.299, pl.207.
105. Zarrinkoob, 1367/1988, p.333 and 416, among early writing Bedlisi's *Sharaf Nameh* written in 1005/1596-7 is noteworthy.
106. Fundamentally, Kurdish *gelims* (as with other Kurdish rugs) can be classified into two major categories. First, those that are produced by Kurds under the influence of Persian culture, that is, Kurds who live in the Bijar, Sanandaj and Kermanshah areas, whom with some exceptions are Shi'ites and who conspicuously display representations of living forms in their work. The second group are produced by frontier Kurds who are primarily Sunni. The *gelims* and rugs produced by these Kurds (and by their brethren north of Mosul and in Turkey) are busier and, in contrast with the first group, more geometric. See, for example, Eagleton, 1988, pp.120, 121, pls.96, 97 and 98; Petsopoulos, 1979, p.122, pl.99.
107. Afshar-e Sistani, 1366/1987, p.223.
108. Tanavoli, 1998, p.67, pl.58. See also, Petsopoulos, 1979, pp.42-7.
109. Ittig, 1981, pp.124-7.
110. Ford, 1987, pp.2-7.
111. Golriz, 1337/1958, p.854.
112. Other examples of this design can be seen in Housego, 1978, p.59, pl.35 and a group of Shirvan rugs, Schurmann, 1974, pl.68 and in some of the Qaraja rugs.
113. Mosahab, 1332/1953, p.589.
114. Minorski, 1934, vol.IV, pp.697-700.
115. For more information on this area see: Al Ahmad, 1370/1991, p.176.
116. The two villages of Ebrahim Abad and Sagges Abad are about the most prolific in *gelim* productions, in this area.
117. An example of large, leopard skin-like motifs is found in Housego, 1978, p.60, pl.36. These motifs must be the same motif of those known as Kuba (Petsopoulos, 1979, pls.290, 291). In north-west Iran the appearance of the motif resembles the animal skin variety found in the Caucasus and is far more geometric and abstract.
118. For another example of Zarand *gelim* with medallion see Housego, 1978, pl.11.
119. Marco Polo, 1926 , p.37.
120. Tanavoli, 1985, pp.30-31 and Housego, 1078, pp.10-12.
121. Parham, 1364/1985, vol.1, p.72.
122. Some say the Qalja'i of Afghanistan and the Khalaj dynasty of India are from the same Khalaj background, Mosahab, vol I, p.907.
123. Fasa'i, 1313/1895, p.312.
124. Cootner, 1990, p.188, pl.56.
125. Sadighi *et al.*, 1990, pl.24.
126. Hakim, 1366/1987, p.712, f.
127. Tanavoli, 1999, pp.80-89.
128. For examples on pile rugs see Edwards, 1975, pl.25. Greater varieties of this motif come from shawls. Anvarian, 1975, pls.70 and 97.
129. Housego, 1978, p.144, p.168.
130. Haqiqat, 1352/1973, p.434.
131. Tanavoli, 1985, pl.21.
132. One way to trace the origins of a rug is through the local markets. These markets all have rug specimens and pedigrees for tribal and village weavings for the nearby areas, though they are generally uninformed about the rest of the country. For example, the weavings of the Shahsavan, whose home territory is Azarbaijan, are far more easily found in the bazaars of Ardebil and Tabriz than in those of Shiraz, and Shiraz rug merchants know very little about Shahsavan weavings. The reverse also holds true. Thus, anyone in search of Shahsavan rugs would have to go to Tabriz, while a seeker of Qashqa'i or Baluch rugs would go to Shiraz or Mashhad, respectively.
133. Among the early moslem historians who considered the Lors as a branch of the Kurds is Hamdullah Mostawfi, 1362/1983, p.537.
134. Herzfeld, 1968, p.169.
135. Amanolahi, 1370/1991, p.8
136. Mas'udi, 1365/1986, pp.84-5.
137. Ibn Battuta, 1348/ 1969, vol.I, p.204.
138. De Bode, 1845, vol.I, p.400 f and vol.II, p.1 f.
139. In 1314/1935 a decree issued by the council of ministers in Iran changed the name Malmir to Izeh. The name Malmir, however, still remains in use among the Bakhtiaris, especially among the elders.
140. In the early 1970s, with the founding of the Tehran Rug Society, it was decided to launch an exhibition of Lori weavings. Such interest sparked a rush among rug dealers to acquire these weavings from Lori areas. By the middle of the decade, rug markets were deluged with Lori weavings, which had thus far remained unknown. Many of them found their way into the exhibition catalogue. For more information see de Franchis and Wertime, 1976, pp.110-118, pls.39-43.
141. For other examples of Shushtari see Petsopoulos, 1979, pls.355-9. Housego, 1978, pl.55.
142. Estakhri, 1347/1968, p.166.
143. Estakhri refers to the *mu'ineh*, which merchants transported to the Caspian region along with furs and pardehs. See Estakhri, op.cit., p.180. As is evident from the word, the *mu'ineh* may have been a hairy or goat-hair *gelim* of the Khuzestan or Siirt variety.

144. Tezcan, 1993, pp.89-93.
145. Ibn Battuta, 1348/1969, p.213.
146. In his diary Polak mentions a woven blanket that he had bought in Kerman (Polak, 1970, p.170). It is possible that what Polak was referring to was a hairy *gelim* or a *gabbeh*, especially since Kerman is known for a variety of goat with soft hair similar to the Angora (Ankara) variety.
147. Wertime, 1998, p.88.
148. The pattern of *gelim* pl.138 is similar to some early Anatolian rugs. See Rageth, 1992, p.96.
149. Peyman, 1348/1969, p.76.
150. Parham, 1364/1985, vol.1, pp.70-2.
151. Sadighi, *et al.* The two and three lozenges, pls.36, 38, 39 and 41, the brick design pls.19-25. Also see Tanavoli, 1990, pls.34, 35 and 36.
152. Besides Qashqa'is, other tribes made plain field *gelims*. Often these *gelims* were used as *sofreh* (eating spread). See Tanavoli, 1991, pls.1, 4 and 13.
153. Ford, 1992, p.20, fig.9.
154. For a discussion on the Lors of Kerman see: Amanolahi, 1370/1991, p.252.
155. Tanavoli, 1991, pp.101-2, pl.16.
156. The proverbs and folk traditions of Khorasan always refer to the *palas*, not the *gelim*, in connection with the floor coverings of the poor. See Shokourzadeh, 1364/1985, pp.570-1. In Baluchestan and Sistan the word *palas* and other local terms are more customary than *gelim*. See Konieczny, 1979, p.49 *et al*. In the past two decades, with the rise in demand for old *gelims* and the activities of dealers looking for commodity, the word *gelim* has become current in Khorasan and Sistan.
157. Although Petsopoulos' book is restricted to the *gelim*, one can find a few specimens of *gelim-palas*. See for example pls.238-244.
158. Borhan, 1342/1963, vol.1, p.415.
159. Gheyas al-Din Mohammad, 1342/1963, p.173
160. Mo'in, 1364/1985, vol.1, p.85.
161. *Hodud al-`alam*, 1372/1993, pp.304 and 417.
162. Ibid, Guzkanan p.304, Choghanian p.334, Moghan p.417.
163. Freshley, 1980, p.235.
164. Wertime, 1992, p.75.
165. Wright and Wertime, 1995, p.36
166. Marvi, 1364/1985, pp.4 and 5.
167. Tavahodi, 1359/11980, vol.1, pp.465 f.
168. An example of these *palases* by the Lorghabi tribes of Afghanistan is in Eiland, 1981, p.242, pl.219.
169. For other examples of Turkoman *palases* see Landreau/Pickering, 1969, p.75, pl.73. See also Hull and Wyhowska, 1993, pp. 254, 258, pls.484 and 491.
170. Wertime, 1985, pp.263-273.
171. Dhamija *et al.* 1977, p.319.
172. Sistan was also the birthplace of several Iranian epic heroes, the most renowned among them being Rostam. In fact, Rostam's entire ancestry was rooted in Sistan. For more on this see Mashkoor, 1367/1988, pp.106 f; Tanavoli, 1985, pp.30 ff.
173. Generally speaking most Sistan carpets are traded under the Baluchi label. However, they can be differentiated. See, Hassouri, *Sistan Carpet,* Tehran, 1993, and for a group of pictorial rugs see, Tanavoli, 1994, pls.63-6.
174. Quoting Gluck, 1977, p.318.
175. Anderson, 1994, p.80. Aside from the Baluch, several other ethnic minorities in Iran claim to have come from Iraq or Syria – a brand of ethnology supported more by religious beliefs than facts.
176. Spooner, 1988, vol.III, p.599.
177. Elfenbein, 1988, vol.III, pp.634 f.
178. Dames, 1913, vol.1, p.627.
179. Spooner, 1988, p.606.
180. Population density in Baluchestan, especially the Iranian part, is as low as 2-3 souls per square kilometre. Communities and villages, therefore, are far apart and it is no easy task to relate their weavings.
181. Vaziri Kermani, 1353/ 1974, p.115f.
182. There is a strong connection among the *palases* in this group, and it affords one great pleasure to compare them. See , for example, Housego 1978, p.144, pl.120; Ford, 1992, p.19, fig.2; Hull/Wyhowska, 1993, pl.525. The first two samples are from Kerman, the last (pl.525) from Taimani people in Afghanistan.
183. Ford and Pohl-Schilling, 1987, p.54, pl.18.
184. Tanavoli, 1992, pp.18-21.
185. Until recently, it seems, a specific group of floor coverings with chequered designs went by the name of *shatrangi* (Mo'in, 1364/ 1985, vol.2, p.204). Anandraj, however, defines a *shatrangi* as a floor covering with a hundred colours. See Dehkhoda, 1341/1962, vol.30, p.384. Little remains of the *shatrangi* other than the name.
186. Petsopoulos, 1979, p.192, pls.238-244.
187. Housego, 1978, p.73, pl.49.
188. Reza, 1360/1981, pp.6 f.
189. Estakhri, 1347/1968, p.156.
190. Le Strange, 1966, p.177.
191. Estakhri, 1347/1968, p.180.
192. Eskandar Beg, 1350/1971, p.16-1. Borhan, 1342/1963, vol.1, p.41.
193. Sa'edi, 1344/1965, p.72.
194. Acar, 1983, pp.67-75.
195. Tanavoli, 1985, p.80.
196. Bayhaqi, 1362/1983, pp.411-12.
197. Ibid, p.460.
198. Gardizi, 1347/1968, p.188.
199. Although the name *Mahfuri* is after the town of Mahfur in Anatolia, but the author has not come across any mentions of Anatolian *mahfuri*.
200. Gardizi, 1347/1968, p.188.
201. Dehkhoda, 1352/1973, vol.4, p.144. Dehkhoda does not make any references to his source.
202. *Hodud al-`alam*, 1372/1968, p.432.
203. Tabari, 1345/1966, p.529.
204. D'Allemagne, 1907, pp.105-6.
205. Nearly all tribes of Iran have produced containers with weft-wrapping structure. Among the most noted ones are those produced by the Qashqa'is, the Lors, the Afshars and the Baluch.
206. *Hodud al-`alam*, 1372/1993, p.432.
207. In the early texts the name Quba appears in different forms, such as Qobak, Qobla and Qoba. Yaqut's contention that, 'Qoba is named after its founder, the Sassanian king Qobad' seems the most logical explanation. Yaqut, 1957, vol.4, p.307 and vol.1, pp.160-1.
208. Tschebull, 1992, pp.83-95.
209. Schurmann, 1974, p.25.
210. Kerimov, 1983, vol.2, pp.158-9, pls.1311-2.
211. Boralevi, 1986. Sabahi, 1992.
212. Bier, 1989, pp.17-25.
213. Kerimov, 1983, vol.2, p.266.
214. Estakhri, 1347/1968, p.158.
215. Tanavoli, 1985, pp.154-7.
216. McMullan, 1965, pp.214-219, pls.59, 60 and 61.
217. In all these languages, *verni* or *varni* has the same meaning as the English word 'varnish'.
218. A chapter on Armenian participation in pictorial carpet is in Tanavoli, 1994, pp.47-9.
219. De Franchis/Wertime, 1976, pls.1-37.
220. Another example is in: Opie, 1994, p.137.
221. Although *vernehs* are often described as sumak or weft-wrappings, since a great portion of the *vernehs* are of weft-faced

plain weave or *gelim* weave, they do not fall in the category of sumak, but are a category by themselves.

222. As an example see: Dhamija, 1977, pp.297-9.
223. Anavian, 1975, pls.9, 14, 15.
224. Kerimov, 1983, p.157.
225. As an example see: Firouz, 1977, pp.256-9.
226. Qavareh may be translated as 'format'. The use of the term in connection with floor coverings varies. The *qavareh* of a pile weave is different from that of a *gelim, jajim* or *zilu*.
227. Naser Khosrow, 1366/1987, p.166.
228. Herrmann offers a different interpretation about the Kerchheim Azarbaijan carpet (Hermann, 1994, p.218). To me the scene on this carpet resembles a fire temple, similar to what one finds on *zilus* (see fig.85).
229. *Zilus* bearing the Tree of Life are used as *pardeh* (curtain). For other examples see Afshar, 1993, pp.32-3, figs.2 and 3. May Beatie, 1981, p.173, fig.5.
230. Ittig, 1992, pp.37-42.
231. Parham, 1364/1985, pp.98-101.
232. Afshar, 1993, p.35.
233. Ettinghausen has discussed the third *zilu* which appeared on the Tehran art market in 1954. Ettinghausen, 1958, pp.261-2, figs.2-3. Quoting Ittig, 1992, p.37.
234. Ittig, 1992, p.39.
235. Gluck, 1977, p.77 and Centlivres-Demont, 1971.
236. For further information on *Zilu* loom see: Jon Thompson and Hero Granger-Taylor, 1995-1996, pp.29f.
237. Wulff, 1966, p.210 f.
238. Thompson and Granger-Taylor, 1996, p.39f.
239. Tabari, 1362/1983, p.529.
240. Mostawfi, 1336/1967, p.112.
241. Both in Causasus and Turkey a variety of different structures eg brocading and weft-wrapping, are called *zili*. See Kerimov, 1983, vol.3, pls.100-103. Acar, 1983, pp.63-68.
242. The word jajim is composed of two words. *Ja* = place and *jim* = hide, literally meaning a place to hide. Since the main use of jajim is to cover and hide the beds, its meaning makes sense with regard to its function.
243. The Arabic term used by Ibn Hawqal is striped *nakhak*, Ibn Haukal, 1967, p.299 and Searjeant, 1972, p.50. Nakhak in Persian has been translated *jajim*. See the translation of Ibn-e Hawqal in Farsi, 1345/1996, p.66.
244. In Turkey a group of weft-wrapped are called *cicim*, Acar, 1983, p.55 f. However, in the Azarbaijan of Caucasus the polychrome striped warp faced weave are called *jejim*, Kerimov, 1983, vol.3, p.301, table 103. However, in both Iranian and Caucasian Azarbaijan, the unpatterned striped jajim as well as unpatterned striped *gelim* with fewer colours are sometimes called *palas*.
245. Tanavoli, 1985, p.75.
246. Dhamija, 1987, pp.22-6.
247. Wertime, 1992, pp.72-5. Wright, 1992, pp.76-8.
248. Bazin and Bromherger, 1982, p.70 f.
249. Abdoli, 1363/1984, p.6 f.

250. For another example see: Dhamija, 1977, p.317.
251. Ibn Haukal, 1967, p.299 and Parham, 1964/1985, p.41.
252. Similar to these *mowj* are made among the Kurds too, see Dhamija, 1977, p.304.
253. Wertime, 1979, p.35.
254. For more information see: Tanavoli, 1990, pp.108-111.
255. For similar pieces see, Housego, 1978, p.130, pl.106. Tanavoli, 1992, pp.84 and 85, pls.1 and 2.
256. Tanavoli, ibid, pp.84-89.
257. Hull and Wyhowska, 1993, p.266, pls.504 and 505. For Afghani *jajim* like those of Azarbaijan, see Klieber, 1989, p.217.
258. Stanzer, 1988, p.124, pl.124.
259. Dehkhoda, 1346/ 1967, vol.26, p.184.
260. Shahri, 1371/1992, vol.3, p.126.
261. Sadid al-Saltaneh, 1363/1984, p.510.
262. Mo'in, 1364/1985, vol.3, p.4121.
263. Polak, 1976, pp.62-3.
264. Until the 1980s *masnad* was a rug item in its own right from Azarbaijan. See, for example, the price list of the ministry of trade, Export Promotion Centre of Iran, dated 13 Khordad 1367/ 6 June 1988. Here a top-quality *masnad* is priced at 5,000 *rial* per square metre.
265. Mo'in, 1364/1985, vol.3, p.184.
266. For Afshari *masnad* see: Tanavoli, *Afshar: Tribal Rugs from South East Iran* (in press).
267. See the detail on the opposite p.147. Soudavar, 1992, p.167, pl.64.
268. Bayhaqi, 1362/1983, p.112.
269. Tanavoli, 1990, p.15.
270. *Hodud al-`alam*, 1372/1993, p.387.
271. Estakhri, 1347/1968, p.134.
272. Ibid.
273. *Hodud al-àlam*, 1372/1993, p.383.
274. Later Persian kings, it seems, had switched from the use of the *suzani* to the shawl. Paintings and photographs from the Qajar period show the sovereign and courtiers in shawl clothing (Afshar, 1992, pp.6-9). Queen Farah Pahlavi, however, often appeared at official functions in *suzani* dresses. See Gluck, *A Survey of Persian Handicraft*, 1977 (frontpiece).
275. Wearden, 1991, pp.102-111.
276. Hull and Wyhowska, 1993, pp.266-7, pls.506 and 508.
277. Wright and Wertime, 1995. However, according to Peter Andrews neither the Turkoman of Iran nor the tribes of Anatolia use the word *shadda*. I am grateful to Dr. Andrews for providing me with this information.
278. Estakhri, 1347/1968, p.157.
279. The group of Khamseh and Lori rugs (Opie, 1992, pp.199 and 201, pls.11.8 and 11.10). This design was possibly inspired by curtain, since it is more logical to see birds hanging in the space on curtains rather than on the floor.
280. Mo'in, 1364/1985, vol.2, p.2034.
281. Gazali, 1351/ 1972, p.278.
282. Dehkhoda, 1338/1959, vol.12, p.192.

WORKS CITED

This list represents only the works cited in the text and is not a full bibliography

'Abdoli, 'Ali. 1363/1984. *Farhang-e Tati va Taleshi* (A Dictionary of Tati and Taleshi), Bandar Anzali (Iran).

Acar (Balpinar), Belkis. 1983. *Kilim-Cicim-Zilu-Sumak,Turkish Flat-Weaves*, Istanbul.

et al. 1990. *The Goddess of Anatolia*, vol. IV, Milan.

Afshar, Iraj. 1992. 'Zilu' *Iranian Studies: The Carpets and Textiles of Iran*, vol. 25, ed. A. Ittig, Yale University, New Haven.

1371/1992. *A Treasury of Early Iranian Photographs*, Tehran.

ed. 1965. *Iranshahr, A Survey of Iran's Land, People, Culture, Government and Economy*, vol. 1, Tehran.

Afshar-e Sistani, Iraj. 1366/1987. *Moqadameh-i bar Shenakht-e Ilha, Chador Neshinan va Tavayef-e Ashayeri-ye Iran* (An introduction to the tribes and tent dwellers of Iran), vol. 1, Tehran.

Al Ahmad, Jalal. 1370/1991. *Tat Neshinha-ye Bluk-e Zahra* (The Tats of Zahra District), Tehran.

Amanolahi, Sekandar. 1370/1991. *Aqwam-e Lor* (The Lor Tribe), Tehran.

Amir Arjomand, Said. 1993. *The Political Dimensions of Religion*, State University of New York Press.

Anavian, R. & G. 1975. *Royal Persian & Kashmir Brocades*, Kyoto.

Anderson, Jerry. 1994. 'From the Horse's Mouth', Talking 'Baluch' with Jerry Anderson, *Hali: The International Magazine of Antique Carpets and Textile Art*, hereafter *Hali*, issue 76, London.

Anklesaria, B.T. 1964. *Vichitakiha-i Zatsparam* with text and introduction, Bombay.

'Aruzi-ye Samarqandi. 1364/1985. *Chahar Maqaleh* (Four Discourses), ed. M. Mo'in, Tehran.

Athenaeus. 1927. *The Deipnosophists*, tr. Charles Burton Gulick, vol. II, London.

Attar, Farid al Din. 1366/1987. *Tazkirat al Olia*, ed. M. Este'lami, Tehran.

1991. *The Conference of the Birds*, Berkeley.

Bahar, Mehrdad. 1362/1983. *Pajuheshi dar Asatir-e Iran* (A Search in Persian Mythology), Tehran.

Bayhaqi, Abolfazl, 1362/1983. *Tarikh-e Bayhaqi* (Bayhaqi's History) ed. Ghani and Fayyaz, Tehran.

Bayhaqi, Ali ibn Zayd. 1317/1938. Tarikh-e Bayhaqi, Tehran.

Bazin, M. & C. Bromberger. 1982. *Gilan et Azarbayjan Oriental Cartes et Documents Ethnographiques*, Paris.

Beattie, May H. 1981. 'A Note on Zilu' *The Arthur Jenkins Collection Volume I Flat-Woven Textiles*, ed. C. Cootner, The Textile Museum, Washington.

Bedlisi, Amir Sharfkhan. 1343/1964. *Sharafnameh:Tarikh-e Mofassal-e Kordestan* (Sharafnameh, The Extensive History of Kurdestan), Tehran.

Benjamin, S.G.W. 1887. *Persia and the Persians*, London.

Bennett, Ian. 1991. 'A Qajar Masterpiece', *Hali* 59, London.

Bier, Carol. 1989. 'Weaving from the Caucasus', *Hali* 48, London.

Black, D. and C. Loveless. 1977. *The Undiscovered Kilim*, London.

Boralevi, Alberto. 1986. *Sumakh, Flat-Woven Carpets of the Caucasus*, Florence.

Borhan, Mohammad Hossein-e Tabrizi. 1342/1963. *Borhan-e Qate'*, Tehran.

Centlivres Demont, Micheline. 1971. *Une Commounaute de Potiers en Iran*, Neuchatel.

Chelkowski, Peter J. 1979. *Ta'zieyeh: Ritual and Drama in Iran*, New York.

Cootner, Cathryn M. ed. 1990. *Anatolian Kilim: The Caroline and H. McCoy Jones Collection*, London.

D'Allemagne, Henry-Rene. 1911. *Du Khorasan Au Pays Des Backtiaris Rois Mois De Voyage en Perse*, Paris.

Dames, L. 1913. 'Balocistan', *Encyclopaedia of Islam*, vol. 1, Leyden, London.

Danielou, Alain. 1959. 'Iranienne [Musique]', *Encyclopaedie de la Musique*, Fasquelle, vol. II, Paris.

Davies, Peter. 1993. *The Tribal Eye, Antique Kilims of Anatolia*, New York.

De Bode, C.A. 1845. *Travels in Luristan and Arabistan*, London.

De Franchis, A. and J.T. Wertime. 1976. *Lori and Bakhtiari Flatweaves*, Tehran Rug Society.

Dehkhoda, Ali Akbar. 1345-1352/ 1966-1973. *Loghat Nameh*, Tehran.

1339/1960.. *Amsal va Hakam*, vol. 3, Tehran.

Dhamija, Jassleen, *et al.* 1977. 'Flatweaves', *A Survey of Persian Handicraft*, eds. J. and S. Gluck, Tehran, New York, London, Ashiya.

1987. 'Jajim', *Hali* 36, London.

Eagleton, William. 1988. *An Introduction to Kurdish Rugs and Other Weavings*, New York, London.

Edwards, Cecil A. 1953. *The Persian Carpet*, London.

Eiland, Murray L. 1981. *Oriental rugs: A New Comprehension Guide*, Boston, Toronto, London.

Elfenbein, J. 1988. 'Baluchi Language and Literature', *Encyclopaedia Iranica*, vol. III, London, New York.

Emery, Iren. 1966. *The Primary Structure of Fabric, an Illustrated Classification*. Textile Museum, Washington D.C.

Enay, Marc E. and Siawosch Azadi. 1977. *Einhundret Jahre Orienttepiche-Literatur*, 1877-1977, Hannover.

Estakhri, Abu Ishaq Ibrahim. 1368/1989. *Masalik va Mamalik*, ed. I. Afshar, Tehran.

Ettinghausen, Richard. 1958. '(Review of) K. Erdmann, Der Orientalische Knüpfteppiche', *Orients*, XI.

Falk, Toby. 1991. 'The Shahs' Tents: Royalty in the Field', *Hali* 59, London.

Farahvashi, Bahram. 1355/1976. *Jahan-e Farvari*, Tehran.

Farmer, Henry G. 1981. 'An Outline History of Music and Musical Theory', *A Survey of Persian Art*, ed. A.U. Pope, vol. VI, p. 2793. Ashiya, New York.

Fasa'i, Haji Mirza Hasan. 1313/1895. *Tarikh-e Farsanameh-ye Naseri* (the History of Naseri Farsnameh), Tehran.

Ferdowsi, Abolqasem. 1312/1933. *Shahnameh*. See also Ferdowsi, *The Epic of the Kings: Shahnama, the Natural Epic of Persia*, tr. R. Levy, London 1967.

Firouz, Iran A. 1977. 'Needlework', *A Survey of Persian Handicraft*, eds. J. and S. Gluck, Tehran, New York, London, Ashiya.

and Gluck, Sumi. 1977. 'Qlamkar, Block Printed Cotton', *A Survey of Persian Handicraft*, eds. J. and S. Gluck, Tehran, New York, London, Ashiya.

Ford, P.R.J. 1987. 'Kilims of the Lurs of Harsin', *Oriental Rug Review*, vol. VII, no. 2, Meredith, New Hampshire.

Ford, P.R.J. and Pohl-Schilling. 1987. *Persische Flachgewebe*, Köln.

Ford, P.R.J. 1992. 'Flatweaves of Kerman Province', *O.R.R.*, vol. XII, Meredith, New Hampshire.

Freshly, Katherine T. 1980. 'Glossary', *Turkmen, Tribal Carpets and Traditions*, Textile Museum, Washington D.C.

Fujii, Hideo. 1993. 'The Marked Characteristics of the Textile Unearthed from the At-Tar Caves, Iraq',. *Oriental Carpet and Textile Studies*, vol. IV, Berkeley, California.

Gardizi, Abu Sa'id Abdolhay. 1347/1968. *Zain al Akbar*, ed. A. Habibi, Tehran.

Gazali, Mohammad. 1351/1972. *Nasihat al Moluk*, Tehran.

Gheyas al-Din, Mohammad. 1342/1963. *Gheyas al-Loghat*, Tehran.

Ghirshman, Roman. 1961. *Iran from the Earliest Time to the Islamic Conquest*, Baltimore.

Gluck, Jay and Suni Gluck. 1977. *A Survey of Persian Handicraft*, Tehran, New York, London, Ashiya.

Golriz, Seyyed Mohammad Ali. 1337/1958. *Minudar* (Qazvin), Tehran.

Grube, E. and Sims E. 1989. 'Painting', *The Arts of Persia*, ed. R.W. Ferrier, Yale University Press, New Haven & London.

Hakim, Mohammad Taqi. 1366/1987. *Ganj-e Danesh* (The Treasure of Knowledge). Tehran.

Hali. 1990. '1990 The Year of the Anatolian Kilim' (editorial), issue 50, London.

Hamdullah Mostawfi. 1346/1967. *Nuzhat al-Qulub*, ed. M. Dabir Siyaqi, Tehran.

1362/1983, *Tarikh-e Gozideh* (Selected History), ed. A. Nava'i, Tehran.

Haqiqat, Abdolrafi'. 1352/1973. *Tarikh-e Semnan* (The History of Semnan), Semnan.

Hasouri, Ali. 1993. *Sistan Carpet*, Tehran.

1994. 'Die Turkischen Termini der Teppchkniysfkunst', *Teppich* Welt, Mainz, Germany.

Herrmann, Eberhart. 1993. 'New light on Ancient Designs: Within the Sign of the Great Bird', *Orient Star*, Stuttgart and London.

Herzfeld, Ernst. 1968. *The Persian Empire: Studies in Geography and Ethnography of the Ancient Near East*, Wiesladen.

Hinz, Walter. 1936. *Irans Aufstieg zum Nationalistaat im Funfzehnten Jahrhundert*, Berlin and Leipzig.

Hodud al-`alam. 1372/1993. *Hodud al-`alam men alsharq ula'almaghreb* (Regions of the World from East to West), Tehran. See also *Hodud al-`alam* (The Regions of the World) translated and explained by V. Minorsky, London 1970.

Hole, Frank. 1967. 'Prehistory of Iran: A Preliminary Report', *Proceeding of the Prehistoric Society*, no. 33, Cambridge, London.

1977. *Studies in the Archeological History of Deh Luran Plain, the Excavation of Chogha Sefid*, University of Michigan.

Housego, Jenny. 1978. *Tribal Rugs: An Introduction to the Weaving of the Tribes of Iran*, London.

1989. 'Carpet', *The Arts of Persia*, ed. R.W. Ferrier, Yale University Press, New Haven & London.

Hull, A. and J.L. Wyhowska. 1993. *Kilim: The Complete Guide*, London.

Ibn Battuta. 1359/1980. *Safarnameh-ye Ibn Battuta*, Tehran. See also *The Adventures of Ibn Battuta, A Muslim Traveller of the 14th Century*, London, Sydney, 1986.

Ibn Haukal. 1967. *Opus Geographicum Sorat-al-Arz* (in Arabic), ed. J.H. Kramers, Leyden.

Ibn Hawqal. 1345/1966. *Sorat-al Arz* (in Persian), tr. J. Sha'ar, Tehran.

Ibn Ibri. 1890. *Tarikh-i Mokhtasar al-Dowal*, ed. Al eb-Antone Alyasu, Beirut.

Ittig, Annette. 1981. 'A Group of Inscribed Carpets from Persian Kurdistan', *Hali* 4, no. 2, London.

1992. 'Notes on a Zilu Fragment dated 963/1556 in the Islamic Museum, Cairo', *Iranian Studies, The Carpets and Textiles of Iran*, vol. 25, ed. A. Ittig, Yale University, New Haven.

Kashqari. *Divan-e Lughat-e Tork*, Tehran.

Kasravi, Ahmad. 1352/1973. 'Azari ya Zaban-e Bastane-e Azarbaijan' (Azari or the Ancient Language of Azarbaijan), *Karvand-e Kasravi*, ed. Yahya Zoka, Tehran.

Kawami, Trudi. 1992. 'Archaeological Evidence for Textiles in Pre-Islamic Iran', *Iranian Studies, the Carpets and Textiles of Iran*, vol. 25, ed. A. Ittig, Yale University, New Haven.

1991. 'Ancient Textiles from Shahr-i Qumis', *Hali 59*, London.

Kerimov, Latif. 1983. *Azerbaijan Carpet*, vol. II and III, Baku.

Keyhan, Mas'ud. 1311/1933. *Gogragia-ye Moffasal-e Iran* (The Extensive Geography of Iran), Tehran.

Keyvani, M. 1982. *Artisans and Guild Life in the Later Safavid Period*, Berlin.

Khwand Mir, Ghayas al-Din, 1333/1954. *Tarikh-e Habib-al Siyar*, ed. Jalal Homa'i, Tehran.

Kirchhein, Heinrich E. *et al*, 1993. *Orient Stars, A Carpet Collection*, Stuttgart, London.

Klieber, Helmut. 1989. *Afghanistan: Geschichte Kultur Volkskunst Teppiche*, Landsberg a Lech, Germany.

Klose, Christine. 1993. 'A Persian Tapestry Carpet in a Painting of 1634', *Oriental Rug Review*, vol. XIII, Meredith, New Hampshire.

Konieczny, M.G. 1979. *Textiles of Baluchestan*, London.

Landreau, A.N. & W.R. Pickering. 1969. *From the Bosporus to Samarkand*, the Textile Museum, Washington D.C.

Lentz, Thomas W. and Glenn D. Lowry. 1989. *Timur and the Princely Vision, Persian Art and Culture in the Fifteenth Century*, Smithsonian Institution, Washington D.C.

Le Strange, Guy. 1966. *The Land of the Eastern Caliphate*, London.

Long, John. 1992. 'Yo Ali, The Story Behind Grass', *Oriental Rug Review*, vol. XII, Meredith, New Hampshire.

McDowell, Allgrove J. 1989. 'Textiles', *The Arts of Persia*, ed. R.W. Ferrier, Yale University Press, New Haven and London.

McMullan, Joseph. 1965. *Islamic Carpets*, New York.

Majlesi, Mohammad Baqer. 1369/1990. *Helliyat al Mottaqin*, Tehran.

Malcolm, John. 1815. *The History of Persia, from the Most Early Period to the Present Time*, London.

Maqdesi, Abu Abdullah. 1906. *Ahsan al-Taqasim fi-al ma'rafat Al-aqalim*, tr. A. Monzavi, Tehran.

Marco Polo. 1926. *The Travels of Marco Polo*, ed. Manuel Komroff, New York.

Marvi, Mohammad Kazem. 1364/1985. *Alam are-ye Naderi*, ed. M.A. Riahi, Tehran.

Mashkoor, Mohammad Javad. 1367/1988. *Iran dar Ahd-e Bastan dar Tarikh-e Aqvam va Padeshahan Pish as Eslam* (Iran in Ancient Times: The History of the Tribes and Kings Before the Islam Era), Tehran.

Mas'udi, Ali ibn Hossein. 1965/1986. *Al Tanbih va l-Ashraf* (Warning and Remarks), tr. A. Payandeh, Tehran.

Mellart, James *et al*. 1990. *The Goddess of Anatolia*, vol. 1, Milan.

Minorski, V. 1934. 'Shah-Sewan', *Encyclopaedia of Islam*, vol. iv, Leyden, London.

1934. 'Tat', *Encyclopaedia of Islam*, vol. iv, Leyden, London.

Mo'in, Mohammad. 1364/1985. *Farhang-e Mo'in*, Tehran.

Mosahab, Gholamhossein. 1347/1967. 'Sistan' & 'Ahamiat-e Sistan dar Afsaneha-ye Iran' (The Importance of Sistan in Persian Legends), *Da'erat al Ma'aref-e Mosahab*, Tehran.

Mostawfi – see Hamdullah Mostawfi

Naser al-Din Shah. 1363/1987. *Safarnameh-ye Atthebat Naser al-Din Shah Qajar* (Travelogue of Attebat [Karbela and Najaf] of Naser al-Din Shah Qajar), Tehran.

Naser Khosrow. 1366/1987. *Safarnameh-ye Naser Khosrow* (Travelogue of Naser Khosrow), Tehran.

Nasr, Seyyed Hossein. 1976. *Islamic Science, An Illustrated Study*, London.

O'Bannon, George W. 1994. *Oriental Rug, A Biography*, Metuchen, N.J. and London.

Olearius, Adam. 1669. *The Voyages and Travels of the Ambassadors*, London.

Opie, James. 1992. *Tribal Rugs*, Portland.

Parham, Cyrus. 1364/1985. *Tribal and Village Rugs from Fars*, vol. I, Tehran.

Petsopolous, Yani. 1979. *Kilim: Flat-woven Tapestry Rugs*, New York.

Peyman, Habibollah. 1347/1969. *Il-e Qashqa'i* (Monograph on the Qashqa'i Tribe), Tehran University.

Pickering, Russel W. and Ralph S. Yohe. 1993. 'Foreword', *The Tribal Eye*, New York.

Polak, Jacob E.. 1976. *Persien: das Land und seine Bewohner*, Hildesheim, New York.

Pope, Arthur Upham. 1977. *A Survey of Persian Art*, vol. VI, Ashiya, New York, Tehran.

Qoran [Koran]. 1980. Tr. A.J. Aberry, London.

Rageth, Jurg. 1992. 'A Turkish Rug', *Hali 61*, London.

Reza, Enayatollah. 1360/1981. *Azarbaijan va Aran* (Azarbaijan and Aran), Tehran.

1365/1986. *Iran va Torkan dar ruzegar-e Sassanians* (Iran and the Turks at the Sassanian Era).

Ross, Denison E. ed. 1933. *Sir Anthony Sherely and his Persian Adventures*, London.

Rudenko, Serghei I. 1970. *Frozen Tombs of Siberia: The Pazyryk Burials of Iron Age Horsemen*, London.

Sabahi, Taher. 1992. *Weft-Wrapped Flatweaves*, Rome.

Sa'di. 1367/1988. *Golestan*, Tehran.

Sadid al-Saltaneh, M.A. 1363/1984. *Safarnameh-ye Sadid al-Saltaneh* (Travel Accounts of Sadid al-Saltaneh), Tehran.

Sadighi, et.al. 1990. *Kelims, der Nomaden und Bauern Persiens*, Berlin.

et al. 1991. *Stammesteppische der Bergnomaden au Zagros*, Berlin.

Sa'edi, Gholamhossein. 1344/1965. *Khiav ya Meshkinshahr Ka'be-ye Yeilaghat-e Shahsavan* (Khiav or Meshkinshahr, Mecca of Shahsavan Summer Pastures), Tehran.

Schmidt, Erich F. 1979. *Persepolis*, Chicago.

Schurmann, Ulrisch. 1974. *Caucasian Rugs*, Basingstoke, England.

Searjeant, R.B. 1972. *Islamic Textiles: Material for a History to the Mongol Conquest*, Beirut.

Shahri, Ja'far. 1371/1993. *Tehran-e qadim* (The Old Tehran), vol. 3, Tehran.

Shafi'e, Mohammad. 1369/1980. *Majm'a al Mo'aref va Makhzan al-avaref* (Collections of Learning and Treasures of Common Laws), Tehran.

Shiloah, A. 1976. 'The Dimension of Sound', *Islam & the Arab World*, London.

Soudavar, Abolala. 1992. *Art of the Persian Courts*, New York.

Spooner, B. 1988. 'Baluchestan', *Encyclopaedia Iranica*, ed. Ehsan Yarshater, vol. III, London, New York.

Stanzer, Wilfried. 1988. *Kordi*, Vienna.

Tabari, Mohammad ibn Jarir. 1345/1964. *Tarikh-e Tabari*, Tehran.

Tanavoli, Parviz. 1985. *Shahsavan: Iranian Rugs and Textiles*, New York.

1988. 'The Afshars, Part 1: A Tribal History', *Hali* 37, London.

1990. 'Waves from the Zagros", *Hali* 52, London.

1990. 'The Gelim Girl', *Hali* 52, London.

and S. Amanolahi. 1991. *Gabbeh*, Zug.

1991. *Bread and Salt: Iranian Tribal Spreads and Salt Bags*, Tehran.

1992. 'Muteh and its Mushaki Gelim', *Oriental Rug Review*, vol. XII, no. 5, Meredith, New Hampshire.

1992. 'Shisha Derma, Iranian "Black and White" Textiles', *Hali* 63, London.

1994. *Kings, Heroes and Lovers: Pictorial Rugs from the Tribes and Villages of Iran*, London.

1998. *Riding in Splendour: Horse and Camel Trappings From Tribal Iran*, Tehran.

1999. 'The Varamin Mosaic', *Hali* 106, London.

Tapper, Richard. 1966. 'Black Sheep, White Sheep and Red Heads', *Iran*, vol. IV, London.

Tavahodi, Kalimollah Oghazi, 1359/1980. Harekat-e Tarikhi-ye Kord-e Khorasan dar Defa' as Esteqlal-e Iran (The Historical Movement of the Kurds of Khorasan in Defence of Iran's Independence), vol. 1, Tehran.

Tezcan, Hulya. 1993. 'Velenses of the Topkapi Palace Collection', *Oriental Carpet and Textile Studies*, vol. IV, Berkeley, California.

Thompson, Jon and Hero Granger-Taylor. 1995-1996. *The Persian Zilu Loom of Meybod*, Lyon.

Tschebull, Raoul. 1992. 'Zeikhur', *Hali* 62, London.

1995. 'Sarab', *Hali* 79, London.

Wearden, Jennifer. 1991. 'A Synthesis of Contrasts', *Hali* 59, London.

Wertime, John T. 1985. 'The Classification and Description of Fabric Structures in Near Eastern Textiles:Another Example of Weft-Wrapping', *Oriental Carpet and Textile Studies I*, London.

1992. 'Three Silk Jajims: A Case Study of Transcaucasian Silk Product', *Hali* 63, London.

1998. 'Back to Basics: Primitive Pile Rugs of West & Central Asia', *Hali* 100, London.

Wright, R.E. and J.T. Wertime. 1995. *Caucasian Carpets & Covers: The Weaving Culture*, London.

Wulff, Hans E. 1966. *The Traditional Crafts of Persia*, Cambridge, Mass., London.

Xenophon. 1972. *The Persian Expedition*, London.

Yaqut al-Hamavi [Yagut al-Rumi]. 1957. *Ma'jmal al Buldan*, vol. I and iv, Beirut.

Zarrinkoob, Abdol Hossein. 1343/1964. *Tarikh-e Iran ba'd az Eslam* (History of Persia, in Early Islamic Centuries), Tehran.

1357/1978. *Arzesh-e Miras-e Sufiyeh* (The Value of the Sufi Heritage), Tehran.

1367/1988. *Tarikh-e Mardom-e Iran, Iran-e Qabl az Eslam* (The History of the people of Iran Prior to Islam), Tehran.

FURTHER READING

Allgrove, John *et al. The Qashqa'i of Iran: World of Islam Festival 1976*, London, 1976.

Amiet, Pierre. *Suse: 6000 ans d'Histoire Musée du Louvre*, Paris, 1988.

Amir Arjomand, Sa'id. *The Shadows of God and the Hidden Imam: Religion. Political Order, and Societal Change in Shi'ite Iran from the Beginning to 1890*, Chicago, London, 1984.

Arberry, Arthur John. *Aspects of Islamic Civilization. As Depicted in the Original Texts*, London, 1964.

Ardalan, Nader and Laleh Bakhtiar. *The Sense of Unity: The Sufi Tradition in Persian Architecture*, Chicago and London, 1973.

Bakhtiar, Laleh. *Sufi: Expression of the Mystic Quest*, London, 1976.

Barth, Fedrik. *Nomads of South Persia, The Basseri Tribe of the Khamsah Confederacy*, Oslo, 1961.

Beck, Lois. *The Qashqa'i People of the Southern Iran*, Los Angeles, 1981.

Bennett, Ian. 'Carpets of the Khans Part I and II,' *Hali* 43 and 44, 1989.

Bier, Carol, ed., Woven from the Soul, Spun from the Heart: Textile Arts of Safavid and Qajar Iran, 16th/19th Centuries, Washington D.C., 1987.

Biggs, Robert D., ed. *Discoveries from Kurdish Looms*, Evanston, Illinois, 1983.

Chardin, John. *The Travels of Sir John Chardin into Persia and the East-Indies*, London, 1686.

Christensen, Arthur. *L'Iran sous les Sassanids*, Copenhagen, 1936.
Les Types du premier homme et du premier roi, Leiden, 1934.

Corbin, Henry. *Les Motifs zoroastriens dans la philosophie de Suhrawardi*, Tehran, 1948.

Digard, Jean Pierre. *Techniques des nomades baxtiayari d'Iran*, Cambridge, England, 1981.

Eagleton, William. *An Introduction to Kurdish Rugs and Other Weavings*, New York and London, 1988.

Ellis, Charles Grant. 'The Flat-Woven Kilim of the East', *Near Eastern Kilims*, Textile Museum, Washington, D.C., 1965.

Enderlein, V. *Orientalische Kelims, Flachgewebe aus Anatolien, dem Iran und dem Kaukasus*, Berlin, 1986.

Erdmann, Kurt. *Oriental Carpets*, Tubingen, Germany, 1955; rep. Fishguard, Wales, 1976.

Eskenazi, John K. *Kilim*, Milan, 1980.

Field, Henry. *Contributions to the Anthropology of Iran*, Chicago, 1939.

Garthwaite, Gene R., *Khans and Shahs: A Documentary Analysis of the Bakhtiyari in Iran*, London, New York, New Rochelle, Melborne, Sydney, 1983.

Ghirshman, Roman. *Persia, From the Origins to Alexander the Great*, London, 1964.

Herrmann, Eberhart. *Seltene Orienttippiche*, vol. 1-10, Munich, 1978- 1988.
Asiatische Teppich-Und Textilkunst, vol. 1-4, Munich, 1989 - 1992.

Herrmann, Georgina. *The Iranian Revival*, Oxford, 1977.

Housego, Jenny, 'Northwestern Iran And Caucasus', Part 1: *Yoruk*, Pittsburgh, 1978, pp. 42-5.
'Some Flat Weaves of Azarbaijan', *Hali* Vol. 4, no. 2, 1981, pp. 118-23.

Hubel, Reinhard G., *The Book of Carpets*, New York, 1964.

Kopackova, Regina, 'A Safavid Kilim Mystery', *Hali* 55, London, 1991.

Lambton, Ann, *Islamic Society in Persia*, London, 1954.

Mackie, Louise W. 'Piece of Puzzle: A 14-15th Century Persian Carpet Fragment Revealed', *Hali* 47, London, 1989.

Mallett, Marla. *Woven Structures: A Guide to Oriental Rugs and Textile Analysis*, 199

Mortensen, Inge D., *Nomads of Luristan*, Copenhagen, 1993.

Nasr, Seyyed Hossein. *Science and Civilization in Islam*, Preface by Giorgio de Santillana, Cambridge, Mass., 1968.
Sufi Essays, London, 1972.

Oberling, Pierre. *The Qashqa'i Nomads of Fars*, The Hague, 1974.

Petsopoulos, Yanni. 'Qajar Kilims of Sehna', *Hali* 31, 1986.

Pinner, Robert, 'The Earliest Carpet', *Hali* vol. 5, no. 2, 1982, pp. 111-15.

Ravandi, Morteza. *Tarikh-e Ejtema'i-ye Iran* (The Social History of Iran), vol. 5, Tehran,

Scarce, Jennifer M., ed., *Islam in the Balkans/Persian Art and Culture of the 18th and 19th Centuries*, Edinburgh, 1979.
'Role of Carpets within the 19th Century Persian Household', *Hali*, issue 6, no. 4, London, 1984.

Shaffer, Daniel, 'Persian Collection', *Hali* 34, London, 1987.

Spuhler, Freidrich. *Islamic Carpets and Textiles in the Keir Collection*, London, 1978.

Stone, Peter F. *The Oriental Rug Lexicon*, Seattle, 1997

Tapper, Richard. *Pasture and Politics, Economics, Conflict and Ritual Among Shahsevan Nomads of Northwestern Iran*, London, 1979.

Thompson, Jon. *Carpet Magic, The Art of Carpets from the Tents, Cottages and Workshops of Asia*, London, 1983.

Victoria and Albert Museum. *Brief Guide to the Persian Woven Fabrics*, London, 1937.

Wertime, John T. 'Flat-Woven Structures Found in Nomadic and Village Weavings from the Near East and Central Asia', *Textile Museum Journal*, vol. 18, Washington D.C., 1979.

PHOTOGRAPHY CREDITS
and courtesy of the lenders

Adil Besim: Plates 58, 101, 103, 141, 150, 158, 159, 169, 181, 182, 183, 186, 187, 190, 191, 195, 204, 223, 236, 243

Anonymous: Figure 77

Art and History Trust Collection, The: Figures 73, 74, 79, 81

Bani Ahmad, Bijan: Plates. 215, 216, 217, 218, 219, 220

British Museum, London: Figure 25

Carpet Museum of Iran, The: Plate 45

Cavanna, Roger: Plate 70

Chester Beatty Library, Dublin: Figure 60

Christieís London: Plate 46

Cole, Thomas: Plates 166, 167, 168

Contillo, Giuseppe: Figures 44, 45, 47, 48, 49, 50, 51, 52, 53, 54, 55, 65, 68, 69, 70, 72; Plates 196, 197

Craycraft, Michael: Plates 63, 134, 239

Dehghanpour, Yahya: Plates 5, 6, 32, 33, 90, 91, 100, 240

Ehteshami, Majid: Plates 36, 37, 38, 39, 40, 41, 42, 53, 59, 110, 115, 140, 175

Fogg Art Museum, Cambridge, Mass.: Figure 75

Haberli, Theo: Plates 21, 234

Harvard University Art Museum (Arthur M. Sackler Collection): Figure 80

Herrmann Eberhart: Plate 10

Hermitage Museum, St. Petersburg: Figures. 6, 8

Kailash Gallery: Plates 87, 135

Kasraian, Nasrolla: Figures 11, 22, 23, 26, 36, 37, 59, 78

Kirchheim, Heinrich: Plates 177, 228, 230, 231, 232

Klose, Christine: Figure 12A

Longevity, London, Plate 7

Marcuson, Alan: Figure 7

Metropolitan Museum of Art, New York, The: Figure 10

Murat Oriental Rugs: Plate 47

Musée de Louvre, Paris: Figure 4; Plate 1

Museum of Cultures, Basel: Plate 189

National Museum of Iran, Tehran: Figures 27, 28, 43A

Nazemi, Akbar: Plates 24, 25, 34, 44, 89, 107, 113, 123, 125, 129

Oundjan SA, Zurich: Plates 51, 157, 205

Petsopoulos, Yanni: Plate 50

Qajar, Ahmad: Figure 12

Residenz Museum, Munich: Plate 2

Rippon Boswell: Plate 47, 139

Sailer Gallery: Plate 61, 77, 238

Sadeqsa, Davood: Figure 5, 76; Plates 8, 9, 30, 31, 35, 43, 45, 99, 111, 121, 161, 162, 193, 194, 196, 197, 198, 199, 200, 201, 202, 203, 205, 206, 207, 208, 209, 210, 211, 212, 213, 214, 221, 222, 224, 225, 226, 237

Sadighi, Hamid: Plate 87

Salimi, Qasem: Figures 21, 29, 58; Plates 86, 192

Shaffer, Daniel: Plate 7

Sevruguin, Anton, Freer Gallery of Art, Arthur M. Sackler Collection: Figures 24, 67

Studio K. Hamburg: Plates 13, 14, 15, 16, 17, 18, 19, 20, 21, 22, 23, 26, 27, 28, 29, 54, 57, 60, 62, 64, 65, 66, 67, 68, 71, 72, 73, 75, 78, 79, 80, 81, 82, 83, 84, 88, 92, 94, 102, 104, 105, 109, 112, 116, 117, 118, 119, 120, 122, 126, 127, 130, 131, 132, 133, 137, 138, 144, 145, 146, 147, 149, 152, 155, 156, 160, 163, 164, 165, 171, 172, 173, 174, 176, 178, 180

Tanavoli, Parviz: Figures 3, 30, 31, 32, 33, 46, 56, 57, 61, 62, 63, 64, 66, 71

Thyssen Bornemisza Collection, Castagnola, Switzerland: Plate 3

Victoria and Albert Museum, London: Plate 233

Vok Collection: Plates 12, 49, 55, 70, 74, 93, 136, 142, 143, 148, 151, 153, 154, 185, 188, 229, 241, 244

Waibel, Joachim M.: Figure 1

Weber, Werner: Plates 11, 52, 56, 67, 76, 95, 96, 97, 98, 108, 114, 128, 171

Wertime, John T.: Plate 242

All drawings and maps by
Houshang Adorbehi

INDEX

Page numbers in bold type refer to illustrations and captions